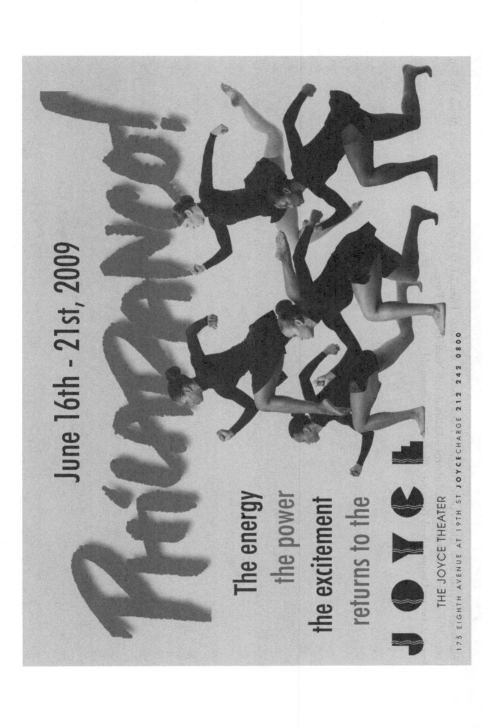

Philadanco in pose from Christopher Huggins's *Enemy behind the Gates.* From left to right: Crouching—Mora Amina Parker, Dawn Marie Watson, Elisabeth Bell. Airborne – Odara Jabali-Nash, Bellamy Eure.
Source: A.Turner Design/Alfred Turner Jr. Photo ©Lois Greenfield

Advance Praise for *Joan Myers Brown & the Audacious Hope of the Black Ballerina*

"Joan's artistic accomplishments and contributions to the dance world occupy a special place in history. Generations of dancers have her to thank for the doors she opened. For years, I've appreciated her wisdom, enthusiasm, and support. Joan has been a trailblazer in her professional life, and I feel fortunate to call her a friend."

—Michael M. Kaiser, President,
The John F. Kennedy Center for the Performing Arts

"Smoothly-written by our most accomplished chronicler of American dance and race politics, this essential volume demonstrates the impact black Americans have made in the performing arts against long odds. Brown's story will be familiar to every African American girl who ever wanted to be a ballerina. Newly mined documentation of the vibrant dance cultures of Philadelphia and the inner workings of Philadanco, the internationally recognized modern dance company that Brown created to international acclaim, provide cogent context to understand dance, gender, and especially race in the American performing arts. Gottschild reveals a hidden history of black ballet crucial to understanding the African American presence in contemporary dance."

—Thomas F. DeFrantz, author of *Dancing Revelations: Alvin Ailey's Embodiment of African American Culture* and Professor, African and African American Studies, Duke University

"*Joan Myers Brown & the Audacious Hope of the Black Ballerina*, a critical analysis of the life and work of Joan Myers Brown, is a visionary study that breaks new ground in several ways: It provides a much-needed history of the development of dance in Philadelphia, examining its unique racism as well as the more general racist values espoused by the entire country. It integrates oral history with a more general portrait of the community and its sense of identity, offering a commanding overview of the changing beliefs around African American identity and rights from the 1940s to the present. It details the vital relationship between a company, Philadanco, and its school and the staff who administer both. It shows how there are no rigid boundaries between the worlds of concert dance and entertainment and social dance productions. And it provides a brilliant analysis of the motivations on the part of the African American middle class to assimilate white culture but also to adapt it and make it their own. As in her other works, Dixon Gottschild gives us a deeply thoughtful and complex rendering of the participation of dance in the formulation of identity and community, one that also provides a powerful revisionist focus on the importance of Philadelphia in the formation of concert dance in the United States."

—Susan Leigh Foster, Distinguished Professor,
Department of World Arts and Cultures/Dance,
University of California,
Los Angeles

"In telling the story of Philadanco, Brenda Dixon Gottschild not only brings a dance company's history and vibrant present to life, she thoughtfully and insightfully discusses the ethos of Philadelphia, the lifestyles of its black community, changing race relations, and the decades-ago experiences of African Americans who, like Philadanco's spunky founder-director, Joan Myers Brown, aspired to be ballet dancers."

—Deborah Jowitt, dance critic and historian, and author of
Jerome Robbins: His Life, His Theater, His Dance

"Brenda Dixon Gottschild brings a bracing mix of scholarship and unsentimental compassion to bear on the story of Joan Myers Brown, a classy, feisty, eminently pragmatic visionary whose life and dance company occupy a vivid and important place in the largely unexamined history of dance in Philadelphia. This book is an indispensable good-read about an individual and her epic fight to make a place for herself in a world that did not accept black-skinned dancers like her and then to build and maintain a major American dance company. But the book is much more. In the detail of the day-to-day work of being a dancer and developing dancers against the odds, so vividly evoked, too, in Myers Brown's pithy and unexpectedly poignant observations, Dixon Gottschild has captured the struggle of black Americans to help shape the culture of their country."

—Jennifer Dunning, former dance critic,
The New York Times

JOAN MYERS BROWN & THE AUDACIOUS HOPE OF THE BLACK BALLERINA

Other Books By Brenda Dixon Gottschild

Digging the Africanist Presence in American Performance
Waltzing in the Dark
The Black Dancing Body
The History of Dance in Art and Education (coauthor, third edition)

JOAN MYERS BROWN & THE AUDACIOUS HOPE OF THE BLACK BALLERINA

A BIOHISTORY OF AMERICAN PERFORMANCE

Brenda Dixon Gottschild

Foreword by
Robert Farris Thompson

Afterword by
Ananya Chatterjea

JOAN MYERS BROWN & THE AUDACIOUS HOPE OF THE BLACK BALLERINA
Copyright © Brenda Dixon Gottschild, 2012.

All rights reserved.

First published in 2012 by
PALGRAVE MACMILLAN®
in the United States—a division of St. Martin's Press LLC,
175 Fifth Avenue, New York, NY 10010.

Where this book is distributed in the UK, Europe and the rest of the world, this is by Palgrave Macmillan, a division of Macmillan Publishers Limited, registered in England, company number 785998, of Houndmills, Basingstoke, Hampshire RG21 6XS.

Palgrave Macmillan is the global academic imprint of the above companies and has companies and representatives throughout the world.

Palgrave® and Macmillan® are registered trademarks in the United States, the United Kingdom, Europe and other countries.

ISBN: 978–0–230–11409–8 (Paperback)
ISBN: 978–0–230–11408–1 (Hardcover)

Library of Congress Cataloging-in-Publication Data

Gottschild, Brenda Dixon.
 Joan Myers Brown & the audacious hope of the Black ballerina : a biohistory of American performance / Brenda Dixon Gottschild ; foreword by Robert Farris Thompson Afterword by Ananya Chatterjea.
 p. cm.
 ISBN 978–0–230–11408–1 (alk. paper)—
 ISBN 978–0–230–11409–8 (alk. paper)
 1. Brown, Joan Myers. 2. African American dancers—Biography.
3. Dancers—United States—Biography. 4. Ballerinas—United States—Biography. 5. African American dance—History. 6. African Americans in the performing arts—History. I. Title.

GV1785.B3797G67 2011
792.8028092—dc23
[B] 2011024636

A catalogue record of the book is available from the British Library.

Design by Newgen Imaging Systems (P) Ltd., Chennai, India.

First edition: January 2012

10 9 8 7 6 5 4 3 2 1

With generous support from The Pew Center for Arts & Heritage through Dance Advance.

Transferred to Digital Printing in 2012

For JB, with love,
and
To the next generation,
and the next, and the next—
May our struggles be the labor
that births your triumphs

CONTENTS

List of Illustrations xi
Acknowledgments xv
Foreword: Ballet Becomes Black Uplift xvii
 Robert Farris Thompson
Prelude xxi
Prologue xxiii

1. **The Backdrop—1920s–1940s** 1
 Introduction and Background 1
 Early Black Philadelphia Dance Schools 5
 Essie Marie Dorsey 10
 Sydney King and Marion Cuyjet 25
 Joan Myers Brown: The Early Years 27
 Photo Gallery 1

2. **Spectacularly Black on Black—1940s–1950s** 33
 PART ONE 33
 Introduction 33
 Color, Caste, Dance—and Philadelphia's Black
 Bourgeoisie 36
 Role of the White Community: Interaction and
 Double Standards 40
 The Sydney-Marion School, Judimar School,
 Sydney School, and Trips to New York 48
 PART TWO 59
 The Annual Christmas Cotillion 59
 Recitals and Other Performance Opportunities 71
 Timing and Survival: Historical and Professional 81
 Photo Gallery 2

3. **But Black is Beautiful! 1950s–1980s** 91
 Introduction 91
 From Ballerina to "Beige Beaut" 92

A School and a Company 107
Photo Gallery 3

4. Nose to the Grindstone, Head to the Stars: The Philadelphia/Philadanco Aesthetic 135
 PART ONE 136
 Introduction 136
 Rennie's Ruminations: Laying the Foundation 137
 The Philly Sound 141
 PART TWO 143
 The Philadelphia/Philadanco Dance Aesthetic 143
 PART THREE 169
 Embodying the Aesthetic and Issues of Continuity 169

5. Audacious Hope: The House That Joan Built— 1980s–Twenty-First Century 187
 PART ONE 187
 Introduction 187
 Ensemble Dynamics/Keeping the Standard/Touring/ Community Outreach 189
 The Joshua Generation 201
 The Moses Generation 210
 PART TWO 223
 Funding Issues 223
 The Where/Why/How: Race Issues in Contemporary Practice 229
 Critical Gaze/Cultural Contexting/Community Voices 237
Photo Gallery 4

Epilogue 251

Afterword: Brenda Dixon Gottschild—A Critical Perspective 255
 by Ananya Chatterjea
 From Dorsey to Danco: A Philadelphia Dance Family Tree

Appendix 1: Joan Myers Brown—Annotated Resume 263
Appendix 2: Philadanco Home Seasons Repertory Chronology: 1975–2010 267
Appendix 3: Philadanco Choreographer Profiles 285
Appendix 4: Dance Practitioners Mentioned in Text 293
Appendix 5: Philadanco Activity Schedule 303
Appendix 6: Interviewees 307

Notes 309

Index 331

ILLUSTRATIONS

Visual "albums" appear at the end of each chapter and are numbered sequentially.

FRONTISPIECE

Philadanco in pose from Christopher Huggins's *Enemy Behind the Gates*

PHOTO GALLERY 1
appears between pages 30 and 31

1.1. Essie Marie Dorsey
1.2. Essie Marie Recital

PHOTO GALLERY 2
appears between pages 90 and 91

2.1. Dorsey, King and Cuyjet
2.2. Sydney School Recital Program
2.3. Judimar Handbill – 1950 Recital
2.4. Joan Myers Brown and Mary Johnson in performance
2.5. Joan Myers Brown and colleagues in ballet variation
2.6. Sydney School in *Jamaican Carnival*
2.7. Judimar School dancers
2.8. Sydney School flyer – front cover
2.9. Sydney School flyer – back cover
2.10. Billy Wilson and Joan Myers Brown
2.11. Delores Browne, Judith Cuyjet, and Franca Jimenez
2.12. Judimar Students around piano
2.13. Donna Lowe and Elmer Ball
2.14. Marian Anderson at Christmas Cotillion
2.15. Joan Myers Brown Cotillion Society Award
2.16. *Blue Venus* rehearsal

2.17. *Blue Venus* guests
2.18. Eighth Cotillion mailer/flyer
2.19. Poster—Ninth Christmas Cotillion

PHOTO GALLERY 3
appears between pages 134 and 135

3.1. Savar Dancers
3.2. Larry Steele's "Smart Affairs"
3.3. Joan Myers Brown with Billy Eckstine
3.4. Joan Myers Brown with Cab Calloway
3.5. Cab Calloway Revue—newspaper advertisement
3.6. Joan Myers Brown onstage—Larry Steele Revue
3.7. Joan Myers Brown backstage with Sammy Davis, Jr.
3.8. Atlantic City Events, with Joan Myers Brown as poster girl
4.1. The Philadanco Aesthetic Personified—Odara Jabali-Nash

PHOTO GALLERY 4
appears between pages 250 and 251

5.1. 1986 Philadanco fall Newsletter—cover
5.2. Philadanco—20th Anniversary events
5.3. Danco on tour—Germany
5.4. Panoply of Philadanco collateral designs
5.5. Letter from President Bill Clinton
5.6. Mural honoring Danco dancers/Philadelphia creative artists
5.7. Danco dancers in Gene Hill Sagan's *Elegy*
5.8. Danco dancers, group pose
5.9. Danco leaping men
5.10. Three male Danco dancers
5.11. Polish dance festival program—cover
5.12. "Dollar Day" Fund-raising drive
5.13. Philadanco/PSDA 40/50 Anniversary celebration
5.14. "Moving On"—Philadanco, 2011

FROM DORSEY TO DANCO—A PHILADELPHIA DANCE FAMILY TREE
appears between pages 262 and 263

FRONT COVER

1. Left—Atlantic City paste-up from JB's scrapbooks, Convention Center handout, July 1963. JB private collection.
2. Center left headshot of Joan Myers Brown. © Deborah Boardman, Philadelphia.
3. Center right, JB in black leotard, on pointe. Gaston DeVigne. The DeVigne family.
4. Far Right—JB as showgirl on pointe. JB private collection.
5. Portion of Sonia Sanchez poem dedicated to Joan Myers Brown. © 2011 Sonia Sanchez. All rights reserved.

BACK COVER

1. Left, top—Kristen Irby and Warren Griffin. © Deborah Boardman, Philadelphia.
2. Left, bottom—Old newspaper photo of young Joan Myers. Clipping cut out and pasted in JB's personal photo albums. JB private collection.
3. Top, center—Ghosted image of Savar dancers. JB private collection.
4. Bottom, center—Odara Jabali-Nash. © Lois Greenfield.

ACKNOWLEDGMENTS

To acknowledge is to know that I couldn't have done this work alone. I know/acknowledge that, though this book carries my name and represents three years of concerted effort with me at the helm of this ship, I had many "mates" on this odyssey—and it was, by definition, an odyssey—a long, adventurous, sometimes arduous journey.

Where to begin? First, thanks to JB—Joan Myers Brown—for putting up with me since August, 2008, with my interviews, probings, questions, clarification requests, and all the rest. With good reason, your generosity is legendary in this community. May this work do you proud! Thanks to the twenty-some-odd additional brave souls, listed in an Appendix, who allowed me interview time in their all-around heavy schedules. I can't say enough to thank Kim Bears-Bailey for the support she showed me every step of the way, taking time out of no time to shoot me information, seek out old performance programs, ease my tasks in countless ways. Engrid Bullock provided information, conversation, and a shoulder to lean on (if not cry) on, when the going got tough. Likewise for Vanessa Thomas Smith, then and now. Thank you, both, for a diplomatic, humanizing touch! Thanks to the dancers whom I've observed over these years in rehearsals and performances here and at the Joyce Theater: you are simply amazing treasures, with a fearless leader in JB! A shout goes out to Alfred Turner, Philadanco's longtime graphics designer, and to photographer Deborah Boardman, for standing at the ready when I needed help.

I thank Samantha Hasey, my editor at Palgrave Macmillan, for sharing my vision, giving me space, and encouraging me every step of the way to trust the process; production editors Alan Bradshaw (for calm, wise advice) and Heather Faulls; and my indexing guru, Lisa Rivero. And what can I say to Robert Farris Thompson, Ananya Chatterjea, and Sonia Sanchez, except a heartfelt "thank you" for your very special contributions to this volume.

Big props go out to Bill Bissell and The Pew Center for Arts & Heritage through Dance Advance. A truly generous grant in 2011 from this organization made it possible for Palgrave Macmillan to work with me and expand the

production values of this book as you, the reader, will witness. Thanks, Bill, for always standing behind my work and for acknowledging that Joan Myers Brown is a national treasure and a credit to Philadelphia. I also thank and acknowledge The Leeway Foundation for their generous Transformation Award (2009) that helped me get the ball rolling toward completion. An earlier Pew/Dance Advance grant (2008) made it possible for me to carry out the interviews essential to this project and to hire a research assistant—Takiyah Nur Amin, a spunky go-getter. I am deeply grateful for the support I have been given by these Philadelphia-based institutions.

The most recent Pew grant allowed me the "leeway" to assemble a dynamite team on the production end. I deeply appreciate and thank you all: research assistant Nadine Patterson, administrative assistant Vanessa Thomas Smith, public relations duo Laura Henrich (my sounding board, in so many ways) and Sacha Adorno, Kelly Holohan (who designed the Family Tree from my sorry sketches), and cover designer/photographer Lonnie Graham (who stepped in at the eleventh hour and saved the day).

Thanks to my peer readers, whose comments helped refine this product: Thomas DeFrantz, Susan Glazer, and Sharon Friedler. Neil Hornick, London-based literary consultant, again performed his mojo in reviewing and editing, early on, and deserves big-time thanks. I gratefully acknowledge Thomas Whitehead and the Special Collections Department of Temple University Libraries for their generosity in facilitating my use of the Joan Myers Brown Dance Collection. Almost all the reviews quoted in chapters 4 and 5 are housed in that Collection, as well as other treasures that were important contexting tools for this book. I credit the Charles L. Blockson Afro-American Collection, Temple University Libraries, for locating several important archival photos used in chapter 2. Anna Leo, Associate Professor in the Emory (University) Dance Program, performed an invaluable service in retrieving the Thulani Davis article from that institution's African American Collections while I was there to give a lecture—little things mean a lot!

Finally, I acknowledge, celebrate, salute, and thank my friends and family—the personal "team"—especially Ilse Pfeifer and Helene Aylon, lifetime friends who give constant support; George Dixon, my brother, who is always in my corner; Laru, Sky, and Sanji-Rei Larrieux (my son-in-law and granddaughters), whose presence alone inspires me; and dear Amel Larrieux—what a daughter!—who more than once has had to reverse roles and mother me through this process with her wise and loving advice. Last is for Hellmut, my soulmate, helpmate, lover, friend, critic, and confidant—the husband who husbands me—the Leo who keeps this Libran grounded, centered, present, and whole: thank you, liebling!

Thank you, all! May this book resonate your contributions. Om tare tuttare ture svaha.

perfection and self-realization through ballet. Dixon Gottschild assures us: "to be a black ballerina is not a simple rejection of one's African and Afro-American heritage but instead a challenge to those who would say 'stay in your place; your body, and abilities are not capable of doing this.' It's an embracing of our full heritage—black and white—just as white Americans can see fit to embrace black genres."

Joan Myers Brown welcomed men to her world of ballet, giving them movements that were strong. Like male dancers of mambo ballet, they gravitated toward athletic or acrobatic accomplishments, for the men of Philadanco, Brown's group, always were strong. Brown demonstrates: their "stride-like walks, wide-legged pliés, arms raised in a muscular fashion—in a combination of walking, stamping, running, turning, and jumping."

Joan Myers Brown was herself no less athletic, no stranger to feistiness. Like black running backs and wide receivers of the NFL, she liked to be challenged. Her forte was a combination of training in ballet, jazz, and show business.

Once, while working in the latter realm, a black impresario got mad at his dancers and in revenge commanded the orchestra to play fast. Gottschild remarks, "Barefoot modern dancer than I am, I naively asked how one could perform anything fast in three-inch high-heeled shoes with pointed toes:

Gottschild: You can't do high kicks and fast jazz in those heels!

Joan Myers Brown: Yes you can...you put your Dunham stuff, you kept your ballet stuff and stuff than I learned—you just incorporate everything you learn into whatever. And then we learned how to cut a step so that we don't do it full out. We'd cut part of a step so we could get to the next step.

Gottschild concludes, "The dancers trumped the wily producer and learned how to finesse any curve ball thrown their way. For JB it was part of the game: she relished the challenge." Her taste for contingency helps explain her conquest of ballet, a gift fed back into creative black Philadelphia via her school. Her dancers are trained not only to dance but to teach.

Joan Myers Brown translates the "smooth but funky," "sassy but classy" black Philadelphia dance into action. This inspires Gottschild to give us a chapter devoted entirely to the aesthetics of Joan Myers Brown and her world.

Philadanco style reflects Philadelphia "attitude." And this, in turn, presupposes toughness, energy, professionalism, and, southern small-town etiquette. But much has to do with sass: "Yeah? So? Get on with it!" This is pure Philly. Something is going on in the City of Brotherly Love that Mr. Jones don't know. Think of the jazz stars that grew up there—Philly Joe Jones, Rashied Ali, Sun Ra, and John Coltrane—and luminaries of tap and flash dance—Honi Coles and The Nicholas Brothers. Black Philadelphia teaches the world to be "on it"—all the time.

This leads to an unforgettable black ritual of self-assertion:

[Rennie] Harris: When we were younger, you couldn't be caught dead talking about performing if you weren't together, clean, and ironed.
I used to iron my money and put starch on it.
Brenda Dixon Gottschild: Ironing your money?
Harris: Ironing my money so it could feel like new, [fresh] from the bank.

Savor the ritual—iron and starch dollar bills with the care you'd address to your own shirt and jeans, and maybe your money, refreshed and clean, will bring you luck, and mystically multiply.

Read this book and be exalted. The accomplishments of remarkable black women in a remarkable city await you in dancelike freeze-frames, each shaped with clarity and poise.

<div style="text-align: right;">
Robert Farris Thompson

Col. John Trumbull Professor, History of Art,

Yale University

June 1, 2011

New Haven.
</div>

PRELUDE

I grew up on a black college campus in the segregated south, and I spent hours (because of a lack of babysitters) sitting in a corner of the dance studio at the college watching the students practice. I wanted to be like them and like my mother. And, you might be amused to know, that since my mother and these young women were the only dancers I had ever seen, it was some years before I found out that there were white ballerinas! My father later took me to see Maria Tallchief, which didn't exactly straighten that out. I was amazed, when I was in college during the sixties, that there was a problem with black bodies in ballet.
— *Thulani Davis*[1]

I gave my daughters ballet so they could know how to walk and create the picture I wanted. I wanted them to have an excellent education. I didn't want them to suffer the pains of racism.
— *Robert Joseph Pershing Foster*[2]

If you think you can dance without studying ballet, it's like thinking you can go to college without taking English.[3]

PROLOGUE

SATURDAY AFTERNOON, JUNE 13, 2009

I arrive around 1 P.M. at 9 North Preston Street, the West Philly location of the Philadelphia School of Dance Arts[1] and the Philadelphia Dance Company, also known as Philadanco. The building housing their joint headquarters stands in a humble, working-class neighborhood of mainly African American inhabitants that is on the way to gentrification due to the influx of white students from the nearby University of Pennsylvania community. Some years ago, in homage to its internationally renowned inhabitants, this short street was renamed Philadanco Way by the city of Philadelphia. Inside, the joint is jumping, but that's always the lay of the land all day Saturday and weekday evenings from September to June, when this dance center is in full swing. Three weeks ago, six hundred students performed in two separate recitals at the venerable Academy of Music on the stretch of Broad Street that's been renamed The Avenue of the Arts. Today, the last day of classes, is the coda: it's another season wrap, marking forty-nine years of continuous operation.

I enter the school through the narrow door on the Preston Street side of the compact three-storey building. I proceed past the student registration desk, situated in a small vestibule that opens into the center of a longish narrow hall whose walls are covered with awards received over the years. At the far end of this hallway are two small, oblong dance studios, the second one serving double duty as a costume room and, in the vest-pocket chamber tucked inside it, a one-on-one meeting space. At the near end of the hallway is a door leading to the main office. I check to see if anyone is in, and there she is—Joan. Joan Myers Brown. I'm the only one here who calls her by her given name, with no title or embellishment. To everyone else she's "Aunt Joan," "Mom," "Miss Joan," "Ms. Brown"—or, to the cooler types, simply "JB."[2] This building, this school, is her home, her world, and all who enter are her children.

More on her in a minute, but back to her home-away-from-home. Like Dorothy in Oz, once you enter the school, you know you're no longer in Kansas.

But neither are you "over the rainbow," because the atmosphere here is anything but otherworldly. This is the world according to Joan, and you are in the house that Joan built, powered by her steam and run by a cadre of women whose extraordinary commitment to prevail, against all odds, is what's kept this machine up and running, without interruption, for nearly five decades. And her organization has owned this property since 1982.

Here's what's going on today:

JB is in the front office, going through mail and doing other paperwork-driven catch-up tasks that never seem to end. This square space, the size of a small hotel room, is flanked by three cubicles that serve as offices for Engrid Bullock, Executive Administrative Assistant; Marlisa Brown-Swint, Artistic Administrative Assistant and the younger of JB's two daughters; and Vanessa Thomas Smith, General Manager.[3] Intermittently, Brown-Swint's zone is shared with the director of development Sandra Haughton[4] and part-timers hired to deal with fiscal matters. The area where JB stands contains the usual office equipment: mailboxes, desk, copy machine, and so on. Perched on a bookshelf, a couple of framed photos show a beaming JB with celebrities from African American show business and the dance world. But what makes this room unusual is the fact that every wall, shelf, and glass partition is covered with photos: snapshots of company members and friends, past and present; and pictures of everyone's children, grandchildren, cousins, nephews—babies, babies, babies! This is a matriarchal den of pride in parenthood, motherhood, sisterhood—family. It's a different way of thinking about professional space and the need to make—or blur—the boundary between life and work; and a slap in the face to mainstream notions of what the headquarters of a major arts organization should look like. It forces the newcomer on first entrance to adjust expectations and reassess value judgments. We are definitely not in Kansas.

On the other side of the main office is the door leading to an empty plot that serves as the school's parking lot. (Like Los Angeles, Philadelphia is a car-driven city; it's the only way to get around in a metropolis as spread out as this. Moreover, having an off-street parking facility raises the status of a business.) But today the parking lot is a back yard party, set up with a long table full of goodies—hot dogs, soft drinks, pretzels—that can be purchased for a token fee. Loyal parents act as volunteers, deftly taking care of the buying and selling while enjoying friendly chitchat on this fine pre-summer afternoon. Next, as I wend my way up to the second floor, I glance at the staircase walls lined with dance posters and framed photos of former members of the Philadelphia Dance Company, founded and directed by JB, as well as memorabilia from other companies and concerts. There is a sense of history on these walls, a black dance history that is beyond the achievements of this one ensemble.

"You can't exist in the black community without servicing a lot of needs. You can't just be a dance company, you have to do more." Those are JB's words, quoted from an interview she did back in 1995.[5] She lives what she speaks, and she and her staff are shape shifters when it comes to pressing studio space into community service. (Once, I found a baby shower going on in a downstairs studio; general meetings for the 2010 International Association of Blacks in Dance[6] (IABD) conference were held in the costume room.) Her commitment is acted out today on the second floor, in the large dressing room normally reserved for Company members, where an Aerosoles party is in progress. The space has been transformed into a makeshift shoe salon; footgear is lined up, on display for prospective customers, and a company rep is taking orders. And customers there are: women who've come to pick up their kids or grandkids, or who never left after they dropped them off, have brought friends to this event. Kim Bears-Bailey, a gifted former dancer with the ensemble and now its Assistant Artistic Director, sits next to me. We try on summer sandals while she dials up someone whom she encourages to come over and check things out. A nominal percentage of each transaction will go to Dance Arts, but that is not the point. More importantly, these events build up community trust and the sense that this school belongs to the people. And there's definitely a festive feeling in the air. People are having a good time, and the small fry are running around, playing tag, and waiting for Karen Still-Pendergrass[7] to finish teaching her final class of the season in the studio adjacent to the "shoe salon." One woman, trying on a fashionable sandal, turns to Bears-Bailey and points out a toddler whom she identifies as her great-grandchild. There are traditions and generations here: people who sent their children now send their children's children to study at Ms. Joan's school.

Soon this flurry of activity will be over and the second floor spaces vacated for rehearsal by the Philadelphia Dance Company, Philadanco—also affectionately known as Danco. Their New York City Joyce Theater season runs next week, and today's rehearsal begins at 4 P.M. This brings us back to Joan—JB—the grounding wire for the school and Danco. The school, the professional ensemble, and the youth groups (the Instruction and Training Program and its own performance group, known as D/2; and the Children's Program, also with its own performance unit, D/3) make up the three "halves" of JB's life.[8] (Since she works "24/7," year round, this woman needs an extra half-life.) Every dimension of her existence snakes through this squat building of shared spaces, so that the school and the ensembles contain and embrace both her personal and professional biography. In the second floor kitchen, adjacent to the upstairs bathroom and diagonally across the hall from the main studio used by the company, I've seen JB prepare lunches for her grandkids or, on Sunday mornings, prerehearsal

breakfasts for her dancers. (The flagship company trains and rehearses Saturdays through Wednesdays.) Usually, a pot of strong brewed coffee sits on the countertop. And then there's the third floor, up a steep flight of stairs—as narrow and dizzying as those in the houses on the canals in Amsterdam.[9] They lead to "heaven," everybody's tongue-in-cheek nickname for the top-floor private space where JB and Bears-Bailey can retreat to work in quiet, or Marlisa Brown-Swint can take her babies for a nap, and where I carried out many of the interviews for this book. All told, this edifice is peopled by folks who love JB and who love dance. Much, if not most, of JB's private life is centered in this building, and the extent of her sacrifice in creating her school and company is reflected in the single-focus nature of her life. *This is her life*, for which she compromised relationships with two husbands (who were often ignored for love of dance) and managed to bring both her daughters, Marlisa and Danielle, into this female stronghold. As adults they are members of the select nucleus of women who surround JB, having fashioned their lives of commitment based on her model, and spending the better part of their days at Danco/Dance Arts, making things happen.

But let us make no mistake or be fooled by the homespun, "Mom and Pop" neighborhood-store veneer. This is a sophisticated organization carrying out complex tasks under perennially difficult circumstances. It's a case of triple jeopardy: an arts organization run by a woman who happens to be black. JB has been described as a nurturer, a fighter, a giver, a believer. All of this is bundled into one dynamic lady who knows the value of tough love in the making of a dancer and shows it in her no-nonsense leadership style. It is remarkable that this willow-slim, 5-foot 5-inch-tall woman with the cool personality and sharp tongue has created a dance company whose reach has expanded from the black Philadelphia community that reared her to national and international renown. Hers was one of the first dance companies in the nation to provide fifty-two-week salaries for its dancers, and the first in Philadelphia to provide them with low-income housing. Though principally composed of African American dancers, Danco hires Diasporan black dancers (that is, from Africa, the Caribbean, and South America) as well as Asian, Latino, European, and white American artists. The company tours regularly, performing, teaching, and going on residencies nationwide and abroad.

BACKSTORY

When I moved to Philadelphia in the 1980s, I was introduced to and became part of a unique and fertile dance landscape that since then has grown and blossomed to become even richer and quite diverse. JB was and still is central to this picture. Her personal and professional history reflect hardships as well as advances

of African Americans in the artistic and social developments of the second half of the twentieth century and the transition into the twenty-first.

Born in 1931, JB began studying dance as a youngster. She cut her eyeteeth in the same Philadelphia dance classes that spawned the likes of Judith Jamison and Billy Wilson. Dance was her passion and, over time, became her mission. To give black dancers quality training, she founded the Philadelphia School of Dance Arts in 1960 at a time when racial discrimination kept African Americans out of white classes. Ten years later she formed the Philadelphia Dance Company so that her highly skilled black dancers would have performance opportunities commensurate with their awesome abilities. As a dancer herself, and in establishing her school and dance ensemble, she had to work against great resistance in a city where racial equality was not the norm. Against all odds and with "audacious hope" she succeeded in forging a national and international identity, and Danco tours are now a regular feature on concert stages and in festivals, stateside and overseas. Some who trained at her school or danced in her company have had careers with other world-class dance companies, such as the Alvin Ailey American Dance Theatre and Jiri Kylian's Netherlands Dance Theatre, as well as on Broadway and in Europe. Others have gone on to establish their own dance schools and companies across the nation.

Moreover, living up to her community commitment, she offers scholarships to needy children for the annual summer Danco Dance Camp. She renovated buildings on the run-down block across the street from her headquarters, transforming them into modest but comfortable living spaces for her dancers. In 1992, when Philadanco toured in Bermuda, she organized for community members and company supporters a low-cost "winter vacation," accompanying the ensemble for a weekend getaway on the island. She seizes opportunities wherever she sees them.

The book begins with discussion of a quartet of elite dance schools in the segregated Philadelphia of the 1920s, particularly the school of Essie Marie Dorsey, who mentored both Marion Cuyjet and Sydney King. In turn, and passing on the legacy, Cuyjet and King were JB's mentors. I examine JB's birth decade—the 1930s—as it affected Cuyjet and King, who were teenagers at that time. Contact with the Catherine Littlefield Ballet Company and other white dance professionals helped to shape a nascent aesthetic that would come to fruition in the founding of dance schools by both Cuyjet and King in the 1940s. It is remarkable that, despite their exclusion from the white ballet world, these women and their students nurtured the seemingly impossible dream of becoming professional ballerinas. I will consider the color-caste system in the black community and discuss

racial "passing," as both Dorsey and Cuyjet passed as white for limited periods in order to dance in white ballet companies (and occasionally to gain entry to venues prohibited for darker-skinned African Americans).

Some readers might ask why African Americans would dream of studying and performing classical European ballet. It's simply another example of black Americans' long struggle toward social and racial integration and equal opportunity with other Americans on every level—from the ballot box to the ballet stage. To be a black ballerina in twentieth century America was the artistic equivalent of staging a civil rights protest. If this book seems to be repetitive at times, it is because this area of dance history and practice has been so neglected that insistently pressing home the message (cultural, aesthetic, racial, societal) is a necessary corrective.

JB's beginnings are focal points for examining the artistic, communal, and sociopolitical climate of the 1930s through the 1950s. As in other cities, the existence of dancing schools in the black Philadelphia community indicates an upwardly mobile aspiration and potential and a radical departure from learning by imitating peers or dancing in the streets. As a child at the Dorsey school and later as an adolescent, the young JB was blessed with the guidance of an inspiring (white) high school dance teacher, commited mentors King and Cuyjet, and internationally renowned choreographer/teacher Antony Tudor. JB's life in show dancing and modern dance were a direct result of the fact that, as a black woman, she couldn't be a ballerina. Starting a school of her own in 1960 and a dance company in 1970 move the narrative to another level of social and cultural investigation. Through her life and career we can understand the Philadelphia example of performance and race as a microcosm that reflects American mores of the era but with its own singular characteristics.

JB regards Tudor as a major early influence. Beginning in 1949–1950, the English choreographer broke the city's color barrier by allowing her and other talented African Americans (including John Jones, Billy Wilson, and later, Judith Jamison) to take his classes. JB danced in Tudor productions presented by the Philadelphia Ballet Guild, but a bigoted remark in a local newspaper review helped convince her that the mainstream ballet world was not ready for a black ballerina. She commuted to New York City and studied ballet with Karel Shook and Dunham technique with Walter Nicks at the Katherine Dunham School. Later in the 1950s she entered show business, touring with Cab Calloway, Pearl Bailey, Sammy Davis Jr., and others. The implications of Dunham's teaching philosophy—that dance is a mirror of the world—had a profound influence on her after she ended her performing career and became a dance educator and company director.

FAST FORWARD

The Philadelphia School of Dance Arts is a world unto itself and teaches life skills along with ballet, modern jazz, hip hop, acrobatics, and tap. As the resident dance company at Philly's new Kimmel Center, Philadanco has two home seasons a year. There's also D/2 and D/3. JB is a constant presence at her school and with her programs. Despite her full plate, she still manages to focus concentrated attention on Danco, touring with the company, dropping in on dance classes, and occasionally teaching a company class.

And there is the larger picture. In 1991 she cofounded IABD to "preserve and promote dance by people of African ancestry or origin." Since then she also received an honorary degree of Doctor of Fine Arts from Philadelphia's University of the Arts, an honorary Doctorate of Humane Letters from Ursinus College (Collegeville, Pennsylvania), and is a Distinguished Visiting Professor at the University of the Arts and Howard University. This woman has walked the walk on behalf of dance. As it says in her resume, "She speaks out, talks back, and shows up."

Fulcrum — the point or support on which a lever pivots; an agent through which vital powers are exercised.
—*American Heritage College Dictionary*

The "fulcrum" definitions offer a supporting metaphor for JB's status and influence in the concert dance world and the nation's black community. In a professional career of fifty-plus years, her perspective and vision have affected generations of dancers and dance makers. Arguably, her Philadelphia School of Dance Arts and Philadelphia Dance Company are responsible for an approach to performance that I call the "Philadelphia School," paralleling the renowned Philly Sound created by composers Kenny Gamble and Leon Huff. (Unlike its musical counterparts, dance milestones are often "invisibilized.") I use JB's career and achievements as the fulcrum to leverage an investigation of the interface between performance, cultural formation, and race politics as evidenced by the development of a dance community in black Philadelphia and the rise and spread of its influence beyond community and regional borders to national and international distinction.

Although its focus is a person whose influence emerges from a specific setting, this work should not be construed as a regional study. It is an American primer — the story of a woman and the institutions she erected in tandem with the story of a community, a city, a style — a tradition.[10] I came up with the compound

word "biohistory" to describe my *biography-as-history* approach to this work; someone pointed out that the new coinage can stand for *biology-history* as well, meaning the *ecology* of this community—the interactions between the people and their environment. Both interpretations are valid. Moreover, the Philadelphia black community's dance tradition outstrips regional specificity and must be interrogated in terms of broader concerns in contemporary American life—issues of identity, social change, and cultural comfort levels—allowing us to understand that dance is, indeed, a measure of culture and a barometer of society.

Rather than attempting to cover every detail in her rich and ongoing life of service, I aim to present a chaptered album picturing highlights of Joan Myers Brown's growth, development, and influence. Each text portrait concludes with a visual album of photos and an occasional document. Beginning with the conditioning forces and circumstances that nurtured her, the book progresses through her performing career in show business and examines the wide-reaching impact of JB's legacy as a mentor and aesthetic agent in concert dance and matters of stage presentation that extend far beyond her Philadelphia beginnings. The "audacious hope" designation resonates with the title of President Barack Obama's second book, *The Audacity of Hope*. The phrase rings true for who our protagonist is and what she represents. Although unique to her time and place, JB's cultural ecology is a slice of American history that shares common ground with other African American stories. Nevertheless, and without a doubt, it is also a prototype for Americans of other ethnicities—an object lesson in survival, resolve, persistence, and reconciliation, particularly for those who have come through, in spite of social, racial, and economic constraints. It is a looking-back-leaning-forward weave of historical documentation, interviews, and critical analysis that resonates with African American twentieth-century history, on the one hand, and the promise of the new millennium, on the other. It may serve as a model for other communities of dance to tell their respective stories.

This book belongs to Joan Myers Brown and the dance environment and culture she helped create. As much as possible I have allowed the people who populate this ecosystem to speak in their own voices, with substantial portions of interview transcripts embedded throughout the chapters. So, now, let's begin.

CHAPTER ONE

THE BACKDROP—1920s–1940s

The worst colored dance school is better than the best white dance school for a colored child. They will have more love and attention, more one-on-one, and they will come out of there smiling.
—Marion Cuyjet, paraphrasing Essie Marie Dorsey

I didn't feel the pressures of being black. I felt the pressure of saying to myself, "You know you have to do better, so you do better. You work harder, or else you'll never get a chance."
—Joan Myers Brown

INTRODUCTION AND BACKGROUND

This book is about the urge, the desire—the *need*—to dance, against all odds. It begins as a story of elite performance in humble places, of growing up black in the United States of America at a time when racial segregation was so potent that the black poor, working class, and middle class lived together in the same neighborhoods and had limited access to, or were deprived of, the same services. But it is also the story of one community whose black elite's ceremonial, festive, and charitable traditions outstripped those of other communities, black *and* white. Keep in mind that such a tradition arose even though the black bourgeoisie (and a small community of aristocrats of color) lacked the financial means to compete with whites of similar rank and station. The economics of discrimination meant that a typical black person might work for a white or black employer in a menial position such as

a janitor, laundress, or seasonal farm worker. A number of working-class service positions in the white world—including sleeping car porter, caterer to white clientele, or maid or butler to a wealthy family—carried middle class status in the black community, despite the low wages accorded them. (On the job market in the white world, blacks were systematically paid less than whites employed in the same positions and performing identical labor.) Within the black community, middle-class status came from small business occupations such as dressmaker, tailor, carpenter, mortician, milliner, or owner of a beauty shop or barbershop. In general, white-collar positions in the white world—secretaries, salespersons, and such—were off limits to blacks.[1] African Americans with professional skills—doctors, teachers, nurses, lawyers, professors, and so on—were limited to serving the black community and its institutions. But they were unable to garner salaries equal to their white counterparts because, with few exceptions, their clientele—middle-class, working-class, and poor blacks—earned menial wages that kept them on the bottom rung of the American economy. At the same time, white privilege gave whites the license to travel between black and white worlds and to choose whether they wanted whites or people of color to provide services for them.

What this meant was that the black middle class had neither the assets nor the earning potential of middle-class whites; money in the black community never equaled the financial and buying power of white resources.[2] Nevertheless, this black middle class had status within its own community, and a class-stratified black Philadelphia evolved over time, composed of people in careers such as those just described and people whose skin tones were closest to white. "By the 1890s building and loan associations, fraternal societies, insurance businesses, libraries, political clubs, cemeteries, and labor unions all flourished within Philadelphia's Black community."[3]

Looking at the interaction between blacks and whites, we discover the double standards that are implicit in the coexistence of a dominating and a subordinated culture, and that account for the "double consciousness" that plagued African Americans, eloquently described by William Edward Burghardt (W. E. B.) Du Bois.[4] Early on, white culture relayed a message to the black subculture to self-reject, to assimilate, and to adopt white standards (by embracing Christianity, by "controlling" unruly hair, by imitating white patterns of speech). But the message created a double bind: blacks were to emulate white society but were prohibited entry into it, and that's where double consciousness comes in. Blacks were in it but not of it; they were obliged to bridge two worlds, black and white, in a delicate balancing act, seeing themselves through the eyes of white society as being both American and black—two ideals at war with each

other. For reasons of survival, blacks learned to "code switch," to be one kind of person in the black world and another when relating to whites—or perish. With free exchange prohibited, African American communities developed internal resources and an extraordinary capacity for self-sufficiency. Time and time again, in the Philadelphias across the nation, black folk engineered masterful reversals of circumstance, transforming what looked like a burden of defeat into a badge of success and, even with limited means, created self-support systems (forming financial savings societies, social clubs, church groups, athletic leagues) and myriad cultural and social forms (in dance, music, cooking, and everyday lifestyles) that counteracted self-hatred and generated racial pride. Whites lusted after and appropriated many of these artistic and quotidian styles as if they were their own creations. In turn, since cultural exchange is a two-way street, blacks embraced ballet, European orchestral music, and white forms of visual arts. The difference was that blacks came up against symbolic "No Trespassing" signs and could not perform or be taught these genres in white venues.

Like its sister communities nationwide, the Philadelphia African American community was inventive, intelligent, and ingenious in getting around barriers and making lemonade out of lemons. Rife with "firsts," and thus an early model for other black communities, the "City of Brotherly Love" is a seat of black history: The Free African Society, established in 1787 and assumed to be the first formal black organization in the Americas; the African Methodist Episcopal (AME) Church, established in 1816, with its leader Richard Allen the first black bishop; and the Institute for Colored Youth, established in 1837, the first high school for African Americans, are just a sampling.[5] In 1855, Philadelphia was also one of the first cities to feature a minstrel troupe composed of black performers (rather than whites in blackface).[6] Though today we regard minstrelsy as stereotypical and demeaning to blacks, it offered black performers a viable, successful means of employment at a time when their options were rigidly limited. With minstrel shows playing in theaters across the nation, it was the first form of legitimate stage theater to allow black participation. Moreover, African American dance and music styles that would otherwise have been lost were preserved, disseminated, and popularized by the black minstrels, who used these forms to express their artistry.[7] More recently, Philadelphia can boast a history of African American artistic excellence in European orchestral and operatic traditions, including the work of Marian Anderson in the mid-twentieth century and Eric Owens, the bass-baritone wonder of the new millennium.

Philadelphia's "colored society," to use the terminology of the times, dates back to the late-eighteenth and early-nineteenth centuries and was led by free individuals who had established themselves in trades and artisanal professions.

Amazingly, some of these blacks succeeded in buying up real estate and moving toward a high bourgeois status in their own enclosed world. Predating Du Bois's landmark study, *The Philadelphia Negro* (discussed later in this chapter), wherein the great sociologist delineated several social classes within the African American community, was a volume published in 1841 by one Joseph Willson, titled *Sketches of the Higher Classes of Colored Society in Philadelphia*, which focused exclusively on Philadelphia's black aristocracy.[8] Willson's intention was to "disabuse whites of their inclination 'to regard people of color as one consolidated mass, all huddled together, without any particular or general distinctions, social or otherwise' and to hold the 'errors and crimes of one...as the criterion of the character of the whole body.'"[9] Willson cited wealth, education, station, and occupation as the grounds for social distinction in this community. He delineated what is now known as "Old Philadelphia" society, a term used in both the white and black worlds, and on the black side, dating back to a cadre of early families that had established hegemony over two centuries earlier.[10] But separate is not equal, and a vicious cycle of second-class citizenship has trapped generations of African Americans. Before the civil rights era beginning in the 1960s, the situation was dire overall—in spite of remarkable exceptions—and the options for getting off the wheel of "misfortune" were few and far between. This may be one reason many light-skinned blacks who could pass for white took the opportunity to do so, as a way of moving on.

In the 1930s Marion Cuyjet became one of the first black dancers to perform in Philadelphia with a white ballet company. Granted, this occurred by default and, in the spirit of making headway, by hook or by crook. Philadelphia's Littlefield Ballet Company did not realize that Cuyjet was black until her friends came to visit her after a performance. Needless to say, her tenure with the group was abruptly ended. Cuyjet recounted this incident when I interviewed her in 1985.[11] Like many white-skinned blacks in similar positions, she was passing by omission rather than commission—meaning that she didn't declare that she was white or that she was black when she applied to the school. She just allowed circumstance and the general assumptions about skin color to hold sway. Her example points to issues central to this story and will be discussed more fully in the next chapter.

Making a substantial but necessary digression before moving on, I must give attention to W. E. B. Du Bois's study *The Philadelphia Negro*—a major assessment of the Philadelphia black community carried out a generation before our story begins. Du Bois's monumental project sets the stage for any debate about African American class, caste, or social ecology. By 1896, when he was invited by white reformer (and aristocrat) Susan P. Wharton to the University of Pennsylvania and to

the College Settlement Association (part of the mid-nineteenth-century settlement-house movement across the nation that served the urban poor) to study the status of Philadelphia's African American populace, the city had the largest black population north of the Mason-Dixon Line.[12] Du Bois's research and subsequent book are, arguably, the milestone that marked the birth of American sociology.[13] A tome almost 600 pages long, *The Philadelphia Negro* contained categories of information that together provided a sophisticated, scientific portrait of the community. Divided into four sections, seventeen chapters, and including three appendices, it did not describe a wash of unmitigated poverty and lack of initiative that would fit white assumptions about the urban black community.[14] Instead, what emerged was a picture of a multilayered, complex neighborhood of diverse interests. It included Du Bois's minutely detailed street maps of the Seventh Ward[15] — the focus of his study and the area that, though integrated, housed the largest concentration of the city's black populace. By canvassing each household (with helpers from the Settlement Association) and carrying out house-to-house interviews with all the African American families, gathering information from 9,675 informants, he was collecting data by a means and in a volume that had never before been gathered on any one community. He identified four social classes: the "middle classes and those above," the working class, the poor, and the "vicious and criminal classes."[16] He showed how important it is to examine class when studying the African American community. And, rather than letting his work rest on its academic laurels as a landmark sociological study, he exercised political acumen by urging the black aristocracy and middle class not to separate themselves from "the masses" but to educate the "talented tenth"[17] of the African American population to lead the rest toward the rights of full citizenship. It was a radical idea at the time in white America to suggest that there existed an African American elite capable of assuming leadership of its own people. Du Bois's theories of the talented tenth and double consciousness were driving forces in the cultural and political formation of twentieth-century black thought. And Philadelphians, in the seat of his pioneering study, soaked them up.

EARLY BLACK PHILADELPHIA DANCE SCHOOLS

When we look at a dance form like ballet, we see that, in a general sense, it served the same function in black and in white America. Besides being an art form pursued for pleasure or professional aims, it was a symbol of privilege signaling a level of acculturation inaccessible to the masses. Regardless of dance genre, attendance at dancing school was, in itself, a status indicator, and the person who studied pointe and went up on her toes was often idealized above the one who "got down" and tapped or stomped. It was not surprising that a ballet tradition would take hold in

black Philadelphia. This community's achievement in the arts has never lagged far behind its white counterpart. The period between the two world wars saw the rise of dance studios in the black community as well as the advent of the Littlefield Ballet (1934), which itself was one of the first American ballet companies. Modeling itself on the white upper class, the black bourgeoisie granted prime status to black people who successfully appropriated white cultural forms, and they accorded the greatest esteem to blacks who looked the most white—ironically, most like their oppressor but simultaneously most like who they aspired to be. It was this class-stratified black Philadelphia community that nurtured and supported a concert dance tradition, indicating a black upwardly mobile aspiration to co-opt and be identified with European-based fine arts, and thus with the white upper class. This was W. E. B. Du Bois's talented-tenth ideal in action.

By the 1920s a concert dance culture began to emerge in black Philadelphia. With no performance outlet of their own, black dancers appeared on vaudeville programs and also worked a thriving, semiprofessional circuit, performing at such community-based social events as teas, fashion shows, and the yearly recitals that most dancing schools sponsored. These were the same performance venues for white concert dance as well, so that emerging modern dancers such as Ruth St. Denis, Ted Shawn, and Martha Graham were billed in vaudeville programs and performed at society events. Both black and white traditions are indebted to the turn-of-the-century iconoclast Isadora Duncan, who opened the concert stage for dance to be recognized as a bona fide art form. There were no American ballet companies extant in the early twentieth century, but Russian dancers, including Anna Pavlova, performed in the United States and incited a keen interest among American dancers. Like modern dance, ballet did not have its own performance venues at the time and might appear on a vaudeville program, in an upscale cabaret, or a rented concert hall or institutional auditorium.[18] The role of modern dance is significant in the telling of this story, since the company created by Joan Myers Brown (JB) in 1970, though ballet oriented, is a modern dance ensemble.

The earliest black schools followed the white tradition of the neighborhood studio dedicated to the acquisition of social graces, dance being one of them. According to Marion Cuyjet, four ladies pioneered the black dancing-school movement in Philadelphia—Edith Holland, Jenny Squirrel, Willa Walker Bryant Jones, and Essie Marie Dorsey:

> All these ladies were of the same type of what we called "colored elegance." They looked as though they could have been related. They were all light-skinned; they looked like Creoles. They had extremely good

posture, very lifted, and their hair was always done very high in a bun, and they wore nice jewelry, and they spoke in a lovely manner.

Cuyjet's description—virtually a paragon of feminine gentility—jibes with my assessment of the black caste system based on skin color and imitation of white etiquette. She conjured up memories of her childhood in a vivid account of a past era that today may seem dated but was the foundation upon which she and her friend and colleague Sydney King built their professional careers and the tradition that nurtured JB. Her account puts the four teachers in a social and cultural perspective:

> As I moved around with my mother through South Philadelphia[19] social events and what have you, I would hear their names mentioned often, or that a child or a relative's child attended their classes, or their little girl was taking elocution lessons. Elocution was a big thing then. Of course, we were into an elegant-type era. During the late twenties and early thirties, teas were the social thing to attend, and there would be two or three children performing elocution from Jenny Squirrel. Then they would do some dance steps that were mostly pointings and closings [of the feet], bourrées [a quick succession of small steps on the half-toe], circling around, and curtsies. It was almost a very nice folk dance step. They were learning social graces and that type of thing. When I was in my teens, I don't remember hearing anything more about Jenny Squirrel. She seemed to disappear from the scene....
>
> Willa Walker Bryant Jones's work was more clarified [*sic*] as a dance teacher. She didn't claim to be an elocutionist. She was a dance teacher. I was six years old when I started seeing Willa Walker Bryant's picture as I was passing by on my way to school. That was in 1926. [I had interrupted and asked for dates. Cuyjet was born in 1920.] She had to have been operating for five or six years. I used to pass her place on Twenty-Second Street, on the corner of a small street between Reed and Wharton [in South Philadelphia]. She had a display window with photos of her dancers. They were all white, except there would be one colored child's picture. I understood from seeing the photos that most of her clientele came from the Jewish merchants' children from Point Breeze Avenue, which was then a big shopping center.

At this point, a brief intervention in Cuyjet's marvelous flow (and photographic memory) is relevant to comment on another ethnic group that was striving to

look like, and be like, the white mainstream—namely, the Jews. Immigrants for decades prior to the 1920s, they, too, were relegated to certain types of work, including ownership of such consumer services as delicatessens, department stores, pawn shops, and jewelry stores. The two populations were both struggling to be part of the mainstream, sometimes pitted against each other and sometimes working together. Without a doubt, the Jewish population was several steps ahead of African Americans in terms of economic well-being and the possibility of assimilation. Perhaps the fact that Bryant Jones's primary clientele was a "borderline" population—since Jews, at that time, were not considered white—was a way to ease her own acceptance by, if not entry into, the white mainstream. Cuyjet continued,

> Dancewise, Willa was doing more [than Squirrel]. There was more movement. There was a definite ballet intention there, and of course that was the style then. People didn't expect anything more: they didn't expect any [high leg] extensions or acrobatic moves.
> Edith Holland had a studio in her home. It was around or on Diamond Street in North Philadelphia. My cousin studied with her. In fact, she has a couple of pictures of herself, the same typical pictures, sitting on a piano bench with the legs crossed, the ribbons [of her dancing slippers] tied all the way up to the knees. I think she was about three or four years old.

I asked Cuyjet if she knew anything about their professional backgrounds, with whom they might have studied, where and if they had ever performed. In order to formulate her response, she astutely compared the photos of the student body and the teaching methods of Squirrel, Holland, and Bryant Jones and then contrasted what she deduced from the photos with what she experienced studying with Dorsey:

> I'm sure they didn't [have a professional dance background to equal Essie Marie Dorsey's] because I can still remember the pictures that were in Willa's window.... Their ballet slippers had ribbons applied to them as though they were toe shoes...and they were tied all the way up to their knees, like Roman gladiators. They couldn't have done very much, because ribbons tied over the calf of the leg would slide all the way down to the ankle when you began to move. And the costume— they seemed to have a chiffon dress that was shaped like a bell when

they sat down. It probably opened like a bell when they turned. It was all accordion pleated from the neck down, sleeveless, or with a little cap sleeve; and they all had a ribbon, wide, tied around their head, which went into a big bow on the side.

[If Dorsey's students had been photographed, they] would be in actual tutus—the long, romantic tutu or the short tutu—with headgear appropriate to the role. They wore tiaras or bonnets. During that era, we danced a lot in the romantic length [skirts] with bonnets or large, horsehair-type hats and parasols. Also, lots of her students would be on pointe—and on good, sound pointe. They would be postured in one of the poses, and they would not be seated. In Willa's photos, many of them were seated with their little legs crossed, dangling. Arm positions seemed to be the main thing. Leg work was really absent.

Dorsey's pictures would include tap dancers in motion poses, with canes, top hats or derbys, and Ruby Keeler black shorts or trunks, and the white satin blouse with the big, full sleeves or the halter-neck bra.... You would see Dorsey's students with high extensions, but not the other dancing teachers.

Some of Dorsey's faithful students who went on to professional dance careers—including Cuyjet, Sydney King, Jerome Gaymon, and Louise Carpenter—saved newspaper clippings and printed programs that authenticate their recollections.[20] However, there is no way of knowing how Squirrel, Holland, and Bryant Jones entered the dance field or with whom they studied.[21] My guess is that, given their ability to pass racially, they took classes in ballet or early modern dance—probably the Delsartian system of aesthetic and gymnastic dance—with white teachers in Philadelphia or elsewhere. These turn-of-the-century dance genres were in fashion among the middle class as a badge of social grace. Cuyjet continued her admiring appraisal of her teacher and mentor—and later, friend—contending that Dorsey's studio was set up for "hard work," with ballet barres of different heights for young and older kids and "a complete line of acrobatic mats. We went there to sweat."

Through her mother's social circle, Cuyjet knew of the Dorsey school well before she began studying there. Her mother took her to two recitals that she remembers vividly: "They were held at the old Broad Street Theater" (which indicates that it was 1931, as is explained in the next section). Cuyjet was eleven. "I loved the shows. Dorsey herself was a beautiful dancer. She danced four or five times in her own show."

ESSIE MARIE DORSEY

In 1977, Joan Myers Brown wrote an article on Dorsey in the *Philadelphia Tribune*—the oldest continually published African American newspaper in the United States, created in 1884. She opens her essay with the following quote from William Dollar, the (white) internationally renowned dancer, choreographer, and ballet teacher, who was a lifelong friend and dance coach to Dorsey and her star students. Dollar said, "Essie Marie Dorsey deserves a place in black history as a pioneer spirit for the advancement of the black dancer in American ballet."[22] Yet despite Dollar's words and JB's tribute, Dorsey and her followers remain invisible in the annals of dance history and American and African American history, and black dancers are still the exception in American ballet.

The printed program for Dorsey's memorial service (June 13, 1967) states that she was born in 1893 in Goldsboro, North Carolina, and raised in New York City. JB's article mentions that she lived in Atlantic City, New Jersey, and Baltimore, Maryland, before moving to Philadelphia. She purportedly studied with Mikhail Mordkin (and may have performed in his dance company, with audiences assuming she was Spanish); with Michel Fokine; and at Denishawn schools. There are no records to prove these contentions about her training, but from newspaper clippings, photographs, and anecdotal evidence, it is clear that she studied with respected leaders in her field and, as with William Dollar, maintained professional contact with them throughout her career as a teacher and dance school director. She married a community political leader, H. La Barr Potts, in 1923; opened her first studio in 1926; and for a while had an extension school in Harlem, which she opened in 1929. She was divorced from Potts in 1931. In 1932 she married Carroll Dorsey, who died in 1951. (Although known as Mrs. Potts until her divorce from Potts in 1931, I refer to her as "Dorsey" throughout this book. She was known as Essie Marie Dorsey from the time of her 1932 marriage until her death.) For three decades she was a popular figure in Philadelphia black society. Besides her enormous contribution as a teacher and role model, she was instrumental in establishing, building, and developing black organizations that became hallmarks of the Philadelphia black bourgeoisie and that, in charity matters, benefited the entire black community. She was a founder of the Germantown Civic League; a charter member of the Philadelphia Cotillion Society (the city's legendary Cotillion balls are discussed in chapter 2); the head of the Dra-Mu Opera[23] Dance Department; and at one point the writer of a social graces column for the *Philadelphia Independent*, another black community newspaper. As a member of the Mercy Service Club, she and many other well-heeled black Philadelphians raised funds for Mercy Hospital.

A major achievement for the black community of West Philadelphia, this facility was built to serve the black community in an era when white hospitals could, and often did, turn black people away.[24]

Dorsey's first studio was in her home in Southwest Philadelphia, at 1208 South Forty-Sixth Street, around the corner from the home of little Sydney King. In my 1985 interview with King, I asked her how she found out about the school. She said that Dorsey "came around the neighborhood and knocked on doors and asked parents." King explained that Dorsey had transformed the second floor of her home into a dance studio, "and it was only around the corner, so I could go by myself, and it was only fifty cents [per class]." King continued studying with Dorsey, thrilled with the lessons and recitals, and when King was about eleven years old, Dorsey moved her studio to 711 South Broad Street, on the second floor of the Elate Club, a cabaret.[25] Sometime around 1939 (the year King married), Dorsey moved again, this time to 525 South Broad Street, into studio space in the Apex Building, an edifice that housed the Apex Beauty School, where many black women went to buy the company's hair products or to have their hair done at bargain prices by beauty school students.

The Broad Street locations of Dorsey's school attracted a wide geographical range of students, probably more so than her black predecessors. When interviewed in 1985, JB said that "her school was the biggest [black] school in the city. Everybody went to her. There weren't many white there, and some you couldn't tell if they were white or light. You know, it's that kind of thing with our racial mixture." That year, I also spoke with a number of other people in the black dance community, some of whom are now deceased, including the late John Hines, who had been trained by Dorsey and was still a renowned and revered teacher when I met him. With regard to the racial diversity of the school, his description parallels JB's:

> Mostly children of professional people went to her school. She had some Italians whose parents were crazy about her because she [hers] was better than all the white schools. She really knew her ballet, and she could still dance it and still get on pointe. That was her main thing. She also knew Spanish dance and played castanets, Flamenco style. And she looked Spanish. She had long hair, and it was wild when she let it out.

Dorsey and her star students were performing as well as studying and, according to Cuyjet, "were out all the time, dancing at teas and benefits, NAACP [National Association for the Advancement of Colored People] membership meetings, in addition to Mrs. Dorsey's annual recital." The Dorsey school

offered a curriculum of ballet, tap, acrobatics, and social dancing. As for tap, Cuyjet recalled that

> Mrs. Dorsey would engage tap teams who were in the city working at the Lincoln [one of the vaudeville theaters on the black touring circuit] and then working around in other clubs. I remember she would send either Sydney or myself, and we would have to go and wake them up on Saturday to remind them that they had a commitment to teach our tap class. We had to go to the Dunbar Hotel, which was on top of the Showboat [cabaret].[26]

These tap dancers taught professional routines to student teachers, including Cuyjet, Hines, and King, who in turn taught them to the general classes. Students were also taught to use castanets and cymbals for ethnic dances. This array of dance styles was typical for the era's dance culture, both white and black, reminding us that cultural exchange is a two-way street, in spite of segregation and discrimination. Dance schools on both sides of the racial divide were teaching a similar curriculum, and their recitals mirrored one another in the styles and genres represented. Later, as her star students' technical expertise so warranted, Dorsey engaged Thomas Cannon, a principal teacher at Philadelphia's white Littlefield Ballet School, to give them private classes, since black students weren't allowed to study at the white school.

On a possibly even larger scale than their white counterparts, the Dorsey recitals were lavish spectacles, creating a tradition that King and Cuyjet continued in their own dance schools. They were held in the late spring at locations such as Town Hall, Plays and Players Theater, and the Fleischer Auditorium of the Broad Street YM/YWHA.[27] Parents and students were enlisted to make costumes, sell tickets, and act as ushers or stagehands. The sets for certain theme dances had to be built, assembled, and painted. Rehearsals began months in advance. The recitals were written up in the society pages of the black Philadelphia newspapers, listing who had danced what and who had been in attendance. Hines recalled one Dorsey recital number whose theme was "Tumbling into Health," in which students did somersaults and performed acrobatics as part of the routine. King reminisced, laughing, telling me that she had

> about seven dances to do in every recital. We had a ball doing Indian dances. One year my sister and I both had the mumps. We came to the recital with our heads all tied up, and we ran out there [onstage]. We were Japanese that year.[28] We didn't look too bad, but we were all

swollen up.... I did the [*Dying*] *Swan* one year, and that was beautiful. That whole dance is done on toe. You don't get down until you're finished. I remember that. I must have been about sixteen. She [Dorsey] wouldn't let you do dances that were too old for you if your age wasn't up to it. She did this gypsy dance, but [she told me] I wasn't old enough to do it. She said, "You think you can, but you haven't lived long enough, and you have to understand what you're doing." She was very precise on those things.

Echoing King's recollections, John Hines remembered Dorsey as a strong teacher who

would know who could do things and who could not. By just seeing them for a little while and looking at them, she could tell exactly what they needed, and then she would work on it. That was one of her best features. Discipline was one of her strong points too — very strong with Marion [Cuyjet] too. Marion is almost another Essie: strength and stamina — living through the dance.

Clearly, Hines's statement overlooks her faults, whatever they might have been, and embellishes Dorsey's strengths. In any case, Dorsey began a teaching tradition in black Philadelphia that was carried forth by King, Cuyjet, and Hines and continued in the next generation, represented by Joan Myers Brown and Arthur Hall, among others. Hines noted that Dorsey took in anyone who could dance and gave out many scholarships, a policy that her followers continued in their own studios. Hines, one of the few boys at the school, "took every class she had. I saw ballet at first by standing at the door. I was to take the acrobatic classes, and before you knew it she had me with some of the little kids [Hines was fourteen at the time] showing them how, because she saw how loose my back was. Then she asked if I wanted to take tap, and I said 'yeah' and smiled from ear to ear!"

Teacher training was an important part of the professional dance experience for all of these leaders. I asked King how she learned to teach, and this is the process she described:

She [Dorsey] would say to me, "Sydney, take [so-and-so] over in the corner and show them how to do [something]. I must have been about eleven. Then, when I was twelve, I went to Darby, Pennsylvania [a nearby city suburb], once a week to teach a class there at a center. And then, when we were at 525 [South Broad Street], I used to teach social

dancing when they were doing the Big Apple and the waltz and the foxtrot and things like that. I was eighteen by then.

Dorsey's clientele was composed of children and adults. But, in the tradition of the true dance *maestra*, the desire was to nurture and develop select, gifted dancers from childhood through adolescence and to usher them into a professional career. It was also a custom for the best dancers, like King and Cuyjet, to become wards of their mentor, a tradition that owes its roots both to the ballet world and the African American extended family custom of guardianship. According to King, "I liked pleasing her because she was real nice...like a mother to me. She was my matron of honor when I was married, and she bought all my wedding stuff for me. She was a really nice person. She never had any children."

Dorsey, Du Bois, and Washington

The collection of Dorsey's newspaper clippings and recital programs (passed on to me by Joan Myers Brown and Marion Cuyjet), sketch a picture of a woman who indeed could have easily passed for white but who set her stakes on her African American identity and the possibility of bringing European-based forms of dance, manners, and mores to the talented-tenth of her community—to once again use W.E.B. Du Bois's term—and to create such a culture inside the community. Indeed, it's quite possible that Dorsey, like many of her generation, was directly influenced by this concept. She can be regarded as a member of the talented tenth and, by bringing ballet into her community, could be understood as inviting others into the fold.

At this point in our story, to delve deeper into Du Boisian theory and its ramifications for Dorsey and her ilk in the culture of early twentieth-century black Philadelphia, another considerable but necessary digression is in order. First articulated in print in *The Philadelphia Negro* (1899, hereafter referred to as *TPN*), "The Talented Tenth" was the title and subject of an essay Du Bois published in September 1903 that had an impact on the trajectory of the NAACP and "Negro" thought for generations to come, and, like his double-consciousness concept, is a phrase that has been part of academic parlance ever since.[29] As explained earlier, and resonating with the title of the NAACP (an organization Du Bois helped to establish)—namely, an "association for the advancement of colored people"—the theory of the talented tenth posited a select cadre of African Americans, probably one in ten, who would pursue higher education and intellectual and social pursuits in the service of working for social change. These individuals would obtain a European classical education rather than the industrial course plotted

by the Tuskegee Institute's first president, Booker T. Washington,[30] who believed blacks should train for trade and agricultural employment.

From the beginning, Du Bois's theories and politics stood in stark contrast to those of Washington, his major opponent. From the late 1890s through the early 1910s, when Washington passed away, these two giants, both with convincing premises, were pitted against each other in a contest that was actually controlled and manipulated by white establishment powers — political, social, and industrial — to advance their own agendas and beliefs concerning how best to utilize, benefit from, or perhaps solve "the Negro problem." In 1899, Du Bois's *TPN* was published; that same year saw the publication of Washington's *The Future of the American Negro*. A coeditor of the *Yale Review* wrote a brief review of both books in 1900.[31] Of *TPN* he said, "It is the sort of book of which we have too few, and of which it is impossible that one should have too many.... [W]e have long held that it is in monographs like this that we shall be likely to find the most trustworthy help in solving our great racial problem." (The online editors comment that, although the author of the review praised Du Bois's work, the reviewer "did not fully escape a patronizing tenor,"[32] a problem that reflected the Eurocentric preconceptions of the era. Nevertheless, it is not dissimilar to our own millennial zeitgeist, with many whites failing to acknowledge that the race problem is more a white problem than a black one.) Regarding Washington's book, the reviewer had this to say: "Mr. Washington's work is not that of a scholar, but of a shrewd, sane and tactful leader of the people and administrator of affairs.... His book is a contribution, not to knowledge, but to that good temper and good sense which is perhaps of equal importance."[33]

Each position represented by these two outstanding black leaders had white support. Northern white liberals like Susan Wharton (whose name lives on through the University of Pennsylvania's Wharton School of Business); a number of Yankee academics like the above-quoted *Yale Review* editor; and social reformers, including Jane Addams, John Dewey, and Lincoln Steffens, supported Du Bois. Conservative white industrialists, businessmen, and philanthropists backed Washington. One of his major supporters was Andrew Carnegie, the steel magnate. These individuals supported the Washington program because it assured them a relatively cheap nonunionized labor supply from the African American working class.

In a nutshell, Washington's strategy was economic-industrial, while Du Bois's was educational-political. Both positions are justifiable. Given the horrible conditions that existed for African Americans in the postslavery, post-Reconstruction era (1880s–1920s), when lynchings and other blatant forms of racism were a common occurrence, Washington's realistic program was about

cautiously moving forward, one step at a time, in a way that would not contest white supremacy or make claims for equal rights and shared, racially integrated public spaces. Unfortunately—because this clearly was not his intention—Washington's strategy of "separate but equal" remained the modus operandi for white America in its relationship to black Americans until the 1960s. In fact, whites could rationalize their racism by asserting that Washington's policies reinforced the legitimacy of *Plessy vs. Ferguson* (the Supreme Court decision in 1896 that gave legal sanction to "separate but equal" public facilities). But Washington envisioned the separation of races and the menial-industrial-agrarian work ethic only as a starting point for African Americans to show their mettle and to finally be accepted as "worthy" of full citizenship by their white neighbors, some of whom in the South, which was his domain, came from formerly slave-owning families. However, this position implied that Washington accepted the premise that African Americans were lesser citizens than whites, even if only in his era and generation.

Du Bois could not, and would not, accept this doctrine of black inferiority, based on his own experience. He was a northerner, a Yankee whose family had gained its freedom by serving in the Revolutionary War; Washington, whose father was white, had been born enslaved. In 1895 Washington gave a speech before a group of southern white industrialists at the opening of the Cotton States and International Exposition held in Atlanta, Georgia—the same year that Du Bois earned his PhD in history from Harvard University. It is worth noting that both were firsts: Washington was the first African American to address such a powerful and large group of white southerners, and Du Bois was the first African American to receive a Harvard doctoral degree.[34]

Du Bois was a forerunner of the civil rights era of the 1950s and 1960s, and his NAACP was at the forefront of the struggle for integration, a challenging concept that even today raises some white hackles. What researcher Isabel Wilkerson said about the relationship between Du Bois and Rufus Clement (the president of Atlanta University who fired Du Bois from his professorship in the 1940s) was also the case with regard to Du Bois and Washington: "The two men were the very embodiment of the North-South divide among black intellectuals."[35] What we may conclude, with the twenty-twenty vision of hindsight, is that both approaches could be supported simultaneously—that it wasn't a matter of either/or but both/and. In any case, we can understand the talented-tenth concept as providing a raison d'être for the black bourgeoisie nationwide.

More than a digression, this essential sidestep into African American history helps us locate the aspirations and inspirations of the socially responsible

contingent of Philadelphia's black bourgeoisie: its intimate connection to Du Bois through *TPN*; its consciousness of living in two worlds, black and white; and its choice of the Du Boisan path over Booker T. Washington's. Dorsey's intentions in the dance world were consonant with those of Du Bois in the world at large: both were interested in creating a middle-class elite educated in European-based forms of endeavor and were dedicated to racial integration. For the first installment of her column in the *Philadelphia Independent*, titled "Social Graces," Dorsey declares her interest in her eponymous subject and continues,

> Good manners and proper conduct are paramount in our every day association with our friends or fellows.... Good manners expresses [*sic*] character, kindness, consideration of others, gentleness, good will, self respect, and ethical integrity. It distinguishes one as a thoroughbred.[36]

I find Dorsey's final word, *thoroughbred*, remarkable and revealing. More or less, she is saying that if blacks can calibrate their presentation of self in everyday life to the right standard, they will be looked upon as a special "breed." Granted, even white Americans in the 1920s, 1930s, and 1940s continued the nineteenth- and early twentieth-century pursuit of gentility and social grace; nevertheless, to the degree that these things became a major concern in the parallel black world, it may mean an ambivalent relationship to traditional black forms. For, although good manners and etiquette are important in all cultures, this line of thought seems to suggest that African American success is based on fitting into a white comfort zone. Granted, to be one of the talented tenth implies being special; yet, there is a double-consciousness subtext in Dorsey's message that as an African American I recognize.. Without it ever being said, I was raised with a keen awareness that there were black rules to live by in family life, with the kids on the block, and in our (Baptist) church that were different from the rules that governed my behavior when I was moving in the white world—thus, the double consciousness. On the one hand, certain black ways of talking and acting were misconstrued and unacceptable in the white world. On the other hand, having access to ballet, aesthetic dancing, elocution lessons, tea parties, and so on, introduces white conventions into black culture. That was Dorsey's intention—and Du Bois's. My sense is that neither Dorsey nor Du Bois intended to reject black traditions but to extend to black people the right to a white education and white pursuits—for Dorsey in particular, ballet. However, although she extolled ballet, Dorsey was also trained in tap dance, and both tap and black-based ballroom dances were popular offerings at her school. On the other hand, in the "racial

uplift" vein, when Dorsey taught at the Christian Street Young Men's Christian Association (YMCA), a black branch of the nationwide organization located in the black area of South Philadelphia, she gave classes for women and children in what was billed as "aesthetic dancing, gymnastic dancing, ballet, and harmony exercises."

To conclude this section and give a sense of the tradition that Dorsey helped establish—one that would be adhered to by King and Cuyjet—let's survey a selection of newspaper items and recital programs from her career. She created a niche for concert dance in the black bourgeois Philadelphia community that ultimately made it possible for Joan Myers Brown to establish a stable dance school and an internationally famous dance company that survives into the twenty-first century.

The first recital of the Essie Marie School of Dancing took place Thursday evening, June 16, 1927, at the New Century Drawing Rooms on Twelfth Street (between Walnut and Sansom Streets). Although Dorsey continued to give classes at her home studio in West Philadelphia until 1930, she understood that she needed to present her yearly late-spring recitals in a centrally located venue. She was already established in black Philadelphia society by virtue of her marriage to Potts, who himself came from "Old Philadelphia" lineage, meaning a bourgeois family that had established its class and status sometime in the nineteenth century. Each Dorsey recital was an event on the social calendar of upwardly mobile blacks and, as future programs confirm, would, like this one, last a couple of hours and probably be followed by a reception with refreshments. This 1927 program had a line-up of thirty-three separate numbers, including a majority of solos, a couple of duets, and an adult lady, Mrs. Ruth Deane, who sang two vocal solos (number 8 on the program, "Spring Is Here," and number 32, "In the Garden of My Heart"). After the welcome address the first dance on the program, "Toe Dance," was performed by Sydney Gibson, all of eight years old at the time. She also performed number 18, "Acrobatic Dance," and number 28, "A Little Chinese Doll." These dances were performed with live piano accompaniment. Later concerts would have orchestral support. There were also Spanish dances; nymph dances by the "senior class" and the "junior class"; an "Exhibition of Technique in the Essie Marie Studio," which included the students and was led by Dorsey; more toe and acrobatic dances; a "swan" dance; and so on. Dorsey performed in these programs, sometimes joining the routine of a touring professional tap artist (who had probably been recruited, as Cuyjet described, to teach at the school while he was performing in town), or dancing on pointe, or doing one of her character numbers, for which she drew upon her knowledge of Spanish dance.

Besides the annual recitals, Dorsey put on numerous community performances, including benefits for such organizations as the NAACP and the Mercy Hospital fund and made a host of appearances at society events. An undated clipping, circa 1929–1930, reports on a Delta Sigma Theta sorority "tea [*sic*] dansant" on New Year's Day that included the following treat: "As an extra feature to please the guests, the Deltas presented two of Essie Marie's darling little dancers Sydney Gibson and Selma Headspath. These little elfs danced beautifully, giving everyone a kick with their artistic interpretations."[37] An announcement for the April 15, 1930, community concert at the Berean School, a manual training institute established by the Berean Presbyterian Church in North Philadelphia, heralds the guest appearance of "Essie Marie herself and her work." Dorsey brought one of her classes to this event, and they performed a dance titled "Soaring." It was praised in print as "a beautiful frieze come true." In the same review the writer commends another dance, "Betty's Music Box," and describes it as "a long skirt ballet...those tiny tots being adorable in their long, fluffy skirts and were indeed a credit to Essie Marie." Dorsey appeared at the end, concluding her school's section of the program: "Mrs. Potts in 'Beggar Dance' was beautifully and exotically done. Mrs. Potts could be an actress as well as a dancer, so well did she portray the various emotions of the beautiful Italian beggar girl."[38]

In October 1929 at the Renaissance Casino, situated at 138th Street and Seventh Avenue in Harlem, Dorsey brought a group of her Philadelphia students to a special event sponsored by Harlem socialites to introduce the Essie Marie Studio of the Dance Arts to New York City. A clipping from a Harlem newspaper contains a glowing account of the event, and again Dorsey's rendition of the Italian beggar dance was highly praised. The event concluded with Dorsey announcing that her classes would be held at the A'Lelia Walker studios each Saturday from eleven, beginning that week,[39] thus suggesting that Dorsey traveled to Harlem on Saturdays during this period while keeping up her Philadelphia classes during the week. In 1930 a clipping announcing the school's fourth annual recital at the Gibson Theater (at Broad and Lombard Streets in Philadelphia) mentions that the New York class would participate in that year's concert. Another clipping announcing the same event placed Dorsey's work front and center in the Philadelphia social calendar:

> One of the rare treats of the June season are the various recitals which are crammed into the month of roses.... Perhaps no affair arouses the keen enthusiasm and joy that Essie Marie and her dancers excite. She has a wonderful group of youngsters who are well trained and in many instances really talented.[40]

"Society Danseuse Wins Divorce" was the headline accompanying a photo of Dorsey when her divorce from Potts was granted in 1931. One clipping declared, "Just last week Mrs. Potts conducted her fifth annual recital before a crowd which packed the Broad Street Theatre. Mr. Potts, who is a political leader in his division of the 40th Ward, is of an old Philadelphia family and holds a responsible position in the sheriff's office."[41] It is noteworthy that Dorsey never used the surnames of her husbands in her school programs. She appears in newspaper articles as either Mrs. Potts or Mrs. Dorsey, but her professional tag was the "Essie Marie School of Dancing."

In the Baltimore edition of the *Afro-American* (newspaper) on October 17, 1931, we learn that Dorsey intended to open a dance studio in that city as well. With branches in Philadelphia, New York, and Baltimore, she was taking her lead from Ruth St. Denis and Ted Shawn, whose Denishawn schools were a fixture in numerous cities nationwide, the first having opened in 1915. In June of the same year, the Dorsey recital announcement boasted of holding this annual event at the Broad Street Theatre, located at Broad and Locust Streets. The copy read as follows:

> It is with pleasure that we announce that we have secured the palatial Broad Street Theatre for our Annual Student Dance and Recital.
>
> We are certain that you appreciate this marks a definite RACIAL advance, and we assure you the artistry that will be displayed will even be HIGHER than heretofore.

African Americans live with the hope that each time a fellow African American gets his or her foot in the door of a previously segregated institution, such as this particular theater, it will bring more and better opportunities to "the race" as a whole.

Firming up her Baltimore base, Dorsey gave a spring dance recital there in May 1932. One clipping still referred to her as Essie Marie Potts, although she had divorced the year before and married Carroll Dorsey some time in 1932:

> Baltimoreans will be treated to the biggest event of the season when Mrs. Essie Marie Potts presents her students in a dance recital at Ford's Theatre on Saturday evening, May 28th, 1932, at 8:30 p.m.
>
> Mrs. Potts is known throughout Philadelphia, New York and Atlantic City, and with her invasion of Washington and Baltimore, has acquired national fame as an instructress in the arts of the dance.... Mrs. Potts will feature her students in character, aesthetic, Spanish, Denishawn, toe and tap dancing.[42]

Another uncredited clipping from Dorsey's collection is a sparse cutout pasted on a sheet full of such entries. Penned in at the bottom is the date June 22, 1933; the item reads, "Plenty of folk from out-of-town dashed up to the closing of Essie Marie's dancing class. Dr. and Mrs. George Hall, Dr. and Mrs. J. McWray of Baltimore, Mr. and Mrs. Dick Lockett, Miss Alice Banton and Mr. Walter Fleming of Atlantic City dashed into Philly to enjoy this marvelous demonstration which has become one of Philly's real events." That a children's dance recital could be construed as the biggest event of the season tells us something about Dorsey's clout on the social circuit due to her marriage into an old family, her skin color, and her expertise in ballet. But it tells us even more about the class and caste that placed this woman and her art form on a pedestal, representing the highest achievement of their cultural life. This black bourgeoisie lived and moved in a bubble, a segregated city during a racist era. These skilled but amateur concerts were their cultural lifeline, since they were unwelcome at professional performances in white Philadelphia. It is to Dorsey's credit that tap and ballroom dance were offered alongside ballet and aesthetic dance, bestowing her esteemed stamp of approval on both black and white dance forms. Nevertheless, the shows concluded on a note that featured Dorsey and highlighted her specialties, such as the Italian beggar dance (part of her Spanish repertoire) or a ballet. Take, for example, this description for the finale of the Twelfth Annual Dance Recital (1938): "The climax of the show was the appearance of Essie Marie in a ballet of the rainbow, assisted by a bevy of her ballet dancers. Essie Marie wore a fluffy white creation, with gold accessories. Her surrounding chorus was attired in bouffant dance frocks of blue, orchid, pink, and white chiffon."[43]

It is interesting, and also a little ironic, that African heritage was absent from these offerings. Like the classes and recitals at white dance schools, the Dorsey school's concept of the colorfully "exotic" was represented by European/Latin models (Spanish, Italian) and other national styles (Indian, Persian). Tap and ballroom dance had their place because all Americans declared ownership of those popular forms, and no one, black or white, knew about (or talked about) the African roots in these styles. Tap dance and ballroom dance were regarded as all-American forms. At this point in African American history, upwardly striving blacks were trying to assimilate and integrate, rather than emulate a separate African-based tradition. "Black pride" meant demonstrating that black Americans were the same as whites. On the other hand, continental African dance was depicted in Hollywood films as a savage display devoid of technique or aesthetic value. It would not be until the next generation of dancers—Dorsey's students— that black pride would mean a celebration and affirmation of African roots. For example, in 1947, as a result of John Hines's interest in Afro-Caribbean/

Afro-Cuban forms, we see the appearance of a "Caribbean Suite" on the first recital program of the Sydney-Marion School. Thereafter, King and Cuyjet presented African-based dance forms as a regular part of their curricula, thanks to their connection with the Katherine Dunham School and its teachers.

Dorsey's success continued, with the 1930s her golden age. Her 1939 recital at the Fleisher Auditorium featured forty-six separate program events, beginning with an overture by the recital accompanist Eugene Broadnax, followed by the welcome address (a standard feature of every recital), and filled out by an ocean tide of dances performed by the ever-growing student body at the school. With the looming specter of World War II, number 34a on the program was "Spirit of 1939 (Before the War)," followed by 34b, "Spirit of 1940 (After the War)." What is remarkable is that Dorsey added to her conventional variety program a dance with social meaning—a modern concept. One society page reviewer said, "Unusual was the contrast of the Spirit of 1939–1949 [*sic*], before and after the war dance. The first year was depicted by an all-girl group of soldiers and the 1949 [*sic*] group was of wounded soldiers."[44] This same reviewer pointed out the Persian market scene as the high point of the program, wherein "were mingled flower venders, snake charmers, perfume venders, camel drivers, temple girls, dancing girls, and royal entertainers." Indeed, this scene, number 45 on the program, included eight subdivisions—one for each of the categories just named, plus a separate category for Dorsey's finale—and was danced by "Essie Marie Dorsey and her entire Ballet Ensemble," according to the printed program. Another review gave a rundown of the dance genres on display in the concert:

> The program was interspersed with tap numbers done by the youngest to the oldest student; interpretative dances, such as "Deep Purple," marvelously danced by Betty Nichols; "The Wooden Indian," a fantasy danced by Josephine Castellente;"Little Red Riding Hood," a ballet daintily danced by Irene Palmer. Sydney Gibson executed her number, "Enchantment" beautifully. The descriptive dance of "The Storm," with all its fury, and the calm that follows in its wake, was exceptionally done by Dorothy Bagby. There were many more, showing that time and earnest energy were put into perfecting these lovely numbers.[45]

Number 46 on the program was the awarding of prizes, another recital staple. Prizes included scholarships as well as awards for perfect attendance and for selling the most tickets to the event.

Here follows a letter, passed on to me by Marion Cuyjet, that was written and signed by Dorsey following the 1939 concert, demonstrating that this woman

was seriously committed to the function and meaning of the arts in community life, not just during the month of her recitals. The letter is quoted, verbatim:

The Essie Marie School of the Dance Arts
525 S. Broad St., Philadelphia
Pen. 7025
Essie Marie Dorsey, director

Dear Friend:

The Essie Marie School of the Dance Arts invites you to a series of Sunday Afternoon Symposiums, in honor of the children of Philadelphia. The first of these occasions to be presented [sic] on Sunday, October 1, 1939, from 4.00 to 6.00 p.m.

Mrs. Evelyn Crawford Reynolds will read poems of her own composition; Dr. John P. Turner will speak; Miss Alice Dorsey will be our vocal soloist; The Essie Marie students will interpret the dance. Mr. Eugene J. Broadnax will present his own piano compositions.

Following this occasion, we will present one each first Sunday of the month: Oct. 1; Nov. 5; Dec. 3, 1939; Jan. 7; Feb. 4; Mar. 3; Apr. 7; May 5, 1940.

A different artist will be presented at each Symposium. From time to time, there will be talks and demonstrations on all types of arts. It will be most interesting, constructive, and beneficial to our young aspiring artists.

Place.... Essie Marie Studio, 525 S. Broad St. Phila.
Purpose.... To develop an appreciation for all types of art, and to develop and promote our aspiring, local artists.

Sincerely yours,
[Dorsey's signature appears here]

P.S. The Essie Marie School will re-open Saturday morning, September 9, 1939, at 11 a.m. Please register early.

This letter is an invitation to something more than an afternoon tea, although the two formats share common ground. But Dorsey's event takes on a grander, more purposeful significance, as evidenced by her statement of purpose. Having already established the largest school run by and catering to an African American populace, she is now charting a path to bring the arts to as many "aspiring, local artists" — read "black people" — as possible. This woman was, indeed, a leader in her field.

Nonetheless, she closed her school at some point during World War II, with wartime belt-tightening continuing and enrollments dropping off. In 1946, instead of reopening her school, she passed the torch to King and Cuyjet. In 1955, with Cuyjet's encouragement, she opened the Essie Marie Dance Clinic in her home on Rittenhouse Street, in the Germantown section of the city.[46] This was obviously a smaller operation than in her glory days of the 1930s. The major schools were now operated by King and Cuyjet. Flyers in the late 1950s and early 1960s announcing the Essie Marie Dance Clinic include an insert at the bottom of the page advertising the Germantown branch of Cuyjet's school in the same location. The flyer gives a separate class registration date for Germantown from that of Dorsey's clinic, but the same phone number and address are given for both. In addition, Cuyjet's main Center City address and phone number are listed on the very last line. Thus it seems that Cuyjet had a hand in bringing Dorsey back into the professional fold.

Before I close this section, I must mention the costumes Dorsey wore for her recitals and for print media publicity. A *Philadelphia Tribune* photo accompanying an announcement of "the initial recital of the school" (1927) shows her balancing on pointe on the right leg, the left leg bent and lifted in front attitude, the arms stretched, one forward, one backward, in a ballet port de bras (carriage of the arms). She wears a white strapless tutu with the full skirt hitting her midthigh, and her hair is cut in the flapper-style bob so popular in the 1920s. She looks like the perfect though unlikely combination of all-American girl and Russian ballerina. She adorns the program cover of her June 1928 recital standing on pointe, both toes touching the floor and legs together, one in front of the other. She wears a long lacy dress and, arms akimbo, holds the skirt folk-dance fashion, hiked up to just below her knees. She is slightly arched in her upper torso. The sleeveless bodice of the dress has a ruffled neckline. This time, Dorsey's hair is pulled back, with a spit curl at the forehead and a flower behind one ear. The portrait suggests both ballerina and Spanish dancer.

By 1931, her recital flyer for the Broad Street Theater broadcasts the racial uplift message already mentioned. Here Dorsey takes on the classic costume of the nineteenth-century European ballerina and wears a beautiful, ankle-length romantic tutu made of several layers of netting with tight bodice and filmy peekaboo net sleeves ending at the elbows, as well as a period-style bonnet with a huge brim that frames her face and is tied with a big, gauzy ribbon at the side of her chin. Again she is on pointe on the right leg, with the left leg lifted in front attitude so that the wide skirt bouffants over the lifted leg. Here she is a woman of tradition and gentility. Her other popular performance "look" seen in several newspaper clippings is that of the gypsy, or the Spanish dancer. She is

wearing a tiered skirt or, alternatively, harem pants fitted around the waist and buttocks and flared to ankle length; a tight-fitting bodice, sometimes with the midriff bared, sometimes sleeveless; Flamenco dance shoes (low-heeled pumps with straps across the arch); chainlike necklaces and cuff bracelets on both wrists; and most frequently a bandanna tied Spanish style on her head, with spit curls peeking out from underneath. One or both arms are overhead, and she is clasping castanets. This is the daring, sexy woman who seems to declare that dance is a sensual and emotional art form, and she is both competent and in command.

Dorsey's pioneering achievements set the stage for Cuyjet and King. Their parts in creating the Sydney-Marion School and their separate dance studios will be discussed in the next chapter. Here follows a brief biographical portrait of each woman before closing this chapter with a glance at Joan Myers Brown's early years.

SYDNEY KING AND MARION CUYJET

Born Sydney Gibson in Kingston, Jamaica, in 1919, King grew up in Southwest Philadelphia, where her family moved when she was a toddler. She studied dance with Dorsey from the age of seven until she was twenty-one and danced in innumerable community performances as well as the yearly recitals of the Essie Marie School of Dance. She graduated from West Philadelphia High School in 1939. That same year she married Elwood Wilbur King. When Dorsey closed her school in the early 1940s, King taught dance on her own for a while. By September 1946, now the mother of two small children, King joined forces with Marion Cuyjet to open the Sydney-Marion School at the former 711 South Broad Street location of the Dorsey school.

In 1948 King and Cuyjet went their separate ways. King remained at 711 South Broad Street until 1961. She moved the Sydney School of Dance to Sixty-First and Market Streets in West Philadelphia, with a satellite studio in Camden, New Jersey. As of 2010, both branches were still in operation, with nonagenarian King still symbolically at the helm. Like Dorsey, King continues to hold annual late-spring recitals. Although times have changed, King's perspective and methods represent a preservation of the traditional model of the neighborhood dance studio that somehow survives, and sometimes thrives, without the aid of government or private funding or comprehensive publicity. Word of mouth and student enrollment, often from one generation to the next, are the basis for the continuity. King wisely carved a niche for her institution in her community and has managed to maintain it for over six decades.

As of 2010, King lives in Yeadon, Pennsylvania. Her husband is deceased. They had two sons, born in 1941 and 1944, and a daughter, born in 1956.

Marion Cuyjet (1920–1996), born Marion Durham, was raised in Philadelphia by parents who were from a mixed community (African American, Native American, and Welsh) near Delaware known as the Delaware Moors. She attended Landreth Elementary School, Barrett Junior High School, and the South Philadelphia High School for Girls. As a preadolescent she appeared locally in the Alma Polk Kiddie Shows. When she was fourteen she began formal training with Dorsey, under whose tutelage she also studied privately with Thomas Cannon of the Littlefield Ballet. Later on (around 1940–1941), Dorsey also sponsored Cuyjet's study in New York for three semesters at the Ballet Arts School, with teachers such as Lisan Kay and Antony Tudor. She was married in 1938 and divorced after the birth of her first child, Judith Colvin, who was born in 1940. She remarried in 1943 to Stephen Cuyjet, who is deceased. She had two sons, born in 1944 and 1953.

After her stint codirecting the Sydney-Marion School, Cuyjet maintained the Judimar School of Dance for twenty-three years (1948–1971; the name of the school is a combination of her name and that of her daughter, Judith). After relocating to three different Walnut Street locations, the school moved to North Philadelphia. In 1954 the school relocated to Chancellor Street (in Center City) and then, in 1958, it moved into Cuyjet's home in Southwest Philadelphia. The year 1958 also marked the opening of branch studios in Germantown (at the site of Essie Marie Dorsey's home) and Center City (at the Jay Dash Dance Studios), and at the Maryland State College in Princess Anne, Maryland (where Cuyjet taught dance). It is a testament to Cuyjet's quality as a dance teacher that she did not lose students in this string of moves. According to those I interviewed in 1985, her clientele traveled with her from site to site.

While teaching and managing a dance school, Cuyjet continued to study. On day trips and holiday trips to New York, she availed herself and her best students of classes with such renowned professional teachers as those on faculty at the Ballet Arts School, including Lisan Kay, Vladimir Dokoudovsky and George Chaffee for ballet, and Luigi (the professional name of Eugene Louis Facciuto) for jazz. She became an authorized teacher of the Luigi Technique, Facciuto's formalized system for learning jazz dance. She also choreographed for her students who, like King's students, performed regularly on Philadelphia's black community circuit and as guest artists in educational programs in Philadelphia public schools. Cuyjet is responsible for the early training of Judith Jamison and many others who went on to professional careers in dance.

When I interviewed her in 1988, Cuyjet had long since given up her school but continued to teach at Joan Myers Brown's Philadelphia School of Dance Arts and at La Cher Teri, the Mt. Airy (Philadelphia) school run by Cheryl Gaines, one of her former students.

JOAN MYERS BROWN: THE EARLY YEARS

Born on Christmas Day 1931 at Philadelphia's Graduate Hospital, JB was the only child of Julius and Nellie Myers.

Julius Myers (1910–1978), the youngest of six brothers in a family of seventeen siblings, moved to Philadelphia from Wadesboro, North Carolina, with his siblings. His father, Charles Myers, was a dark-skinned man. His mother (JB's paternal grandmother), Mariah Sturdivant, was German Jewish. Interestingly, however, on Julius Myers's birth certificate she is listed as "colored." This designation would be entirely possible, given the tenor of American racism during that era: for a nonblack woman to marry a black man in the American South at that time would have been illegal. As a result of this union, JB explained, "My father had brothers with blonde hair, with straight black hair, kinky hair; light skinned with straight hair, dark with straight hair, dark with light hair. It was a mixture there." One brother worked for Abbotts, a local white-owned milk company, by default. As JB commented, "They assumed he was white. They didn't ask; he didn't tell."

As for JB's matriarchal lineage, she recounted this story:

> My mother's mother and father, they came from Virginia. It's so funny. I went to a fortune teller, and she was telling me that she saw me dancing. I said "okay" [sarcastically]. She said, "but no, you're dancing. You're wearing beautiful gold fabrics, like Indians wear." I thought she was talking about American Indians. When I told my mother what this person said, she told me my grandfather was from Ceylon!

When I questioned her about this part of her heritage, JB reconfirmed that was what her mother told her. In photos, her grandfather certainly looks East Indian, and one of her maternal aunts, still alive, is dark skinned with straight hair. Mixed lineage is commonplace among many peoples, African Americans included. Indeed, children in the same family may have different skin colors, physiognomies, and even body types, reflecting different streams of genetic information. The privileging of light skin or straight hair could thus separate members of the same family into different castes in a social pecking order.

Both parents held what were considered middle-class jobs. JB recalls that her father worked as a chef at one or two private clubs, "because I remember going sometimes after school and helping him." He was also a cook at Philadelphia General Hospital. Before World War II he had his own restaurant in West Philadelphia; he was forced to close it during the war, when like all other unenlisted men, he had to take a defense job. He worked at the Sun Ship Yard as a "burner" (which, JB told me, is similar to a welder). Her mother had worked in the restaurant and attended night school, studying chemistry. She later worked in research and chemical engineering for the Arcos Corporation, where "they made welding rods. She worked there for thirty years."

JB lived with her parents at Sixteenth and Christian Streets in South Philadelphia until 1934 or 1935, when they moved to Forty-Second and Woodland Avenue, and then to 4638 Paschall Avenue in 1938 or 1939.[47] Like many African American girls brought up in a striving, middle-class environment, Brown lived a sheltered childhood in her South and West Philadelphia neighborhoods, attending the Alexander Wilson elementary school, Shaw Junior High School, and West Philadelphia High School. JB said of her upbringing in black Philadelphia,

> Everybody on my street was sort of family. So when you came home from school, you stayed on that street. The only time you left that street was when you left with your parents, and you didn't really venture too far out of your neighborhood until you got out of high school. I remember being kept very closely confined. I went to bed at 7:30 at night. You sat on your doorstep and you didn't move unless your mother said you could go.

This description is as much a reflection of JB's particular life circumstances as it is of the overall cultural mores of Philadelphia's African American communities in the first half of the twentieth century. First of all, the Myerses had married young and were only in their midtwenties when their daughter was in grade school. Both held steady jobs and may have been overly zealous in their parenting. Secondly, the little Myers girl had her own particularly lively, maybe even willful, personality (to judge by the woman she has become). During elementary school years, JB was, in her own words, "very busy in school. The teacher said that maybe I should do something else to curtail my energy, but I was always in trouble. I was just really bored." The third consideration is the fear factor in the lives of African Americans, particularly parents' fear for their children growing

up in a racist society. It was important for black people—even in the North, and even children—to "know their place" and behave accordingly, so little boys and girls were taught their manners, and frequently, as was the case with a live wire like little Joan Myers, the brakes were applied full force.

By way of comparison, let us look at the upbringing of Delores Browne, the African American ballerina who is discussed in chapter 2. Born in 1935, she lived in South Philadelphia, on Twenty-Second and Naudain Streets, in the old Seventh Ward, as detailed by Du Bois. By age ten she and her brother were allowed to walk, by themselves or with a pal, all the way to Center City, nearly a mile away, to window shop or stroll. Wanting to take dance classes, Browne went so far as to go into white dance studios on Walnut Street and inquire—without her parents present—about registering for classes. (She was never told that blacks weren't admitted; instead, the excuse was that the classes were all filled, and she'd be placed on a waiting list.) What is significant is that Delores Browne and her brother were able to walk and ride bikes to places outside their neighborhood, and her parents felt assured of their safety. Thus, it can be misleading to assign one mode of behavior to a given black community, even in the same city.

The neighborhood on Paschall Avenue was racially mixed when the Myers family moved in. By the mid-1940s, when JB was in her teens, it had become predominantly black, thanks to white flight. She explains that her elementary school was all black, and Shaw Junior High and West Philadelphia High School, both in a different neighborhood of West Philadelphia, were mixed. (She walked almost a mile each way every day to get to and from these institutions.) She had been sent to dancing school as the result of an accident. At the age of seven or eight playing "curb tag" with her friends (jumping on and off the curb, from the sidewalk to the street) she was struck by a truck and sustained an injury to one foot. The doctor suggested to her parents that it might help her rehabilitation to take dance classes. Her mother enrolled her in the Essie Marie School of Dance, where Sydney King, Marion Cuyjet, and John Hines were all student teaching by then. Of this early experience, she says, "I went for about two years. I lost my slippers and lost other things, so my mother said that I should stop." Although she may not have been the most attentive student, her teachers noticed that she had extraordinarily articulate feet, and at one point King called in Dorsey to show her how well the youngster could point her toes. And of this early experience something important stayed with JB: "I vividly remember my first recital. You know, after you dance, you sit out and watch the rest. And Miss Sydney did this dance, 'A Bird in a Gilded Cage.' She was in this cage that was, you know,

like [made of] crepe paper, and she came out and she had on pointe shoes. That, to me, was the most amazing thing in the world." Nevertheless, the dance bug didn't really bite her until late adolescence:

> I was almost grown when I really started dancing. I was in high school. My gym teacher, Virginia Lingenfelder, suggested that I dance. Since she was a ballet teacher and dancer herself, she gave us dance exercises in class as well as the regular gymnastics. So in gym class she saw that I was doing what I was supposed to do, I guess, and she asked me to join the ballet club. She really inspired and encouraged me a lot.... Until then I had wanted to be an artist first and then an airline stewardess. But by the time I graduated from high school in 1949, I knew I wanted to be a dancer. I wanted to be a ballet dancer, but you know how it was in those days. I tried to get into white schools, in 1948 and 1949. They simply were not taking blacks into their classes.

At a time when a generation of jazz musicians were learning their profession at public high schools on borrowed instruments, so, too, quality instruction and a dance legacy were established at West Philadelphia High School by Lingenfelder's ballet club. It is interesting that it was not a modern dance club or a social dance group but was devoted specifically to ballet. Delores Browne attended the same high school a few years after JB, and also received crucial training through this outlet.

JB's narrative is one of determination and hard work. Traditionally, dancers begin training for a professional career in childhood or early adolescence because of the demands of the technique and the limits of the human body. Those who begin in late adolescence work against chronological and anatomical odds in a field where the prime years for performing are generally over by the time the ballet dancer is about thirty-five years old. Like athletes, dancers continue to train throughout their professional careers. Occupational hazards of the field are high, and many dancers are forced to retire early or to abstain from dancing while their injuries heal. Both modern dance and ballet are glutted with women dancers, and the competition for performance opportunities is stiff. Fewer men enter the dance field, and due to supply and demand, male dancers, even late starters, have more career opportunities than women. Antony Tudor, JB's renowned teacher, did not begin studying dance until he was nearly twenty. Joan Myers Brown began with at least three strikes against her career objective: gender, race, and age. It is noteworthy that the late bloomer Tudor should become the teacher/mentor of the late bloomer JB, giving her the grit to persevere.

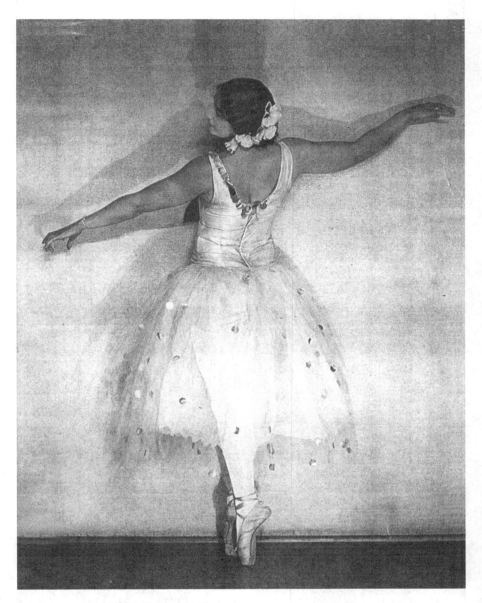

Figure 1.1. Essie Marie Dorsey, 1920s.
Source: Brenda Dixon Gottschild Private Collection. Gift of Marian Cuyjet.

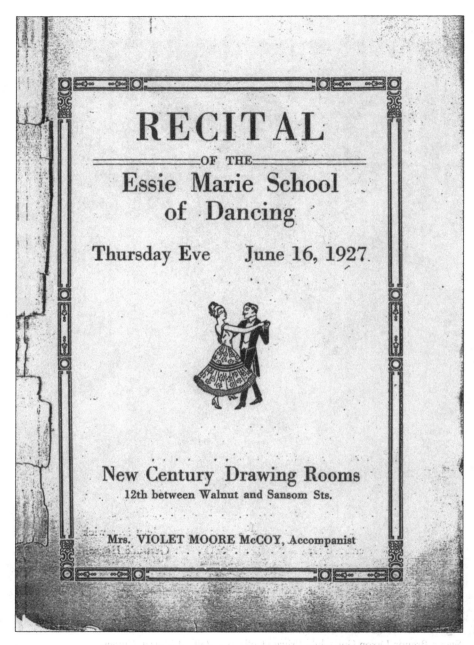

Figure 1.2. Program cover for Dorsey's first recital, 1927.
Source: Brenda Dixon Gottschild Private Collection. Gift of Marian Cuyjet.

According to Cuyjet, JB did, however, have a few additional points on her side despite her late beginning. The fact that she had taken acrobatics with King at the Dorsey school when she was seven or eight paid off, with the muscle memory of that training dormant but still extant in her body. Cuyjet also explained that JB had "an athletic body. She can stretch like most people cannot, and she could really move." Cuyjet surmised that it was because JB had a small, lithe, compact body—preferred for female gymnasts and ballet dancers—that Lingenfelder took such an interest in her and allowed her in the ballet club. Nevertheless, JB knew she had some catching up to do:

> I was aware of the fact that I was beginning late—and black! But I had a lot of determination, and I think I did very well with it. It was my sole life. That's all I did. My parents were very restrictive of my other activities, so, being involved in dance, I could really totally be myself in that. When I began dancing, I wasn't doing anything but dancing and going to dancing school. I was studying, not performing professionally. I performed at recitals and the Cotillion and those kinds of [semiprofessional] things.

JB also said that, "In spite of all this, I didn't feel the pressures of being black. I felt the pressure of saying to myself, 'You know you have to do better, so you do better. You work harder, or else you'll never get a chance.'" Because she was not allowed to take ballet classes in the white dance studios, JB had to work extra hard to keep up with her ballet club cohorts, the white girls who were taking classes at places like the Jay Dash studio or the Littlefield School in Center City. As she tells it,

> In the high school club, I had to learn "behind the barn." I had a couple of good girlfriends from the Littlefield School who used to get to school at 7:30 in the morning and teach me what they learned the previous night in dancing school. They were white. There was a girl named Virginia Terigian whom I will never forget and another girl whose name I cannot remember. We used to come in early, and they would show me what they knew so that when we got to ballet class [the club] I wouldn't look like an idiot. I learned a lot from them. Then Ms. Lingenfelder sent me to a friend of hers who was teaching [renting space] at the Jay Dash School—Eleanor Breckenridge. I studied with Eleanor, but there was quite a "to-do" about me being a black student in her class.

> I met Jay Dash later in life. He was excited and talked about how he had wanted to meet me. I told him that he knew me. He said that he never met me before. I said that he did—when I was a girl of eighteen and wanted to take dance lessons at his school and was told he was not accepting black students. Well, of course, he could have gone through the floor! He said that it wasn't him, but the parents. I said I felt that he was in a position to say who came into the school and who didn't, and if it hadn't been for Eleanor Breckenridge I never would have gotten a class.

This is the same Jay Dash who had befriended Marion Cuyjet and by the early 1960s was renting his studio to her. Whether it was "the parents" or Dash himself, it seems that it fell more within his comfort zone to embrace Cuyjet than the darker-skinned JB. Nevertheless, JB danced with the ballet club at public events in venues such as the old Philadelphia Convention Center, where she recalled that

> a "Schools on Parade" program was featured, . . . and West Philly would always have the ballet club in it, and Eleanor Breckenridge would always be the soloist. When Ms. Lingenfelder would do her productions at high school, for the assembly programs, Eleanor would always come in and be the teacher.

JB took private classes with Breckenridge in 1948 and 1949, thanks to Lingenfelder's recommendation, and in 1950 began studying the Dunham technique and taking tap classes, as well as student teaching at the Sydney School of Dance. In 1950 and 1951 she took Antony Tudor's classes at the Ballet Guild, and "then I would come back and teach what I learned with Tudor at the Sydney School." Asked how she found out about Tudor's classes, she explained that, "again, Ms. Lingenfelder had some input into the arrangement. She knew Ethel Phillips, who was running the guild at that time." The Ballet Guild classes that JB attended were held at Phillips's studio on Frankford and Orthodox Streets in Northeast Philadelphia. "I was the first black to be admitted to the guild. I think John Jones, Billy Wilson, Delores Browne, and all those kids studied there after me."[48] Judith Jamison later studied with Tudor as well.

With this taste of JB's early training, we move on to the next chapter, which continues where we left off, picking up with the schools, teachers, performances, and issues that were central to the black Philadelphia dance experience in the 1940s and 1950s, and to JB's entry into the professional dance world.

CHAPTER TWO

SPECTACULARLY BLACK ON BLACK— 1940s–1950s

My actual, formal training began when I came here to Philadelphia [in 1952]. My way of learning things is to get lost and then find my way back home. So I got lost in Center City and saw all these black people going into a building. I looked at the marquee inside. It said, "Judimar School of Dance Recital." I went in and was just taken away.

—Arthur Hall

I had to become a dancer after seeing, in one week of performances [in Los Angeles], the American Ballet Theatre with Erik Bruhn, a performance with José Limon, and Carmen de Lavallade and Alvin Ailey in their younger days with Lester Horton.

—Gene Hill Sagan

PART ONE
INTRODUCTION

What makes a person decide to become a dancer? What are the drives, ambitions, and inspirations that lead people to choose this difficult, short-lived, poorly paid profession over others? My intention is not to attempt a psychological assessment and resolution; in fact, I am not seeking answers but pose the questions rhetorically so as to bring us into the rich dance world that existed in the Philadelphia black

community in the post–World War II era. For many, the calling was fortified by a peak experience, as Arthur Hall and Gene Hill Sagan attest. The clincher for Marion Cuyjet was a windfall from Essie Marie Dorsey. The renowned community artist offered Cuyjet a scholarship and allowed the fourteen-year-old to work at the school, an arrangement that, in Cuyjet's words, was as though she'd

> died and had gone to heaven! The only thing I could think of was that I would be there all the time, seeing all the classes, seeing everybody—never thinking I would [even] be in the classes. But that's how I really got in. Of course, I covered three years' worth of work in less than a year, because I went right from high school [to the studio].

Later Dorsey, Cuyjet's mentor–mother figure, took her aesthetic daughter "to a very inspiring first ballet. It was the [Ballets Russes de] Monte Carlo. Then I saw the Paris Opera Ballet with Yvette Chauviré." Dorsey also took her young protégée to see the Ice Follies to absorb a lesson about smoothness and speed. Similarly, John Hines mentioned that, falling in love with the speed of movement, ice skating was his entry into dance. For Joan Myers Brown it was the encouragement she received in her high school ballet club from Virginia Lingenfelder, the gym teacher/dancer who provided inspiration, performance opportunities, and a link to professional training through private classes. And when she was about nineteen, seeing a photograph in a magazine had a long-lasting effect:

> I saw an article about her [ballerina Janet Collins] in *Life* magazine when she performed with the Metropolitan Opera Ballet Company. That was my first picture or anything of a black ballet dancer. This is what I wanted to do! So I wrote to her and told her. I sent some photographs of myself, and she made some remarks about them. In fact, for several years she sent me postcards when she had been traveling. Then I got married and we lost contact.

Like other special professions, dance creates a subculture in which people live apart from the concerns of ordinary life. If we consider the black world to be a subculture in the United States, then we can say the black dance world represents a sub-subculture—a site of special means, needs, and aims, with a population following its own unique game plan. In the words of Sagan, who moved from the solo art of painting (his first pursuit) to the communal realm of dance, entering this new world was "like discovering a family outside of your family. It put me in direct contact with people who were as introverted as I was and who

could only be really extroverted in their work." There is a psychological truth in Sagan's words, perhaps well worth following up by another author in another book. In any event, the major part of the dancer's life is spent in the studio—as student, performer, choreographer, or teacher. Like their counterparts in the white dance world, students like Cuyjet and King became the aesthetic wards of a mentor and replicated her style of teaching, leadership, and institutional organization in their adult careers, and intensive study for their students and continuing education for themselves was part of the deal. Judith Jamison, in her youth one of Cuyjet's star students, described herself as an adolescent who practically lived at the Judimar studio and had little or no interest in her everyday peers who didn't share this special focus.

It is noteworthy that the ambition and sense of dedication Dorsey inculcated in her students and transmitted to subsequent generations was to do one's best. Stardom was a by-product that might or might not occur. The aim was to encourage commitment and mastery. There was a student-teacher system in these schools in which the older, more experienced students taught the younger ones. Students performed solos when they reached the appropriate age and training point in their development. But there were no stars. Arthur Hall described the atmosphere at Judimar as one of

> work and fun and love and get involved...but Marion would not tolerate any kind of petty stuff. She would just raise hell. She wanted to make sure that we looked at each other as artists and that we were all struggling young people. The school attitude of working together was what it was all about.

With this as their credo, it became conceivable for these Philadelphia dancers to work against the odds—for example, to master ballet, though one might never become a professional ballet dancer. Their ambitions were such that dance itself—and their continuity within the discipline—kept them in the profession, in spite of racial discrimination and lack of recognition in the white dance world. They studied in Philadelphia, took private classes from white teachers when racism kept them out of white classes, went to New York to study at the best white, midtown ballet studios, and kept on teaching, choreographing, and performing—creating recitals, community events, and cotillion ballets and waltzes that knocked the socks off their audiences, time and time again. Dance was their vocation, their calling—and no persons or circumstances could take it away.

This chapter looks at some of the obstacles they were up against and examines some of their successes.

COLOR, CASTE, DANCE—AND PHILADELPHIA'S BLACK BOURGEOISIE

As discussed in chapter 1, the limits racism imposed on African American economic, social, and political advancement drove the black middle class to develop unique criteria for the privilege of membership in its ranks. Another subculture within the larger African American subculture, the black middle class evolved a convoluted caste system that directly affected the black dance world and warrants discussion. To recapitulate, many men whose families became part of the African American elite worked as valets, sleeping car porters, and caterers[1]—jobs that put them in contact with the upscale side of white America and afforded them ample opportunity to absorb information on the workings of the white gentry. Along with black professionals—doctors, dentists, lawyers, college educators, and undertakers—they formed the backbone of the black middle class. The skin color element also factored in, as did the church one belonged to. Light skin, plus attendance at a revered established church—namely, specific AME, Catholic, or Episcopal congregations—and participation in its social activities provided a loophole for entry into polite society for working-class families like Marion Cuyjet's.

On a superficial level it may appear that the light-skinned African American woman had an easier time in both black and white worlds. If she also had the genteel manners cultivated by Dorsey and Cuyjet, she was more likely to be accepted in "respectable" white society because her near-white physical appearance and manners posed little threat to the dominant culture's comfort zone.[2] By the 1930s, because of her nonthreatening physical appearance or because she was actually passing for white, she was the one more likely to be chosen for positions in the white world such as bank teller, department store salesperson, or waitress, rather than the more menial posts ascribed to her darker-hued kin. Thus, the black community learned to prize white skin because it represented a potential passport to the earning power and respect accorded to whites. Light skin was *de rigueur* for the black woman who hoped to be admired by the black bourgeoisie, especially its male contingent. This, too, seems to reflect trends in the dominant culture: before suntans became fashionable, women used parasols and sunbonnets to prevent their skin from browning; tanned skin represented exposure to the sun in menial jobs. Billy Wilson remarked on this unusual skin tone phenomenon in his comments on the Philadelphia Christmas Cotillion balls:

> There were all kinds of people in the Cotillions, all kinds of colors from black to white—but [they were] all black people. That was really kind of interesting. But I would say the majority of the girls were fair-skinned. The guys could be any color: just get a man, as long as he's doing something. He had to be the son of an undertaker or lawyer or

doctor, or his brother had to be in this or that fraternity, or whatever. He had to come in with some sort of credential that said that he was going some place. The girls could come from almost anyplace, as long as they looked a certain way.

It is noteworthy that "looking a certain way" did not mean the girls had to be pretty or shapely—although that would gain them points. It was enough to be light-skinned, which confirms my assertion that this requirement is about being as close to white as possible, not about standards of beauty. Still, skin color alone did not guarantee entry into black society. Despite its self-deprecating preference for light skin, black America continued to reflect the traditional values of West African systems that relied on one's family-, club-, and religion-centered organizations. As Cuyjet put it, "it was personal quality—how you carried yourself, who you moved with, that old adage, 'show me your friends, and I'll know who you are.'" Just as her mentor had married into an old Philadelphia family and thus put herself into the "right" places, Cuyjet was also able to profit from being in the right places and rubbing shoulders with the "in" crowd, even before she married. As usual, she gave a shrewd, detailed explanation when I questioned her on this touchy topic:

Between the club group from the church and my brother going to the same church—he was very active in the Sunday school there—I got into "colored society," as they call it here in Philadelphia. Since I was a child, I came along with their children. I met them in Sunday school. We were put together by a reputable person—my Sunday school teacher. My parents belonged to that church, and I sort of oozed in that way. I was further sanctioned by my older brother who was very handsome and was the one who played the violin. The girls who were eighteen or nineteen, the older girls, were very anxious to please him, so they took me under their wing. It furthered it [her status] when I went to Essie Marie Dorsey's school, because I became her protégée. She was very prominent in colored society. She also squired me and pushed me around in different circles.

Social clubs and church clubs remain a way of life in traditional African American circles, be they elite or grassroots. They are models of assimilation, or what cultural anthropologists call "syncretization." On the one hand, they imitate the white clubs, sororities, and fraternities to which their members could never hope to gain admission. On the other hand, they are throwbacks to our West African heritage, passed along from one generation to the next by custom and tradition,

offering shelter and protection from "outsiders." These two cultural influences combine — syncretize — to create an entity with a particularly black American flavor. Some of the more recent and better known of these organizations include the Jack and Jill of America clubs (for mothers and children, originally formed in Philadelphia in 1938), the Links (also originating in Philly and one of the major black society ladies' clubs, formed in 1946), and a number of male and female Greek letter societies, all with branches in cities nationwide and a full calendar of social and charitable events.[3] Their color and caste rigidity has declined in the post–civil rights era. It is noteworthy that these organizations serve a useful function in their respective communities by their charitable acts of volunteer work, fundraising, and donating to worthy causes. Significantly, these were the primary organizations that supported black dance. Billy Wilson remembers first meeting Cuyjet

> at a Jack and Jill Club. I was performing then with the Creative Dance Group [from his elementary school].[4] I remember being the darkest person there. [Wilson had luminous brown skin, about the color of Denzel Washington's]. There were black children everywhere, and not one was brown. I thought that this was absolutely extraordinary. You know, I tell people stories like this, and they don't believe it, but it's absolutely true.

Given the high status accorded light skin, it is clear why Cuyjet's father chose to keep his family in the black world, rather than attempting to pass for white. Although many light-skinned blacks did choose to pass, it was a long shot that could easily backfire. It meant that one would never be able to visit or be visited by dark-skinned relatives (even in the whitest black families there is always a range of skin colors). Old friends would have to be avoided. (For example, as discussed later in this chapter, Cuyjet's friends were the giveaway when she performed at Wanamaker's Department Store[5] in Center City with the Littlefield Ballet Company. But she did not reject them when they greeted her after the performance, and the white dancers immediately understood that they had been duped.) A working class family like the Cuyjets would not automatically advance into polite society in the white world. Her father, a paper hanger, would have had to move his family to live in a low-class white neighborhood suitable to his means, where background and credentials would not be questioned. They would be at the bottom rung of the white world, whereas in the black world they could be big fish in a small pond. They had the opportunity to advance, and they did..

But, in the long run, no one wins in a vicious color-caste system. Regardless of skin color, all blacks face levels of discrimination in the white world;

dark-skinned blacks may be treated as second-class citizens by their light-skinned peers; and light-skinned blacks endure a confusion of identity unimaginable for most individuals. In my 1988 interview with Cuyjet, she highlighted this dilemma in a way that is possible only by one who bore the scars. She describes a singular brand of double consciousness:

> [Cuyjet's elementary schoolmates] didn't like that I was colored and looked like white. At the age that I am now, if I could just pause and digress a minute. What is really wrong here is [the subliminal message I got from them, which was], "How dare you look so white and walk around telling everybody you are colored! That makes the rest of us look different. You're not the different one, because most of the world looks white and, since you look white, why don't you just go on and *be* white, like the rest of your relatives who went over the [color] line? You're really a pain in the neck. You're an oddball in the middle of our colored society!"

This was the affect that registered in the mind and heart of a kid in a black neighborhood school, between grades one and six. Of course, once Cuyjet's family moved her in the "right" circles she had the upper hand, at least externally. Nevertheless, her contested feelings about her identity stayed with her:

> I'm very ambivalent about how I feel about my color. My father was a very realistic man. He preached to me all through my youth: "Do *not* go for white and, especially, don't pass in marriage. Don't marry and go away and leave your family. It will not work." He was able to show me living examples of his own brother's family and how they had to sneak his brother back to see his old relatives in Cheswold, Delaware. They couldn't bring their families with them. It's a very inconvenient life.
>
> However, my mother couldn't make up her mind what she wanted. She enjoyed the neighborhood that she lived in on Wilder Street with "colored people" [her mother's terminology]—like Mama isn't colored, right? But she always preached to me, "Don't bring anybody home from school." Well, not anybody white was going to come in my direction because a lot of colored people lived over where I lived. So I got the message: she didn't want anybody too dark in the house. Meanwhile, we still had friends and relatives that did not look like white....
>
> I was really a confused child. When I got old enough to have boyfriends...Mama...didn't want me to have anybody dark....When I went

back to Delaware to visit the relatives, she didn't want me to bring back any relatives who looked white because she said they were just farmers. She wanted more than that for me. I don't know what she really wanted. At the same time, while I'm looking like white, and Mama can't make up her mind, she's the one who first took me to the First African Baptist Church at Sixteenth and Christian Streets. Then she expected me to turn around and tell my schoolteacher, when they asked me, "Are you colored?" to say, "What do I look like?" She told me to tell the children that. I told them that a couple of times, that's all...because I got beat up!

This is a side of the black experience that is as unexamined and hush-hush in the black world as it is in white circles. Old habits die hard, and old demons take generations to exorcise. Though the civil rights era (roughly 1955–1970) changed the stakes for black-on-black as well as black-on-white relationships, many of the old attitudes still prevail. Many blacks and whites still privilege light skinned blacks, even in the new millennium.

Cuyjet's connections with Philadelphia's black elite would be crucial when she and King broke up their partnership. Although both women kept ballet at the center of their schools' curricula (and taught a variety of other dance forms as well), the Judimar School was understood to be the "in" place for the bourgeoisie to send their children. Cuyjet was the Dorsey protégée who, like her mentor, was light enough to pass for white. King was not brown-skinned but could be more clearly identified as black and, perhaps with the strong sense of identity characteristic of Caribbean peoples, did not wage a battle around who she was and where she should locate her allegiance. Moreover, regardless of how the issues of race, class, and caste played out in this and similar black communities, they did not affect the way children were taught at Cuyjet's or King's schools. All the kids were valued in the hard-working, extended-family atmosphere that was, and is, so common to social institutions in African American communities. Talent was particularly rewarded and always trumped color. For example, Judith Jamison—tall, willowy, short-haired, and dark-skinned—was one of the "prima ballerinas" at the Judimar School and was encouraged unconditionally to pursue her professional dance ambitions.

ROLE OF THE WHITE COMMUNITY: INTERACTION AND DOUBLE STANDARDS

As varied as any other example of black–white relations in the racially polarized United States, the role of the local white dance world in relation to the black Philadelphia dancer of the 1940s and 1950s is an area that begs discussion.

Sometimes the rules of racial discrimination are neither national nor regional. Like the intricacies of dialect, they may vary even at the local level,[6] from street to street and depending on the persons involved, or even the time of day. Cuyjet (South Philadelphia), JB (Southwest Philadelphia), and Sagan (North Philadelphia) grew up in racially mixed neighborhoods that had become more exclusively black by the time they were adolescents. White flight is a perpetual motion machine in our nation, abetted by real estate agents who, using the fear factor, profit by getting whites to sell out at any price and blacks to buy in at exorbitant mortgage rates.[7] In these transitioning neighborhoods there is frequently a remarkable etiquette in which blacks and whites are polite to one another, though not friendly. Recalling her childhood on Wilder Street from 1926 until she entered high school in 1934, Cuyjet said,

> [The neighborhood] stayed the same for a long time. People just lived together and respected each other's homes. They would mingle outside and do for each other. But I noticed that they did not run in and out of each other's houses. There was a kind of neighborhood etiquette.

In addition to this semblance of residential integration, some of the city's public schools were mixed, particularly the high schools, to which students came from all areas of the city. For JB and Delores Browne, early dance influences came in the form of the junior high and/or high school ballet club. Browne had been admitted to the club at Barrett Junior High School at age 13, and began her first formal classes in ballet there.

Cuyjet told me two stories that highlight the convoluted interface that simultaneously connected and separated Philadelphia's African American and white ballet communities. The first is about "integrating" the Littlefield Ballet Company and was mentioned earlier; the second, her recollections about Virginia Lingenfelder, and Thomas Cannon. Both experiences speak volumes about black–white relations in this hidden area of African American artistic endeavor. I asked Cuyjet how she came in contact with the Littlefield Company. She told me that Dorsey had paid for her to have lessons there, and that

> some of us high school girls were selected to dance in the ballet of "Caucasian Sketches" in the Ladies' Better Dresses [department]. Wanamaker's was not only open on Wednesday evening, like Lit Brothers and Strawbridge's and the other big stores, but they were also open on Friday evenings. We had two ballet performances a week. This was in '37,'38,'39.

Here follows the bulk of her recollections, preceded by my questions:

>BDG: Why did Dorsey send you to this school?
>
>MC: She was very fond of Thomas Cannon, who was their leading male dancer. She thought she was doing something by sending me to this school. There wouldn't be any problem, looking the way I did. [Meaning, because she looked white.] There wasn't any problem until, well, being a teen-age girl, I did tell some of my friends I couldn't take tennis with them because of ballet class. They asked me where I went. I said I still went to Mrs. Dorsey. But I don't know what compelled me to say: "Well, now I'm with the Littlefields." Well, really, they didn't know anything about the Littlefields. I thought that would be easy to handle. But somebody had seen me in a performance at Wanamaker's. It was obvious: someone had seen me, and I didn't know it—somebody black! So in another performance they came in a little group, my friends from the YWCA club and from church. They came backstage to say hello. Well, you know in the thirties, white people—especially white people who worked in Wanamaker's, were not surprised to see a colored girl who looked like white. There were lots of us who worked at Wanamaker's as salesgirls, and Wanamaker's knew about them. Also, we were in the age of the great Walter White, National Chairman of the NAACP, and Adam Clayton Powell [both men could have easily passed for white]. They [the Littlefield people] were really not surprised. They believed that I was colored. It was easy to believe because I didn't have a pal. Teen-age girls could be seen coming in couples, at least. They have a buddy and stand at the ballet barre with their buddy.
>
>BDG: So did the Littlefields know you were black?
>
>MC: They didn't know before the girls came, but [then] it was easy for them to believe it.
>
>BDG: What happened once they found out?
>
>MC: Out! Out! Out! Definitely out! And don't come back! It was a lady who worked at the desk who takes the money and answers the telephone.
>
>BDG: Did she say why?
>
>MC: No, but I knew what she meant.

In one fell swoop Cuyjet's friends had opened a can of fat worms, and the conflicted racial narratives of American society spilled out. Someplace in the grey

subconscious realm where reality is not so "black-and-white," the Littlefields may have suspected that Cuyjet was black because she had sort of come to them out of nowhere, having no friends in the class nor anyone waiting afterwards to pick her up, to give her an identity, a name. (This was the way black people passed into the white world—with no close relationships, no strings attached.) Had she intended to begin permanently passing, Cuyjet would have rejected her friends when they came backstage and might even have proclaimed her whiteness to the Littlefield staff, in one way or another. Meanwhile, a cadre of white-skinned African Americans were already working at Wanamaker's and other places, some having been hired with the knowledge that they were black, as long as they could easily fit in without threatening the comfort level of the white customers;[8] and others who maybe were passing for white—a practice so widespread in the United States throughout the twentieth century that white people would be shocked to know the true story and to learn that they may have black relations, black "blood."[9] Essie Marie Dorsey and Thomas Cannon are also implicated: Dorsey knew that Cuyjet would be able to pass, but why didn't the "maestra" teach her ward how to handle herself so she wouldn't be found out? Or what to say or do if her secret was disclosed? And how much did Cannon know? Could he have changed the story's ending? After all, he was the co-founder of the Littlefield Company. What if he had stood up for even just this one little white-looking teenager and allowed her to stay? But everyone played the "don't ask, don't tell" game with the fervor of a society, a nation, that couldn't, and still can't, come to terms with its racism.[10]

The second part of Cuyjet's story has to do with the black-white interaction around the dance clubs in Philadelphia public schools in the 1930s and 1940s. Virginia (Zane) Lingenfelder and her tenure at a middle school and then a high school, is another object lesson in pre–civil rights era race relations. Our interview continued:

> MC: Strangely enough, there was a young woman in my [Littlefield] class who had been my gym teacher at Barrett Junior High School, who had the ballet club there. She danced with Littlefield. Her name was Virginia Zane—her maiden name. She would never let me in her ballet club when I was in junior high school. I would say she was about twenty-four years old then or twenty-five. By the time I was in high school I understood why. She did not prefer my [body] type. Her preference was the smaller, more compact body, the same type of body that is preferred for female gymnasts. She had all her girls practically the same size, since she had a wide selection over

the entire school.... Years to come, Virginia Zane becomes Virginia Zane Lingenfelder. Then she divorced Lingenfelder and married someone named Black. Then she remarried Lingenfelder and remained that [name]. In the meantime, she'd been promoted to West Philly High School. Their ballet was excellent and gorgeous. She taught some marvelous classic work to girls who had no ballet at all. I sent all of my best dancers to her—at that time, there wasn't a zoning problem. So I guess you can say I was a headhunter for Virginia Zane, who would never let me in her ballet club!

BDG: Why didn't she let you in her club?

MC: I think she didn't want a tall girl. It was not a race thing. She didn't have any brown-skinned girls in it, though.... I don't think she was really aware that I was colored or white because I was in her gym class in seventh grade. [Then] I was in high school when I went to the Littlefields, and there she was in the ballet class.

BDG: You said Dorsey knew Tommy Cannon. Was that the class you were taking?

MC: I was generally taking class. But after I was ousted, then Mrs. Dorsey paid Tommy Cannon to come to her studio and teach me privately.

It is remarkable that JB and, earlier, Cuyjet were both influenced by Lingenfelder. JB is small-boned, compact, and flexible; whereas Cuyjet was taller and less supple. I was surprised that Cuyjet attributed her exclusion from the club to body type. Nonetheless, she made it clear that Lingenfelder did not have any identifiably brown-skinned dancers in the mix. Was this by intention? Accident? Circumstance? What is apparent is that these ballet clubs worked on a pre-professional model that challenged the concept of dance as a hobby. The club members performed and rehearsed regularly. Since there were no arts high schools at that time, the clubs functioned as their precursor, allowing the teacher to audition students and accept or reject whom she wished, be it according to size, skin color, body type, competency, or anything else. This was, and remains, the way things operate in professional dance culture: choreographers pick the dancers they want to use based on whatever standards they choose to fulfill their creative vision. Dance is not an equal opportunity profession! Thus, Cuyjet was not admitted to the middle-school ballet club. A decade later, JB, identifiably though modestly brown-skinned, was admitted to Lingenfelder's high school club. Perhaps Lingenfelder had softened her color-uniformity rules during the interim, either for reasons of social consciousness or, more probably, because JB

showed such promise. JB told me that she was the only brown-skinned student in the group, and the two other black dancers in the club, both light-skinned, did not associate with her. Her close buddies were two white girls from the Littlefield School who came to her rescue and taught her what they'd learned in their segregated ballet classes, since she couldn't possibly pass for white and didn't even get a foot in the door at the Littlefield school. So we can say that, whether consciously or unwittingly, Lingenfelder, along with JB's white ballet friends, overrode racial barriers and supported her aspirations.

Thomas Cannon was of central importance in the black-white concert dance network of the city. His long-standing friendship with Essie Marie Dorsey was continued with Cuyjet. In about 1944 he began teaching a special class at his studio for black dancers, which he continued until about 1948, after the Littlefield School had folded and long before local white dance schools were integrated. Cuyjet took private classes with him well into her adult life. Ironically, when Cannon began admitting blacks to classes at his own school, they were all light-skinned. His white clientele considered them acceptable (and referred to them as "the mulattoes"), but were not willing to take class with obviously black dancers.[11] This was the tenor of race-based segregation in our country until the civil rights advances of the 1960s. Racism permeated every facet of American life, and could be seen in actions such as these as well as by more overt examples in other walks of life. The fact that Cannon opened his classes to black students at all must be considered progress in this pernicious system. Cannon—and Antony Tudor before him—were among the first to break this barrier in Philadelphia. William Sena, a popular local ballet master, also arranged to teach black students privately and gave individual lessons to Cuyjet, JB (1950–1951), and others at his school on Twentieth and Chestnut Streets. The final irony is that—with a few notable exceptions and continuing into the twenty-first century—blacks, whether light or dark skinned, simply did not have a chance for professional success in the white ballet world.

Another crucial link in the white–black interaction driving the Philadelphia dance community was the Tudor connection. Prior to the founding of the Pennsylvania Ballet Company in 1963, the Philadelphia Ballet Guild brought in Antony Tudor to teach weekly classes for selected students from the city's major dance studios. He started probably in 1949 or 1950 and continued these classes through most of the decade. JB was the first black dancer to avail herself of this special opportunity, followed by Billy Wilson, John Jones, Delores Browne, and the very young Judith Jamison, who recalled staying close to Browne in class because there were so few black people. According to Billy Wilson, "It started at 10 o'clock [A.M.] for the intermediate class. After that it became the advanced

class. Then, after that, there was the boys' class—jumping—while the girls put on their pointe shoes. Then the girls had pointe, and we ended up with an adagio class." In other words, Tudor's once-a-week Sunday visits were daylong intensives. What was refreshing for the black students was that he corrected and treated them as equals in a select group of dancers—a new experience for them. One can only speculate about whether this white man from London was aware of the social change he was engineering in Philadelphia dance culture by accepting them and acknowledging them. Both Jamison and JB said that he often called upon them to demonstrate. JB said, "I think a lot of times I wasn't even demonstrating correctly, because he would correct me. But the fact that he would [call upon me] made me feel aware that [he knew] I was there." We can assume that, with Tudor and JB "aware that" she was there, the class as a whole was also obliged to acknowledge, if not accept, her presence. Wilson added that "Tudor accepted us.... All of a sudden it made the people who were a little bit borderline, or out-and-out racists, take another point of view about us. Of course, we had to partner the white girls, and all of that. None of them seemed to be upset by it all. I know that when I arrived, some of the people who were rather cold to me later became very warm when he said that these boys have talent."

JB remarked that Tudor's teaching style was new for her, "so you're following. But often I would be his partner, because the other boys didn't want to be my partner, so he'd be teaching adagio, with me as his partner." It is not uncommon for a teacher to ask a student to demonstrate a movement with him; but it is unusual for this to turn into a partnering situation lasting longer than a few beats. Tudor didn't make a big deal of stepping in to save her from this racial animosity, but acted as though his behavior was perfectly natural. In her typically thorough, cut-and-dried manner she continued, hammering in her point: "He would say, 'Joan, come be my partner.' He knew that nobody wanted to be my partner...and when we lined up [to do movement combinations going across the floor, often with a male and female moving together, two at a time] he would say, 'well, Joan, come down front,' even if I was struggling because I really didn't know [the movement]."

It is noteworthy that Wilson's partnering experience with white women in the class was different from JB's encounter with the men. Of course, with males the minority in the class (and the dance world), the women couldn't afford to be picky about partners. Dark-skinned dancers like Arthur Mitchell and John Jones were members of American ballet companies[12] at a time when black female ballerinas in white companies—for example, Janet Collins and Raven Wilkinson—had to be light enough, without actually passing, to blend in with the white dancers onstage.[13] And still, they struggled to maintain their positions.

Again, the strict rules of skin color were harder on women than men in both black and white worlds and in both personal and professional circles.

JB mentioned that some of the white female Guild dancers were kind to her. Had it not been for them and Tudor's generosity, she probably would have given up. Summing up her experience under his mentorship, she said,

> You felt that Mr. Tudor cared. And when you walked in—I never felt like "the black person" in the room, even though very few people were friendly. There were a couple of girls that I was friends with. But you never felt that he didn't see you [a common complaint of black dancers in white classes: they can pay their money to take class, but it's as though they are invisible, and they receive no corrections or support]. He corrected you. He told me my attitude looked like "a dog at the fire plug"—I mean, those kind of things. He would hit your chest and say, "that's something I beat your husband to"—things like that, things that you don't forget. And there was a connection, because you wanted to dance!

Besides the fact that he was a foreigner and hadn't inherited white America's antiblack racism, Tudor's sensitivity to his African American contingent may have had something to do with the fact that he, too, was a member of a minority, at least in the nondance world. As a homosexual he may have had personal experiences that clued him in to the unfairness and loneliness of being "othered."

Other than dance classes, the Guild presented performances accompanied by the Philadelphia Orchestra. Jones, Wilson, JB, and Geraldine White, another of the black dancers in class, all performed with this group. Under Tudor's auspices, JB remembered a particular performance when "Mr. Tudor put me into *Les Sylphides* and then said he had to balance it, so he also put Gerri [Geraldine] White in. We were the two blacks on either side of the stage, and this was an all-white ballet. Let me tell you, people raised a ruckus!" Wilson added that the master also choreographed productions of *Offenbach in the Underworld* and parts of *Gaité Parisienne*.

In touch with the real world and good mentor that he was, Tudor talked to his black contingent about their careers. Wilson said that

> finally, after we had been there a while [a couple of years], he called us in to talk. He said there was little possibility of going on to a ballet company in New York or something, and it was time to leave, to move on. We could go to Dunham or to musical comedy. He told us to think

about it. John [Jones] did, in fact, go to Dunham and I did, in fact, go to Broadway. We still studied ballet every day.

This pep talk suggests that Tudor probably integrated his classes because the black students were exceptionally talented, not out of social or political convictions. Had he been a politically minded person, he might have told them to keep at it and find a way to dance ballet, even if it meant starting one's own black ensemble or leaving the United States. Jones and Wilson did become ballet dancers—Jones with Jerome Robbins's Ballets USA, the Joffrey Ballet, and the Harkness Ballet; and Wilson in Europe, including a stint with the Dutch National Ballet (1961–1965). According to JB, and again this was slightly a different message than he communicated to Wilson, Tudor's advice to her was not focused on her chances for a career in ballet: rather, if she really wanted to dance professionally, she would have to leave Philadelphia. His message to these dancers, male and female, was primarily about Philadelphia, a city that wasn't going to tolerate them on its main stages; they needed to get out of town if they hoped to make a professional dance career for themselves. In a sense his was a Booker T. Washington message, as opposed to W.E.B. Du Bois: do what is possible given the status quo, rather than change the score. Nevertheless, Tudor's influence had a lasting effect, particularly on Wilson and JB. Wilson was choreographing a dance for Philadanco when I interviewed him in 1985. He contended that in creating the new work, he was using some of the techniques he had learned in Tudor's classes three decades earlier. Although the ballet classes currently taught at her school are in the Russian style, on the rare occasions when she leads the company ballet class, JB still teaches in Tudor-Cecchetti style.

THE SYDNEY-MARION SCHOOL, JUDIMAR SCHOOL, SYDNEY SCHOOL, AND TRIPS TO NEW YORK

Following the nation's involvement in World War II, enrollments at the Essie Marie School of Dance dropped. Dorsey took a job in the post office and moved to Germantown with her second husband. In September 1946, Cuyjet contacted King and, with Dorsey's blessing, proposed they open a school together. They codirected the Sydney-Marion School of Dance from 1946 to 1948 at the 711 South Broad Street location of the former Dorsey school. With their years of experience in Philadelphia's black dance world, these two women were able to recruit students from contacts established during the Dorsey days. The new generation of students was the offspring of people they had danced with as adolescents. And

again, for these two years of the school's existence, the annual recitals played a major role. The many scenes that made up a full program were in the narrative style then popular in ballets and musicals. Sydney King remembered that

> one year we had something that we called "The Drug Store." The children in the ballet were different kinds of things in a drug store. Judy [Cuyjet] was a powder puff.... Then we had groups of children who were ice cream sodas.... Judy sat on a bench and did a ballet. I think she was on pointe. That was the first solo I choreographed.... I remember one year we opened up with a schoolroom. These were really like sets.

The 1947 recital brochure lists the "Corner Drug Store" with this program note: "In the wee, wee hours of the morning, most anything could happen, in any corner drug store—the inanimate may become the animate!"

It was just one of several dance suites on the program and was typical of Dorsey-style recitals. Sections of the drug store dance are listed as follows:

A) Snoopy Mouse;
B) Story Book of Peter Rabbit [listing a cast of 13 characters from the Potter stories with a Patricia Stubbs "At the Piano," and "Narration by Miss Marion"];
C) Powder Puff, Judith Cuyjet;
D) Vitamins;
E) Peppermint Sticks;
F) The Lime Soda;
G) Lemon Phosphates;
H) Miss Cherry Coke;
I) Strawberry Sodas;

and, lastly,

The Tummy Ache Finale.

The title page of the program reads as follows:

<div align="center">
Marion D. Cuyjet and Sydney G. King
present the
Sydney–Marion School of Dance
In their First Annual
RECITAL
with a cast of 85
Thursday Evening, June 5th, 1947
</div>

8:30 p.m. precisely
at Fleisher's Auditorium
Broad and Pine Streets
Philadelphia

Like Dorsey, King and Cuyjet brought in guest teachers. In 1947 Syvilla Fort, a principal teacher of Katherine Dunham's dance technique, commuted to Philadelphia from the Dunham School in New York and gave classes at the Sydney-Marion School. But King and Cuyjet took the concept a step further, traveling to New York to take classes themselves as part of their continuing education. John Hines, their buddy from the Dorsey school, had begun studying at the Dunham School after WWII. It was he who introduced the women to this institution and to George Chaffee and other ballet teachers. According to Hines, "Chaffee fell in love with Marion because of her dedication. He taught her privately and let her bring her best girls over."[14]

Research and interviews have not revealed why Cuyjet and King split up. It is possible that two directors made for one too many cooks in the kitchen. Both were strong, independent women, experienced dancers/teachers, and mother figures to their students and colleagues, but they nurtured in different ways. Cuyjet, whose astrological sign is Leo, was true to the attributes associated with her birth sign—daring, if not fiery, with an initiating spirit that gave her the impetus to strike out and challenge the status quo in a quest for the impossible dream (namely, training and launching into a mainstream professional career the first black ballerina). King, a Virgo, was grounded, protective, meticulous, and disposed to set her sights on the possible, against known odds—although she, too, aimed to make a place for black ballet dancers. Once again, the Du Bois/Washington paradigm can explain the two approaches; neither is right or wrong—just different. Without implying conflict, it is conceivable that these two temperaments, both committed to dance and education, would reach a point at which they were obliged to follow separate paths.

When the two women had parted ways in 1948, King had remained at the 711 South Broad Street location until the city took over the building thirteen years later, in 1961. Today, it is the site of a firehouse. After they separated, Cuyjet continued to make study trips to New York, taking her finest students with her and increasing her own knowledge of the craft and mechanics of ballet and jazz dance. King relied more on the resources of local teachers and the inherent strength in the community. When they dissolved the partnership, the teaching staff and student body followed one director or the other. Both women continued the tradition they had inherited from Dorsey of having their top students become

teachers. Thus, Joan Myers Brown and Billy Wilson, King's advanced dancers, started out as student teachers and then became part of her staff, imparting to students at the Sydney School all that they were learning elsewhere in their own studies, particularly in the area of ballet. King's friend and colleague Jerome Gaymon taught interpretive dance, and Ellen Harris taught tap. Delores Browne and Judith Jamison were student teachers at Judimar, while John Hines and, later, Arthur Hall taught regularly for Cuyjet. In subsequent years, the best black Philadelphia dancers were associated with one or the other of these two schools. They were not the only dance schools in the community, but they were the most famous and the two that seemed to be engaged in some level of polite competition, perhaps because of their prior union and similar top-notch status. Indeed, King and Cuyjet continued to work together in large-scale local performances, particularly in coordinating the Christmas Cotillion balls.

Delores Browne met Cuyjet when Browne was at Barrett Junior High School. She was in the school's ballet club, which by then (1948) was run by a Ms. Weir. This was also the year that Cuyjet and King split up. Browne contends that the adolescent dancers had stayed with King. Cuyjet needed older kids, so she visited Barrett to recruit for her new school, offering scholarships to Browne and two other girls. In 1949, at age fourteen, Browne began studying at Judimar. Similarly to the way that Cuyjet's life—also at age fourteen—was forever changed by a scholarship from Dorsey, Dorsey's ward offered a grand opportunity to the next generation. Browne's path was set for life. Browne told me that she considers Cuyjet her *teacher*. Everyone else was, for her, a coach.

John Hines summed up Cuyjet's strengths as a teacher:

Her strong points are centering and strengthening those backs and legs. All of her girls were strong. The feet were very important to her. If they didn't have them before, boy, they could use them when they left there! The poise she taught was very good. She wouldn't allow you to be slovenly. You had to look like a dancer or else.... She was also strong in underpinnings and working from the inside out.... There are a lot of loose dancers around who cannot control their bodies That's dangerous. All of Marion's dancers knew how to control their bodies.

The training Judith Jamison received at Judimar gave her a firm foundation for professional success. She explained that the work was disciplined and focused. Dancers were not taught to emote, to "be a tree," but to learn and increase technique and performance values in preparation for professional work. Technical proficiency went hand in hand with Cuyjet's demand that the students

perform—*dance*—in class, not simply execute the movements. There was a seriousness at Judimar that this willowy young adept appreciated and emulated. It was a microcosm of the professional world that she would enter a few years later. "Miss Marion's little ballet school" provided Jamison with the tools she would need to enter that world and succeed. When the stellar students like Browne and Jamison reached a certain level of accomplishment, they became student teachers, passing their knowledge on to younger students. Thus, when Jamison was about fourteen years old, she began teaching the nine-year-olds.

By and large, Cuyjet's students came from the black bourgeoisie. In her own words, most of her students were "children whose parents were professionals. I had the schoolteachers, the clergy, the doctor's children, and the other children [whose parents held non-professional positions] had seen my children dance at public schools or at some church or some fund-raising event. Later, I began to get people who were very dance conscious, and they were responding to our ads in the [*Philadelphia*] *Tribune.*" She willingly sent her finest students to New York professionals who could offer them training beyond her capabilities, and she afforded the same opportunity to her teachers: "I remember one whole season, I taught all day on Saturday, every single class, because I sent all my teachers to Maria Swoboda," she recalled with a laugh, amazed at her own stamina.

Both schools continued the annual recital tradition. According to JB, Judimar tended toward full-length ballets—a complete *Cinderella* or *Swan Lake*—whereas the Sydney School followed the Dorsey tradition and usually offered a more conventional recital format of excerpts, the variety allowing all the dancers equal opportunity to show off their talents. But the recital brochures from each school show many similarities that balanced out the differences. They both served many students. Parents at both schools expected their children to perform after having studied for the past year. Then as now, parents were the financial bedrock of the neighborhood dancing school—paying tuition, buying and/or making costumes, soliciting ads from community businesses to underwrite the cost of producing recital brochures, and sometimes purchasing or selling blocks of tickets to their little darlings' performances. Therefore, a variety of dances, skits, group numbers, and solo turns were essential to provide performance opportunities for anywhere from one to several hundred students. The first half of the Judimar recitals consisted of a variety program, followed by an intermission, with the rest of the program given over either to a full ballet or a major portion of a three-act work. The Sydney School offered several theme-based dance suites as well as freestanding solo or group dance numbers.

Let's compare the Judimar and Sydney recital programs of 1950. The inside cover page of Cuyjet's program shows a photo of her in the swan costume

of a traditional ballet blanc—the all-white tutu and the headdress made of feathers. Captured in the position assumed by the "swan" as it sinks to the ground, she is wearing pointe shoes, although she is not on pointe. Under her photo are the words "Ballet Cinderella," followed by the date, Friday evening, June 16, 1950, and location, Town Hall. *Cinderella* occupied the second half of the program and included a prologue, entr'acte, and epilogue, plus three acts, and could have taken nearly two hours to perform, given all the sections, cast members, and costume and set changes involved. Delores Browne danced the title role. The first part of the program also probably ran for close to two hours and was composed of two additional dance suites: *Western Suite* and *Ballet Le Lac*—each containing its own story ballet; as well as a number of other individual and group dances, including "*Liebestraum*—a study in balletic lyricism," and "*Diablito*—ceremonial salute to the sun." The choreographers were Cuyjet and John Hines, the latter responsible for the Cuban-inspired *Diablito* and a Rhumba and Samba elsewhere in the lineup. Sometimes the programs were so lengthy that the recitals were performed on two evenings. Such was the case in 1953 when the Judimar recitals were offered on Thursday and Friday, May 7 and 8. A version of *Cinderella* was the centerpiece on each evening, but with two different suites of additional dances, so that the program didn't simply repeat itself. Gwendolyn Riley danced the title role on Thursday; Judith Cuyjet, on Friday.

King's 1950 concert was also held in Town Hall. Her program booklet is smaller than Cuyjet's, and the cover photograph features six of her adolescent girls costumed, like Cuyjet, in ballet blanc swan tutus and headdresses and pointe shoes, though they, too, are not on pointe. (They also are not in character; they are smiling at the camera and look like they're having a ball.) The first page announces "The Sydney School of Dance in 'The Melting Pot' at Town Hall, Monday evening, June 5, 1950, 8:30 P.M.," and we learn that the concert will be accompanied by the Philadelphia String Ensemble. King hit upon an ingenious way to give an overarching theme to the varied dances on the program. The "melting pot" is introduced as follows:

New York City, 'The Melting Pot of the World'
 In the harbor of New York City, "The Melting Pot of the World," stands the Statue of Liberty, symbol of democracy.
 People of the many nations of the world have passed her way, some seeking security, others freedom of expression.
 Tonight our performers are demonstrating dances from a few countries of the world.

The program lists several large cast dances, including *Japanese Garden*, *Oriental*, *Pavanne* [*sic*], *Hawaiian*, and *Park Scene*. Essie Marie Dorsey must have decided by then that King was mature enough to handle it and had bequeathed to her former student the right to perform the *Italian Beggar Dan*ce. It was included in this potpourri and danced by King. The last dance suite before intermission was *Afro-Cuban Ceremonial Suite*, with several sections. As mentioned in chapter 1, it was not in Dorsey's time but that of her followers that we see the introduction of African and Afro-Caribbean dance forms, largely due to the influence of the Dunham School and its visiting teachers and reinforced by John Hines's study in Cuba and Haiti. King's Jamaican heritage may also have played a part.

It is unclear from the layout of the program whether the dances following intermission were also part of the "melting pot." In any case, there are two suites in the second part to end the evening: *Jamaican Carnival*, another Afro-Caribbean dance; and the program closer, *Ballet de L'Heures*, a ballet suite with sections titled "Sunbeams," "Sunset," "Twilight," "Midnight," and finally, "Dawn"—a concluding solo danced by King. JB danced in both of the Afro-Caribbean numbers and the ballet finale—along with a cast of hundreds! Choreography for this recital is attributed to King, Jerome Gaymon, and Eleanor Harris, the tap teacher. JB remarked that King's school generally attracted a less affluent clientele. Whether this is fact or surmise, we know that, with excellent training available at both schools, Philadelphia's black middle class and working class parents could give their children high-quality dance instruction.

With a set of strengths different from Cuyjet's, King was renowned for her expertise in training young children. In JB's words, "She had that mother thing that I guess we all respond to. She did just wonderful things with little children and had a great core of them that she worked with. I remember her as a very beautiful woman, very motherly, very protective." Billy Wilson elaborated,

> When I think of Sydney, I think of her warmth, I must say. She made it possible for me to be able to participate in this thing that I wanted to do so badly and still make a couple of bucks doing student teaching. I would teach with her sometimes in Camden [New Jersey, the satellite studio location]. That [money] would send me to Tudor's, pay for my lessons there, and then I would come back and teach what I had learned to the students at Sydney's. It was wonderful. It gave me the opportunity to do what I wanted to do, to feel that I could contribute something to what had been given to me; and it also allowed me to grow as a teacher and to do choreography. As I look back on it now, it was a

tremendous and enriching situation. For whatever may not have been ideal in moments, they are so vague in my mind that the positive things are the things that remain.

Sydney was not what I would call a taskmaster. She was most effective with children. She had the patience to work with the youngest ones. They adored her. *It was not in her nature to take that tough thrust to make the others do what they had to do. Joan [Myers Brown] was better at that and, of course, Marion Cuyjet was excellent at that—that was her forte* [my emphasis].

Wilson gets at the basic difference in these personalities. We might characterize it as tender loving care, on the one hand, and tough love on the other. JB is Cuyjet's heir in this regard (see the dancers' and choreographers' reflections about JB in chapter 4). Nevertheless, the Sydney School produced its share of strong ballerinas, including Betsy Ann Dickerson. According to Wilson, the work of Dickerson and another dancer, Barbara Harper, was on a par with the Cuyjet students Browne and Jamison. Dickerson went on to a career in musical theater in New York. She also opened her own dancing school on Long Island. JB contends that she also passed for white and thus became one of the first black dancers at Radio City Music Hall, dancing in the corps de ballet. Carole Johnson, another former Sydney student, became a modern dancer after moving to New York, and then moved to Australia, where she pioneered the modern dance movement in that country, bringing Aboriginals into the fold of the country's previously segregated mainstream dance community.

The annual recital was a major event for her school, and like Dorsey before her, King featured herself on the program each year. In the mid-1980s when I interviewed her, she was in her mid sixties and still performing in these concerts. For the 1984 program, the guest alumna was Lola Falana, King's former student and at that point a successful singer–entertainer, working with such stars as Sammy Davis, Jr. and Bill Cosby. Falana performed in a trio with King and another dance teacher and also did a solo. At the 1985 recital, the grand finale was an extravaganza based on the hit song, "We Are the World." To mark the fiftieth anniversary of the Sydney School in 1996, the recital booklet was replaced by a spiral bound brochure over a hundred pages long and filled with concert and recital photos dating back to 1946 and running right up through ads purchased by the proud parents of current students to celebrate their childrens' first, fifth, or tenth Sydney School recital. As of this writing, King is alive and still committed to directing both the West Philadelphia and Camden branches of her school. Of course she is not actively teaching these days, but she has a

staff of faithful educators who have been with her for decades. And the recital remains an annual tradition, as it has also become at JB's Philadelphia School of Dance Arts.

⁂

The Philadelphia black dance community's relationship to the New York dance world in the 1950s warrants further discussion. To reiterate, besides training in Philadelphia with guest teachers who commuted from New York, many black Philadelphia concert dancers studied at New York studios. Some relocated to the Big Apple, either for a short time or permanently. Others, like JB and Cuyjet, kept their base in Philly. The city has profited by its proximity to New York, which has given these artists the opportunity to avail themselves of the concentration of energy, talent, and expertise that makes New York an important dance center in the United States. But Philly has its own talent, initiative, drive, and creative spirit—all of which I look at in chapter 4. Philadelphia is increasingly becoming a dance center that challenges New York's hegemony, no longer just an outpost living in its shadow. In some ways, the decades-old trend of leaving Philly to dance in New York or elsewhere—the route Antony Tudor suggested to JB, Wilson, and others—is shifting, and the City of Brotherly Love is transforming itself into a particularly dance-and-dancer-friendly locale. Indeed, as Wilson put it, Philadelphia has supplied "not only New York but the dance world at large with fine dancers and fine dancing." For Cuyjet, the importance of the New York dance connection began in her days as Dorsey's protégée. After she finished high school, she was sponsored by Dorsey, three days a week for nearly a year and a half, to stay in the city and study with some of the same teachers to whom she would take her own students a decade later.

In the 1940s and 1950s an important difference between training in New York and Philadelphia was that in the Big Apple, African Americans were allowed to study at professional (white) ballet schools. They were not necessarily welcomed with open arms or encouraged to pursue ballet careers; they may not have been given the individual attention they craved. But they were permitted to take classes at the ballet studios located in the theatre district and the Carnegie Hall area of Manhattan—classes taught by leaders in the field and peopled by accomplished dance artists and talented hopefuls like themselves. Marion Cuyjet and her stalwart little group of dancers had a lot to do with integrating these classes. And, once again, it was the person who looked white—Cuyjet—who worried the color line in preparation for its penetration by her brown-skinned "family." It took some crafty planning. Delores Browne told me an interesting

story about how it all began. From 1949 or 1950 until about 1958, Cuyjet and her husband drove groups of their students to New York. A week before the first such outing, Cuyjet went alone to the city to register them and purchase their class cards, knowing that the registrars at Ballet Arts and Ballet Repertory, two of the most prestigious schools, wouldn't suspect she was African American. Next, Browne was sent ahead a couple of days before the other students arrived; she had been carefully instructed by Cuyjet to ask for a refund if there was any funny business about her taking the class. Sure enough, the registrar was taken aback when the fifteen-year old showed her class card, and Browne was told to go to the "annex building" for her classes—obviously not what she had registered for. With fear of disobeying her taskmaster–mentor overriding any feelings of intimidation, Browne refused and requested the refund. Instead, she was allowed in the class. By the end of the 1950s, my own Harlem friends were taking classes at both schools, experiencing not much encouragement but few problems. It seems that Marion Cuyjet and her adolescent ballerinas broke the color barrier in New York City's major ballet studios!

Still, it wasn't all smooth sailing for them. Browne remembered the first day they showed up for Vladimir Dokoudovsky's class. When it was partnering time, the (white) men wouldn't partner the black women—a reminder of JB's plight during her tenure with Tudor. Cuyjet, always resourceful—she had already instructed the girls not to get emotional and to keep a dispassionate face and demeanor, whatever happened—told her girls to partner one another; when they returned to Philadelphia they'd teach this partnering to the men at Judimar. They did this for the first Dokoudovsky class. When they showed up for the second class and it came time for partnering, Browne said she'll never forget that an Asian guy came over to her, extended his hand in invitation, and said, "Ms. Browne?" The gesture broke the ice, and the girls were partnered from then on.

As mentioned earlier, John Hines introduced Cuyjet and King to George Chaffee. Now that Cuyjet was running her own school, she took her students to classes with Chaffee, Lisan Kay, and Thalia Mara, who all taught in midtown studios. Chaffee's was on Fifty-Sixth Street, around the corner from Carnegie Hall, where the Ballet Arts and Ballet Repertory schools were located. These student trips occurred during summer vacation. Hines told Cuyjet about the Tatum House YWCA on Thirty-Seventh Street and Lexington Avenue, and there they stayed. This, too, was different from Philadelphia, where there existed a black YWCA in South Philadelphia, but African Americans were unwelcome in other branches. There were branches of the Christian Association institutions uptown in Harlem, but Cuyjet and her students, without passing for white,

were comfortably accommodated in this centrally located branch. A typical day's schedule would look something like this:

> We would do two at Chaffee's, his 11:00 and his 6:30 classes. In the afternoon, we went to Ballet Arts. I would have a couple of girls who were not up to the Ballet Arts class, so they sat in the waiting room, and they would catch a look-see through the door whenever they could. But when we stayed for the week we traveled about. At Ballet Arts they had a ballet class and a character lesson, and I had a few girls who attended [a jazz class taught by] Matt Mattox. Later, our fine black dancers were coming into my life, like Harold Pierson, and I shot some of the money through to Harold, so he rented a studio at Eighth Avenue, and they had jazz [classes] from him.

Bear in mind that professional dance classes are usually an hour and a half long. In the early years, the honored group of students included Browne, Judith Cuyjet, Judith Jamison, Frances (also called Franca) Jimenez, and Donna Lowe, representing a range of skin colors among African Americans, and only Lowe and Cuyjet white enough to pass.

Although African Americans were allowed in these classes, the only well-integrated institution was the Dunham School, which whites attended in great number. In 1950 and 1951, JB studied there, taking ballet with Karel Shook and Dunham technique with Walter Nicks. She was also watched over by Syvilla Fort, who took a liking to "the skinny little girl" who commuted weekly from Philadelphia. Back home, Cuyjet and the young JB immediately put their New York learning to use in teaching their classes. Indeed, these New York jaunts were not only for the students: they were the blood that brought vitality to Cuyjet's dance life. Besides continuing her ballet education she studied jazz dance with Luigi and became an authorized teacher of his technique. Always aware of her ethnic heritage as a partner to her love of ballet, she was inspired by black New York dancers like Harold Pierson, as well as Joe Nash and Leigh Parham—two of the many masters who commuted to Philadelphia to teach and choreograph at Judimar. Cuyjet exclaimed,

> Oh, I needed inspiration! I needed a teacher around me who was much better than I was. While they were teaching, I was watching and picking up things and enjoying their discussions. I would drop in very early, before classes started, and I would sit and listen to them—to their criticisms of the ballet or a Broadway play....

Jamison raved about tshe wonderful training she received through Judimar, Tudor, and the trips to New York, declaring that they had prepared her for eventually living in New York and studying with major teachers.

For others, a life in Manhattan was not the answer. On his own and living in New York in the mid- to late-1950s, Gene Hill Sagan studied at the American Ballet Theater school at a time when there were only a handful of African Americans in class, including himself, Raven Wilkinson, and Louis Johnson. He made this incisive comment about life in Gotham:

> I cannot live in New York. I dislike New York. I can't survive [there]. For me it is a graveyard. I've seen too much potential die, too many lives come and go, too many broken dreams, too many people collapse. Everyone feels that New York is the only place in the world, so they're willing to give up the ghost there.

Sagan, Hines and JB brought their creative energies back to Philadelphia, choosing home turf as the place where they could develop their artistry without sacrificing their lifestyle. Were it not for them, the City of Brotherly Love would not have developed such a rich dance tradition.

PART TWO
THE ANNUAL CHRISTMAS COTILLION

> *More than 6,000 persons, with representatives from 20 foreign countries, stood and paid tribute to Mrs. Franklin D. Roosevelt, widow of the late President, as she became the fifth recipient of the jeweled Cross of Malta, presented annually to one of the nation's outstanding citizens by the Philadelphia Cotillion Society.*
>
> *Judge Herbert E. Millen of Municipal Court, general chairman of the society, introduced Dr. You Chan Yang, Korean Ambassador to the United States, who, in turn, made the presentation to Mrs. Roosevelt Tuesday night at Convention Hall.*

Thus read the opening paragraphs of an article in the *Baltimore Afro-American* reviewing the 1952 annual Christmas Cotillion Ball.[15] Involving massive numbers of community members onstage and behind the scenes and months of preparation, the Christmas ball was an annual event, attracting national attention and participation by foreign dignitaries, and it satisfied the needs of a community that refused

to be defeated by the isolation inflicted through racial segregation. Although each ball featured a Cotillion Waltz danced by perhaps 50 to 100 young couples—the women dressed in white gowns and accessories, the men in black tuxedos—the gala was more than a coming out party for debutantes: it was a celebration of the community in all its aspects. And dance was at the very heart of its agenda.

From its beginnings in 1949 to its demise in the 1960s, Philadelphia's annual Christmas Cotillion was a major social event for the black bourgeoisie of cities up and down the East Coast and as far west as Detroit and Chicago. In spite of its similarities with the full-dress festivities of white elite society, it also grew out of the spirit that spawned such popular black entertainments as Caribbean carnivals and neighborhood parades. According to John Hines, like traditional vernacular displays, preparations for the Cotillions were begun nearly a year in advance, starting almost from the moment the previous year's event was over. The balls were characterized by the extravagant spectacle that became their trademark. The occasion was one of the few black social events recognized by white Philadelphia and even the national press.[16] Unlike the nineteenth-century black Philly society events that were restricted to the card-carrying aristocracy, these mid-twentieth–century galas allowed entry and participation by blacks of every class as long as they adhered to the rules, took the training required for participation, and paid their way.[17]

The Christmas Cotillion's mastermind and guiding spirit was Eugene Wayman Jones, an educator, musician, patron, and public figure well known in black society who conceived, produced, and directed the balls. The man held a near-legendary status among black Philadelphians of his era.[18] Born in West Virginia to a musically gifted family, he came to Philadelphia as a teenager to live with an uncle, the Rev. Henry P. Jones, who was pastor of the socially well-appointed Mother Bethel AME Church. At this tender age he played the organ for services and directed the church choir. Later, he returned to West Virginia, received a bachelor of science degree in education at West Virginia Institute and became a master sergeant in the Army, conducting a chorus during his service. In 1946 Jones returned to Philadelphia and began implementing the social and educational aims he envisioned for the black community—and, indeed, the man was a visionary. He was awarded master's and doctorate degrees in education from Temple University; became an instructor in educational methods at that institution (at a time when Temple's student body, not to mention faculty, was white);[19] and left that position to teach at the Berean School, a manual trades institution, where he created and directed an a cappella choir. He also produced other events hosted by the black bourgeoisie besides the Cotillion, conceiving

entire programs and making these spectacles—and his genius—the talk of the town. A 1951 newspaper article claims that

> No one in the broad social life of the city within memory compares with him in versatility and originality in the field of public entertainment and social planning....
>
> He produced the first Links Coronation Carnival, the first Christmas Cotillion (in 1949), the famous Debutantes Ball and other spectacles.
>
> At these he has conceived the entire programs, written much of the music, delivered recitations, designed sets, managed individual performances, and done about everything else.[20]

The article also cites him as "one of the finest interior decorators in Philadelphia or anywhere else." According to Jerome Gaymon, choreographer of the annual "Cotillion Waltz,"

> The day [of the ball] was declared "Christmas Cotillion Day," and it would be on the radio, and they would sell tickets at Wanamaker's. When we needed decorations he [Jones] would go to department stores and get things that were in the warehouse, they would lend it to him. He could sew; he could paint anything.

Gaymon spoke dryly, if not enviously, of Jones, cutting to the heart of his social success:

> He became friendly with the top social arbitrators at that time; the top one was Evelyn Reynolds,[21] and because of his color—he was fair—she thought he was a living doll. And they formed the Cotillion Society. It started with thirteen and ended up with seventeen members. She belonged to one of the old clubs in Philly and got her club to support him.

Not just fair-skinned—he had blond hair, courtly manners, and advanced academic degrees to match and surpass most Americans of any color. Gaymon had to admit, a bit begrudgingly, that Jones had a talent for getting people together, and not only high society:

> He could take a hoodlum off the street and would have them doing things—the kids just loved him.... He would go out and get all these

underprivileged kids—not that he would associate with them—but he got scholarships for them and everything. He dealt on one level but worked on another level. When he went on his social thing it was a different group altogether. When Sidney Poitier [the actor] came [to town], he had a party. He could get anything he wanted.

The man was an educator, humanitarian, social worker, artist—and a socialite. He was a paragon of the Du Boisian ideal of the talented tenth and fulfilled that sociologist's concept of serving grassroots black folk by his commitment to community service. It is essential to know this background to understand how one man could conceive the entire Cotillion event—a panoramic undertaking that included:

- a classical (European) music concert at the very beginning and/or as an interlude;
- a ceremonial procession of honored guests, (including ambassadors, embassy representatives, and foreign dignitaries) led by a renowned black municipal judge or other dignitary, Jones himself, and his board of directors;
- a welcome address from the mayor of Philadelphia;
- a tree-lighting ceremony for an oversized Christmas tree;
- the Cross of Malta award ceremony-within-a-ceremony, bookended by its own reception and speeches[22];
- the bestowal of a gift to a particular charity, again with its own miniceremony;
- a sit-down formal dinner at reserved tables, the tables closest to the performance area the costliest;
- ballroom dancing to live music by a major band following the formalities and continuing till the wee hours of the morning; and
- two staged dance events of central interest to our story: first, the Cotillion Waltz, "presenting" a host of young couples in a staged waltz with a particular theme; and second, the centerpiece—the jewel in the evening's crown—a ballet spectacle.

Although he didn't choreograph it, Jones conceived the ballet's theme, detailed the story line, and communicated that information to Cuyjet and King, who then gathered the dance forces of the black community, including smaller dance schools, to make his dream come true.

The first Christmas Cotillion was held in 1949. Most of the 1950s events took place at the massive Convention Hall in West Central Philadelphia. The Cotillion

Society was the ball's umbrella organization and served as a shelter for the activities of voluntary and fundraising groups connected with the Mercy-Douglas Hospital. Thus, it was a philanthropic arm for continued support of a hospital serving black people during the segregation era. According to its bylaws its aims were:

> To make more secure those creative forces which are the foundation of Democracy [*sic*]; to increase interest in the cultural arts; to provide opportunities for training and education in these areas; to sponsor such events as may reinforce this training and education; to maintain and operate Heritage House, a place for the displaying of books, documents and works of art; to perform any other functions related thereto.[23]

Heritage House provided "educational and cultural opportunities to underprivileged Negroes, particularly the youth,"[24] including coaching in academic subjects, dance and drama classes, etiquette and diction lessons, and group outings to cultural and social events. It was as significant an achievement as the Cotillions. Heritage House represented Jones's philanthropic vision, while the balls and other society events displayed his artistic flamboyance. The Cotillion Waltz is the one instance wherein both visions merged. As Gaymon explained to me,

> When the Cotillion first started it was for the elite, but when I took over [the Waltz—the first two years it was directed by Essie Marie Dorsey, with Gaymon as her assistant] in the third year I went to Gene [Jones] and then we took it to the committee to open it up to the public school kids in high school. He wanted a cast of thousands, and I had four hundred and something in my waltz sequence alone. We couldn't get that from the middle class people, so we had to go to the schools, so there was a mixture of the low income, middle class and upper middle class, but it was a great thing to be in the Cotillion. Of course, the kids had to pay their own expense. For some of the poor people we got the people [in their community] to sponsor them—the girls with the gowns and the fellows from whom we rented the tuxedos would give us so many for these kids, and different organizations would sponsor some of the fellows so they would have the complete dress. We had some rehearsals in North Philadelphia neighborhoods, in the public schools.

From Gaymon's perspective—and like other examples in the African American community—the Cotillion may have started as a white tradition, but it was transformed to meet the black community's needs, and the result was this new

phenomenon: an elite event geared simultaneously to benefit the upper classes and, in Gaymon's words, meant as

> a means to try to push our people ahead, regardless of whether they were elite or not. It gave them a chance to see how the elite tried to live.... Here you have the intellectual coming, and you get a chance to see people who you would never get a chance to meet.

Indeed, a bona fide debutante ball, black or white, was a small and exclusive event. As fancy as it was, a mega-event of Christmas Cotillion proportions couldn't be categorized in the same league.[25] John Hines elaborated:

> [The black teenagers] were just girls who would dedicate that whole year to the Cotillion society. They would work for it. You had to break them into it. All year you would be after them to stop chewing gum and do this and be neat and all that sort of thing. Gene was good at that. You were to make a lady out of them in a year and then present them. It was like graduation from a finishing school.
>
> They used to have all kinds of classes, too [in diction, posture, etiquette]. It wasn't just a thing for upper class kids. It was kind of to bring them to the upper class as far as being little ladies was concerned. We didn't care if you came from the wrong side of the tracks.

Attended by the African American bourgeoisie—who, in their home cities may have held their own private, elite debutante balls—the Philadelphia Cotillion was a coming together of the upper classes as guests to witness performances by middle class, working class, and underclass youth who were being taught the tools of etiquette to help them move up in the world at large, black or white. Thus, Jones was Professor Henry Higgins to hundreds of Eliza Doolittles. W.E.B. Du Bois would have been pleased.

The assessment of New York–based choreographer Joe Nash concurs with Gaymon's. Nash, who had been invited by Cuyjet to teach at Judimar and to choreograph for several Cotillions,[26] recognized that

> it was basically a major social event, [but] there were economics involved, politics, as well as culture.... It had to have community support, otherwise it couldn't go off, and as a result you would find working class people who had formed coalitions to do these things. You had the major body [that is, the Cotillion Society], but you had subgroups to help them carry out their programs, and that's the only way these

major events could take place.... I imagine people of moderate means wanted to be involved. You know how you want to go to an affair, so you scrimp to make it possible, and no doubt that did prevail because everybody saw the importance of this event and wanted to be there.

Nevertheless, as Cuyjet cogently put it, "While a lot of good was being done, the caste system was being emphasized." I believe she meant that, although the working class could gain entry, it was still an event that emulated and esteemed high society and, thus, reinforced its legitimacy—and it cost a pretty penny to attend. In addition, there was the fact that its leader, Wayman Jones, looked, acted like, and could pass for white. Billy Wilson felt that "it was strange to see this man—very fair, with platinum blonde hair and a tremendously deep, resonant voice—being so [much] about black things." But Cuyjet was right: this was the era of other white-looking black men—Walter White and Thurgood Marshall—whose careers focused on "black things."

This is the world in which Joan Myers Brown performed before entering the real world of show business a couple of years later. In 1950, thanks to the Cotillion Society, she had competed in a ballet competition with several other dancers and won a $100 scholarship to study at any dance school of her choosing. Having experienced racial discrimination in the Philadelphia studios, she chose the Dunham School in New York City (knowing it was run by African Americans), and her dad financed her weekly trips. Later on, in the 1950s, while keeping up a professional career in the entertainment industry, she choreographed and danced in Cotillions and in King's and Cuyjet's school recitals. Being seen—and reviewed—at these events was an important way of gaining professional recognition in black America. The *Baltimore Afro-American*, reviewing the 1953 Cotillion, had this to say:

> Joan M. Johnson [JB had married Fred Johnson in 1950], Betsy Ann Dickerson and Billy Wilson were most outstanding. These dancers won great applause for their work. Miss Johnson's past training has given her great confidence and is well reflected in her dancing.[27]

One of Billy Wilson's vivid memories was of this 1953 Cotillion performance with JB, when he was seventeen:

> A peak experience was dancing in the Christmas Cotillion with Joan Myers Brown to the Rachmaninoff *Piano Concerto*.... It was the first time I said [to myself] that I was dancing ballet: "I'm on this floor, and

I don't care who thinks what about anything!" I really broke certain [personal] boundaries at that time. Gene [Wayman Jones] said to me earlier, before the rehearsals: "I want you to go with me to Wanamaker's and...listen to music." We were sitting in a booth listening to all kinds of music, and [when the] Rachmaninoff [was playing], he said: "I can see this: you are going to be Quicksilver, and you are going to have silver on your heels, and you are going to have on a hat, and you will fly through the air."...that sort of thing. *And I believed it!* It happened! He could make these things come true. He was the producer. I choreographed it with Joan. I wore white tights and a blue leotard. On that leotard was silver and wings at the shoulders and wings on my heels, and my hat had wings like Mercury. That was the moment.

They [our mentors] hadn't seen the dance that Joan and I designed. When we did this rehearsal, when we finished, Marion was crying and Sydney was crying. This was the thing that was extraordinary and so enriching. I knew these two women had been together in their business, and I knew they had parted....But I remember that day. They sort of hugged and cried together. It gave you such a feeling of unity.

Wilson got it right: unity was the keynote of the Cotillions. Unity in putting together all the separately rehearsed sections and making them flow together as a whole. Unity in rehearsing and coordinating nearly a thousand students in a major dance presentation. (King and Cuyjet each had upward of 300 students, and other schools participated as well.) Unity in synchronizing a waltz for 50 to 100 couples. And unity, as described by Wilson, in allowing old divisions to temporarily dissolve in the service of the greater good and in the aura of this magical, communal moment. In spite of the shortcomings of an event shaped by the pretensions of a people striving for upward mobility and trapped by the tyranny of racial discrimination—both white racism and the black color-caste system—the Cotillions brought the community together in a huge cooperative effort of creativity with a socially conscious, inclusive subtext embedded in the spectacle. The level of cooperation and volunteerism needed to pull it all off was considerable. Beauticians did coiffures; dressmakers adjusted costumes; parents supervised the children; and everyone sold tickets.

Hines mentioned one Cotillion for which he choreographed "a Brazilian samba, [and constructed it] like Mardi Gras. We took the whole week—Holy Week [as the theme for the dance]. We didn't go into the holy part, but we went into the different dances in a way the street people did." He recalled one of his dancers who had grown up riding horses down South. Ever resourceful, Hines

made use of this talent and cast the young man as "a prince, and [he] came in riding this horse. They just couldn't believe it! In that place [Convention Hall] you could do as you would do at Madison Square Garden [in Manhattan]."

Besides the students, teachers, and local dancers, there were guest soloists at some of the events. In 1956 Leon Danielian and Gertrude Tyven of the Ballet Russe de Monte Carlo[28] were featured in a full-length spectacle, *The Prince and the Rose*. After they performed, hordes of students followed through with unison dances. Arthur Hall recalled, "This group over here would be doing the angels, and this other group the horsemen, others doing the devils, and others..." Generally, Cuyjet was the overall "dance captain," sometimes moving from group to group on roller skates to cover distance across the vast Convention Hall floor.

To get an idea of the scope of a Christmas Cotillion, let us return to the *Baltimore Afro-American* article that opened this chapter and a bird's-eye view of the 1952 event.[29] Before Korean Ambassador You Chan Yang presented the Cross of Malta to Eleanor Roosevelt, a representative from the mayor's office introduced a prominent city realtor who read the award citation. Then Dr. You made the presentation and the former First Lady gave her acceptance speech. Next came "the presentation of the society's annual gift of CARE packages, designated by Mrs. Roosevelt to be sent this year to India, Germany and Yugoslavia. The plight of the so-called 'Brown Babies' of Germany received special interest."[30] A member of the Cotillion Society formally presented the packages to the vice president of Lit Brothers — the high-end Philadelphia department store that was the CARE collection center for the city. These presentations had been preceded by a reception and a buffet supper at Convention Hall, where Dr. You and Mrs. Roosevelt were the guests of honor, and were followed by Jones's ballet spectacle. That year the fantasy was entitled *The Golden Flame*, and the paper reported that "more than 600 dancers and performers took part."

However, the dancers who performed in the ballet spectacle did not actually attend any of the other events. They were backstage with costumers, stylists, and prop movers, preparing for entrances, exits, and costume and set changes. In fact, the dance concert was the servant of the Cotillion. Dancers were figuratively stationed in the "kitchen" (that is, backstage and apart from the actual festivities) and, like "the help," appeared when paged, then retreated to the designated backstage area of the huge arena when they finished performing, rather than mingling with the audience. This was different from the dance school recitals where dancers sat as audience members after their onstage roles were done.

The article gives a blow-by-blow account of the performance, which I repeat in the service of illustrating the sweep of Jones's vision. It was the story of the Emperor — perhaps Jones himself — of a kingdom called Khristkotilyan — read

Christmas Cotillion—who decreed a national holiday for the twenty-first birthday of the crown prince:

> It was a day of double rejoicing for the Princess Feu D'or, 'the Golden Flame,' was to arrive for the announcement of her betrothal to the prince.
>
> **Ballet of the Rainbow Flames**
> First to arrive were the ambassadors of the nations, then the court, resplendent in all their finery. The emperor and the empress, brilliant in imperial garb, appeared to the sound of trumpets. The 10 royal princesses, sisters to the prince, made their entrances. Finally, the young prince approached: the emperor raised his hand, and the fete began.
>
> The ballet of the "Rainbow Flames" opened the performance in the great plaza. The silver, violet and scarlet flames danced in sequence. Then the princess, drawn in a gilded carriage, was received by the prince, as tumblers in parti-color [*sic*] cavorted to a cannonade of military drums.
>
> **The Peasant Dancers**
> A group of peasant dancers in their traditional garb performed the wild Czardas, and as they left the square, a Corps de Ballet Classique glided to the center and enacted the "Star of Gold" ballet. As they retired, a hush prevailed over the plaza, for poised in the gates to the square were 192 cotillion dancers.
>
> Then the assemblage was saluted for the last time, the orchestra and trumpet corps gave the recessional.

Live music was another feature of the event: "The cotillion symphony was conducted by Raymond L. Smith, and at the great organ was Orrin C. Suthern, professor of music at Lincoln University. Dance music was furnished by Count Basie and his band." The article concludes with comments from several people who attended:

> Attorney and Mrs. Mio Murray of Gary, Ind. said: "Mr. Jones did a remarkable job with the 'Golden Flame'":
>
> J.B. Blayton of Atlanta, Ga.: "Wonderful."
>
> Dr. and Mrs. Herbert Tucker of Boston, Mass.: "That's what I call a treat."
>
> John Lloyd, native, and first colored beer salesman of Pennsylvania: "I have seen all the Cotillions and this one, in my estimation, is the very best."

This *Baltimore Afro-American* account helps us to understand the particular mix of illusion and reality that marked the Philadelphia Cotillions. Each event was an eclectic cultural stew carrying within it the contradictions and contested narratives inherent in being black in America. From an ancient Christian symbol [the Cross of Malta] that represents unselfish service to humanity, Jones devises an expensive custom-made gem-encrusted piece of jewelry; bestows it upon a major figure, black or white, respected for his or her work toward human rights; and couches the award ceremony in a fantasy spectacle having to do with gods and goddesses, princes and kingdoms that come from European mythology. The dance performance is ballet, with the "prima ballerina" and other dancers in leading roles dancing on pointe. Africa is nowhere in the picture, but this is before the civil rights era, before the Black is Beautiful movement, at a time when even Du Bois and E. Franklin Frazier, scholar and critic of the black bourgeoisie, were far from advocating acknowledgment of African roots in the black American picture. Nevertheless, the social dance band is a top-drawer, unmistakably black ensemble, and the Count Basie Orchestra played in 1952 and the Duke Ellington Orchestra played at several Cotillion-related events in later years. Many young women are presented to "society," but this Christmas Cotillion was not really a debutante ball; instead of a "coming out," it was a coming *together* of diverse elements of an externally beleaguered but internally sturdy community—some poor, some middling, and some well-off—who tacitly agreed to buy into a fantasy of transcendence. It is carnival, wherein roles could be reversed for one magical night, and we could all be princes and royalty. Yet, social responsibility is not forgotten—so the brown German war babies are remembered, when white America would have been ever so happy to forget they existed. The final irony is that the comments of a humble beer salesman are used to close the written page on that year's night of magic, bringing the reader back to the contours of African American reality. Beer salesman: a working class position in the white world, but a badge of achievement, integration—even class advancement—in the black subculture.

Though these contrary elements were packed into the Christmas Cotillion, it is shortsighted to reduce the affair to its lowest common denominator. That's what E. Franklin Frazier does in his 1957 book, *Black Bourgeoisie: The Rise of a New Middle Class in the United States*. A leading voice in sociology in the 1950s and 1960s, Frazier's take on the Cotillion was as simplistic a distillation as his famous claim that African American culture was not rooted in (West) African traditions.[31] In a chapter titled "'Society': Status Without Substance," he writes,

> In Philadelphia the Debutante Ball known as the "Pink Cotillion"[32] is reputed to excel all others in the country.... [N]oted for the money

spent on decorations and the expensive gowns and jewels worn by the women, an award is made each year to some distinguished Negro. This award consists of a diamond cross of Malta. During the years 1949, 1950, and 1951 [it]...was presented successively to Marian Anderson, Dr. Ralph Bunche, and Mrs. Mary McCleod Bethune. The Debutante balls are written up in the Negro press, with pictures, in order to show the splendor and wealth of those who participate in this world of make-believe.[33]

In Frazier's opinion a good deal of black wealth and power is frittered away on such events. There may be some truth in that assumption, but in my research and interviews I found a picture that was more nuanced, as I have attempted to show. From the dance perspective alone, to give black ballerina hopefuls a stage on which to live their dreams and gain the experience denied them in the dominant culture counterbalances any complaints about the frivolity of the occasion or that African-based dance forms were not central to Jones's vision. Blacks have as much a right to own white culture as whites have to possess black cultural forms. If anything, the Cotillion ballet spectacle reconfirms the fact that cultural exchange is a two-way street, and all Americans have a right to walk that street in whichever direction they please.

Jones died of a heart attack in 1964 at age fifty.[34] The organization lost steam with his passing, but it had had a glorious and unprecedented run for over a decade. By 1965, just a year after his demise, the future of the Cotillion was already jeopardized by insufficient finances, probably caused by the loss of its charismatic, fundraising leader. Cuyjet gave me a letter sent to her by the chairman of the Cotillion Committee, dated November 6, 1965:

Dear Mrs. Cuyjet:

The Philadelphia Cotillion society requests the pleasure of the participation of you and your School of Dance in the Christmas Cotillion, 1965.

I have been asked by a number of the members of the board to invite you to participate. We are planning to have the Cotillion at Heritage House this year. We have agreed to do this in as much as the time is short and because of financial considerations. It is our feeling that a splendid production can be given in the concert hall.

Convention Hall was probably ten times the size of the Heritage House concert hall. The late date of invitation was an indication that the preparations had not

yet begun. Inevitably, the year's event would have to be considerably smaller. It may be that the Society considered putting the entire event to rest—along with its founder—but had a change of heart at the eleventh hour.

More than a mere imitation of white traditions, the Christmas Cotillion serves as an indication that, in spite of racism, blacks and whites share similar aspirations and a similar class consciousness, with upward mobility an integral part of the American dream. Although other coming out parties and balls continued to exist in black communities across the nation (and after the civil rights era, they had a resurgence), none would compare with the size and extravagant sweep of Philadelphia's Cotillion. Here follows a list of the titles of the ballet spectacles and the names of the Cross of Malta recipients from 1949 through 1959, the years of the Cotillion's heyday. All the awardees showed up to accept the prize in person:

1949 – The White Cotillion – Marian Anderson
1950 – Frozen Fire – Ralph Bunche
1951 – Winter Glory – Mary McCleod Bethune; Branch Rickey
1952 – Golden Flame – Eleanor Roosevelt
1953 – King of Dreams – Mary Church Terrell
1954 – Blue Venus – Thurgood Marshall
1955 – Winged Jupiter – Pearl Buck
1956 – The Prince and The Rose – Alfred Gwynne Vanderbilt
1957 – The Wizard – Martin Luther King, Jr.
1958 – Isle of Fire – Daisy Bates
1959 – Impresario – A. Philip Randolph[35]

RECITALS AND OTHER PERFORMANCE OPPORTUNITIES

As with most neighborhood dance schools—including Joan Myers Brown's Philadelphia School of Dance Arts—the yearly recital was of central importance in the life of black Philadelphia's dance culture. The King and Cuyjet examples discussed earlier demonstrate that this annual event was a respected, acclaimed tradition and may have been the reason why many socially striving, upwardly mobile blacks—who likely weren't as dance-savvy as Cuyjet claims—were eager to send their kids to these schools. Bear in mind that the situation was no different than in the Dorsey era of the 1920s and 1930s. With the exception of Cuyjet's trips for herself and selected students to Manhattan studios, these pre-professional venues within the African American community were the sole outlets for black ballet training and performance. Both Cuyjet and King had inherited

from Dorsey the taste for spectacle, for fully costumed scenes with props and sets, but it was Eugene Wayman Jones who put it all together in evening-length ballets.

JB mentioned that props for these spectacles were borrowed from the Town Hall reserves:

> They had a lot of props and things. So when you got ready to do something, you could go and ask for a prop and they would pull them out. If we wanted to do a ballet in the forest they had everything—all the legs were trees and things hanging. They had all this stuff because it belonged to the Masonic Hall before they tore it down. It was at your disposal, so we used everything they had.

It is noteworthy that the ballets offered at the Cotillion balls were full-length narratives. In the world of community performance, the importance of "story dances" must not be underestimated. These narrative works had a way of making a collective from a motley group of dancers and creating a goal-oriented focus for a particular school, providing roles, big and small, for all—from the most talented and experienced dancers to the awkward neophyte. Even for JB—although not used in the service of making story ballets—the camaraderie created by working on the King and Cuyjet performances was a valuable role model for the strong ensemble standard that is central to Philadanco's success. Marion Cuyjet had shrewdly picked up on this wisdom, following Eugene Wayman Jones's lead, to create her own story ballets for most of Judimar's recitals. She often piggybacked on other people's ideas to transform a storyline into her own version, as she explained:

> I produced lots of stories.... [When] I saw [*West Side Story*]...the first year [it was on Broadway], I went right back to my room: by that time I was studying [in New York] without students there, and I had a buddy with me, and together we stayed up nights while I wrote the script. I decided I was going to use that music and call the dance *On the Block*, and I didn't have a boy get killed but a girl [to be played by Melva Murray (Brown), who later changed her name to China White and danced for several years with the Dance Theater of Harlem]. Then, on second thought, I decided not to have her killed but to have her unable to walk, stunted by the opposite gang. We set that up and [the finished product] lasted an hour and three quarters.

It was performed for Cuyjet's 1959 annual recital at Philadelphia's former Town Hall, located at Broad and Race Streets, the venue for many of her recitals:

> We had everyone in it except the smallest children. We had some preliminary thing that we opened with [to give all students a chance to be in the recital]. Our recital for years was the night before Mother's Day, and that was because a lot of the grandparents who lived in the South were able to come up for that holiday to see the children.

As mentioned earlier, she also made versions of *Cinderella*, for the 1950 and 1953 recitals. Another year, she devised a version of *Peter Pan* particularly suitable for the lithe, long lines of Jamison in the title role. By the early 1960s, Cuyjet's daughter was actively choreographing and jointly running the school with her mother. For the 1964 recital, Judith Cuyjet choreographed and played the lead in her own version of *Peter Pan*. Likewise, Marion Cuyjet made her own version of *The Blue Venus* for the 1963 recital, "adapted from a story by Dr. Eugene Waymon [*sic*] Jones," the program note tells us. It was originally the ballet spectacle for the 1954 Cotillion, with sections choreographed by Joe Nash, Marion Cuyjet, Sydney King, John Hines, and Joan Myers Brown, among others.

Particularly gifted Judimar students were rewarded with a "graduation pas-de-deux" in late adolescence, at a time when it was appropriate for them to think about moving on to broader vistas. Jamison recalled that her grand pas-de-deux was from *The Sleeping Beauty*, and in an earlier recital she had played Myrtha in *Giselle*. In Cuyjet's words, describing this "changing of the guard,"

> That was a tradition [at Judimar]: when you became sixteen and you were very good you made your prima ballerina debut.... [I]t was set up so beautifully: following the ballet the family of the new prima ballerina was in the wings, and the former prima ballerina arrived dressed in a gown but wearing the tiara that their family purchased for them when they made their debut. The page moves around to the music from the ballet with a tray and the former ballerina relinquishes her crown to the new ballerina, and then her family appears. It's very touching.

The 1963 Judimar recital brochure listed the past prima ballerinas: Delores Browne (1951), Franca Jimenez (1953), Judith Cuyjet (1956), Donna Lowe

(1958), Judith Jamison (1960), Joyce Graves (1961) and Melva Murray-Brown (1962). It also saluted the current "prima," Veda Ann Bernardino, who

> has studied with Mrs. Cuyjet for 9 years. In addition to her studies at Judimar, Miss Bernardino studied at the Pennsylvania School of Ballet and, along with other special students of Mrs. Cuyjet, attended summer school at the George Chaffee Ballet and the Ballet Theater School, New York City. A sophomore at Philadelphia High School for Girls, she was a featured dancer in the Annual "Schools on Parade," February 1963.

Veda was the daughter of Ann Bernadino, who is listed in the 1953 recital program as the tap teacher. In her debut each prima ballerina was featured in a classical pas de deux. The male partner was frequently an experienced professional. Bernardino was partnered by one Vaino Nassi, identified in the program as a member of the George Chaffee Ballet, New York. They performed the grand pas de deux from *Sleeping Beauty* as choreographed by Chaffee. In 1962 Melva Murray-Brown was also partnered by Nassi in a pas de deux from *The Nutcracker*, again choreographed by Chaffee. The tradition continued until the school folded.

Besides showing her own works, Cuyjet had her teachers and special guests choreograph for the recitals, including New Yorkers like Chaffee and Nash. Arthur Hall related the story of a work created by John Hines that had a lasting effect on Hall's artistic development: "Hines [was] steeped in folklore. He went to Cuba and had danced with Walter Nicks. He had also been to Haiti. [He choreographed] a story of a ticking doll that came to life. *The Black Doll* was basically taking a story out of that particular culture and using dance to bring it about — modern dance, really." (It may have been an Africanized adaptation of E.T.A. Hoffman's *Coppelia*.) As Joe Nash pointed out,

> [Cuyjet's] school was superior to some of the schools I saw in New York because of the caliber of teachers...who had a sense of theater because of their experience....When she sent for me she knew I would bring my background....
>
> I recognize three things: the development of a strong solid technique; the development of a performer's style; and a dancer's professionalism. Because you were entering into a highly competitive field, you have to be not just good, but *damn* good. And these kids picked this up immediately....What she did to influence and instill in these kids was remarkable....

Billy Wilson was one of the best dancers in Philadelphia—when he was still a student! Billy Wilson, Delores Browne, John Jones—they were the [best] dancers. Whenever Marion had a program you expected to see these people. They were already developing a reputation.

Although not an alumna of the Judimar School, Joan Myers Brown was a teacher and choreographer for Cuyjet's recitals and worked with her in choreographing and dancing in the cotillions. When I first met both women in the 1980s, Cuyjet's school had been discontinued for over a decade, but she was still teaching. One of her major commitments was coaching ballet at the Philadelphia School for Dance Arts. Back in 1962, when the Judimar annual recital was in danger of cancellation—Cuyjet having had one of many spinal surgeries that left her physically challenged, though mobile—JB was one of several faithful friends who came to the rescue and taught and choreographed so that the performance could reach the boards. Judy Cuyjet, George Chaffee, John Hines, Essie Marie Dorsey, and Sydney King were among others personally thanked by Cuyjet in that year's program booklet. Here is Cuyjet's tribute to JB:

> A former Cotillion Ballerina and now a renowned teacher, the major positions of the Modern Jazz sequence, Phila. Impressions [a dance in the recital] are representative of her talents. Miss Myers, her busy schedule, notwithstanding, forced time for "Judimar." Presently, she is special choreographer and leading dancer for Larry Steele's Smart Affairs.

The dance Cuyjet refers to demonstrated JB's reach into the entertainment end of the spectrum. (For more about Steele's Smart Affairs and other aspects of JB's show business career, see chapter 3.) Titled *Philadelphia Impressions*, its modern jazz elements were JB's creations, with Afro-Cuban accents provided by John Hines. The sections were named after areas of Philadelphia, stretching from the high-end black suburb Yeadon through North Philadelphia, Germantown, the Fairmount area, and South Philadelphia.

Like Cuyjet, King depended on the creativity of her teachers and looked to supply her students with quality training and a multiplicity of community performing opportunities. In 2010 a short video paying homage to her was produced and directed by Karen Warrington, a former student and teacher at the Sydney School (where JB was one of Warrington's teachers), lifelong friend of King and, as of 2010, an executive staff member for a state representative.[36] Titled simply *711* (for the 711 South Broad Street location of King's original school), it

reaches back across the decades to briefly pay homage to King and her contribution to this important and overlooked dance lifeline. Her part in shaping careers and enriching lives cannot be glossed over:

> Coming out of that subway at Broad and South and walking down to 711 was the most amazing thing, every day. And I went there every day to be there and to be involved with dance and with people who wanted to dance. It was a community, a family.... I loved going up those dark steps.

Those are the words of JB, speaking on camera describing the magical feeling she experienced on ascending the oversized iron steps that led to King's studio. Although most of her early training was with Lingenfelder, Breckenridge, Tudor, and others, JB taught for King, choreographed for recitals, and, like Jamison and Delores Browne at Judimar, practically lived at the King school. LaDeva Davis, dancer, choreographer, educator, and long-time dance teacher at the Philadelphia High School of the Creative and Performing Arts (or CAPA, as it is commonly known), expands on JB's reminiscence, adding, "No matter what went on around the neighborhood, that school was *protected*. If you announced that you went to Ms. Sydney's School of Dance—well, *please*—you were treated like the Queen of the May!"

JB learned from Sydney the importance of teaching students to be "bilingual" in dance, using their minds as well as their bodies, explaining that they were required to read and do research. She also mentioned that "there was so much going on community-wise—the cotillions, the recitals, there were lots of things, and we'd have live orchestras [to accompany us]." Davis talked about a particular program at the Academy of Music, the venue for many of King's recitals: "Ms. Sydney wanted to do a Hawaiian number and so she featured me, and I played [a child-sized guitar] and sang 'Blue Hawaii.' *That was my moment!*"

On camera, King—slim, sprightly, and intellectually alert at age ninety-one—explains her motivation, the force underlying her entire dance life, the force that she'd inherited from Dorsey, and the same force that drove Cuyjet and would later drive Joan Myers Brown: "It seemed odd that there should only be one, what we called 'colored girls,' on toe. [I wanted] to make sure that there was a colored girl on toe the rest of my life."

This statement says just about all that is needed to understand what fueled the concert dance impetus in black Philadelphia during the twentieth century. Dancer–choreographers of other dance forms bought into this dream as well, including the likes of John Hines and Arthur Hall, with their Caribbean and

African motives, or Joe Nash, whose focus was modern dance and jazz. If we as a people could open white professional dance venues to the black ballet dancer, then all of us, within our diverse dance genres, would profit. So King and Cuyjet shared the same objective.

Like Cuyjet, King's interest in ballet did not stand in the way of her support of all her dancers and choreographers. Jerome Gaymon remained a lifelong friend and colleague and choreographed for many of the school's community performances. Arthur Hall, like many of the local teachers named in this chapter, taught both for Cuyjet and King. It was under the King standard that he was able to launch his fledgling company. Composed originally of Sydney School students and alumni and begun in 1958, it was initially known as the Sydney King Dancers before becoming the Arthur Hall Dance Ensemble.

For Cuyjet and King, their dance schools were a hub of community activity and artistic life. They became the mentors of their best students. According to Hines, "We were teachers—not dance teachers. We did more social work than anything else. We always said we were social workers." As an outsider looking in over half a century later, I sense the spirit of Du Bois arching over their intentions and undergirding their drive.

Besides the performance possibilities offered by the annual recitals and the Christmas Cotillions, the African American dancer in Philadelphia worked a thriving social circuit that was an integral part of community life. Billy Wilson's talent was recognized early on, making him a sought-after performer and choreographer on this circuit:

> We performed at many fashion shows, cabarets, parties—I mean, you name it. That was the thing that made the Philadelphia dancer, I would say, two or three heads above the dancer from New York City. You had an opportunity to perform here. A lot of dancers who were New Yorkers might get a chance to be in a show or something every so often, but they didn't have the opportunity that we had here. We were performing all the time, every weekend.

Judith Jamison said that when she arrived in New York (1964-65) she found a lot of beautifully trained dancers in the classroom who had no performing experience, and she felt sorry for them. They'd ask her where she gained such stage savvy, and she'd tell them that she went to a dancing school where everybody performed all the time.

The King and Sydney schools also performed frequently in Philadelphia public schools, even before the advent of the official artist-in-the-schools programs. Cuyjet admitted that

> [e]very dance teacher really wanted to get into the public schools to show what they could do. They especially had favorite schools. They were hoping to get some clientele. The other hope was, if we couldn't get a favorite school, then we figured we were showing our work to the teachers who might bring their children to our schools.

In addition, there were performances for Boy Scout troops, church clubs, nursing homes, and such. A dance studio would arrange programs for a select group of its best students. (It should be understood that, with the exception of John Hines's off-and-on groups and Arthur Hall's emergent Sydney School Dancers, Philadelphia in the 1940s and 1950s was not yet a viable community for professional dance companies.) A group of performers assembled a show for a particular booking, especially for get-togethers hosted by one of the many black social clubs. For such occasions club members rented a ballroom with floor space for social dancing, catering, and live performance. According to John Hines, private social clubs "used to call the dancing schools, and the schools would put together pieces of choreography and...do a cabaret." There were many opportunities for this kind of work since, throughout most of the twentieth century, there were numerous nightclubs and ballrooms in the city and its suburbs. The professional nightclub circuit offered an additional opportunity. Arthur Hall's ensemble sometimes took this route. He described one instance when "[a]fter having seen us as a package with someone else, the Club Harlem [in Atlantic City, New Jersey] brought us back to do a production with Larry Steele. It was a highlight in our life because Larry Steele at that time was a big name in black entertainment."

In fact, JB may have made this connection for Hall, since she danced off and on for years in Larry Steele's *Smart Affairs* revues. In the 1950s, before there were venues especially devoted to concert dance and ballet, upscale nightclubs with lavish floor shows were a dependable performance and employment option taken by many highly trained dancers, black and white, in all genres from ballet to interpretive, with jazz and tap in between. Some of the most famous of these clubs were smack in the middle of major American cities; others were in renowned holiday spots, including Atlantic City, Las Vegas, Miami Beach, and Palm Springs. The nature of the performance venue affects the nature and intent of the performance. Therefore concert dancers adjusted the performance material and presentational style to fit the setting. In nightclubs, they danced

nightclub fare tailored to the cabaret environment. But it was not a matter of total compromise. According to Hines,

> Some of the clubs just wanted an exotic dancer. But, then, they became accustomed to seeing real dance on the floor and wanted that, too.... We made them take what we had! What we did was to do some comedy; we did blues and jazz; we did the Caribbean work—and all of this including ballet. We made them absorb ballet, and they didn't even know it!

Hines made a poignantly apt analogy when he compared this low-paying, but accessible, performance circuit to the Hollywood film milieu as it existed for the extras:

> We didn't get paid much, but we loved dancing.... We would go to colleges and things like that. You might be part of a lecture demonstration or a short performance.... It was just like the movies when they had contract players. The kids would stay for seven years and never be a star, but they learned how to perform.

In other circumstances, a group like Arthur Hall's company could rent a venue, be it a nightclub or a social dance hall, and sponsor its own cabaret. States Hall, "We would have a band, and people would bring their drink and food and rent tables and sit and enjoy themselves and dance. And then we would come on and put on a show. That was our fundraiser and presentation."

Some Philadelphia dancers of this era were engaged for performances by other black performing ensembles such as the African American Dra Mu Opera Company, whose events were sometimes cosponsored by the Cotillion Society. This opportunity afforded dancers the luxury of performing in a concert setting in such operas as *Carmen* on the huge Academy of Music stage.

Jerome Gaymon further explained the nature of some of the bookings, not all of which were paying gigs:

> We did a lot of charity work and a lot of things for the Army recruiting. We danced in the prisons, and this was radical at this time. The Army sponsored us once because we did a big performance in Fairmount Park on the fourth of July. We danced for the USO at Fort Dix [New Jersey]. I just can't think of who sponsored us when we went to the prisons. It was local, state and federal prisons, Eastern and Western Pennsylvania. We did ballet and modern and interpretive dance, the Dunham technique in particular.

Gaymon named himself, Hines, Cuyjet, King and Walter Nicks when I asked him who choreographed these events. He also shared information about other dance adventures. He and Cuyjet were dance partners for fundraising events like the Delta Sigma Theta Jabberwock[37] and charity functions for the *Philadelphia Tribune*, one of the city's three black newspapers.. One unusual gig mentioned by Nash and Gaymon was the 1954 appearance of many of the city's best black dancers (including the pre-adolescent Judith Jamison) on "Today," a morning television show on NBC hosted by Dave Garroway and filmed on location around the Philadelphia Art Museum area of the Ben Franklin Parkway, a major central location.

Essie Marie Dorsey was still active in black social life following the war and through the early 1960s. As a founding member of the Germantown Civic League and an ongoing sponsor of events to benefit the Mercy-Douglas Hospital, she was probably instrumental in securing the charity booking for her former students mentioned in the following uncredited newspaper clipping:

Civic League's Fiesta To Be 'Different'

The Germantown Civic League is sponsoring a spectacular Fiesta at Reynolds Hall, Sunday, May 22, for the benefit of the Mercy-Douglass Hospital.

Members are as busy as Mexican jumping beans assembling ideas and arranging plans for varied types of amusement to make the occasion a fantasy of the real thing.

The decorations will transform the ballroom into a veritable Spanish veranda. Lights, balloons, streamers, noisemakers and all the trimmings. Beautiful costumes, gorgeous senoritas, gypsies to read your palms, games, a wishing well, a sensational orchestra, entertainers, a jovial emcee and all the gay activities of a colorful Spanish festival.

"Different"

This is going to be a different affair, [and] a Band Box Revue will be among the features. Mrs. Hobson Reynolds,[38] [is] mistress of ceremonies; interpretations of Mrs. Reynolds' poem by Andre Drew, dances by Marion Cuyjet, Sidney [*sic*] King, John Hines and the Fisher School of Ballet; Eugene Wayman Jones and the Berean A Cappella Choir....

Such an abundance of performance possibilities kept these dance lovers busy but didn't necessarily pay the rent. Many cobbled together a living by working day or part-time jobs in addition to teaching and doing shows. Moreover, no one was paid for rehearsals: that was an unheard-of luxury.

Escape offered another performance opportunity—namely, expatriating or simply touring abroad. Sagan and Delores Browne danced and toured overseas with the New York Negro Ballet, formed in 1954 by Thelma Hill and Ward Flemyng, two ballet-trained dancers who based their ensemble in New York.[39] Granted, the work was received even in Europe through the lens of the predictable exotic-erotic stereotypes, meaning that the reviewers were most appreciative of the dancers' "rhythmic talent" and gave the most praise to the ballets they felt exhibited their Africanness. Nevertheless, performing professionally at mainstream white venues was progress—and more than they could expect at home. Furthermore, it wasn't necessary to be in an all-black ensemble in order to perform abroad. It is sad and ironic that ballet-ready African Americans were able to find work with white companies in Europe but not in their homeland. Both Wilson and Sagan performed and choreographed with great success for extended periods while living abroad, mounting works for major dance companies.[40] In the United States their choreographies were—and still are—almost always performed by companies of black dancers and ignored by white ensembles. As I write these words in the second decade of the new millennium, African American dancers and choreographies by African Americans have yet to be integrated into the white world of ballet and concert dance beyond token gestures. Yet, we persevere.

Billy Wilson's apt statement epitomizes the role of the black Philadelphia community in developing its dancers:

> Without the black community, it could not have happened, because I was given the opportunity to develop. Had it not been for those teachers in grammar school and then throughout—King and Cuyjet and all those people—long before I got to the others.... I think had it been left up to the white community I would not have ever set foot on a ballet stage or on any other kind of stage, for that matter.

TIMING AND SURVIVAL: HISTORICAL AND PROFESSIONAL

As a teenager growing up in Harlem, once I discovered dance I had found my medium and my milieu. My love affair with dance is the same story told in so many ways in this chapter and this book. It is true for people of every ethnicity, culture, identity, social station, and era. It is "the calling."

In 1959, as a sixteen-year-old freshman at City College of New York—before there was an open enrollment policy and before it was part of City University and was simply known as CCNY—I became a cheerleader. This

came about by happenstance: City College was a "brain" institution, and its athletic teams were beleaguered losers with small followings. But cheerleading was, to me, a kind of dancing, and in those days I would do anything to have an opportunity to perform. On the cheering squad, which was a mixed group of blacks and whites, were two African Americans, also Harlemites, who invited me to join their ballet classes. I'd studied modern dance in high school and jumped at the opportunity. The classes were free for us, thanks to the generosity of a philanthropically minded middle-aged woman who gave scholarships to black and white hopefuls, and who actually took classes with us. They were held in the Carnegie Hall Studios and taught by Mme. Sonya Dobravinska, a cheerful, rotund expatriate who, like so many Russian teachers in similar Manhattan haunts, could still turn out the leg, point the toe, and properly teach the *Dance of the Little Swans*. Well, I was thrilled at this stroke of luck, not that I wanted to be a ballet dancer, but because being in the urbane midtown setting and acquiring a new movement skill made me feel that anything was possible — that the world was my oyster.[41] I became "ballet buddies" with my cheerleader friends: two weekday afternoons we took the subway to and from the studio together and, after back-to-back classes on Saturday mornings, looked forward to a snack of hot apple pie with vanilla sauce at the Horn & Hardart automat cafeteria.

It turned out that my pals were friends with Yvonne McDowell, a young black ballerina who was a legend in our area of (Northwest) Harlem. Beloved by her middle-school teachers and regarded as a beautiful oddity by her peers, she had been featured as a specialty act in assemblies at Stitt Junior High School. Located on West 164th Street, this neighborhood school had also been attended by the singer Diahann Carroll and, later, the doo-wop group, Frankie Lymon and the Teenagers. The community was proud of them all. My friends kept me abreast of McDowell's comings and goings and the ballet world gossip they gleaned from her. We learned that it was common knowledge among black ballet aspirants that Lucia Chase, the director of the American Ballet Theater School and ensemble, swore off hiring blacks in the company. Yet McDowell and other African Americans persisted in taking classes, auditioned for the company, and also attended the Ballet Arts and Ballet Repertory studios. Then McDowell became a member of the New York Negro Ballet Company and toured Europe. The personal stories shared with me about this young woman's total devotion to her art were astounding. She waged a constant body battle, trying to be thin and elongated in a way that was antithetical to her small, powerfully beautiful physique. She lived for ballet, never socialized or dated as a teenager, and had

joined the company when she was fifteen. But the ensemble folded after three years. With false starts from white American ballet companies, few prospects for a future career, and no life outside ballet, she committed suicide in the early 1960s when she was twenty-three.

I tell this story to point out that not everyone could turn history around the way those who survived a life in dance managed to do. The recipe for success contains many variables that lie beyond individual control. If opportunity had knocked at her door, might Yvonne McDowell's life have been spared? She was not able to switch gears and adjust her aspirations, as many of her peers did. Survival is often a matter of timing, and timing is a function of history. McDowell wasn't in sync with the times, whereas Judith Jamison was. The careers of these two dancers, one thwarted, the other resoundingly successful, are reminders that conditioning forces and the zeitgeist dictate the fate of even the most astounding individual talent.

Jamison couldn't have succeeded had she arrived in the professional dance world a decade earlier. The 1940s–1950s stage was not prepared for a 5-foot 10-inch ebony-colored concert dancer. Success was based on the confluence of her adaptability (choosing modern dance, knowing that being black and tall would exclude her from a conventional ballet company), and her being in the right place (New York City, at the ascendant moment for the Alvin Ailey Company) at the right time (during the 1960s liberation movements for African Americans and women). Jamison's timing dovetailed with the realities of a new generation. Rather than trying to revolutionize the ballet establishment, she entered the world of modern dance and crossed barriers that were ripe for penetration. McDowell—and all the black ballet dancers discussed in this chapter—was ahead of her time and would have still faced racial barriers in ballet had she lived in the twenty-first century. What Delores Browne said in 1996 about blacks in ballet is still true: "People are not just seeing beautiful ballet dancers. They're seeing black dancers."[42] This is not to imply that spectators should be colorblind, but that biases and stereotypes should be left behind, with the dancers better regarded as "ballet dancers who happen to be black," rather than "black ballet dancers." The difference is subtle but profound.

Cuyjet—the woman with a vision—recognized that the time was ripe for Jamison. Serving for a decade as her teacher (which, as Delores Browne pointed out, is more than a coach or rehearsal director), she knew that Jamison's talent and determination were already on her side. By the end of the 1950s and moving into the 1960s, it was apparent that Jamison's type of black beauty was coming into its own, garnering esteem in both black and white worlds. Now

there was space for her ascendance. Again the man of wise words, Billy Wilson explained,

> Donna Lowe was a gorgeous child, very fair [skinned]. She could have been Italian, or whatever. [Good] legs, feet, you name it—everything you could imagine, that child had—and a kind of allure that you rarely see in children. She and Judy [Jamison] were sort of coming along at the same time, among several others. Everyone would be saying things like: "Donna" this, and "Donna" that. Marion said, "Yes, but the one who is going to do it is Jamison." [People] wondered why she picked that little skinny girl. What's she going to do? But she said it! I remember her saying: "She's the one who is going to do it!"

Cuyjet herself reiterated this in her interview with me, saying that Jamison's timing was almost a gift from God:

> She left Fisk [University in Nashville Tennessee, an historically black institution] at the right time, came back up North and came to the right place, the [Philadelphia Dance] Academy,[43] and there she was seen.... What happened? There she was visible for [Agnes] de Mille at a time when that "au naturel" hair [the "Afro" haircut] was fashionable.... and *The Four Marys* was only for a short season and, when that was over, she stayed in New York.

It was rare for a female dancer of clearly African lineage to be cast in a leading role in a production for a major white ballet institution. Ballerinas like Janet Collins, Raven Wilkinson, and Carmen de Lavallade were light skinned. So were Donna Lowe and Betsy Ann Dickerson. Their looks were assimilable. But by the 1960s, at the height of the Civil Rights Era and the "Black is Beautiful" movement, time was on Jamison's side.

In the 1940s and 1950s, the time was not ripe for Cuyjet, either as a performer or as teacher who could realize her ambition to lead her prima ballerina (Delores Browne) to a ballet career in white America. She ruefully recalled that

> [i]n 1947 and 1948 I thought I was going to be able to put the first black girl, on pointe, in concert in New York as a member of somebody's company. And then, here comes Janet Collins [who became premiere danseuse with the Metropolitan Opera Ballet, 1951–1954, beating Cuyjet to the goal]. I had very high hopes. Delores Browne was my best, but I

was not realistic at first. Her work is gorgeous, but I was not realistic to the fact that her legs are too short.

For readers who are not denizens or aficionados of the dance world, its focus on proportions, anatomy, height, size, weight, color, and so on must seem obsessive, if not downright perverse. Why should it matter what the length of the leg or the height of the body is when a dancer's work is "gorgeous?" This is the tyranny of the dance world—a dictatorship of physical "type" that is accepted, if not advocated, even in cases where the assessment reeks of racial stereotyping and ethnocentric overtones. What is alarming is how deeply audiences buy into these standards, thus supporting arbitrary conventions that highjack young careers, even driving sensitive souls to suicide. Issues about dancer anatomy fueled the epidemic of anorexia, which is still a problem, now gone underground. Janet Collins made it to a major white ensemble; Delores Browne did not. Even in the twenty-first century, racial biases abound, and the number of black ballet dancers, especially women, in white companies is disproportionate to the number of competent black hopefuls.[44] Do we need more Negro ballet companies, more Dance Theaters of Harlem? In 1996 Delores Browne compared this separatist syndrome to the Negro Leagues in baseball when she said, "separate is never equal."[45]

Timing is a keynote in the most prosaic ways. Occasionally, it is a matter of taking a leap of faith and seizing the moment. Facing resistance from his parents to go into the dance profession—they wanted him to attend college and pursue a white-collar profession—Billy Wilson could have chosen another line of work, although it would have meant relinquishing his deepest ambition. However, he acted on faith and seized the opportunity that launched his career in 1954 when he was nineteen:

> There was a call from George Mills [a theatrical booking agent] one night. He said they were having auditions for *Carmen Jones*, a revival. Muriel Smith [African American opera singer] was coming back from Europe, and it was for the light opera season, and I should go over to audition for it. I remember saying to my mother and father, who were sitting in the living room, "That was George Mills, and they are having auditions." I was then working as an interior decorator in the mornings and going to Temple [University] at night. I had been to business school and was beginning to feel very frustrated. This was while I was still with [Sydney] King. I said, "He wants me to come to an audition the next day. You told me when I got something I could go." My mother said, "I think you should go when you know you have the job."

That absolutely destroyed me at that moment because I so desperately needed her to say, "Go!" My father said, "If you don't go, who knows? If you go, something might happen."

I think that was the moment I left home. I got on the bus, and I was sick all the way with a nervous stomach. I did go and audition, and they called me back, and I got the job, and I've been working ever since.

Good timing!

⚭

I opened chapter 1 with an Essie Marie Dorsey quote. She said that a black dancer would be better off at the worst black dance school than the best white school because of the attention that would be paid to the black student on home turf, as opposed to being "invisibilized" at a white school. Racism is one of the few circumstances that can cause the worst to be perceived as the best. But the survival urge seeks pathways of possibility, despite the winds of stasis whispering that the best option is to turn back. So lemonade is made from lemons, tables are turned, and the worst can lead to the best. The survival instinct goes hand in hand with timing: knowing when to do what—and how to do it—makes things happen, and has even been known to break through roadblocks when it looked as though the way was impenetrable.

One survival mechanism is taking what could be an obstacle and using it—even broadcasting it—as an asset. Again, I turn to Judith Jamison's example as a good illustration. Height and skin color could have been impediments. Instead, this artist worked with choreographers who regarded her tall sensuous frame as a fortuitous extension of the long line so sought after in contemporary dance. Her anatomy and complexion, combined with her talent and dedication, became passports to solo work and specialty roles. In my interview with her, she told me that as a child she had revered tall, slim role models—including Watusi warriors in magazines and movies—thus reinforcing her positive self-image. Even early on she was programming her natural characteristics as assets.

Survival also meant having the flexibility to shift one's aims. Browne, JB, and many others like them remained in the dance profession although they didn't become ballerinas in mainstream companies. The world wasn't ready, and even love of ballet couldn't push the river. Survival meant that Cuyjet submerged her first desire to be a performer and became a stellar dance educator instead. According to Cuyjet,

At the beginning I wanted to be a [ballet] dancer, but I was too tall. We're talking about the late 1930s, early 1940s. This condition existed through

those decades for most dance companies. However, [by the early 1950s] the New York City Ballet had already begun to prefer lengthy, lean, tall females. Being too tall means that you can be in a ballet company, but you will never be chosen to do any kind of pas de deux, especially on pointe: because, at 5 feet 7 inches, you've got to add seven more inches to allow for the full length of the foot when the heel is lifted and you're working on pointe. That would make me over six feet tall!

Cuyjet omitted mentioning that, as an African American who was in her thirties by the 1950s, she wouldn't have been accepted in this ensemble—even if she were exceptionally talented. For Delores Browne the issue was the opposite. Besides the fact that she is African American, she developed at a time when, as Cuyjet described, the ballet body image was in flux and the longer ballet line was beginning to prevail. Browne—who had a stellar technique, still wears a size two dress, and is all of five feet tall—was perfect for the aesthetic ideal that prevailed from the nineteenth-century Romantic era through the 1940s era of Ballet Theater soloists—that is, until the rise of the Balanchine/New York City Ballet aesthetic that Cuyjet refers to in the above quote. Browne did better than Cuyjet by taking advantage of the performing experience afforded her in the New York Negro Ballet. She should have had a longer career, but time was not on her side. Instead, she became a ballet mistress of the first rank. For years she trained young professionals at the Alvin Ailey School. As of this writing she continues to teach the weekly company ballet class for Philadanco, commuting from New York.

For others, Wilson and Sagan included, expatriation was the solution for a period in their careers, affording the opportunity to develop without the external constraints imposed by American racism. After nearly a decade of dancing and choreographing in major Western European cities, Sagan then lived and worked in Israel: "For ten years I worked with every company in Israel. I was nourished and I flourished," he said. Perhaps Sagan's real home was not any one nation or culture but dance itself. He was the quintessential dance professional for whom dance is a way of life or, better put, for whom dance *is* life. Beyond the years of expatriation, his most reliable tool of survival was to submerge himself in dance and dancers, both for the love of the art form and as a way of blocking out the harsh realities of everyday existence.

Billy Wilson also took the route of expatriation:

It [racism] is so much a part of the fabric of my life that it affects everything. Of course, I lived and worked in Europe for ten years. I left America with *West Side Story* for the London Company. Before I returned

to America I was asked to join the Dutch National Ballet. I did join them as a guest soloist for a year, and then I stayed on. That was when I really made my career in Europe. I was able to do anything I wanted to do. Particularly, at that time, they [Europeans] were extremely excited by a black American dancer, and all doors were open. I danced all the big roles. I was able to develop and make my mistakes, which was so important. See, that's what doesn't happen here, and that's what's so important.

At the opposite end of the spectrum, some persevered by remaining a part of the traditional order of regional African American endeavor, and there's a lot to be said in affirmation of this choice. Sydney King was one such person, and it is notable that she has survived a life in dance by running a low-profile neighborhood dance school that continues to give a yearly recital, serves a population of children and adolescents, and depends on paid tuition (rather than grants or other outside funding) for its operation.

Passing for white must also be understood as an emergency measure and a survival mechanism. Like Cuyjet at many periods in her career, those who could sometimes passed for white in short stints. These occasions didn't mean that someone openly lied, but that the powers-that-be didn't necessarily inquire beyond an assumption of skin color. As a temporary employment route, a booking of short duration might be secured without having to endure the loss of one's family connections. On the other hand, Cuyjet insisted that Donna Lowe, described earlier,

> spent eleven years with the Philadelphia Grand Opera Company passing for white. It was assumed that she was a white dancer because she looked so white. However, the members of her ballet company knew that Donna was mixed blood. Now, in Florida where she is [Note: this was in 1988], she's very interesting. She doesn't explain to anyone why she looks like she does. Her dance school is called the Philadelphia School of Dance in Florida.

This is indeed interesting—that the white Philadelphia opera ballet company colluded with Lowe in fooling the audience—and reminds us of Cuyet's contentions about white-looking blacks working in Wanamaker's in the 1930s. And it is interesting that her Florida clientele had no idea about who she was. It seems that Lowe played both ends against the middle and was more fortunate than many "passers" who are obliged to live a life of pretense and secrecy. Certainly, this is a tempting and understandable option in a racist society. In a similar

vein, light-skinned African Americans took Thomas Cannon's ballet classes in the 1950s when they knew their dark-skinned siblings could not.

The old black vernacular phrase, "keep on steppin," is the keynote for survival. It means that one doesn't avoid reality, but also doesn't become ensnared in its inevitabilities. A dancer struggles, but struggle is part of the road to success in any métier. For those who would survive a life in dance, Jamison's advice is worth repeating: She contended that when she couldn't deal with a situation she dropped it, moved on, sought out the next possibility, and dealt with that one.

The relations between teacher and student, dancer and choreographer, artistic director and company member, are the bottom line for survival of all dancers of all ethnicities. Survival as a dancer means cultivating good relationships with peers, role models, guest artists—in other words, being a team player.

Survival meant that, instead of breaking down walls and becoming a ballerina, JB went on the road as a nightclub dancer/choreographer through the 1950s and 1960s. She then shifted her sights from performance to teaching and artistic direction and has trained some of the finest concert dancers on stage today. Other former students have themselves become artistic directors of their own companies. JB's school began like King's and Cuyjet's so many years before. Students were brought in by word of mouth and advertisements in the black Philadelphia newspapers that helped establish the careers of many performers. The yearly recital drew more people. Guest teachers were invited. Cuyjet's influence on JB is evident in the company's name—Philadanco—rather than a letter sequence like DTH (Dance Theater of Harlem) or ABT (American Ballet Theater). Years earlier, Cuyjet had combined her name and her daughter's to give her school the Judimar moniker.

Timing and survival: to end this chapter and segue into the next, I conclude with a brief forward glance at the career of our heroine, Joan Myers Brown, and the ways in which time was on her side. She founded her dance school in 1960 and the Philadelphia Dance Company in 1970 at a time when funding for the arts was at its height, and the social, racial, and cultural climate of Philadelphia and the nation were in transition. JB created a unique career direction that had not existed for the likes of Cuyjet, King, or Dorsey before her. History is always in the making, and change is the measure of history. The spirit and tenor of the 1960s that initiated the growth of JB's institutions have changed considerably. It has been a rocky road, and financial support has been neither constant nor generous, so keeping the ship afloat has been an ongoing struggle for her. Against all odds, and standing on the shoulders of her forebears, JB has put Philadelphia's

black concert dance culture into the mainstream, nationwide and abroad. Only the tenor of the times to come will tell what new directions are possible.

JB's survival in and transcendence of the world of show business will be taken up in the next chapter wherein we discuss her career in the entertainment industry, her transition from performer to educator and administrator of the Philadelphia School of Dance Arts, and her early years as Artistic Director of the Philadelphia Dance Company—Philadanco.

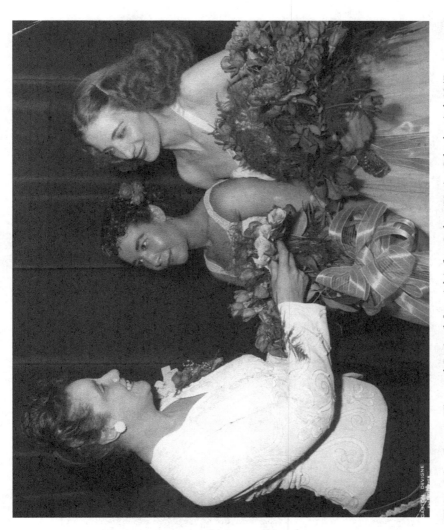

Figure 2.1. Dorsey, King, and Cuyjet (left to right), first Sydney/Marion School recital, 1947.
Source: Judith Marian Cuyjet, private collection. Photo by Gaston DeVigne. Courtesy of the DeVigne family.

SYDNEY G. KING

proudly presents

The Sydney School of Dance

IN RECITAL

WITH A CAST OF 150

Monday Evening, June 6, 1949

8:15 precisely

at

Fleisher's Auditorium

Broad and Pine Streets

Philadelphia, Pa.

BILL CARTER'S ORCHESTRA

Figure 2.2. Page from Sydney School recital program, 1949.
Source: Joan Myers Brown, private collection.

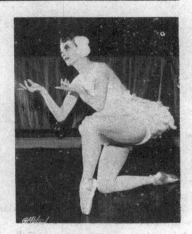

Marion D. Cuyjet
presents the
Judimar School of Dance
in 2nd
ANNUAL PERFORMANCE

Friday Evening, June 16th, 1950

TOWN HALL, Broad & Race Sts.

featuring

"Ballet Cinderella"

JOSH SADDLER'S ORCHESTRE de SALON

Tickets on Sale
JUDIMAR STUDIO — 1310 Walnut St. — PE 5-8327
HOWELL BROS. LABORATORY — 5414 Girard Avenue.
or any Student of JUDIMAR SCHOOL
Orchestra — $1.95 Balcony $1.65 All prices inc. tax
Special Children's Tickets
" THE UNUSUAL INTERRACIAL SCHOOL"

Figure 2.3. Marion Cuyjet, Judimar handbill, 1950 recital
Source: Judith Marion Cuyjet, private collection.

Figure 2.4. JB, (front) age 17, and Mary Johnson in performance at YMCA, Seventeenth and Christian streets, 1949.
Source: John W. Mosley Photograph Collection, Charles L. Blockson Afro-American Collection, Temple University Libraries.

Figure 2.5. JB, age 17, in ballet variation, 1949. Identified dancers: JB in seated pose; Faye Peamon, standing center; Ann Mackey, standing left.
Source: Joan Myers Brown, private collection. Photo by G. Marshall Wilson.

Figure 2.6. Cast of "Jamaican Carnival," Sydney School recital, 1950. Identified dancers: JB cradling drum, kneeling, center right; Mary Johnson, kneeling, center; Faye Peamon, kneeling, center left; Joan Hill, reclining on floor; Jerome Gaymon, standing second row center. *Source:* Joan Myers Brown, private collection.

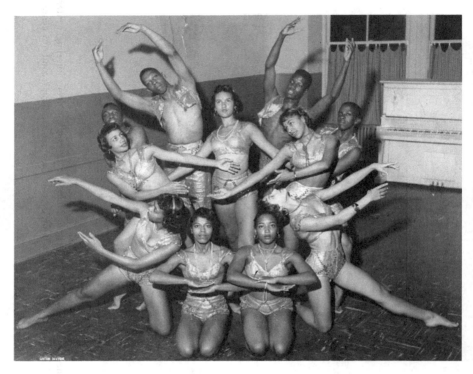

Figure 2.7. Judimar School dancers in preparation for a community performance, ca. 1954. Identified dancers: front row, seated on heels—Ione Nash, left, Gwendolyn Riley, right; Judith Cuyjet, lower right, on right knee, in backbend; standing women, left to right – Franca Jimenez, Doris Davis (center), Marie Jimenez; males – Arthur Hall (far left, directly behind Franca J.), John Jones (second male from right, arms overhead).
Source: Judith Marion Cuyjet, private collection. Photo by Gaston DeVigne. Courtesy of the DeVigne family.

Sydney School of the Dance

711 S. Broad Street
Philadelphia 46, Pa.

Ki 5-6281 Ba 2-6419

Registration: September 4, 5, 6, 7.

Faculty

SYDNEY G. KING, Founder and Directress
JEROME B. GAYMON
JOAN B. MYERS
ELEANOR B. HARRIS

"An institution dedicated to cultural, physical and social development through the medium of the DANCE."

Figure 2.8. Sydney School class-schedule announcement, front cover, 1949.
Source: Joan Myers Brown, private collection.

STAFF

MRS. SYDNEY G. KING -- charter member of the N.A.D.A.A.

"Miss Sydney", as she is affectionately called by her students, is the Founder and Directress of the School. She has studied under Leon Varkas, Betty Nichols, and Carl Peterson, all of New York City, and is a former teacher at Essie Marie's School in Philadelphia. Dancing since the age of seven, in this country and abroad, she is considered one of this city's most accomplished dancers and teachers of the Dance. Eminently well qualified in all forms of the Dance, her specialty is the beautiful, classical Ballet.

MRS. ELEANOR B. HARRIS

Academic training at Clark University, Atlanta, Georgia, and has studied extensively at the Henry LeTang School of New York City, specializing in tap, choreographing tap routines, and the various methods of tap dancing education to beginners and advanced students alike.

MR. JEROME B. GAYMON

Academic training at Howard University, combined with extensive theoretical as well as practical experience in the freedom of dance expression as exemplified by the courses in Primitive and Interpretive, specializing in Choreography, have prepared Mr. Gaymon for his place on the Staff.

MISS JOAN B. MYERS

Educated in the public schools of Philadelphia, with special dance education training at the Sydney School, under Sena and Anthony Tudor of the Ballet Theater, Miss Myers is the newest addition to the Staff which is expanding to meet the need for more classes to handle the increased enrollment. She is also in charge of school registration and its other secretarial functions.

MISS DOLORES E. BOX

Also a product of the Philadelphia school system and of the Philadelphia Musical Academy, one of the outstanding music training schools in the country. A student of piano since the age of five, she has had four years training under the renowned pianist and teacher, Herbert Sigel. The School welcomes this brilliant and accomplished musician to a place on its Staff.

Figure 2.9. Sydney School class-schedule announcement, back cover, 1949.
Source: Joan Myers Brown, private collection.

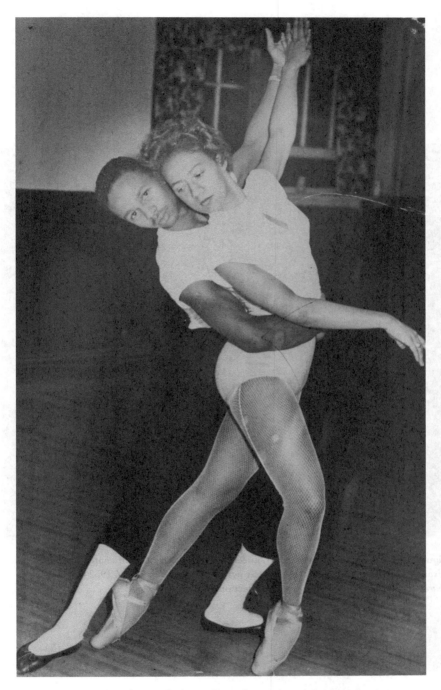

Figure 2.10. Billy Wilson and JB in rehearsal at Sydney School, early 1950s.
Source: Joan Myers Brown, private collection.

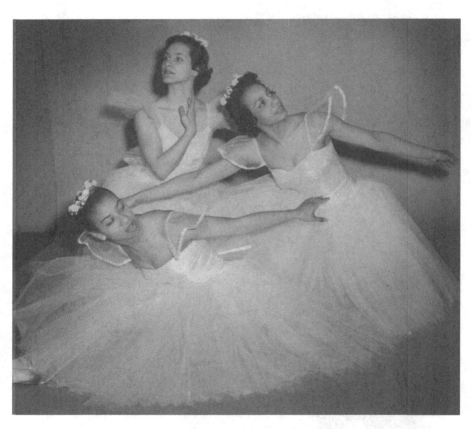

Figure 2.11. Delores Browne (front, kneeling), Judith Cuyjet (left center), and Frances "Franca" Jimenez (right center), Judimar performance, *Les Sylphides*, 1952–1954.
Source: Judith Marion Cuyjet, private collection.

Figure 2.12. Judimar students on a break at Chancellor Street Studio, ca. 1956. Identified performers: Steve Cuyjet, Jr. (holding conga drum); atop piano, from l. to r., first girl, Judith Jamison; third girl, Joyce Graves; fourth girl, Donna Lowe; fifth girl, Sally Ann Richardson; girl seated on floor in black leotard/white tap shoes, Veda Bernadino.
Source: Steve Cuyjet Jr., private collection.

Figure 2.13. Donna Lowe and Elmer Ball rehearsing at Judimar School, ca. 1959.
Source: Judith Marion Cuyjet, private collection.

Figure 2.14. Marian Anderson (Cross of Malta Awardee), Eugene Wayman Jones, and Judge Theodore O. Spaulding, Christmas Cotillion – 1949.
Source: John W. Mosley Photograph Collection, Charles L. Blockson Afro-American Collection, Temple University Libraries.

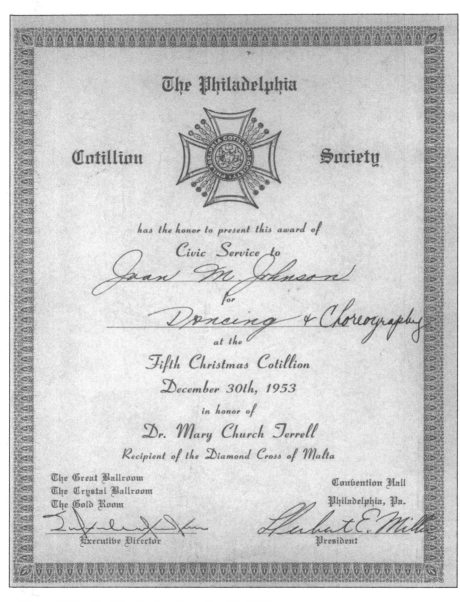

Figure 2.15. Cotillion Society Award to JB, 1953.
Source: Joan Myers Brown, private collection.

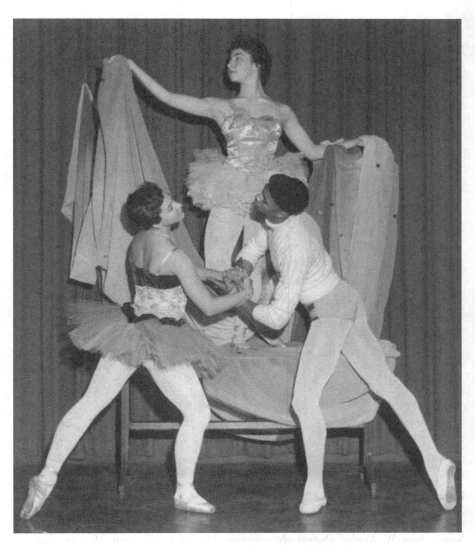

Figure 2.16. Cotillion rehearsal for *The Blue Venus* ballet spectacle, 1954. Judith Cuyjet (left) as Margaretta; Billy Wilson as Pietro; Betsy Ann Dickerson as The Blue Venus. *Source*: Judith Marion Cuyjet, private collection.

Figure 2.17. *The Blue Venus* Christmas Cotillion, 1954. Left to right: Noble Sissle (of Sissle & Blake musical renown); Marion Cuyjet; Eugene Wayman Jones; Leigh Whipper (actor and founder, Negro Actors Guild); Sydney King.
Source: John W. Mosley photograph collection, Charles L. Blockson Afro-American Collection, Temple University libraries.

SAMMY DAVIS, JR. . . . "Is a powerhouse . . . works with tremendous energy . . . he has warmth and charm as well as talent . . . there is a distinct quality about his work, a direct communication and loveable assertiveness, that makes this dynamic little cricket a star . . ."
—William Hawkins,
N.Y. World Telegram & Sun

Sammy Davis, Jr. will receive the Star of Malta for his especial achievements in the world of entertainment.

CHRISTMAS SPECTACULAR

Starring

SAMMY DAVIS, JR.

and

WILL MASTIN TRIO

CONVENTION HALL
Friday Evening
December 28, 1956
8:30

BALLET FANTASY: *"The Prince and The Rose"*

Starring Leon Danielian - Gertrude Tyven

PARTICIPATING DANCERS: The Sydney School, Ballet Guild, Judimar School and Academy Dance Theatre
CHOREOGRAPHY: Antony Tudor, Marian D. Cuyjet, Nadia Chilkovsky, Sydney King, Thomas Cannon, Betsey Dickerson, Jerome Gaymon

LEON DANIELIAN, leading dancer, Ballet Russe de Monte Carlo, and one of the most outstanding dancers of our time. Before he joined the Ballet Russe de Monte Carlo, he appeared in Broadway musical comedy, night clubs and Ballet Theatre. Mr. Danielian's dancing is so facile that it seems effortless. He is especially noted for his bravura technique and his sense of comedy. Regardless of the role he undertakes, Mr. Danielian never fails to give an outstanding demonstration of dance artistry.
Mr. Danielian dances the role of Prince Adriano.

GERTRUDE TYVEN has been with the Ballet Russe de Monte Carlo since 1942, and is one of the company's brilliant ballerinas. Her technique is magnificent, and her "arabesque" and "developpe" are equalled by few dancers. Miss Tyven has worked her way through the ranks of the Ballet Russe de Monte Carlo to her present high position. Her present leading roles include the Snow Queen and the Sugar Plum Fairy in the "Nutcracker", the Swan Queen in "Swan Lake" and the leading part in "Les Sylphides", all of which show her very special classical quality.
Miss Tyven will dance the role of Princess Lilas.

Figure 2.18. Eighth cotillion mailer/flyer, 1956.
Source: Brenda Dixon Gottschild, private collection. Gift of Marion Cuyjet.

Figure 2.19. Poster, Ninth Christmas Cotillion, The Wizard, 1957.
Source: Brenda Dixon Gottschild, private collection. Gift of Marian Cuyjet.

CHAPTER THREE

BUT BLACK IS BEAUTIFUL! 1950s–1980s

I woke up in a hotel one time—you know how those mattresses cave in? And you're in a hole and it's dingy and it's dark and you just want to go home? Well, that's what happened to me. I felt I had enough of this running around the country and all over. I was tired and came home and decided that I wanted to teach. But when I decided to have my own school, I had to go back to work to pay people.

—Joan Myers Brown

Why do we have to be exceptional, when some of their dancers are just adequate? Why can't they find some adequate black dancers too? But they don't.

—Joan Myers Brown

INTRODUCTION

JB's words serve to launch us into the central chapters of this book and put the spotlight on her work, her influence, and her presence. Like a true matriarch, Joan Myers Brown has a power that draws people back to her and to the "home" she has created—as teachers, choreographers, guest performers—allowing them to extend their artistry by working with Philadanco and the Philadelphia School of Dance Arts. Indeed, JB is a nurturer, a magnet, a fulcrum—defined as "an agent through which vital powers are exercised."

In this and succeeding chapters selected voices from her community testify and bear witness to her vision and to the voice they share in common with her. Since her biography is also their legacy, I have given them the opportunity in these pages to be her mouthpiece, articulating who she is and what she has achieved. They define her, just as her institutions have defined them.

FROM BALLERINA TO "BEIGE BEAUT"

Entering the Field

Like Gene Kelly in the "Gotta Dance" dream episode of the movie *Singin' in the Rain*, JB *had* to dance. But there were some hurdles to clear. At age eighteen she still lived at home and was commuting to New York to study at the Dunham School, but her dad was pressuring her to give up dance and continue her education. Instead, she

> got married very young so that I could dance. If I got rid of my father, then I could do what I wanted to do. But my first husband was worse than my father! But fortunately for me he was drafted in the Korean War. So here I was married, my husband was in Korea, and I was free! But my mother said she was just waiting for me to grow up so that she could get a divorce. So she divorced my father and she and I moved in together. I went this way, and my mother went that way—two free souls. I was nineteen and started dancing in nightclubs.

The newly liberated women moved to 1220 North Broad Street at Girard Avenue, in Philadelphia's first high-rise apartment building for black people.[1]

The beginnings of her professional career hark back to the many performance opportunities for students at Judimar and the Sydney School, described at the end of chapter 2. JB seamlessly slid into professional performing by way of the semiprofessional black dance circuit in her hometown. As noted earlier, both Cuyjet and Sydney often hired seasoned veterans to guest teach at their schools and choreograph various performances. Joe Noble, a skilled choreographer who taught jazz and what was called "interpretive" dance at Sydney's, was seeking dancers to perform in the Creole Follies, the name given to the in-house dance chorus for a little club, the New Town Tavern, in the small town of Delair, New Jersey. A man named Izzy Bushkoff was the owner. Noble hired JB, and she performed there from 1950 to 1952, overlapping the time she was commuting to the Dunham School (1950–1951) and studying with Antony Tudor (1951–1952). An anecdote from this stage of her life shows JB's feistiness and

devotion to detail when it comes to dance technique. In her first ballet class with Karel Shook at the Dunham School, he gave a combination that included a pas de bourrée, but he did it differently from the way JB had learned it in Tudor's classes.[2] So she said aloud, in the middle of class, "That's not a pas de bourrée!" Shook took offense and threw her out, although just for the day. Sevilla Fort was the Dunhamite who helped this young upstart smooth out her rough edges and adjust to the new environment. And many other lessons were to be learned as JB took to the road.

Early on, then, she grew accustomed to wearing many hats, changing personalities, and dancing, dancing, dancing—excellent preparation for the many roles that she would continue to play once she started her own school and dance company. This show business background also played a major part in formulating her ideas about what constituted a good concert dancer and good programming. As Joe Nash explained,

> You had the concert style of dance, the Broadway style, the nightclub style. We developed an understanding of all these styles.... Sure, [Katherine] Dunham had to work in cabarets and nightclubs as well as in the theater itself, so your experience is rooted in a variety of performances and places and it contributes to your overall development because when the time comes when you can do what you want to do all of this background leads into your art form and you become the supreme artist because of all this background. *It's how you use it.* For that period of time [the pre–civil rights era] on Broadway [and in nightclub work] you had to show a lot of teeth, but that weekend when you did the concert you were the concert artist, very serious, dedicated. You had to make those shifts.

JB and her close fsriend, Mary Johnson Sherrill,[3] had been hired to replace dancers like Flo Sledge at a time when the older dancers were leaving the Follies. (Sledge was the mother of daughters who later became the pop singing sensation known as Sister Sledge.) The club in southern New Jersey—a stone's throw away from Philadelphia—followed the conventional vaudeville format and traditions that had held sway for most of the twentieth century. JB recalled that the Follies lineup consisted of

> four girls and two guys. It was a nightclub with a small stage. We wore skimpy costumes but we did a lot of good dancing—and we did a lot of crap! The guy's wife [Mrs. Bushkoff] used to make our costumes.

We stayed there for about two years. We performed every night except Monday. It was two shows a night, three numbers each show. There was an opening, a production number, and the finale. We had a stripper and a comedienne and a featured act. We would change our routines every four weeks. We worked it out with the band. We had great fun.

The New Town Tavern, like cabaret culture nationwide, subscribed to the Cotton Club protocol, meaning black entertainers playing to white audiences. As JB explained, "Once in a while somebody black would come in, but [they] were sure to be related to somebody in the show. They weren't thrown out, but they sat them in the back, though." The chorus performed what she explained as "old time jazz" but managed to incorporate ballet and modern dance as well. This goes along with what John Hines said (in chapter 2) about bringing to cabaret work more than was expected and exposing club owners and audiences to other dance genres. For JB, the dance terminology was now "fall off the log" and "fan kick," more than "pas de bourrée" and "pirouette." But the work ethic was the same, and the dancers were committed to rehearsing and perfecting their routines and creating interesting combinations. They performed

> a lot of, like, I guess it was Broadway-type stuff. We didn't do butt-shaking stuff. Andre [Gilbert Pitts] and I were always doing pas de deux, [with him] lifting and catching [me]. In fact, Andre and I ended up dancing for Larry Steele together [some years later].

Later JB worked again with Noble when he was choreographing for Cab Calloway. She mentioned that he sometimes choreographed to popular songs of the day, like "Hey, There, You with the Stars in Your Eyes," from the 1954 Broadway musical *Pajama Game*; and "(Tropical) Heat Wave," the 1930s hit repopularized by Marilyn Monroe in the 1954 film, *There's No Business Like Show Business*. Asked how she learned the ropes of this new performance medium, JB explained that the dancers learned from one another, and "nobody worried about whether I pointed my toes, or if I turned out, or if my arabesque or my line was right: you just danced!" Most importantly, she mentioned that, "some stuff is in your body that happens regardless of what you're doing. The training is in your body." And it seems that she was gifted with a heaven-endowed "thinking body" that was her key to success, even after her late start. Of course, it would have meant nothing without dedication, commitment, and perseverance. But it was that "stuff in your body" that had enabled her, as a seventeen-year-old, to pick up with Virginia Lingenfelder where she had left off with Sydney King as an eight-year-old. A quick study, she was a

sure bet on the Philadelphia area's black vaudeville/cabaret circuit, dancing in routines that backed up the big-name acts of the era.

A word must be said about the quality of performance during this period. There was genuine artistry to the musicianship, chorus work, tap dancing, acrobatic specialty acts, singing, and comedy routines that cannot be overlooked. Vaudeville—whether performed in nightclubs or theaters—is the cradle that rocked a host of talents, including tappers like Charles "Honi" Coles (a native Philadelphian), the Nicholas Brothers (who grew up in Philly), and the Berry Brothers; vocalists like Lena Horne and Ethel Waters; composer/musicians like Louis Armstrong, Dizzy Gillespie, and Duke Ellington; and comedians like Slappy White and Jackie "Moms" Mabley. It was on these stages that the future stars perfected their routines and refined their aesthetic. Even stripping—or striptease—was a finely developed genre on a par with the other forms of entertainment. At the New Town Tavern JB met one of the best of the lot, Kay de Congé.

> They would be fully dressed and you just would never see the piece come off. And you look and they would be in a g-string and pasties. We're watching and going 'How'd they get that off? We're watching and we never could tell. It was definitely an art form.

De Congé's striptease was so seamless, so cool, that JB and her friends cooked up a tongue-in-cheek phrase—"Do the Kay de Congé."

After her initiation into show business at the New Town Tavern, JB moved on to higher ground. First, Noble and his dancers got an offer to work at the Latin Casino in Philadelphia, where they stayed for several months.[4] Many other bookings followed. Between 1950 and 1967—when she finally threw in the towel to devote her energies to her school—she worked almost constantly. Her list of credits is large and commendable, but in this area JB had great difficulty pinning down dates in my many interviews with her. I'll therefore discuss the scope of her entertainment career as a whole, rather than follow a chronological/linear approach.[5] She had performed and lived in Montreal, Canada for about two and a half years spanning 1955 and 1956. I asked her what events led up to this gig, and here follows our conversation:

> JB: Hortense Allen had a group of dancers going to Montreal.... When I heard about the money they were making, I thought that maybe I should go for a little while. So I signed a four-week contract. When we got there for four weeks the guy that owned the club [Café Montmartre, on Boulevard St. Laurent, owned by Bill Savar]

asked me if I would take about three girls and stay there and just be the dancers for the club. Then he wouldn't have to import people from the United States all the time and pay their transportation and all that. So we became known as the Savar Dancers and stayed in Montreal. While we were there we got asked to perform in other places. So we ended up spending weeks at the Montmartre, and then we would go two weeks somewhere else and two more weeks somewhere else, and go back and spend another eight at the Montmartre. I stayed there for a good two and a half years till I really wanted to come back to America. What really brought me back to America was Cab Calloway's group.

BDG: Up there [in Canada]?

JB: Yes. He invited us to be a part of his show that was going to open in Miami. So we went to Miami with his revue and stayed with him for almost a year. After that, our group broke up because one of the girls wanted to go back to Montreal. She was in love. Another girl wanted to go somewhere else. The next year Cab had auditions for his show again, and I auditioned. I went out with his show the second year just as a dancer, not with an act.

BDG: What kinds of routines did you do in Florida?

JB: Anything we could think of. Calypso, blues, jazz—anything we wanted to do was fine with him.

BDG: How did you manage the music?

JB: We got with the bandleader, and he would write the music, and we would do three numbers every night. Sometimes it would be the same numbers with different costumes. We changed every eight weeks. When you have free rein to do whatever you want to—as long as you don't have on too many clothes and you're kicking and dancing—then nightclub dancing is fine. *I got a lot of experience with choreography that way.* We had gorgeous costumes and we were all good dancers. [My emphasis]

BDG: What was the club like in Montreal?

JB: It had a black show, black band, black dancers, and black stars. The audience was all white. There were a few blacks that were coming in, who were usually tourists. But it was just a black revue in a white club.

BDG: You said you performed elsewhere in Montreal?

JB: The other places were outside of Montreal. We went to Quebec City, Ottawa, Toronto, and then a place called Valdora that is the

end of the train line in Canada. The train doesn't go any further and the tracks just stop. They have what is called the Sullivan Gold Mine there, which is the largest gold mine in the Eastern Hemisphere or something. We worked up there. Some of the guys would throw gold nuggets at us and we thought it was dirt! There wasn't anybody black up there. We would walk down the street and people would step off the sidewalk and let us pass because they just hadn't seen black people.

BDG: So in all those clubs you performed in, were you part of a black show?

JB: Not always. I remember once dancing in Toronto in a New Year's Eve show and Dr. Joyce Brothers was the headliner. She was talking about marriage problems and all that. What a thing to talk about on New Year's Eve!

BDG: After Montreal, what brought you back to Philly?

JB: I didn't have a job! I came back home and stayed home for about three months and then went out with Cab again for his Cotton Club Revue. I stayed out for about nine months. When I came home after that I went with Larry Steele's show. I stayed with Larry off and on for about six or seven years [roughly 1959-60 through 1967].[6] While I was with Larry, Pearl Bailey asked me to come and join her show. So I was always working and just kept doing what I was doing. *But the whole time I was working I would always take classes. So I had a chance to study [in] a lot of places. Usually, we would stay four, six, eight weeks. So I would get a lot of training. I studied with the National Ballet of Canada when I was there. When I was in California, I studied with Marie Bryant, which is something you don't get a chance to do from the East Coast. In Detroit I studied with Ziggy Johnson, one of the old teachers of jazz.* [My emphasis]

There are several noteworthy items in this exchange. The fact that JB was able to use this opportunity to explore and learn about choreography says something about her resourcefulness. And she managed to satisfy her first love during these years by using ballet—including pointe work—in her nightclub engagements and by taking ballet classes whenever and wherever possible. It was fortunate that her talent was recognized and she was allowed to experiment. Since she has a down-to-earth, no beating-around-the-bush personality, she could be trusted to not go too far; yet her ability and experience made it clear that she could bring some welcome expertise and class to the cabaret routines. She was in good

company: this was a time when ballet as a concert dance form was just finding its American legs, and many white ballet dancers performed in similar show business venues in the parallel white world.

JB mentions that there were few black people in Montreal except for tourists. Before the civil rights era, while white Americans packed up for summertime getaways and were free to go wherever the wind blew, African Americans either visited relatives down South or in the Caribbean or went to special areas (Sag Harbor, Long Island; Atlantic City, New Jersey; Idlewild, Michigan; Oak Bluffs, Massachusetts; or Log Cabin Beach, outside Williamsburg, Virginia, to name a few) where they had established their own segregated vacation spots, since racism prevented them from enjoying mainstream accommodations.[7] (In fact, JB mentioned having worked at a club in Idlewild with a lineup consisting of her dance group, another dance group, and a male singing group who later became The Four Tops.) Montreal and Bermuda were two of the holiday destinations vetted by African Americans as places where we might have a decent vacation without encountering racism. Both have long been regarded as havens for black tourists.

It amused me when JB spoke of people stepping off sidewalks when she and the Savar Dancers strolled the streets of Valdora, Quebec. How ironic a reversal: until the 1960s, in many of the southern states in her homeland, black people were expected to step aside when whites passed. Twenty years later, in our 2008 interview, when I asked her about this period, she elaborated, pointing out the differences in the reception blacks received between the English and French Canadian provinces.

> They would move off the sidewalk and say "belle noire," and we'd be, like, " 'chile, you talking 'bout me?" You know you never had that happen in the States. [BDG: I know!]... People running behind me; I was glad to stay!
>
> BDG: Exactly. You want to be appreciated.
>
> JB: Oh listen! But now, it was different when we went to Toronto, which was non-French. It was very much like America. [BDG: In terms of?] In terms of the way you were treated. The way you were ostracized.

Finally, the fact that she never stopped studying is quite remarkable. Her stamina carries over into the way she trains her dancers (see chapter 4). The expectation, and this is true for all top-notch dance professionals, is that, after a

long night of performing, one is ready to arise the next morning to take a class, teach, and rehearse—as the natural rhythm of living a life in dance. For JB, the freedom to take classes at the school of the National Ballet of Canada contrasted with the restrictions she'd experienced in being shut out of white classes in her hometown. This opportunity to continue studying must have fed into the choreography she contributed to the nightclub routines. In our 2008 interview she elaborated, saying "the classes in Canada were the first time I went to a ballet class where I didn't feel that I was out of place. Even with Tudor, y'know, it didn't feel welcome. But in Canada, when I went, I was just somebody in class." She took class regularly at the school when she wasn't touring other parts of Canada. In Chicago, she and Harold Pierson "took a class with some black school, and sometimes you'd just give yourself a barre, but you could always find a school."

She mentioned that Café Montmartre was a beautiful club. The old vaudeville variety format still prevailed, be it in Montreal, Atlantic City, Vegas, or elsewhere: an opening dance number; a comedian; a singer; the middle (dance) production number; a specialty act; the hour-long headliner's spot; and the finale, which could go on for half an hour and included the full lineup of performers. The dancers performed three numbers in each show, two shows a night—opening the show, doing a spot in the middle, and then the finale. It was a big club, so headliners included major crooners like Billy Eckstine and Billy Daniels.

Besides working with Cab Calloway and Pearl Bailey, JB spent almost four months with Sammy Davis, Jr. She came in contact with other stars during her years of working with Larry Steele, who hired her after an audition. Steele was famous for auditioning beautiful, talented "girls" in every city where he had a show. Let's examine some of JB's experiences with these top-drawer artists and see how race issues figured in the picture.

Steele/Calloway/Bailey

By necessity, Larry Steele and his renowned *Smart Affairs Revue*—as smart as it was—performed exclusively in the black neighborhood of Atlantic City and to segregated audiences in classy Miami and Las Vegas venues. That was simply the protocol of the era, and nothing could be done about it. Nevertheless, black communities had upscale businesses and self-sufficient infrastructures, as mandated by the politics of exclusion. Thus, Steele's Atlantic City shows were at Club Harlem, the posh cabaret in the city's African American enclave, owned and operated by Leroy "Pops" Williams, an enterprising black businessman. In JB's opinion, and for other African Americans, Steele was nothing short of a

genius, in terms of management and production values, and was ahead of his time as a producer, presenter, and entrepreneur. *Ebony* magazine did an eight-page spread on him in 1960 and claimed, "His production grosses from $400,000 to $500,000 a year and keeps 40 to 50 people at work from 40 to 45 weeks a year."[8] These were big profits back then. Had he been white, his name would have been a household word and he would have appeared on some television variety show. His *Smart Affairs* was one of the first all-black shows to play Las Vegas (at the Dunes Hotel). He helped launch the career of Lola Falana, who was a Steele headliner before going on to Hollywood. A long list of renowned performers appeared in the *Smart Affairs* lineup at one time or another, including Sammy Davis, Jr., Nancy Wilson, Sam Cooke, Aretha Franklin, Peg Leg Bates (the one-legged tap artist), comedian Dick Gregory, Sarah Vaughan, Billy Eckstine, Dionne Warwick; the list goes on and on.

Steele's obituary in the *Baltimore Afro-American* announcing his demise in Chicago (in 1980, aged 67) gives a thumbnail retrospective of his achievements, mentioning that he started out as a bandleader in 1934 and in 1969 celebrated his twenty-third year at Club Harlem:

> In 1952 Larry Steele's "Smart Affairs" was the only complete all-black show on Broadway since the folding of the Cotton Club. Following the Atlantic City and Broadway run, this show toured nationwide.
>
> Sparking that show were the Four Tunes, Butterbeans and Susie, Marian Bruce, George Kirby, The Fontaine Brothers, Derby Wilson, The Four Kongaroos, Steele's 12 Beige Beauts and Jimmy Tyler's 12-piece Band....
>
> AFRO files recall an opening night at the Club Harlem in 1952 as against a backdrop of soft amber and blue lights, the 12 dancing beige beauts whirled to the rhythmic beat and the tall, polished Larry Steele introduced the show.
>
> Men of all ages sat forward and women gazed in envy and across the bar $100 bills changed hands.
>
> And that's the way it was when Larry Steele put on a show.[9]

In 1967 Club Harlem published an oversized souvenir brochure devoted to Steele, which includes photos of JB (listed as "Joan Myers—featured ballerina and one of the choreographers for Smart Affairs") on pointe as a soloist and in the middle of a lineup of "Beige Beauts"—Steele's term for the Smart Affairs female personnel. Many pages feature photos of the man himself with big name stars or rehearsing chorines or posing in formal dress. Positioned throughout this

array of lush photos are praiseful reviews of the shows and congratulatory ads taken out by entertainment industry entrepreneurs. A quote by a writer named Jack Murray, taken from an article in *Las Vegas Magazine* written the previous year says in part,

> Every year, since 1947, this daring showman has taken his revues into every village, town and city in America, as well as abroad. His is the only revue of its type to tour annually with a new theme, book, and cast for each year. 'Smart Affairs' is not just another collection of acts following each other on stage, but a well-produced show with every segment blending together into the greatest rhythm musical of the century.[10]

In their book on the culture of southern New Jersey, Jim Walzer and Tom Wilk write that "Debonair promoter Larry Steele packaged his annual Smart Affairs tour for Miami Beach and Las Vegas as well as Club Harlem, and from the cabaret duskiness of singer Nancy Wilson to the vaudevillian zip of comic [Slappy] White, it all worked."[11] JB marveled at Steele's multiple talents:

> He wrote the songs, made up the production numbers, designed the costumes, designed the lights, and we would do the choreography. He starred in it [according to the Ebony spread he stayed onstage while everyone performed]; he would tell you what he wanted you to do, more or less, how he wanted it.

Emcee, producer, and entrepreneur par excellence, Larry Steele was a show business version of Eugene Wayman Jones (chapter 2), only instead of ballet spectacles he produced "smart affairs." He had a large personality to fit his tall, lean, but imposing frame—and he could be deviously tough, at least on the dancers. "Sometimes Larry would be mad with us," JB said. "He would say to the band, 'play that music fast,' but I don't care how long it played we would dance! We could be real fast." Barefoot modern dancer that I am, I naively asked how one could perform anything fast in high-heeled shoes with pointed toes:

> BDG: You can't do high kicks and fast jazz in those heels!
> JB: Yes you can!
> BDG: So what do you mean, "fast jazz"? How did you choreograph that as a ballet dancer?

JB: It's easy. So, you put your Dunham stuff, you kept your ballet stuff, and other stuff that I learned—you just incorporate everything you learn into whatever. And then we learned how to cut a step [so] that we don't do it full out. We'd cut part of a step so we could get to the next step.

Thus, the dancers trumped the wily producer and learned how to finesse any curve ball thrown their way in the process. And for JB it was part of the game. She relished the challenge.

Unlike the New Town Tavern, the floor space in these clubs was huge. The Steele, Calloway, Davis Jr., and Bailey shows had large casts in addition to the headliners and specialty acts—usually eight showgirls, eight chorus girls, and four men. Lon Fontaine was a frequent Steele choreographer, and Andre Pitts and JB would assist as needed. Besides the fast dancing, they also performed ballet-inspired work. Pitts, Clyde "Jo-Jo" Smith, and Frank Hatchett (now a renowned jazz dance teacher based in New York) were her frequent partners. There were some daring lifts. She told me that "Andre would throw me, and Frank would catch me, or vice versa." For this kind of partnering, she wore the Hermes brand of soft-soled jazz sandals, popular with professional dancers. She danced with Steele in Atlantic City and on tour at the Flamingo Hotel in Las Vegas, the Deauville in Miami, and the Riviera Club in New York City, as well as other dates that she couldn't recall, in her off-and-on tenure with *Smart Affairs* during the same decade that she launched her school, the Philadelphia School of Dance Arts.

Again, the race issue was the same. Even though Club Harlem was in the black section of Atlantic City, owned by an African American, and had no official white or "colored" seating arrangements, JB said that most audiences were white: "the white people would be the first people in there, and then the black people got the seats that were left." There is no way to prove or disprove this blanket statement, but we can perhaps assume that choice seating was more expensive, although there are, of course, always some wealthy African Americans in the picture who could afford the higher prices. Another unpleasant possibility is that whites didn't care to sit with blacks, and intimidation—conscious or unwitting— was used to keep African Americans "in their place." As JB contended, "The only time you saw black people at the ringside [seats] was when [someone like] Nat King Cole or Joe Louis came in. But the rest of the time it would be all white people."

Housing was also segregated: "We stayed on the black side of town, which was the north side," she said, "and the white people stayed on the south side,

where the big hotels were. It was prejudiced then." Segregation was the great equalizer, and everyone was more or less in the same boat. Regarding accommodations, JB gave more information:

> In Florida we all stayed at the Sir John Hotel [located in Overtown, a traditionally African American neighborhood in Miami]. And then in Vegas, since we were there so long, most people had their own little apartments or their little places to stay. You know, you rent an apartment with a kitchenette or something. Or three or four girls would rent a house. But in Miami we all stayed in the same hotel. You know we would go to Miami Beach—to work—and when the show was over, you better get your butt back off of Miami Beach, back to Miami....
>
> When we were in Vegas the town was totally segregated. [But] segregation had its benefits, because you were forced to be with people that you wouldn't meet today—because of integration, they are not put up in the same facilities where you are.... And we all went in the back door and came out the back door together. Billy Eckstine and Nat King Cole ate in the same restaurant [as we did] because they had to live on the black side of town, too. Then at night it would be back to work on the white side, and then home to the black side.... They had that picketing with the blacks marching up and down the strip in Vegas saying that if they can perform on the strip, why couldn't they live on the strip.[12] [in 1959 and 1960]...
>
> In Miami we worked at the Eden Roc with Pearl Bailey, and we came in through the kitchen, took the elevator up to whatever floor the theater was on, and you went into the dressing room and you put your costume on and you did your show. And then you took your costume off and caught the elevator down, went through the kitchen and out the back door.

Having performed in Las Vegas several times with shows that would last for three to six months, she talked about a backhanded benefit of this convoluted system:

> I went to Vegas with Pearl in 1961. I was the only black girl in her show. White girls used to get mad at me because they had to mix and I couldn't. That was a blessing. As soon as the show was over, you had to go out into the nightclub and to the bar and mix. You would sit around

and the guys would buy you drinks and talk. I was like "Yes! I don't have to mix! I don't have to go into the casino and stay half the night. My friends are back on the other side of town, I'm outta here!"

JB was doubly happy to be spared this burden. In her words, "I wasn't a hangout girl. I didn't drink; I didn't do drugs. You know, I would go eat and I would turn in, because the next day I would go and try to find a [dance] class."

JB and I talked about her determined quest for dance classes. Here is part of our conversation:

BDG: And why were you always looking for classes?

JB: Because we just wanted to stay in shape. Because we weren't dancing that much.

BDG: Three numbers and two shows a night???

JB: We would dance for five or ten minutes. You didn't warm up: you'd just go and put on your makeup and costume and you're dancing. So we were always looking for classes.... When I was in a second tour with Pearl a girl named Bootsie Wade and I, we used to always wanna go to class. And Pearl would be mad because she wanted us to go play golf with her. Marie Bryant was the choreographer, and we wanted to go take class.

BDG: They must have thought that you were a nerd.

JB: Well I was.... I remember my twenty-fifth birthday. I was in Miami with Pearl. They gave me a surprise birthday party, and I got mad 'cause they invited people I didn't like.

BDG: And were they show people?

JB: People in shows, people around, people that were, y'know, hanging out in the club. But you would be in a club—like, okay, we were in St. Louis or Kansas City. The first week we're there it's Ray Charles [headlining], the second week we're there it's Jackie Wilson. The next week it's the Drifters. But the same girls that were there the first week with Ray Charles would be there the second week, going with the guys in that group.

BDG: The dancers?

JB: No, the groupies in the clubs!

BDG: To hang out?

JB: To hang out! So you didn't want to be friends with them. [But] they want to be where you were.

BDG: Right, right—so they can get with the guys.

JB: They'd be running around the hotel at night, doing drugs maybe—you don't want to be with them. [In Miami or Vegas,] even though the black girls couldn't come to the club, they would hang out where the artists hung out afterwards. You see the same girls; you know what they're doing.... Now that's the fast life. You can either be involved in it.... I mean, I walked down a hall being asked 'hold this, hold this thing' [heroin apparatus] while he's [shooting up]. 'Okay, now. Yeah, thanks baby.' And you keep going. You know, you see that stuff.... I just knew that was something I didn't want to do.

BDG: You did also say that you had fun.

JB: Because you had your good girl friends that you hung out with. That you went to dinner with. You always meet a couple of nice guys who would take you to dinner or something. We had fun. But you just had [to set] your limitations.

Performing with the racially integrated Bailey ensemble was a novel experience. How the vocalist got away with it during the Jim Crow era is a small miracle. Bailey was married to her drummer Louis Bellson—a white man. Unlike the rest of the African American performers in Las Vegas, she didn't return to the black side of town for housing. According to JB, Bailey and Bellson stayed in a bungalow in back of the Flamingo Hotel. A mixed company headed by a mixed couple would have been unheard of in the 1930s or 1940s. So this unique couple and their performing unit can be regarded as a precursor to desegregation. Bailey played top spots on this elite cabaret circuit and enjoyed nationwide popularity. On this engagement, JB was the only black dancer, but there were two black singers; everyone else was white. When the show performed in cities like Chicago, she shared a room with a white dancer, saying it wasn't a problem until they were in Las Vegas or down South. In those places, she stayed with an African American friend. In Chicago they performed at the Regal Theater, the windy city's answer to Harlem's Apollo. JB said that Bailey changed the racial mix in her various engagements: "First it was four of us [dancers], two white girls, two black girls. Then one time it was just me and the other white girls. Then another time it was four black girls. She had another black girl doing pointe—it wasn't me."

JB's first Vegas experience was at the Royal Nevada Hotel, where the segregation was, in her words, "really bad. And then I went back and I was with the

Flamingo Hotel, twice with Pearl." The first booking was with her friend, Joe Noble, who was choreographing for Cab Calloway. JB mentioned that Calloway "called me Red. [JB's natural hair and skin color are a sandy, reddish-brown.] He said I reminded him of his daughter.... And then his sister [Blanche Calloway] was there, and I really was friends with her. She was a bandleader." Later she returned to Vegas with Larry Steele and then twice with Pearl Bailey, as already mentioned. When I remarked about the famous places she performed, she added another: "I was at the Wilshire Hotel in Beverly Hills. I worked a lot of top clubs because I was working with top acts." Bailey actually stole her from Steele, as JB tells it:

> When I was working with Larry Steele, Pearl had her show in a club around the corner. It was my day off and I went. She asked if it was me who she saw dancing last night. I said yes. She asked me to come up and dance for her. I was dressed, and she and I started dancing on the floor and she said "Don't you want to go with me?" I said I already had a contract. She said she'd buy it out for me, and that's what she did so I could go with her!

Salaries were decent, compared to the workaday world and the median salaries for African Americans in the 1950s and 1960s, which, invariably, were below white levels. In Atlantic City JB earned $150 weekly. This was for a grueling schedule: "We were doing two shows a night and three on Saturdays, and then the Sunday morning breakfast show, seven nights a week." The breakfast performance attracted other performers in the seaside resort, from Frank Sinatra and the Rat Pack to other African American artists, who would attend this select set after completing their own shows and as the last stop of their Atlantic City clubhopping. A recent newspaper article described the scene:

> It was mostly the slicksters, the fast people in the fast lane.... They bounced from Timbuktu to Little Belmont [two of the hundred-odd black clubs that flourished in the city]. They would wait, and go to this early-morning show. They would be just decked out. Everybody who thought they were hip would be there.[13]

Another article stated

> there was a 6 a.m. breakfast show on Sundays. Usually, about 1,000 people lined up to get into the breakfast show. They were all dressed in their finery—tuxedos, gowns, suits and cocktail dresses. It was the place

to be in Atlantic City late Saturday night and early Sunday morning. In fact, performers working in Boston, New York City, Washington and Baltimore finished their Saturday night performances and then drove to Atlantic city to be walk-ons at the breakfast show. Between 9 and 10 a.m. the shows would finish and a stream of people could be seen walking up Kentucky Avenue. You would think they were going to church, not coming from a nightclub.[14]

Eventually, the harsh schedule caught up with this woman who still adored ballet, managed to perform on pointe for Larry Steele revues, and refused to surrender her dance training and discipline. In fact, whenever she was in her home town, she continued to choreograph for and perform in Judimar recitals (see chapter 2) and to make dances for society events in the black Philadelphia community, while keeping up the maddening pace of a show business dancer on the road.[15] As she says in the epigraph at the beginning of this chapter, she woke up one morning in a dingy hotel and knew that she'd had enough. This was some time around 1960, and the reason she continued in show business for seven more years was to support the school until she could get it up and running on its own steam. Nevertheless, looking at the photos of young, talented, gorgeous Joan Myers in feathers, makeup, and high heels, smiling joyfully whether she's dancing or wrapped in a bear hug in Billy Eckstine's arms, it is clear that, indeed,

> [i]t was really fun. I met so many stars of that era: Ray Charles, Jackie Wilson, Nat King Cole. I knew everybody. We all used to be in Vegas in the same funky black club, after work, hanging out. Cab used to give me his money and say, "Baby take my money. I don't care what happens, don't give it to me" [laughter]. And a half hour later he'd be knocking on my door.

A SCHOOL AND A COMPANY

Starting Out

> *A school serves many functions on many levels. Those who are pursuing the art form, or just want appreciation for themselves, or just to improve their physical appearance or to develop a sense of well being—there are many reasons. Many parents knew their students were never going to pursue a career, but there was some sort of satisfaction in knowing the*

student was in an atmosphere that was developing their potential as human beings. I think that was very important.

—*Joe Nash*

Those wise words of Joe Nash, talking about the Judimar School in the 1950s, also apply to the precepts and premises that guided JB in creating the Philadelphia School of Dance Arts (PSDA, or Dance Arts). It stands to reason, since Cuyjet was JB's mentor and role model. We must also remember that, as a young dancer hoping to be a ballerina, JB was turned away from the white dance studios in the city. Still, she claims that she did not want to start a school to "combat racism"—the terminology I used in asking her the question. Instead, she claims, "When I came back to start my school I wasn't thinking about that at all. I just thought, 'Well, maybe I'll go back and I'll train kids so somebody can get the opportunity I didn't,' and that I had to do it within a certain period of time." (Perhaps the difference between her response and my question is a matter of semantics. I interpret her phrase "get the opportunity I didn't" to mean her contribution to the ongoing battle against racism. In any case, the common thread linking our thoughts is the need for change.)

Throughout her show business career, JB remained in touch with contacts from her pre-professional days. This network of friends and performance colleagues would prove crucial in getting Dance Arts on its feet. Curious about how she made the transition from the entertainment industry to the task of starting an institution from the ground up, I asked her about the connection between the two worlds. Her response showed that there was actually a disconnect, though she was diplomatic in keeping the two realms separate:

> Well, you know, I think when I opened my school, the credentials are different, needed to be different. A lot of times I didn't talk about what I had done.... A lot of the women who brought their children to my school knew me from Atlantic City, had seen me dance in Atlantic City, saw me dance in cotillions, grew up with me, and became parents. Then there was a whole cadre of people that didn't know anything other than I had this school.

Before she opened PSDA she had thought about simply returning to Philly to teach for Sydney King, drawing upon her community credentials and profile. She wanted to take the old model to a new standard, incorporating her own ideas about teaching and including her newfound performance knowledge acquired from a decade of touring and taking classes, far and wide. However, just as King

and Cuyjet knew at some point that they needed to go their separate ways so, too, with King and JB. Too much had changed. The time was ripe for her to strike out on her own:

> So I started my own school in 1960. At that time I was still dancing professionally. I had a very good girlfriend [Mary Johnson Sherrill], who has since died. We used to teach all day to a school of thirty kids. We used to clean and sit and wait for the phone to ring. Then I would go to Atlantic City and dance all night. A couple of times I went on the road with Pearl Bailey and my girlfriend would teach all day. We had to try and keep the school going between the two of us. Then a couple more friends came around and they helped. I've always had good friends who would work with me. Even if I only had thirty dollars, we would divide that money between us.
>
> My mother was paying the rent to keep the school open. For the first five or six years I depended a lot on my mother and friends to keep the school running. I think at about 1966, the school really started to support itself. I was making enough money to pay people and pay my rent out of the school income.

Asked how she managed to gain a following, especially since Cuyjet, King, and several other teachers already had well-established dance schools, she explained:

> I advertised a little bit because I couldn't afford to advertise a lot. I advertised in the *Tribune* and the *West Philadelphia Scene* because I was located in West Philly at Fifty-Second and Walnut [the school's first location]. Most of my students came by word of mouth. Then I had girlfriends who had children, and they would tell their girlfriends. Then, after I had my first show two years later [1962], it included about 10 percent of the kids in the school, and then everybody else who I knew who could dance. So it was a very good show. Then people started coming because they liked the shows. Every year after the recitals, I usually get a large influx of students. I don't even advertise anymore.

These comments were extrapolated from one of my 1985 interviews with her, meaning that before the school was twenty-five years running, it was already self-sufficient in terms of continually generating a student body. It is impressive that JB came on the scene when her former teachers were still active and successful

and was nevertheless able to bag a profitable corner of the market through sheer perseverance. But there was also a touch of competitiveness plus performance savvy in the strategy she used to get things moving. Her comment about her first "show" is interesting and a clear illustration of the shrewdness she'd picked up in her years on the road. This community was accustomed to lavish recitals and a high level of performance. Knowing it was too risky to depend solely on the skill of her new students, JB upped the ante in this game by bringing in professionals and near-professionals to perform at that first recital. She understood that the quality of the recital would be a key factor in establishing her reputation. We can surmise that, just having returned from a decade of performing and with energy to burn, this thirty-one-year-old dynamo put on a show that laid down the gauntlet to any other recital in town. She represented the younger generation and the new. In one of the 1988 interviews, here is how she summed up the recital phenomenon:

> People ask me now with my recitals how I think of all these things. I say that you think of them because you have to. I have 300 little kids and all of them can pas de bourrée. So how many ways can you make pas de bourrée look: front, back, turning, sideways. To make all the kids look like they are not doing the same thing, you have to come up with different costumes and a different way to do pas de bourrée. You also don't want to bore the audience to tears. But a recital is a necessary evil. It gives the children a chance to be onstage. It gives you money for your rent all summer when you don't have classes, and it gives the audience a chance to know that you have a school—so that's your PR for the next generation of students. It's something you have to do. I try to do it as well as I can because I've been to too many where you fall asleep!

This assessment is not what we imagine King or Cuyjet might have said. The difference is that JB has a dance company in addition to the school, and, as much as she is devoted to dance education, her major performance apparatus is her professional company, which was itself an achievement that changed the game and put the black Philadelphia dance community in a different league. For Cuyjet and King, recitals and the community social circuit were a substitute for a bona fide dance company. Moreover, JB understates the quality of her recitals. Her students are well versed in ballet, tap, acrobatics, and jazz dance vocabularies. "Pas de bourrée" is simply her catchall phrase designating the dance culture represented by a community-based school like hers.

PSDA Tenth Anniversary Recital

Dear Parents and Friends:

So quickly time passes, already 10 years have gone, and Dance Arts has become an active part of Philadelphia's community. But this has been made possible only with the encouragement and constant help of so many persons.

We, the staff and students, sincerely hope you will find our 10th Anniversary Concert enjoyable, your afternoon with us pleasant. We, as always, are thoroughly delighted to see all of you. Definitely none of this would be possible without your help and encouragement. Kindly continue to patronize our subscribers and advertisers, help them, as they help our children. May our work continue for another 10 years.

Without your unselfish support and generous contributions none of our work would be possible. We are able to continue our scholarship help to our children, some underprivileged, some culturally deprived, yet all talented and eager to learn. We have seen many of them gain confidence, grace and poise through our program. We try to give them good technical training in all phases of the dance arts, but never unmindful of our regular student body at both studios.

Our continued thanks to all who worked incessantly to make our program a success.

Sincerely,

Joan Myers Brown
Staff and Students

This letter from JB to her constituency appeared in PSDA's Tenth Anniversary Recital progam book. Given at the Academy of Music, the recital, the book, and the date are important milestones. The fact that the dance school made it through its first decade was something to be applauded. By 1970, JB had withdrawn from the entertainment industry and for the past few years had devoted all her time to this enterprise. The school's two locations at that time were 6249 Market Street (that is, between Sixty-Second and Sixty-Third Streets) and the satellite studio at 7516 Ogontz Avenue. Her pal, Mary J. Sherrill, is listed in the program as "Assistant to Directress"), and a photo of the larger Market Street studio and its waiting room grace the page that lists faculty and staff. A line at the bottom reads, "Philadelphia's Largest Sunlit Modern Studio."

The program book itself contains all the usual features: There's a "Who's Who at Dance Arts" page that gives short bios of the regular and guest faculty. At this time, both Billy Wilson and Harold Pierson were choreographing for Philadanco and also teaching for Dance Arts. There is a special spotlight focused on Saundra Williams, a young woman voted Miss Black America of 1969 who had been studying at PSDA for several years. (This entry reminds us that, even at this late date, beauty pageants were still segregated, and there were no African American entrants in the national Miss America contest. Besides this Miss Black America pageant, there were lesser contests in more local settings leading up to such a title.) The entry explains that Williams is presently a student at "Maryland State College, commuting to continue her dance studies and assist in classes whenever her busy schedule permits." It ends by stating that, "[a] student at Dance Arts for 7 years, we are all familiar with her dance capability and thank her for not forgetting she was our 'cookie' first."

In typical recital-brochure fashion, local merchants, individual parents, and groups of supporters purchased ad space in the publication to support the school and the costs of printing the program. Quite touching is a half-page ad from JB's mother that simply reads as follows:

MY SINCERE BEST WISHES FOR ANOTHER YEAR
OF CONTINUED SUCCESS
TO MY LOVELY DAUGHTER
"JOANIE"
from
MOTHER
I Am So Very Proud of You

The half page ad that follows it is from the Galaxy Restaurant, the dancers' regular after-class hangout, sending "compliments to the students of Dance Arts." Harold Pierson took out a full-page ad featuring a publicity photo of himself in a dance pose, center page, below which are listed a few of his impressive Broadway musical credits. At that time he was performing in a new production of *Purlie* and had previously been in *Sweet Charity*, *Hallelujah*, *Baby*, and a host of television shows.

The actual recital, billed as "Programme I" and "Programme II," consisted of twenty-three dance numbers in all, separated by one ten-minute intermission and a warning: "Please do not attempt to come backstage at this time." Like her mentors, JB's program contained a wealth of dance genres representing the different styles taught by her teaching staff: acrobatics, tap, jazz, and ballet, with excerpts

from the ballet, *Coppelia*, danced by two local semi-professionals. Following the requisite presentation of awards by the president of the Mother's club, the entire program ended with a dance called "Gangland," which, with its two opposing gangs, was obviously modeled on the 1957 Broadway hit *West Side Story*.

The final pages are devoted to several full-page ads taken out by parents, each bearing a roster of names of people who contributed to the success of this recital. One such entry reads, "Congratulations and best wishes to Lori J. Roundtree from Mom, Dad, & Brother, also The Employees of the Marine Corps Activity Supply," followed by fifty names of the coworkers of Lori's dad or mom. Another one reads, "To Theresa Betters on her third recital. Good Luck! Mom & Dad and the Data Processing Division," again with a lengthy list of people from her parent's place of employment who had contributed by purchasing recital tickets and/or ad space.

JB had made it this far, already gathering around her the community that would grow incrementally over the years and continue to support her. Not bad for the "skinny little girl from West Philadelphia."

You Don't Have to Go Home, but You Can't Stay Here!

Joan Myers Brown is a hands-on kind of teacher in her school and with her company. She directs and shapes the dancer toward professional status by subjecting them to a demanding agenda. Indeed, she can be tough, but she is also nurturing, which is why she's called "Aunt Joan," or "Mom," by her community. As the testimonials in this chapter confirm, she created a dance culture that served as a second home for its denizens. Sometimes, as classes and rehearsals were winding down and the clock was approaching midnight, they stayed on—adrenaline, ideas, and youthful enthusiasm fired up by creativity and comradeship. This was the character of JB's first company in the 1970s and early 1980s, when most of the ensemble members were Philadelphians in their late teens or early twenties.

What follows are excerpts from the interview I conducted with Zane Booker, who grew up dancing with PSDA, then danced with Danco, and then with companies in the Netherlands and Monaco, before returning to continue performing in the United States. He is back in Philadelphia, where he is a freelance choreographer (sometimes employed by Danco), teaches at the University of the Arts, and runs his own arts and culture organization, The Smoke, Lilies and Jade Foundation. It was formed in the new millennium specifically to serve the gay, lesbian, bisexual, and transsexual community by giving its adherents performing opportunities (as a presenting organization), educating them about health and social issues relevant to their survival, and disseminating this information to the

general public. He is the organization's founder and artistic director. Let it be said, at this point, that the gay and lesbian presence in dance, the arts, and everyday life is so central and significant that its invisibilization over generations has been unconscionable. The need for organizations like Booker's to combat and dispel sexism parallels the need for anti-racist movements.

Booker's experience of a smooth segue from Dance Arts to Danco says a lot about JB's tenacity in encouraging and mothering a young dance talent:

BDG: What's the first impression that comes to mind when you think of Joan Myers Brown?

ZB: Like an oak tree. Like something really rooted and strong like a tree. Like a strong tree whose roots go really deep and branches that extend out.... I grew up in West Philadelphia not far from West Catholic High School for Boys, at Fiftieth and Brown Streets. I started [at PSDA] when I was about seven. [He was born in 1968.] And I walked into a class that was supposed to be a jazz class. But I know now that it was Dunham based. So they started at the barre. But that confused me because I thought it was a ballet class. So after that class I didn't come back.

BDG: And how did you get there?

ZB: My cousins were part of Dance Arts, had already started taking classes. My mother went to see a dance recital, and it had some young men in it. And the men at Philadelphia School of Dance Arts recitals are always featured. [JB's ploy to attract more men — always a prized minority at the school and in the dance world at large.] They're always gonna be in the middle [of the stage action]. So that really made my mom excited, 'cause she thought I could dance anyway. So I joined first around age seven and then I think I came back around nine. And then from nine I really stayed.

BDG: Okay, so what would that mean?

ZB: I started with tap. And that was my way in because that had nothing to do with ballet. But each year Aunt Joan would push me to take on another technique. So it was, first it was jazz, and then it was ballet, and then I was in the training programs for the summers. And then soon, I mean my trajectory at the school was really quick. I was performing with the Company by the time I was fourteen. Each class was on a different day. And it was at the old school on Sixty-Third Street. We had only two studios, one big, one small,

but it was great because you couldn't miss the Company. Like I think [after] my last class, they always came in right after—at least the training program. So when I started to be in the training program and the school, I would take both classes. But before then I would just stay and watch....

BDG: Obviously, there must have been something in you that was a calling to do this.

ZB: I think I was one of those kids who just danced well. You know, it was like a gift.

BDG: At home?

ZB: At home, across the floor, moving from the trash can to my desk. At school they started using me for stuff: I went to a Catholic school so we always did Easter shows and, you know...by the second grade I remember learning a dance solo with my teacher. I [had] tried so many different things and was not successful. This was the thing that I liked and could do well.

BDG: Well, there couldn't have been so many things you tried and were unsuccessful with at ages seven, eight, nine!

ZB: I took drum lessons. I took piano lessons. I played baseball. I played—tried to play—basketball. I tried to play tennis. Those were about the five things that I tried. I fell asleep at my drum lessons, I got bored with the piano class—I don't think I even made it to the recital. Baseball I did for like half a summer. Basketball I never really took to—I ended up being the scorekeeper, keeping the stats! I was in Boy Scouts: that was fun. I liked camp. But none of the sports stuck; but dance kinda' stuck.

BDG: So you begin at PSDA when you're seven. When did you meet Joan Myers Brown?

ZB: I met Aunt Joan immediately; I mean, the first face you remember is Aunt Mary's.

BDG: Mary Johnson Sherrill?

ZB: Yeah. That's the first face I remember, that was all the stuff about what you needed to wear and all that [registration] stuff. But I'm sure I met Aunt Joan because, I remember, at the old building she always came into the studio. So you knew who Aunt Joan was. I don't remember the first meeting. I remember her always being there, though. I remember her telling me that I had to take jazz, and that it was time for me to take ballet. All that stuff.

BDG: She really is like "Aunt Joan," in that sense.

ZB: Totally! She was my mentor. She really shaped my entire career. When I think about it, whenever I was told that I had to take another [kind of] class, I usually quit! I would quit for a week or two and then I would come back. So when I had to take jazz I think I may have quit then. But for sure, when I had to not wear shorts. I used to wear these shorts and cut-off socks. When I was told I couldn't wear that anymore, I quit. When I was told I had to take ballet class, I quit!

And I tell you this one story I remember. Aunt Joan taught one of my afternoon Dance Arts classes. I think it was a jazz class. And she asked us to improv. And I remember improvising this solo that ended up with a manège.[16] Now, don't ask how I knew how to do a manège or how it had gotten into my vocabulary! So I remember doing some kind of jeté [jumping] series in the circle and Aunt Joan was like, "Oh, my God!" And she went out and called Aunt Mary, and then I did it again for Aunt Mary. So things like that I remember. I remember the first time I realized that I could jump. Harold Pierson called Aunt Joan into the studio, and she was like, "look at this boy!"

BDG: Oh, I love it!

Besides generous praise, careful nurturing, and an uncanny ability to spot and inspire talent, JB is also a hard taskmaster and a regular practitioner of "tough love" (discussed in chapter 4). She has a reputation for speaking her mind in no uncertain terms in ways that can be uncomfortable and unpleasant to those who are the brunt of her criticism. I was surprised that Booker and others extolled this quality and praised her directness and her frankness, even though feelings could be hurt.

For Debora Chase-Hicks, Deborah Manning St. Charles, and, later, Booker, the transition from being a Dance Arts student to a Danco company member was a smooth one. In fact, it was for these and other top students that JB started the company: to give them a place to perform. Taking her time in the shift from show business to dancing school, she was ready by 1970 to make the next move. Her statement in the second epigraph opening this chapter gives some indication of the level of frustration she felt, then and now, about black dancers not having equal employment opportunities in the dance field. Her deep commitment to her young dance students was such that she established the performing ensemble for them, and it was actually supported by the school during its first

decade. Although this new company was a natural outgrowth of the school, JB makes it clear that school and ensemble are separate entities. In a 1988 interview with me she said:

> Philadelphia Dance Company is a non-profit entity. Philadelphia School of Dance Arts is a profit-making thing that supports me and my family and supported Philadanco in its first ten years. When we didn't have any money for Philadanco, the kids that taught for me [at PSDA—Deborah Manning, Debora Chase-Hicks, and Vanessa Thomas Smith] would teach the classes for the company just to keep it going. The school's classes...work around the company schedule. Now my other school up in West Oak Lane [the PSDA satellite branch, in the Germantown section of the city, on Ogontz Avenue] has nothing to do with Philadanco whatsoever. We don't rehearse there. We don't go there or anything. At Sixty-Third Street the dance company used to use Dance Arts space. Now [that is, since 1982 and the move to Fortieth and Preston Streets] Dance Arts uses Philadanco's space.

This fledgling dance ensemble made its performance debut some time in 1972 at "a formal silver champagne benefit reception to be held at the Academy of Music," as reported in an uncredited newspaper article in the Joan Myers Brown Collection at Temple University's Paley Library Dance Archives. The article, which may have appeared in the *Tribune*, the *Philadelphia Inquirer*, or the now-defunct *Bulletin*, continues with what sounds like JB's early mission statement:

> Joan Myers Brown...said [that] with the new dance company the black youth of this city will have the opportunity "to seriously study the classics of dance in addition to the arts of their natural heritage, and to further utilize these talents by creating performing opportunities."
>
> She indicated that it has gone unnoticed that there is no present opportunity of this type available to the black youth of Philadelphia.... The Philadelphia Dance Company, which is a non-profit organization, according to its director, is dedicated to providing opportunities for young people thru [*sic*] the arts and dance.

The opportunity the school and company provided for David St. Charles was a lifesaver. He, too, is a "recycled person": "He danced with us for five years, then with Alvin Ailey [American Dance Theater] for 12 years," Brown says. "Now he's back teaching for me." He had come from a troubled family, she says, and an

environment rife with drug and crime problems. "One day his mother came up to me," Brown continues, "and she told me if he hadn't danced, he'd have ended up in jail."[17] St. Charles and Deborah Manning were in the Ailey Company at the same time, got married, and both returned to the Philadelphia fold.

The emphasis on youth was, indeed, a driving force in JB's rationale for forming her dance company. If Booker began dancing with Danco at age fourteen, most early company members were only a few years older. Unlike the trained dancers in their early twenties who now come to auditions from far and wide, including Europe and South America, these early Danco-ites were teenagers, home grown and trained by JB herself. Their youth and relative inexperience gave the company a verve and energy, plus a certain raw, edgy quality, that remains at the core of the Danco experience and has helped shape and define its aesthetic, as I discuss in detail in chapter 4. JB waxes nostalgic about those early, hardscrabble years and claims they were the best: "I wasn't paying anyone. Everybody volunteered; everybody wanted to be here. Everybody spent their life here...at the beginning, when I started, [19]70 up probably until [19]78."

It is noteworthy that, despite its phenomenal growth and expansion into a world-class, internationally renowned arts organization, there is a tight-knit feeling of community in this institution, largely due to the ongoing presence of some of its founding members—those "good girlfriends" mentioned by JB. On the administrative side her friend, Sarah Conway, codirector of the West Oak Lane Branch, has been there from the beginning, as has Mary Johnson Sherrill:

> Mary was an excellent bookkeeper, so she started off being the bookkeeper for the company, which she did up until she died in 1999. And I never had any misappropriation of funds, I never was delinquent, I never owed anybody as long as she was doing it, and she was doing it by hand—writing everything, because computers weren't used [when she started out]. I never had any problems. And when she got sick and died, after that, all was downhill.

Her reflections refer to a nightmare situation that the company experienced with a string of dishonest accountants who stole from the organization in the early years of the new millennium.

JB's recollections of pulling in her first male dancers also point to a grassroots mentality that has since become a cornerstone of the Danco standard for the men:

> [There were] these boys dancing at West Philadelphia High School in Faye Snow's little school stuff. They were all football players. So when

I said I want to start a company and I need some men, she sent them all here. And Gary [DeLoatch] was one of the guys. There were seven.

DeLoatch stayed with Danco for two years after graduating from high school. Thereafter, he auditioned for and was accepted into the Dance Theater of Harlem (which was then a new, young company giving ballet opportunities to black neophytes) and subsequently moved on to star status with the Alvin Ailey American Dance Theatre. JB described the first piece he danced in, *Time, Space,* choreographed by her pal Harold Pierson:

> That set the style for Philadanco because those guys couldn't dance! They had no training, and Harold worked those guys so they looked good. Now, the girls were all trained. The movement that he gave them was all very masculine. He wasn't giving them pirouettes and tour jetés. No: he was giving them stuff where they looked [here she makes angular, "masculine" body gestures] you know, *so people always talk about Philadanco's men were always so strong. So anybody I hired had to fit into that mold and that's kind of how I've kept it. I like the big, strong men — that look — and I tell the guys if I wanted all girls I'd hire all girls. You gotta be a man on my stage....* [My emphasis]
>
> Now you're talking about the era where they go to college and they're being trained. They're not dancing in the community center and the neighborhoods, but they've lost some of the other stuff with all this training....
>
> There was one step Hal would do. [Again she describes, half-demonstrates, and mimes a prototypical type of masculine movement — stride-like walks, wide-legged pliés, arms raised in a muscular fashion — in a combination of walking, stamping, running, turning, and jumping.] Then they would run around and just jump, and run around and jump. And by the time they got to the end there'd be seven or eight of them, and the house would come down. Well, if you'd asked them to pas de bourrée, they'd be like, 'huh?' But he gave them stuff that they could do and look good. And they just looked like great [ordinary] men dancing. And [since] the guys were football players, they had these [great] bodies....

Debora Manning St. Charles echoed these recollections, stating that "Harold Pierson instilled that in them, constantly, constantly: You *must* be a man on stage: the women jump this high, [then] you have to jump *this* high [namely, higher]."

But it is important to understand that the strong male presence called for on the Philadanco stage had nothing to do with the offstage sexual lives and preferences of JB's male dancers. The question of a dancer's homosexuality, bisexuality, or heterosexuality was of little interest to her. She was building a dance company, and it was a signature professional image that concerned her. Being "manly" was an onstage aesthetic device, not a demand on the male dancer's personal life. For JB, it was about the ballet tradition of the male dancer supporting the female—being the one to lift her, both literally and figuratively. Although the Danco male image and its demands may seem stereotypical, JB—and the dance world in general (like the world of fashion)—embraced male dancers and did not discriminate against homosexuals. They were her "children" once they entered her realm. And the city's black gay male community supported her, in turn. For example, in 1972 The West Set, a gay gentleman's social club in West Philadelphia, voted JB "Miss West Set of 1972–73." According to one member's recollections posted online: "They would have the Miss West Set Competition. Miss West Set was a straight woman, and reflected the jet-setting style of these Gentlemen [*sic*]. The first prize winner would receive a trip, maybe to Puerto Rico. That's how they did things."[18]

Like so many other dance institutions in the 1980s and 1990s, Danco lost a cadre of its male artists to the AIDS epidemic, including Carlos Shorty, Al Perryman, Tony Parnell, and Gene Hill Sagan. Others who had danced with the company were also lost, including Gary DeLoatch and Kevin Brown, who had gone to Ailey following their tenure with Danco. Billy Wilson, JB's earliest partner and a renowned choreographer, also succumbed. These were devastating losses, personally and professionally, in JB's life.

Pierson was one of JB's good buddies from her touring days. They had danced together in one of the Pearl Bailey revues, and JB got in touch with him when she started Danco, asking him to choreograph something, "so the first piece we ever did he choreographed: *Time, Space* to Nina Simone's [version of] 'Sinner Man.' And John Hines choreographed another ballet that we've since lost. And that was our repertory." And *Sinner Man* is the Pierson piece that JB mimed-demonstrated during the interview. Early on, she had choreographed for the company as well but realized that she was, in her own words, "no great choreographer. I better take care of the store and hire somebody to choreograph. But there's a piece called *Holy, Holy*, and that's probably the best piece I ever choreographed. I will not lay claim to choreography except at the Club Harlem!" Also in this early period she made a dance called *Promulgation* for David St. Charles. I asked her to describe it: "Actually, it was a guy sitting on a stool and just emoting his butt off, that's all! And everybody else was using a chair,[19] so I decided to use a bar stool—'cause I had it!"

Early company members hold a wealth of memories about their Danco experiences "back in the day." In my interviews with Manning St. Charles, Chase-Hicks, Zane Booker, and Vanessa Thomas Smith in 2008 and 2009, I gathered detailed information on the human dynamics of JB's institutions. Born in 1958, Chase-Hicks studied at Dance Arts for three years before becoming a Danco dancer from 1974 to 1981. Born in 1959, Manning St. Charles studied at Dance Arts from the age of three (by special permission: usually students are not admitted until they are six years old) and subsequently was a Danco dancer from 1973 to 1981. Thomas Smith was born in 1957 and came to Danco in 1975 by way of audition and stayed till 1979, when she was accepted in the circus.[20] Born in 1968, Booker studied at Dance Arts from the age of seven and danced with Danco from 1982 to 1986. All four are "recycled people" still affiliated intimately with JB, her school, and her company. Their careers demonstrate the aesthetic continuity between the early school and the neophyte company.

Manning's beginnings bear repeating. She attended the school when it was located at Sixty-Third and Market Streets

> above the Galaxy Restaurant. I was the youngest student ever taken in the school. I started at the age of three.... The story is that my mom took me to the dancing school and Miss Brown was there and she said, "Well, we take them at [age] five" and—they tell me this is how it went—I started crying so bad, and I wouldn't leave, and my mom said, "Well, can you just keep her for the day? Can she just stay and watch?" And I've been here ever since. I studied at the school until I was fourteen, then Philadanco was formed when I was about twelve. I went straight from school to dancing school—that was my life. And I would stay. I had a little office job, like filing papers and stuff like that. Then I'd stay and watch the Company. And then I started taking class with them.... I would still take my own regular classes [at Dance Arts], be in the recital, and then start working with the Company and taking their classes.

The Company classes in this early period laid the groundwork for building the ensemble, and some of the original teachers are still there: Delores Browne (ballet) and Pat Thomas (Graham technique) have taught the ensemble for over three decades. Milton Myers has been resident choreographer, also teaching Horton technique, since 1986. Even though dancers come and go, the company maintains its identity and character through the continuity provided by its staff of supporting artists. Other guest teachers regularly come in from New York. Manning

St. Charles explained that, in the early days, they trained rigorously and performed infrequently. Summertime engagements included performances for Dancemobile open-air concerts in public spaces, dancing on a makeshift stage perched on the flat back of a big truck. Company members would take on other duties, so at one point, Manning was the costume mistress, a job that included washing everyone's costumes, as was Thomas Smith later on. I expressed surprise that a core of dancers stayed on, in spite of the fact that they were training religiously, performing infrequently (and gratis), and taking on auxiliary jobs backstage and in the office. But Manning St. Charles gave a richer picture, saying that

> There was a group [of us], and we clicked, and we sweated, and my mother would cook dinner sometimes and bring it up to the school in the middle of the night. We still had to go to [high] school in the morning. But we would be so excited to perform. By the time we hit the stage, we didn't even break a sweat. And these were *hard* ballets. And we were *all* in everything. So there was no going back and forth to the dressing room. All your stuff was in the wing....
>
> The guys would look out for the girls. I mean, we couldn't date — nobody could touch us. They (the male dancers) would walk us to the stores. And when rehearsal was over on Sunday, we traveled as a pack — a *herd*! Nowadays they [current company members] split up — which makes a difference in performing. We would go to Tony Parnell's house in South Philly. Now, we'd been dancing all day, in the studio. And he was a DJ on the side. His friend, his companion, was a chef. So, after class, we'd go there. He's already prepared dinner. Tony's playing the music. And we're still dancing until eleven or twelve o'clock at night. And if you didn't want to go home — well, the younger ones had to go. My mom would be like, "Come home!"

St. Charles noted that hanging out together after class and rehearsals "makes a difference in performing." For her — and those in other walks of life who originate a trend, business, or style, move on, and then witness the next generation inherit that "property" but change it — there is something lost. In the dance world, be it an earlier generation of the Martha Graham Dance Company, the New York City Ballet, or the Alvin Ailey American Dance Theater, the same sentiment has been voiced: things were better in days gone by when the ensemble was small, closely united in friendship, and just starting out. But this is how it must be: new dancers represent the new norm, with all its changes and innovations,

and dance culture has to change as well. For Danco or any other social institution—be it cultural, religious, economic, or political—it is imperative to remain relevant and change with the times if it is to survive. The recent ranks of Danco dancers are no longer teenagers who grew up in Philadelphia but professionally trained artists from across the country and around the world who have been chosen by audition and who may or may not be close buddies once they leave the stage or the studio.

St. Charles cited Delores Browne (whom she still calls "Aunt Delores") as her all-time favorite ballet teacher and reminisced about the additional pointers Browne communicated to the girls:

> She is my favorite ballet teacher in the entire, entire world! She would tell the girls you couldn't take class without elastic on your slippers, period—little things that are *important*! And that's part of the discipline in dance. Pull your hair back. Get a brush, keep a brush in your bag.... And she'd say, "Go maybe put a little rouge on. A little lipstick." And so we started coming to class making sure we were [well groomed]—no holes.

These pointers may seem superficial, even frivolous, to some readers. Others may be aware of the potential for minor adjustments such as these to have a positive impact on changing a dancer's posture, mien, and presentation of self—especially the young dancer.

Manning recalls that she performed with JB in one of the PSDA recitals when she was about eight years old: "I think it was called *Me and My Shadow*. She [JB] choreographed it." This was unusual. Unlike King and Cuyjet, JB did not appear in her school recitals. Manning surely was singled out because of her special talents, deep loyalty, and early abilities, even at this tender age. Like her mentor, she had an unusually flexible, acrobatic body and could—and would—do anything she was asked to do. When Manning was fifteen, JB allowed her to perform with the young company at Atlantic City's Club Harlem, using her old connections to arrange these bookings. The other company members were about three years older, and

> every summer they'd go up to Atlantic City for two or three weeks. And one year I think there was one dancer who couldn't go, and she [JB] chose me. My mother had to be in on the discussion—where we're going to stay, all this kind of stuff. And it was three shows a night. Ten o'clock, midnight, and a 6 A.M. show. So between twelve and six we'd sleep in

this dressing room, and after the six o'clock show we'd all gather up and sleep the rest of the time on the beach, go back to the rooms, or whatever. Get ready and go back to Club Harlem. Now that was an experience for a fifteen-year-old.

Debora Chase-Hicks began studying at the Oak Lane Branch of Dance Arts, under Sarah Conway's leadership, when she was thirteen. At sixteen she was performing with Danco. Although the average time that dancers stayed in a company was longer then than it is now (generally six to ten years, as opposed to the current three to five years), she contends that when she began in 1974, the original people were no longer in the group. It seems that the group that worked together in the mid-1970s—Chase-Hicks, Manning St. Charles, and Thomas Smith included—was the company that "clicked" as an ensemble, out of which the Philadanco aesthetic evolved. Along with other early dancers, Chase-Hicks moved from student to company member as a natural progression, without a formal audition process:

> The way I got into the company was at a recital, one of the recitals. Aunt Sarah did a dance, and there was a solo in it for me, and so Miss Brown asked me to come and take class, and I became an apprentice. I was an apprentice first before I was in the company, and how that transition happened is that you ended up being in a dance. You would get the group part and then you would get a role in it, and that might be a duet, and then it's like, "Oh! I got the duet!" So it's not like a "big bang" thing that happened. It was a progression. But each progression was something that made you know you were getting better and you knew you had something. And then you got another dance and another dance, so there wasn't really—we didn't really have auditions then. That didn't start happening until I was almost getting ready to leave.

She explains that she was extremely happy being in this company and especially having the opportunity to work with Gene Hill Sagan. Like so many of the practitioners I interviewed for this book, dance was a central occupation in Chase-Hicks's young life, to the exclusion of most other pursuits, and she found a cadre of like spirits with the same obsession:

> I had made some of the best friends here, like friends for life. Just the environment [made her happy]! It was a place where I discovered that I really liked to dance. When I first got here, it was something that I just had to do because it was the only thing that my parents would allow me

to do. You know, my parents were very strict.... And then I discovered that I really liked it. And then, that I loved it! And it was the teachers and everything, and then I discovered that maybe I *could* dance, you know?

Sagan had a lot to do with this discovery:

> For some reason, we just had something and looking back now—I didn't know it then. I would do anything he said. If he'd said "Run and do a flip and jump off a cliff," I would do it! Just because I loved the way he moved, you know—the abandonment, with all his movement and the passion—for some reason it tapped into something for me. Looking back on it now, I think it was, maybe that was the transition for me to think, "Something really good can happen for me here."...
>
> But wait: let me go back, because I think that the first time that I really felt like this was something I could really do [was when] Miss Brown choreographed a solo for me, and we would always laugh about it. The music was Natalie Cole, and I had this broom; I don't remember the name of the song, but one line was, "Why should I comb my hair when I know I'm not going anywhere?" We were laughing about that not too long ago.... I was probably about nineteen, and I think that this was probably the first time that—like I know she pushed me, and that maybe I felt like I could do something. But Gene was the one for me that really made me believe that it was a possibility—just the full range of it.

She danced in the original cast of Sagan's *La Valse*, and then he choreographed a solo for her, *Autumn Wild*, which he subsequently made into a trio for her and two male dancers.

Despite her joy at dancing with the company and working with Sagan,

> My best friend, Kevin Brown, he's no longer with us, but he took me to see the Ailey Company, and it was the first time I'd ever seen them, and I just thought they were phenomenal. And I just wanted the opportunity to do *Revelations*. I really did—just the images for me. So that was the catalyst.

Manning St. Charles and Chase-Hicks auditioned together for Ailey in 1981, with JB's blessing. After a full day of auditioning with several rounds of eliminations, both were accepted. Manning stayed with Ailey until the 1993–94 season; Chase-Hicks through 1990. Both danced major solo roles with the ensemble.

Vanessa Thomas Smith eloquently addressed the closeness that existed in the early company:

> I was working in bill adjustment, so I was working a regular job, eight hours a day, and then I would leave and come to Philadanco and be here all night. So to be able to stop doing that [when the company received its first grants and could pay dancers for rehearsals] and come to Philadanco Monday through Sunday—eight hours a day full of dance, if the choreographers were here—it was an enchanting time. Chase and I and Deborah Manning, we talk about how we just spent our entire lives together. We'd do class, rehearsals, and then we'd change our clothes and go out. We'd hang out, go to the club and dance all night long, and come in and take a quick shower and put on our dance clothes and be at class Sunday morning at 10 A.M. all together. There was a point in all of that that I would go, "Deborah Chase is going to wear this leotard today, and she's going to wear that color tights, and that other color skirt for ballet class," and lo and behold, she'd walk in with that on. It was like, we were so close it was spiritual!
>
> I had a Volkswagen, Chase had a Pacer and, like a clown car, we'd all pile in and go somewhere. There was a restaurant underneath [the studio] called the Galaxy, and we would leave rehearsal and go downstairs to the Galaxy and stay there for another hour and a half eating. *And we weren't eating anything!* We had bread pudding, we had—one of our favorites was steamed broccoli with a little bit of lemon juice squeezed on it! They used to make this soda for us: they'd take all the soda syrups and mix them together for us, and we would drink that!

Chase-Hicks's memories accord with Thomas Smith's, as she recalls how close-knit a group they were:

> I remember that she [JB] used to always say—and this is a testament to how [close] we were in Philadanco at that time—she would always say, "You don't have to go home, but you can't stay here!" She'd be flicking off the lights and saying that, and we'd be bouncing off the walls, still dancing, and it was near midnight. You know, I wish I could say that today in the studio.

Like all the Danco women, Thomas Smith had a ballet background. She began studying dance at the age of four with Anna Massey at Massey's School of Dance

in West Philadelphia, taking classes in ballet, tap, jazz, and pointe until she was sixteen and a senior in high school. She talked about performing in *Octet* [1979], a dance to be done on pointe made for the company by ballet master William Dollar. She was happy to be a part of it

> because that reflected back to me as a little girl and thinking, like Joan Myers Brown, that I was going to be a black ballerina. Joan had the foresight to do this ballet because we were a modern company.... It was going to be a piece that would be in our repertoire, and it would showcase the skills of dancers with ballet training, and it was absolutely wonderful because all of the movement that you learn as a little girl for ballet—and now I'm teaching a ballet class again—it brings you back to kind of why you dance: how you felt when you put on your first tights and your slippers and looked at yourself in the mirror with your hair up in a bun. So I got to feel that again in this ballet, and it's the same feeling I have now when I teach these girls in class—that I hope, twenty years from now, when they are in their careers and some are married, that they'll have some kind of moment where they go, "Aaaah! that's when I decided that I was exquisite and that I was pretty and that I was lovely and that I was all these—that I was *precious, lovely, angelic*"—and, you know, all of the words that come when you think of a young lady doing ballet.

This statement is, to me, a revelation that cuts to the core of why these young African American women were so enamored of and intent on being ballerinas: it meant validation for them as women who wished and needed to be both treasured and idealized. It meant the bestowing upon them of acceptance and approval from the other world—the white world—that surrounded and limited their hopes, dreams, and daily movements and had "othered" them in a category that fell far short of any ideal. Once again we can see the Du Bois talented-tenth concept at work, for, above all, the ballerina represents a European ideal. To the degree that black women master the genre, they become masters of their own image in both the black and the white worlds. And it is important to read this information in context: to be a black ballerina is not a simple rejection of one's African and African American heritage but, instead, a challenge and victory over those who would say, "Stay in your place; your body and abilities are not capable of doing this." It's an embracing of our full heritage—black and white—just as white Americans can see fit to embrace black genres.

The other resonant part of Thomas Smith's statement is her wish that, many years hence, her former students will remember the moment when ballet gave them

a sense of self-image and self-possession. She is not necessarily thinking of those who go on to professional careers but of the bulk of dance students who know they won't live their lives onstage but who will acquire personal grace, poise, and grooming—as well as a sense of achievement, self-worth, and group cohesiveness—from having taken dance classes. This reminds us of Joe Nash's statement quoted earlier about the many reasons people study dance. He is interested in and one with Thomas Smith and their cohorts in teaching the whole person.

For Thomas Smith and the other black ballerinas in this book, the ballet ideal existed *in partnership with* black-based dance forms, and jazz, tap, and African-based—then called "interpretive"—dance were equally valued experiences. JB made her mark in show business by fusing jazz dance and ballet, for example. And, as Thomas Smith pointed out, Philadanco is a modern dance company. Along with her reminiscences about *Octet*, she commented on working with Talley Beatty, a choreographer whose approach and influence taught her a life lesson:

> I was in the company when we did *Pretty Is Skin Deep, Ugly Is to the Bone*. And I kept thinking that if I could get through a rehearsal with him, that I could do anything: I could be the President of the United States—and you know that has a different connotation these days—that you possibly could be riding that high because, as the kids say, he was "no joke!" He wanted what he wanted when he wanted it. His brain was always very quick. He taught the choreography in reverse—his vision was that he saw first the end of the ballet. Then he would work back to the beginning. And if you're pedestrian, like most people are, you go from A to B to C, not C to B to A. So he actually in that process made me think, and continue to—and not just about choreography but about *life*—sometimes you have to see the end product.

Zane Booker came to Philadanco in the next decade and danced with the Company from 1982 to 1986. He experienced "tough love" from JB and male choreographers like Louis Johnson. When he was a Company member, JB still taught classes but less frequently than she had to the previous generations in the 1970s. Booker recalls having classes with her on Sundays, which he described as

> ballet classes or Dunham, depending, but mostly Dunham. [It was] old school ballet, when we would have ballet: you know, many, many counts and grand pliés several times, and slow, slow, slow. And that's why...the old company didn't get injured as much, because they had stronger quads. [quadricep muscles, along the front of the thighs]. So the stability around

the knees and the ankles and all that stuff was rock solid. Kids [today] go crazy when you give them repetitive, hard, muscularly challenging exercises. And I still have that [training] left over in my classes at UArts. And I'm unrelenting about it—you have to get strong. You gotta be long and placed [correctly aligned], but you gotta do it a hundred times so that your muscles know where to go and that they're strong.

Just as Joan Myers Brown continued to teach in the Tudor tradition, Booker teaches what he learned from her. That is how dance practices become traditions, and Philadelphia's legacy is strong and viable, like the quadriceps of a healthy dancer. Asked to talk about a peak experience performing with the company, Booker cited their Bermuda tour, when he saw the company, the staff, and their hosts in a new light:

Going to Bermuda with Philadanco changed my life! First of all I had never been around so many black people who were so pulled up and professional. You know, you see people in the studio [rehearsing in dance gear]; that's a different thing. And I don't remember being involved in a lot of the Board stuff that Danco went through. So my life was school, home, church, and dancing. So when we went to Bermuda I was in high school. Everybody was black. The mayor was black. Everybody who hosted us at their beautiful homes was black. And the way they ate and talked was on the British side, so it was a whole different way of communicating. The conversation flowed, they treated us well and the hotel was amazing: the Hamilton Princess Hotel. And we dressed, because we had receptions every night, so we got dressed up! Performing in Town Hall we got wonderful reviews.

It was my first window into another world—not that my family wasn't refined, but you take that for granted, you know, the way your grandmother is and the way that we [as normal African Americans, in other words] are refined. These people were lawyers and senators. It was so interesting to me, and the income level was so much higher. I remember dreaming about buying property there!

Having grown up through the auspices of the school and, then, the company, Booker spoke again and again of the feeling that this was his family:

You know, we celebrated birthdays together. At that time it was nothing to leave the studio at midnight. When Louis [Johnson] would

get going we'd look up at the clock and it was a quarter to twelve — not all the time, but many times. Mr. Johnson was still trying to do another step, you know! We spent a lot of time together in and out of the studio. Aunt Joan, when she had her home in Wynnewood [a Philadelphia suburb], used to entertain the company there. We would go swimming, and she would do this amazing gumbo that I haven't had for years. We'd hang out at her place several times during the summer and also have Dance Arts picnics. Now that we have this new space [Preston Street, since 1982] the picnics don't happen in the park but in the parking lot. She doesn't have a big house anymore, so there might be something up in the studio. So that's different. And we were more Philadelphians in the company, and I think that made a difference as to how we felt around each other. And at least a third of us had grown up in the school. It was a different history, a different connection to the organization. I don't know if the dancers that come in from out of town have that connection. They are using Philadanco as a stepping stone.

Like St. Charles, Booker expresses the sense of loss that naturally occurs with expansion. Philadanco by the mid-1980s was on its way to becoming an international and national entity, no longer populated by and serving only a local audience.

Looking back to the mid-1970s, we can see the seeds of growth JB sowed in the tone of the early critical response to her company concerts. A 1975 review in the *Philadelphia Inquirer* stated, "The troupe, directed by Joan Myers Brown, is not as old as this decade but has already produced some able dancers and formed the beginnings of an ensemble." The reviewer concluded by saying that some of the dances "explored ideas that were not fully realized in these performances, but to a company with this much energy, missteps won't matter."[21] In this we see the beginnings of how the company would be received and perceived in the future: a group of able dancers performing with an energy that seemed to translate into charisma, allowing the spectator to overlook the dancers' immaturity or weak choreography. A 1976 review in *The Evening Bulletin* declared, "Hardly anything educating has ever been so sheerly entertaining as Harold Pierson's Bicentennial survey of black dance in America was last night." The writer uses "vital," "swinging," and "stirring" to describe the dances and their interpretations and asserts that

> [s]uch a thorough anthology brought out the best in virile male dancers, women who moved easily from pantomime to wild action, and not least

of all children amazingly well trained who moved professionally on a somewhat limited stage (though it was used well and to the full).

Here, again, we read a favorable critical reception tempered by the use of key words—"wild action," for example—that suggest a stereotyped response to a black dance company. We also learn that the children at Dance Arts have been treated to a professional stage opportunity by appearing in this dance. Indeed, the overall tone of the review is balanced and recognizes the value of this company. The final paragraph reads, "This rich chunk of Americana, entertaining as it is, is the result of much exaltant [*sic*] research by many devotees. The best credit the company deserves is certainly the chance to give this show over and over again."[22]

By this time the company was performing regularly at Philadelphia's Walnut Street Theater, and, notwithstanding her disclaimers, JB continued to contribute choreography that had a positive effect, according to the critics. Daniel Webster, writing in the *Inquirer* in 1978, said:

> The Philadelphia Dance Company offered three new pieces in the first of its weekend performances last night at the Walnut Theater.
> Among them were two by the director Joan Myers Brown, both works that showed craft and economy and showed the dancers to advantage. The best of the evening was her solo for David St. Charles, "Promulgation," a piece that was based on blues music and that used the dancer's projection and strength admirably. The dance has a sure sense of direction and choreography that holds the focus.[23]

The *Bulletin* critic opened his review of the same concert by saying

> Philadanco's vibrant, expressive, and talented young troupe continues to impress; there's not a moment of static dullness in their concerts. The combination of free-spirited motions and the discipline they disguise, in bursts of energy and an unleashed grace, distinguishes their work.[24]

This writer hit on an essential premise in the Philadanco aesthetic—namely, using energy in a way that allows the audience to enjoy the spectacle without having to be aware of the hard work that goes into the final product. This is what gives Philadanco its show business élan: JB sets out to create accessible artistic products performed by accomplished dancers that, above all, are highly entertaining. The *Bulletin* review touched on each of the seven works performed in the concert, three of which JB had choreographed. To show the breadth of the

works performed—and the way that JB highlighted the expanse of her dancers' abilities—let us examine the final paragraph of this review:

> Deborah Manning and St. Charles dazzled in a pas de deu [*sic*] from Drigo's "Le Corsaire," showing traditional style with a free elegance and beautifully sculpted lines; their ballet idiom was sumptuous in Carl Sandemar's choreography and always organic. Miss Manning also did her "Ghettoscape with figure" solo on a ladder, brilliant, scorching, and real artistry; the remaining 3 sections from Talley Beatty's "Pretty is Skin Deep, Ugly is To the Bone" pointed up Philadanco's strengths—handsome, appealing dancers with solo strength, ensemble finesse, and interpretive gifts. An enriching evening.

Featuring Manning and David St. Charles, the *Corsaire* pas de deux was performed on pointe. Manning was then required to switch not only costume but character in order to move from nineteenth-century European romantic ballet heroism to twentieth-century African American blues-jazz angst—from performing on pointe to perching on a ladder. Earlier, the company had performed excerpts from Harold Pierson's evening-length spectacle, *Roots/Reflections*, which traced the history of dance beginning in Africa and progressing from slavery and plantation life through contemporary forms. There was also a piece for four couples, *Jeux D'Enfants*, choreographed by Roy Tobias, plus the three works by JB. With a concert of seven dances from different perspectives, the evening was an events showcase that stretched the dancers physically and mentally. To borrow the title of an early Martha Graham work, these programs required that the dancers be "acrobats of god." By the 1990s, the company had moved to more standard programming, with three or four longer works in an evening's concert. Again, some of the dancers from the early eras bemoaned the change in format (see Kim Bears's comments in chapter 4), but change is part of growth.

In the 1970s some of JB's old contacts from the entertainment world would occasionally call upon her to supply dancers for a local engagement. She sent dancers to work in shows in Atlantic City, and she recalled supplying performers for Louis Bellson, Pearl Bailey's bandleader spouse, when he was playing at the Robin Hood Dell, a popular outdoor concert venue in Philadelphia. Moreover, her instructors were the people who had helped her get the school and company up and running. In the 1985 interviews she told me that

> Most of the people who taught for me I knew from dancing myself. The first few years I didn't pay anybody. I paid their transportation to come

to Philly to teach for me. Take Billy Wilson, for instance. He will come and teach and do a ballet for me for $1500, knowing full well that if he does a Broadway show, he's talking about $50,000 in pay plus box office residuals, and so on. He said when he comes to Philly he feels he's making a contribution. Those are the kinds of things that Louis Johnson did. He choreographed for us for no money. Then when I got a grant, I paid him. I've been very fortunate with people being very supportive.

In its first decade the company participated in the Young Audiences programs, getting up at the crack of dawn and going to various public schools to set up classes, performances, or lecture demonstrations in the auditoriums. In the 1985 interviews, JB explained how it worked, noting with relief that she no longer participated:

> I used to have to get my babies up in the morning so my mother could take care of them while I went off and did Young Audiences. I would have to run around and pick up the kids [the dancers], and the kids would be late. They would always put us in Bristol and Langhorne and Ambler [Philadelphia suburbs] and all those places that you really had to leave early to get to. I hated it, but it was a way of making money for the kids. They would make $45 every time they did one. I would try and do two or three a week so they could have some money.... They would pay you to bring four dancers and a leader and the leader got double. So instead of me getting paid I would take six dancers; we'd go with our record players and our tape.... Sometimes we'd do two programs in the morning back to back or sometimes one in the morning and then one after lunch. Sometimes the kids would be making $90 or even $180 in a week.

For better or worse, race played a part in the bookings. Danco and the Arthur Hall Company were sent into white communities because, according to JB, "this would be the only time they would get to see black dancers. The kids in Langhorne don't come to Philadelphia to see shows."

By this time, the late 1970s, her school enrollment "was enormous. I didn't have enough space to teach classes and give the company their space. We started looking for a place in 1980. A friend of mine was in real estate development and...found this building for me. When he found it, there was a tenant in the building." She used the building as a rental property for two years, paid off the mortgage, and began remodeling. The new building, at 9 North Preston Street, was ready for PSDA and Philadanco by 1982.

When I interviewed her some twenty-five years ago, Joan Myers Brown said she wished that she could retire. Two and a half decades later, this trouper is still at the helm, and still longs for respite. What she told me back then gives a picture of her sense of accomplishment as well as the burden she has to shoulder:

> I think most of my initial goals and all my aims—and I think very few people can say this—have been met. Right now, all I've wanted to do, I've done. The only thing I was unsuccessful at was marriage, and I think that was because of my involvement with Philadanco. I was just here all the time, from 10 A.M. till 4 [P.M.] for Philadanco [business]. At 4:30 dancing school starts [and continues until 7:30 or 8 P.M.]. When dancing school is over, Philadanco has rehearsals [8:30 to 10 or 10:30 P.M.]. I've spent so much time here and have done it for so long....

But she cannot leave, in good faith, until the right person comes along to take over. She is too responsible, and the institutions she's created are too important. So she perseveres. As Debora Chase-Hicks said of JB, "She's a visionary. She just had that vision, way back when it was supposedly impossible.... And the basic bottom line is all she really wants you to do is dance—really *dance*. Put your best foot forward. Be the best that you can be."

How does Danco allow the dancer to "be the best that you can be?" In the next chapter we take a closer look at the aesthetic scaffolding, the internal premises, that support "the house that Joan built."

Figure 3.1. Savar Dancers - Montreal, Canada—1955
L. To R. – Marti Lane, Bobbie Jean Day, Jb, Roxy Young, Tina (Surname Unavailable)
Source: Joan Myers Brown, private collection. Photo Credit- Adrian McCrea

Bill Miller

presents

The Greatest Rhythm Musical Revue of the Century
LARRY STEELE'S
SMART AFFAIRS OF 1959
with an
EXCITING CAST OF 60 FABULOUS SEPIA STARS

Written, Produced and Directed by LARRY STEELE

Choreography by LON FONTAINE

Musical Arrangements by SY OLIVER

Costumes Designed by Johnny Allen Assistant to Mr. Steele, Lyle Smith
Executed by Variety Costumes, N. Y. C. Assistant to Mr. Fontaine, Joan Myers
Assistant to Mr. Oliver, Dave McRae Company Manager, Elmer Waters

Talent Research, Nana Steele

— Original Songs —

"SMART AFFAIRS" — "YOU'VE GOTTA HAVE A GIMMICK"
"THE MODERN HARLEM GIRL — "IT'S THE BEAT"

Composed by LARRY STEELE — Words and Music

Musical Director — SY OLIVER

Furs by Milton Herman; Jewelry by Coro; Gloves by Wear Right
Shoes by Bakers Qualicraft Lifetime Heels
Scenery executed by Chester Bakeman; Costumes by Variety

Manager — ART SCHAEFFER Purchasing Director — HY KUGLER

Stage Manager, Michele

Banquet Directors, Ceil Beckman Jacobs and Sonny Doyle; Convention Manager, Samuel Burger
Publicity by Paul Benson and Jeri Blake; Program designed by Max Hixon, Real Press
Wardrobe for Larry Steele by Cye Martin;

Chef — FRANCOIS TOUZET Maitre d'Hotel — ROBERT

Entire Decor — Scenic Designs and Special Effects by
RUEBEN BODENHORN

Programme

Prologue — "SMART AFFAIRS"

Featuring
Sy Oliver — The Larry Steele Choir — The Modern Harlem Girls

SCENE 1

"OPENING" — "YOU'VE GOTTA HAVE A GIMMICK"

Sung by Larry Steele; Danced by Lon Fontaine; The Beige Beauts and The Beige Beaux

SCENE 2

LEONARD & LEONARD

Genuine Hoofing of the "Old School"

Program continued on last page

Figure 3.2. Larry Steele's "Smart Affairs," Riviera Nightclub, NYC, New Year's Eve, 1959. JB listed as assistant choreographer (above) and dancer (on last page)
Source: Joan Myers Brown, private collection.

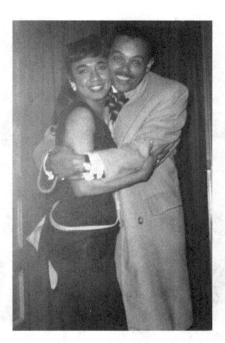

Figure 3.3. JB embraced by Billy Eckstine—1950s, Quebec City, Canada
Source: Joan Myers Brown, private collection.

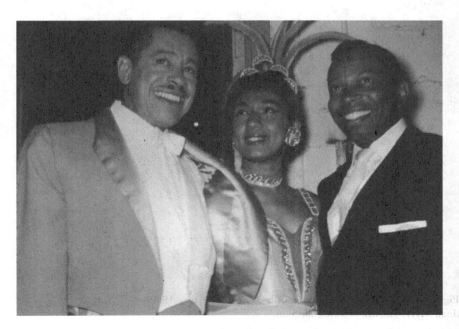

Figure 3.4. JB with Cab Calloway and unidentified tap dance artist—Club Harlem, Atlantic City—ca. 1965.
Source: Joan Myers Brown, private collection.

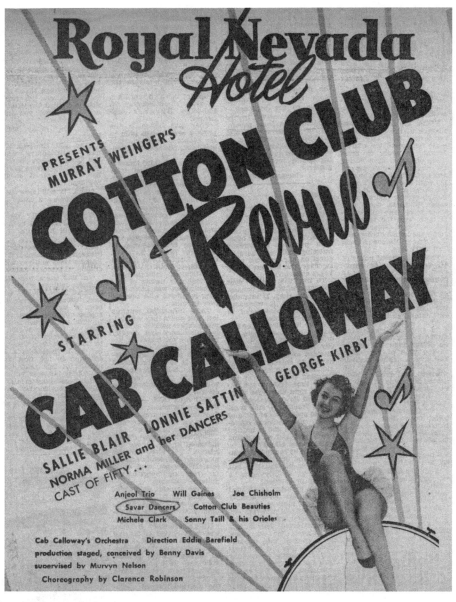

Figure 3.5. Newspaper Clipping, Cab Calloway Revue—1960s Joan Myers Brown, private collection.

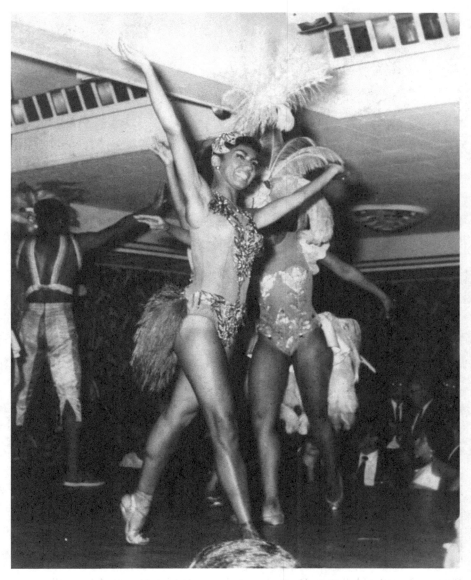

Figure 3.6. JB Onstage—Larry Steele Revue, Club Harlem, Atlantic City—1960s.
Source: Joan Myers Brown, private collection.

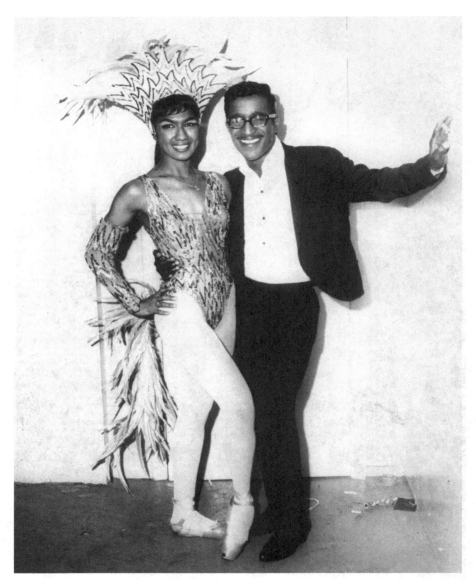

Figure 3.7. JB with Sammy Davis, Jr.—Backstage At Club Harlem, Atlantic City—1960S.
Source: Joan Myers Brown, private collection.

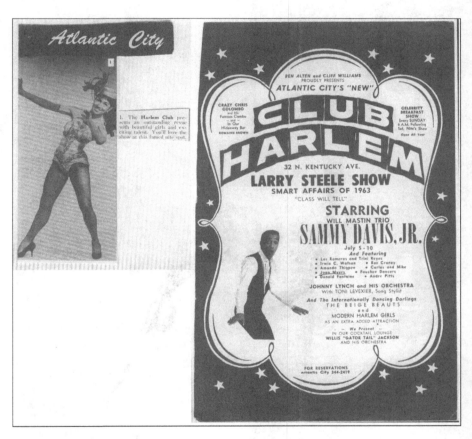

Figure 3.8. Paste-up page from JB's photo album. Left: JB as 'Poster Girl' for Atlantic City Newsletter, July 5–10, 1963; Right: Club Harlem Ad, 1963, JB listed as featured. *Source*: Joan Myers Brown, private collection.

Figure 4.1. The Philadanco Aesthetic Personified. Odara Jabali-Nash, ca. 2003–2004. ©Deborah Boardman, Philadelphia.

CHAPTER FOUR

NOSE TO THE GRINDSTONE, HEAD TO THE STARS: THE PHILADELPHIA/PHILADANCO AESTHETIC

It's important to be here, rather than in New York.... I'm sure I could have had a good company in New York, because I had more selection of dancers there. But I wanted to get away from the rat race. I wanted to get away from the stress. [In Philadelphia] a dancer can relax and really develop their craft in an atmosphere of, as the kids say, family; of knowing that people care about what you do and how far you're going. Philadelphia is my home. I was born, bred, raised here. I studied here. I went to school here. I felt that if I had something to give to someone it should be to people in Philadelphia that I knew.

—Joan Myers Brown[1]

Our style encompasses technique, it encompasses movement, it encompasses energy, it encompasses space, and it includes technique underneath all of that. And that's what used to burn Aunt Joan up, so she was like, well y'all just talk about energy, but look at the technique up under that energy!

—Zane Booker

You're going to feel *a performance by Philadanco. You're not just going to* visually *see a performance.*

—Tracy Vogt

PART ONE
INTRODUCTION

Let me begin with a story about the chapter title, "Nose to the Grindstone, Head to the Stars":

First night of the new year: January 1, 2010. I am in the sound studio of radio station WRTI-FM with Kim Bears-Bailey and Chloe Davis of Philadanco and J. Michael Harrison, emcee for "The Bridge," a crossover music program that explores the musical link spanning bebop to hip-hop and everything in between. The three of us are Harrison's on-air guests tonight to promote the upcoming twenty-second annual International Association of Blacks in Dance Conference, for which Bears-Bailey and Davis are co-coordinators. (Bears-Bailey, former Danco dancer, is now the company's assistant artistic director; Davis, in her fourth season as a Danco dancer, is also an events and marketing coordinator, with a graduate degree in tourism and hospitality management.) Before we are interviewed, Harrison plays one of his inimitable musical sets, beginning with Gil Scott-Heron's "Peace Go With You, Brother," from the *Winter in America* recording—a perfect way to wish in the new year—and segueing into "Sacrifice," a cut from the *Phrenology* album by Philly's hip-hop wizards, The Roots. As I listen to the words of "Sacrifice," struck by what they have in common with the spirit of Danco, Joan Myers Brown, her trials, her triumphs, I jot down those lyrics— "nose to the grindstone, head to the stars." Without knowing it, The Roots provided a thumbnail description of my topic for this chapter—that is, the unique spirit embodied in the community of people nurtured by black Philadelphia, which has shaped and defined a singular aesthetic, as evidenced by Philadanco.

Note: You don't have to be black to be a child of black Philadelphia. It's a state of mind, not a matter of ethnicity. You may be a musician like Jewish Bobby Zankel, whose expression is an outpouring of this city's black-based jazz culture. Or any music lover anywhere on the planet who grew up grooving to the Gamble and Huff "Philly Sound." Or a dancer, writer, or rapper of the hip-hop generation, whether you were born here or, like Chicago-based Japanese-American dancer Makoto Hirano, moved here. It's a tangible quotient, and it can be felt in the streets, on the radio, in the clubs, in the theaters, and in the churches. The Roots exemplify this spirit, as does J. Michael Harrison—and Joan Myers Brown. They are artists who chose to be and remain in Philadelphia. In 2009, in spite of being hired as the house band for the New York–based "Late Night With Jimmy Fallon" television show, most Roots members continued to live in Philly, despite the four-hour daily roundtrip from the City of Brotherly Love to the Big Apple. In a *Philadelphia Inquirer* article the band's drummer, Ahmir "?uestlove" Thompson, admitted that he loved his Philly studio and home so much that he was willing to

endure both the commute and sleep deprivation. Knuckles, a band member living in Landsdowne (a Philly suburb) with his wife and three children, declared his joy at leaving Manhattan every night and returning to home and family.[2]

Nose to the grindstone, head to the stars. That's the spirit that pervades JB's enterprises—her school, her company, her life: work your butt off, and keep your eyes on the prize. Another compelling line from "Sacrifice" says, "You need a heart that's filled with music; if you use it, you can fly." This, too, characterizes not only the music of Philly—be it bebop or hip-hop—but also its dance, whether the concert dance culture created and disseminated by JB or the grassroots styles that nurtured tap artists like LaVaughn Robinson and Germaine Ingram or hip-hop choreographer Rennie Harris. Needless to say, other locales share these characteristics, but each setting shapes them in site-specific ways. This chapter is about the unique cultural flavors produced in and spreading out from black Philadelphia.[3]

So here is my compass setting for navigating this chapter. I aim to get a handle on what constitutes a "Philadelphia aesthetic" in the concert dance legacy emerging from Philadanco and the city's black community—a product that has been exported far and wide to dance companies populated by former "Danco-ites," notably the Alvin Ailey American Dance Theater. I will examine the critics, the voices of the dancers and choreographers I interviewed for this project, and my own notes based on many years of observing the company in action. I focus on articles and reviews written in the 1990s, when the company made its New York City debut and its unique style and aesthetic became a marketable commodity. (The 1970s-early 1980s were its initiation; the late 1980s–1990s, the gelling of the Danco aesthetic. The new millennium is icing on the cake.) I interrogate the Philly Sound of Kenny Gamble and Leon Huff to ferret out musical consonances with the Philadanco dance aesthetic. I attempt to locate and delineate particular elements of this aesthetic, and I conclude the chapter by describing how continuity of style is maintained through a quasi-conservatory tradition, the choice of choreographers, and by the force of those "recycled people"—to again borrow Kim Bears Bailey's wonderful phrase—who return to the fold to carry the torch. Philadelphia is one of the main hubs of dance activity in the United States—along with New York, Chicago, and Los Angeles—and, like the Philly Sound, the Philadanco style is a standard setter beyond the regional borders of its mother city.

RENNIE'S RUMINATIONS: LAYING THE FOUNDATION

Master innovator in moving hip-hop dance from the streets to the concert stage, Rennie Harris is another dyed-in-the-wool Philadelphian. In my interview with

him, the force of the city's attitude —*ATTITUDE*— came across, with Harris delineating that characteristic as an energy that charges all the city's endeavors, including sports, the arts, and everyday lifestyles. He didn't say it, but a subtext in Harris's argument is what I just suggested: the fact that Philadelphia, much more than, say, New York, is a *black* city, or a black-and-white city, with black folk, talk, and life an overarching presence embracing the entire city and its populace. His astute observations set the stage for the propositions carried by this chapter.

Asked what was the first impression that came to mind when he thought of Philadanco, Harris responded with one word—Philly:

> Just Philly. You know, the embodiment of Philadelphia. And it's really strange 'cause even with the dancers that I work with now, even the generations past the original, they still embody this hard core, this groundedness within their movement that separates them from their peers who present dance [in a similar style]—like Ailey or Cleo [Parker Robinson's company].[4] *Completely different* stylistically from those—just a completely different beast.

Harris continues in this vein, getting closer to the heart of the difference and unique status of this company in relation to its birthplace and home. He helps us understand the significance of *place* in creating institutions, giving the city and this dance company the characteristics and personality attributable to a living, breathing human being:

> It could be the brand of training, it could be the brand of philosophy—work ethic, you know. And although it seems like it's the same brand of training and work ethic that a lot of people share, other companies share, it isn't. It's almost like this fiber woven into something other than just the training, where dancers are affected on personal levels, you know, either positive or negative. They're affected in another way than, let's say, Ailey.... It's like this little bit of something that's different in Philly. And I think it has to do with the energy of Philadelphia.

Elisa Monte echoed Harris's thoughts, characterizing Philadanco as having "the feeling of family, and a real coming from someplace. When you look at a bigger company it feels more transient, you don't really feel like the people were developed and nurtured from that place."

Like many others in the dance world, Harris uses the Alvin Ailey American Dance Theater as a frame of reference for talking about Philadanco. Actually, he has the authority to do so, having choreographed works for both ensembles. The fact that the Ailey ensemble was headed by a Philadelphian and, almost since its inception, has been populated by numerous former Philadanco dancers indicates a deep connection—not necessarily publicly acknowledged—between the two institutions. In 2010, Judith Jamison celebrated her twentieth anniversary as artistic director of the Ailey ensemble. I contend that the Philadanco-Philadelphia connection adds a certain accent—or twang—to the Ailey aesthetic. Since the 1970s, when Gary DeLoatch was one of the first of JB's dancers to move on to Ailey, the Danco dancers who have performed with that company brought with them the excellence and particular strengths garnered from their Philadelphia training and inflected the Ailey company with their special contributions. Deborah Manning St. Charles, with JB's blessing, left the company in 1981 to perform with Ailey, where she remained for thirteen years. The Philadanco reputation was already a byword among the company members, even before her arrival. In her words:

> They had heard about these kids from Philadelphia, that these kids dance *holes* through the floor. They wanted to know who we were. Gary DeLoatch was already there, and they'd ask him, "What is it with those Philly kids? They can do anything!" And Gary would say it was the Schuylkill punch![5]

Debora Chase-Hicks assumed the role of Philadanco's rehearsal director in 1992, a position she has held since then. Her comments about the Ailey experience echo Manning St. Charles's:

> We were always "the Philadelphia kids." I don't know if the Philly kids had an edge, but we had a reputation for being what we call "on it." For, whatever you ask them to do they were gonna do it. That was one thing we were really proud of—that we would do anything, we could do anything! And that reputation followed after we left. I'm not patting my own back, but the reality of it is that every Philadelphia dancer that has come after that has had the same reputation—that they could do anything; that they're moldable and pliable.

In fact, the debt owed to Danco by Ailey's ensemble was graciously acknowledged in 1985 by Alvin Ailey himself in the following "Tribute," which is

framed and hangs on a wall in the corridor of the Preston Street building along with the many other awards and honors accorded Danco and its founder over the years:

TRIBUTE

I want to take this opportunity on behalf of myself and the entire Ailey organization to congratulate Joan Myers Brown for her 25 years of dedication to the dance in Philadelphia—first as the founder and director of the Philadelphia School of Dance Arts and subsequently as founder and director of Philadanco—that young and dynamic company which has made such an explosive impact on the entire dance scene. For many years my own personal involvement with Philadelphia and its dance riches have been substantial and rewarding. Philadelphians Morton Winston, Matthew Cameron, Gene Hill Sagan, Judith Jamison and currently Gary DeLoatch have all enriched my company and its worldwide audiences with their Philadelphia-bred genius.

I am proud to have four former Philadanco members performing with us in this our first Philadelphia season in some time, and they are Kevin Brown, Debora Chase, Deborah Manning and David St. Charles, all of whom enrich our repertoire with their versatility, technical fire and unparalleled commitment to the art of dance. I am deeply grateful that such a vibrant and creative force, Joan Brown, has nurtured through her school and company these important talents which might otherwise have been lost. Thank you Joan—we are all in your debt.

Alvin Ailey

Unquestionably, and despite this affinity, the two companies have developed in different directions, with the New York ensemble becoming ever larger in size and more of a corporate-driven organization, for better or worse. According to Nadine Patterson, a Philadelphia-born-and-based videographer, "The spirit that they [Philadanco] bring to each piece is very, very different, whereas with Ailey, I feel like...you see the Ailey 'thing' in every piece they do.... With Danco, it's like an actor being a character as opposed to being a star."[6] Patterson's comments pinpoint an ensemble concept that JB has consciously developed, which is, itself, a definable ethos that characterizes her company and differentiates it from others. Before continuing with Rennie Harris's insights and the Philadelphia/Philadanco aesthetic, let's look at a decisive historical moment in contemporary pop music that relates to our topic.

THE PHILLY SOUND

"Mixing soft soul, gritty grooves, rhythms, strings and big band swing," while "spinning simple truths in complex times," is the website description of the "super deluxe 3 CD box set" reissue of Kenny Gamble and Leon Huff's greatest hits. The legendary duo met in the 1960s. With hits like "Me and Mrs. Jones," "Back Stabbers," "If You Don't Know Me By Now," "Love Train," and "T.S.O.P." ("The Sound of Philadelphia," which became the legendary theme song for the television show, *Soul Train*), they created what became known by the 1970s as the Philly Sound. In 1960 JB started her school and began laying down the principles of a dance aesthetic that moved her to create the Philadelphia Dance Company a decade later. Music and dance from the black side of Philadelphia: two independent streams of artistic creativity emanating from the same community, same culture, same city, same decades. There are other similarities in the visions and creations of Gamble/Huff and Joan Myers Brown.

Interviewed by Terry Gross on her National Public Radio program, "Fresh Air," Gamble described the Philly Sound as funky-classical: it could "get down," while simultaneously incorporating a fully orchestrated production using strings, oboes, and other symphonic instruments.[7] Back then, when public schools gave students the opportunity to study music, Gamble and Huff had both played in school marching bands and were exposed to the range of music "that makes up a fantastic orchestra," according to Huff. Like JB, their secondary public education was instrumental in their artistic development. For her, it was the exposure to ballet during and immediately after high school (through Mrs. Lingenfelder and Antony Tudor). The Gamble/Huff profile resonates with that described by many jazz musicians in the swing era (1930s–1940s), who learned to play music on borrowed instruments loaned out by their local schools in cities like Detroit, Washington DC, Kansas City, and Philadelphia.[8] Stories like these make us bemoan the loss of arts programs in public schools.

Inspired also by the generation directly preceding them, Gamble/Huff cited the Drifters as one of the first pop music groups in the 1950s to utilize strings and tympani, mentioning their hit, "There Goes My Baby," as one of the first fully orchestrated pop songs. Also influenced by such composers as Burt Bacharach, Hal David, (Jerry) Lieber, and (Mike) Stoller, this Philadelphia duo was able to create a unique new sound from a variety of sources. By 1971 they had founded Philadelphia International Records, the umbrella organization for the Philly Sound. Gamble/Huff's show business experiences can be equated with JB's years of hoofing and choreographing for people like Cab Calloway, Sammy Davis, Jr., and Pearl Bailey; creating her own special movement signature from

a variety of sources; and founding Philadanco in 1970. The commanding stage presence of her dance company parallels the staying power of Gamble/Huff's greatest hits. Both Gamble/Huff and JB showed an uncanny ability to know and shape what will please their audiences. For the music world and the dance world, these Philadelphians came up with a new product—their own brand of smooth but funky, sassy but classy art-cum-entertainment.

In 1999 Philadanco and Philadelphia International Records were united in *Tribute*, a dance celebrating both Philadelphia institutions choreographed by Dwight Rhoden to Gamble and Huff's music.[9]

Toward the end of the "Fresh Air" interview, Gross asks the team when and why their "glory days" ended. Gamble astutely explains that music styles evolve and devolve to other forms, especially after the meteoric success of a phenomenon like the Philly Sound. He sums up by saying they had "a good, almost twenty-year run. Strong run, you know," and he was relieved not to be obliged to continue the grueling schedule of putting out twelve to thirteen albums per year.[10] Here's where the Gamble/Huff and Joan Myers Brown stories diverge: modern dance companies don't have "hits." They may have one or two dances integrally associated with their ensemble, as is the case with Ailey's *Revelations* or Danco's *La Valse*. With some luck and a lot of hard work an ensemble might continue to have a shelf life even after the demise of its founder. (Again, the Ailey Company offers a case in point.) It is a testament to JB's dedication and perseverance that Philadanco has operated continuously over the past forty years and made the commitment, through thick and thin, to paying its dancers a year-round salary—one of the first and the few regional companies, black or white, to do so. All the while she continued to shape and refine the company's aesthetic. She took what she had learned in the commercial world of show business and put that knowledge to work in the service of training dancers and commissioning modern ballets for the concert stage. In doing so, she brought a new life and a unique Philadelphia twist and verve to the dance world.

The Gamble/Huff run was upended by the emergence of hip-hop. But here, again, a Philadelphia force was an essential ingredient in the evolution of a new musical form. In their own way, The Roots represent the millennial Philly Sound and, like Gamble/Huff, have a background in a diverse range of musical genres, as demonstrated by the selections they choose in their capacity as house band for the Jimmy Fallon Show. The Philly Sound was a music of lush orchestration wedded to a sensual sound created by musicians and composers trained in both grassroots African American genres—rhythm and blues, gospel, jazz—and European orchestral music. The same holds true

for the Philadanco dance aesthetic. It is a combination of a strong ballet and modern dance technique orchestrated by a "conductor" wielding an African American baton. It is professionalism and *attitude*, tempered by heart and soul or—to borrow *New York Times* dance reviewer Anna Kisselgoff's term—kinetic empathy.[11]

In the October 27, 1997, issue of the *Philadelphia Inquirer*, Bing Mark, a Philadelphia arts critic, wrote a glowing review of Philadanco's fall home season. Titled "Artful Choreography Adds Depth to Pop Tunes," the article described the concert as "a 100 percent performance from a company that makes them look routine." The concert itself was titled "In the Black Tradition" and included Talley Beatty's *Pretty Is Skin Deep, Ugly Is to the Bone* (1976), with music by Quincy Jones and Earth, Wind, and Fire; Milton Myers's[12] *Love 'N Pain* (1992), to seven songs interpreted by Aretha Franklin; and George Faison's *Suite Otis* (1971), to six Otis Redding songs. The program also included Jawole Willa Jo Zollar's *The Walkin, Talkin, Signifyin Blues Hips, Lowdown Throwdown* (1996). To wind up his comments, and reflective of his title, Mark concluded:

> The quick portraits of *Love 'N Pain* and *Suite Otis* show a complex understanding of how choreography can inflect popular music. After Philadanco teaches us how to listen, both to history and the three-minute pop song, we somehow understand both better.[13]

Like the Philly Sound of Gamble and Huff, JB and her Philadelphia Dance Company offer us a depth of experience and a new way of seeing. Let us say that Philadanco is the Philly Sound in motion, and, like the Gamble/Huff innovation, a gift from Philadelphia to worldwide arts and entertainments.

PART TWO
THE PHILADELPHIA/PHILADANCO DANCE AESTHETIC

Used as a noun, the word "aesthetic" is defined by the Oxford American Dictionary as "a set of principles of good taste and the appreciation of beauty." The aesthetic criteria I lay out in this section can also be considered the building blocks of what I call the "Philadelphia/Philadanco style." I could use the term "Philadelphia School" in the same sense that we talk about a New York or Paris school of painting. However, I believe the phrase "Philadelphia aesthetic" or "Philadanco aesthetic" most aptly conveys what I am attempting to

describe. A combination of elements defines this phenomenon and gives it a unique character. They are:

1. Philadelphia *attitude*
 a. Toughness
 b. Raw energy
 c. Work ethic
 d. Southern/small-town etiquette
2. Strong technical training, with ballet at the forefront
3. Ensemble emphasis
4. Rigorous professionalism
 a. Directness
 b. Precision
 c. Do-or-die dancing
 d. Work ethic, revisited
5. A show-biz élan on the concert stage
6. African American old-school elegance

It's important to realize that the components of the Philadanco aesthetic are interlocking principles that overlap and blend. I can talk about toughness, raw energy, rigorous professionalism, black elegance, and so on, as though they are separate entities—that must be done to tease out characteristics and to stimulate a discussion. However, the reality of how they play out in the dynamic realm of real life, flesh-and-blood experience is not as disembodied concepts but as embedded processes that are linked to one another, with no clear boundaries separating them. That said, and at the risk of waxing pedantic—or pedestrian—let's take a closer look at each of these characteristics.

1. *The Philadelphia Attitude.* Shared by the city as a whole, the first principle is this ineffable quality that I will try to pin down. I found, on moving here from Manhattan in 1982, that I heard the word "attitude" a lot more than I'd heard it in the Big Apple. It was often pronounced in a decidedly regional fashion that almost sounded French—as in "atty-tood," with the accent placed on the final syllable and the *t*'s in the first syllable clearly enunciated. So, already in its pronunciation and stress, the term took on a sound that stood in contrast to the pronunciation I was accustomed to. What became clear was that this quality called "attitude" was deemed important in the Philly worldview and was a characteristic shared by the city as a whole and, most certainly, by the city's African American communities. So, even though I deconstruct and define "attitude" specifically in relation to dance, it is a characteristic of the city itself.

Rennie Harris is somewhat of a sage when it comes to Philadelphia matters, and he offered further ruminations on the character of his native city, speculating on the Philadelphia toughness and energy/synergy as mother to the Philadanco personality and to Philadelphians' peculiar relationship to sports. And this is a city that is obsessed with its athletic teams.[14] Philadelphia's sports fans are known for being up there with the roughest and toughest, ready even to turn on their own teams when they're losing. (In the summer of 2010, listening to a Phillies baseball game on the radio, I heard the commentator refer to this spirit as "the blue-collar mentality that pervades this city.") Moving seamlessly among practical, philosophical, and mystical thought, Harris describes this intensity as a

> hard core dynamic.... In New York, you have these places where you can layer off and feel the energy and then go out and it's almost like you're not even in New York. But in Philly it's that same energy everywhere you go, geographically we have these vortexes, these little pockets of energy.... There's one over at the Art Museum, and another in the Northeast, this is the story I heard. So we get pinned with this sort of energy. And then there's the little park over by Fifth Street that is actually a cemetery, but they made it into a park; they didn't move the bodies. So you have that energy, too. It's an old city....
>
> This kind of energy kinda keeps us in Philadelphia, and people who come to Philadelphia get caught in it too. You may be from another place, but you come, you get engulfed with that. You begin to think that certain way. It's like a breeding ground for these artists who hone their craft in a way that is way beyond just getting started. The atmosphere itself challenges them to make sure they rise to a certain level. And this energy/synergy thing that Philadelphia has is a major reason why Danco is the way it is. So it makes sense to me that Danco is at the level that it is. Because it's hard core, too!
>
> Like, they say if you make it in New York: no—if you make it in *Philadelphia*, you have made it. You can make it anywhere!

He doesn't describe this constellation of elements as good, bad, better, or worse than the pulse of any other city—just different, just itself; and it's about a toughness, a relentless energy, and a strong work ethic. His observations and musings stand on their own strength, coming from a native son who cut his eyeteeth and sharpened his skills on the energies he talks about and the legacies that brought him this far.

Parsing its components, I begin with *toughness*. Here is an anecdote about Harris's behavior when he was a burgeoning hip-hop dancer in the 1980s. He described how he used to prepare for a performance or even just for an evening of hanging out (and going to a club or being seen in public is, of course, a level of performance, in and of itself). The picture he limns says volumes about urban electricity, toughness, resilience, putting on a good face—"faking it 'till you make it":

> Harris: When we were younger, you couldn't be caught dead talking about going performing if we weren't tight in our uniforms, weren't together, clean, and ironed. I used to iron my money and put starch on it. My mom used to be like, "Boy, why you using up my starch?!" I'd be on the third floor—S-s-s-t-s-s-s-h [ironing]!
> BDG: Ironing your *money*???
> Harris: Ironing my money so it could be, feel like it's new—came from the bank.
> BDG: How beautiful—how incredible!
> Harris: So, you know what I mean. That's what you did with your clothes, that's what you did with—Boom!

This is the attitude that says, "you bring the whole person to the performance moment, and every detail of your person is part of your presentation and potentially on display."

That toughness is evident in an electrifying piece that Harris choreographed for Philadanco. Titled *The Philadelphia Experiment*, this work explodes like gangbusters from one taut, pressed dance image to the next, pushing the dancers to embody their African-ness (as Harris put it, "we are Africans who happened, by Middle Passage, to be in America") by doing a demanding battery of hip-hop and social dance moves. The piece melds Harris's sense of the city with historical and contemporary events, some presented in taped voiceovers and visual projections—all filtered through the dancing bodies of the Danco ensemble. Thus, we hear the voice of Ramona Africa, one of the leaders and few survivors of MOVE, describing the holocaust that burned blocks of Philadelphia houses in a predominantly black neighborhood, including the MOVE house, killed most of its members, and destroyed their movement.[15] Photos of the U.S. Constitution are juxtaposed with ironic comments on the lack of freedom for African Americans, beginning with the words, "We the people of the United States are sick and tired of getting the run-around." Homeless black men bed down on the street next to newspaper kiosks. A voiceover repeats the chant, "Do you remember the days

of slavery?" as the dancers' movements become a stomping Africanesque chorus accompanied by more scenes of urban blight, including photos of prison inmates. Although it has been taken on tour, this dance will probably never be performed by any other company. It was created by a Philadelphian for a Philadelphia company to say something special about Philadelphia.

Harris talked about the *attitude* of the Danco dancers as they rehearsed this work made for the concert stage yet based on the hip-hop movement vocabulary. Although the dancers belong to a generation who grew up dancing this genre in social situations, having a hip-hop ballet choreographed specifically for them was a new experience. Harris's description of their reaction to this new-for-the-stage vocabulary again says a mouthful about this Philly toughness. He described the Danco experience in contrast to the Dayton Contemporary Dance Company (DCDC) and the Ailey ensemble. In those cases, his work was greeted with anticipation and enthusiasm:

> Any other company [is] like, "Hey, what's up, Yo, I'm excited about the blah, blah, blah, the dit dah. Oh, wow...." [But with Danco] I have to start from the gate, from the beginning, and say "This is what it is." And that's clearly a Philly thing—clearly it was a Philly company. I came in, and they had the Philly attitude—like "Yeah? So? So get on with it!" This is just Philly.

Unlike ensembles in other urban centers, the Danco dancers were not ready to take Harris on faith or trust, and, acting super cool and nonchalant, they sat on any expression of enthusiasm. He had to prove himself to them, when we might assume that, being a Philadelphian himself, it would be easy going for him. So toughness means just that: a tough attitude, a "prove yourself" and "take no prisoners" stance.

For another take on *toughness*, let us turn to JB's professional perspective:

> I try not to be as tough as I used to be because I know what it takes...for a black dancer. Going into an audition there are usually 500 dancers for one role. And if there are going to be 10 spots in a Broadway show or...a company, there may be only one spot for a black person. So the dancers really have to be tough and...ready to take on what comes. They have to be ready to do everything that's given out to them.[16]

This is an interesting conundrum, and part of being black in America—how to train our children to be tough, without replicating at home the toughness they are bound to experience in the white world. Because JB makes a point of teaching

her dancers about the black dancers of previous generations, on whose shoulders they stand, and about the history of discrimination and lack of opportunities for them, her insistence on toughness, precision, technical excellence, and so forth takes on a special urgency.

When I first began to think about *raw energy*, the next attribute in my deconstruction of the Philly *attitude*, I didn't realize why my mind jumped to Robert Farris Thompson, but it was actually intuition leading me to Thompson's concept of *ephebism*. Used in his *African Art in Motion*[17] to explain one of the ten "canons of fine form" he erects in his theory of African aesthetics, the term comes from the ancient Greek word *ephebe*, meaning youth. I use it, as Thompson does, to embrace a network of interfacing attributes associated with the brashness of growing up and the boldness of innocence. Ephebism implies vitality, flexibility, drive, attack, speed, sharpness, and force, if you will. It is the energy JB looks for when she auditions dancers. Moreover, it is trained into the Danco dancer and is one of her defining, distinguishing traits. What would be the closing number—the big, energetic finale—on any other dance program is the opener for a Philadanco program, and the energy just builds from there. When I asked choreographer Ron Brown[18] to relate his first impression when he thinks of Philadanco, he said, "Just this force of energy, just like [making a low, growling sound] pressing forward—just this force of energy. Kind of red." In terms of its energy, this choreographer finds the company is more hot than cool—kind of red, rather than a cool, Miles Davis *Kind of Blue*.[19]

Elisabeth Bell, a Danco dancer from 2004 to 2007 (she was living in Hamburg, Germany, and dancing in that city's production of *The Lion King* when I interviewed her in 2008), talked about this special Danco attribute:

> Danco has a rawness to it, and I think [it's] because JB's still at the helm and still can guide its artistic direction. And she's adamant. The fact that I could do four years of Danco, that I could do a Talley Beatty or a Milton Myers work and then go to Ron Brown—just to have this versatility with what I can do. And then to know—because I was also an asthmatic—to know that I could do four ballets in an evening! After this, I can't stand to be around dancers that complain [about a heavy schedule]. I mean, hard is always relative. Hard is always relative to where you are in time and what you're experiencing. But, I mean, the Danco rep was *hard*.

Bell is correct in attributing this quality to JB's steadfast leadership. And, indeed, ephebistic energy was the starting point for the company back in the 1970s, and

became its trademark and label. As noted earlier, it was a company of very young dancers, some still in their teens, who had energy to burn. Even in the millennial era the company radiates a youthful aura. "They [the dancers] usually range in age between twenty and thirty, and I really consider that a young company," says Zane Booker. "So their character," he continues,

> involves all of that that is used—their insecurity, their assuredness, the artistic level, the emphasis on technique, sometimes the over-nuance. It's a *grooming ground*. In a company [like Danco] that's smaller, the grooming process continues and continues.... Everybody has to be a soloist because it's such a small company, or at least you work to that level. Everybody has to step up to the plate.

Because Danco is not a company of twenty-five or thirty-five dancers with second casts, understudies, and members who know they are destined for a life in the corps and will never be soloists, Booker asserts that there is "a different dynamic."[20] That's what the "grooming process" is about and why it continues. And this dynamic keeps a vibrant, vital energy alive and a democratic sense that everyone can be a star as well as a member of the corps, because "we're all in it together." Booker's observations resonate with and touch on almost all the other Philadanco aesthetic principles: work ethic, strong technique, ensemble emphasis, rigorous professionalism.

Toughness and raw energy were remembered by Deborah Manning St. Charles who began dancing with the company in her early teens. She had this to say about her Philadelphia training—a testament to commitment and vitality:

> Danco *prepared* me to dance for Ailey. Because when we were first starting out there weren't that many performances. We *trained*! We trained like *horses—Clydesdales—*that's what we were! I mean, we trained! We had ballet on Monday, jazz on Tuesday, such-and-such on Wednesday—Dunham, Horton.[21] Sunday mornings we were here 10 o'clock in the morning till 10 o'clock at night. And we would rehearse, rehearse, rehearse, down to the fingertips. If it wasn't right, you had to repeat it.

Claiming that dancing with Ailey was easy compared to dancing with Philadanco, Debora Chase-Hicks shared memories that jibe with Bell's and Manning St. Charles's:

> I didn't dance as hard with the Ailey company, even though I was in every number by the time I was in my third year, because we'd only do

four pieces a night. [Back then] with Danco we did seven! We would do Talley [Beatty], Gene [Hill Sagan], Harold Pierson, Billy Wilson — and these pieces were *hard*. And most were full company pieces. In the Ailey Company you'd have your two leads and then you'd go in and out, in and out, so it wasn't as hard. Here [with Danco], you had to be "on it" all the time.

Taken together, toughness and raw energy say a lot about what is needed for the next principle, the Philadelphia/Philadanco *work ethic*. Harris's, Bell's, Chase-Hicks's, and Manning St. Charles's statements all testify to a strong commitment to getting the job done, regardless of what it takes. The company's work ethic will be further discussed in the section on *rigorous professionalism*. In terms of the city as a whole, when I moved to Philadelphia from Manhattan to assume a full-time teaching position at Temple University, I sensed a different kind of commitment to work. It wasn't that people didn't hang out or have fun; but after working hours the tenor of the downtown area (charmingly called "Center City") was subdued. Block upon block was quiet. The city is revved up during business hours, but only certain areas are lively after the evening rush hour. Although there is South Street (and Main Street in the Manayunk area of the city, and Fifty-Second Street in West Philly), there is no central area to compare with Times Square, no Upper East Side singles scene, no East or West Village night life. And there are row upon row of residential houses in every section of the city, which is how Philadelphia got the nicknames "city of homes" and "city of neighborhoods." Unlike New York or Chicago, where some areas keep jumping till the crack of dawn, this city sleeps! At the moments of my greatest homesickness after moving from New York's Greenwich Village to live in the city's Germantown area, Philadelphia felt like a workaday town. I began to get a whiff of the particular energy/synergy Harris talked about but sensed it was mainly channeled into work. I felt the striving, although I wasn't sure it was a struggle for the excellence he described. But it was a palpable presence, whether the work was artistic and creative, or manual, or bureaucratic. People seemed to take their positions soberly, whether they were in a profession, a vocation, a sinecure, or a temporary stopover—and whether they liked their jobs or not. (And frequently it was job dissatisfaction that accounted for the Philly "atty-tood.") There was an industriousness and a sense of resignation that were different from the headset in New York: Philadelphians honing their crafts, with nose to the grindstone and maybe head to the stars.

Geography may have something to do with it. Pennsylvania shares tri-state status with Delaware and Maryland. (My previous tri-state configuration was New York, New Jersey, and Connecticut—Yankee territory.) It's a mid-Atlantic

state, not really the Northeast. Indeed, in African American milieus, Philadelphia has been known as "up South" because of its adherence to "down South" traditions and also because of the state's strategic North-South location. And there is definitely a tinge of the next principle, *Southern and/or small-town etiquette*, in the manners and mores of the black community. Philly exudes provincial familiarity, couched in an urban setting. A good example: children and young adults in the black communities, as well as my daughter's Philly friends, insist on calling me Miss Brenda (or Mrs. Gottschild—which is how Rennie Harris still addresses me—or Dr. Brenda, or Dr. Gottschild), in contrast to the informal, first-name familiarity used by her friends and other young people in New York City. In what I characterize as Southern etiquette, these young people, raised "up North" but honoring the tradition, couldn't conceive of addressing me without preceding my given name with an honorific. Likewise, Joan Myers Brown is identified by almost everyone in black Philadelphia, young and old, as either "Aunt Joan," "Miss Joan," "Mrs. Brown," or sometimes "Mom."

The meaning of this etiquette goes further than simply how one is addressed. It's about a community caring for its members. *Eureka*—that's what separates New York's and Philly's black communities: Philadelphia functions like an amalgam of small southern towns, where the inhabitants know and look out for one another. This may be true for some of the city's white communities as well, I don't know. And it's true for lots of recent immigrant communities everywhere across the nation. Nevertheless, it's an inherited trait in the city's traditional African American community. "Guru" Rennie Harris declared that "from my community [growing up in North Philly], I'm used to the lady down the street saying to me, 'Oh, you have a talent show next week, so here's some money to help you out for uniforms, y'all go buy t-shirts.'" And JB lives, extends, and personifies this tradition. Harris continues:

> So Joan, Ms. Myers, you know, extended her hand out to me on so many levels, in so many ways. In a way she's been guardian angel'ing us, in a way I didn't even know.... She'd pull me in, and say [something like] "you know this is what I heard, just gonna let you know, and you need to get this together." Boom, boom, boom. Right. "If you need my so and so, you need my accountant, need my so and so, let us know...." And we sat down with Ms. Engrid [Engrid Bullock, Philadanco's Executive Administrative Assistant]: "Yeah, we'll let you know, but this is what we do." And there was nobody [else helping us out]—and no fault to any of the presenters in that way other than, just, again, it's a Western [read "white"] way of thinking, assuming that we know.

What Harris says goes back to that "down South/up South" etiquette thing of taking care of one's own as though we are all family, or strangers in a strange land. When one of us gets the hang of it, it's our duty to teach the rules of the game to our brothers and sisters. It takes a village to raise a child! This Afrocentric tradition of extended family has always been JB's guiding model, as evidenced by the way she runs her company and school. Harris recognized that and didn't even fault the (white) presenters who didn't help him when he was starting out. He simply attributed it to a "Western" way of doing things. It's also interesting that, in this part of the interview, Harris reverted to exactly what I described, addressing both JB and Bullock as "Ms." (or, as it is enunciated, "Mizz"). It is important to remember that, in the same way that JB took Harris under her wing, she'd been "angel'ed" by Marion Cuyjet who, in turn, had been guided by Essie Marie Dorsey. It's the tradition and legacy of the Philadelphia black community.

This completes the fundamentals of *Philadelphia Attitude* that are relevant to shaping the character of JB's school, ensemble, and aesthetic. Toughness, raw energy, a strong work ethic, and Southern-style etiquette are intrinsic to her artistic and administrative processes. Interacting with the Philadanco/PSDA principles that follow, they create the Philadanco aesthetic that undergirds JB's legacy.

2. Strong technical training, with ballet at the forefront, is the scaffolding upon which JB constructed her edifice. This training is the first step toward instilling the Philadelphia aesthetic in the Danco dancer. How to get there? Through toughness, raw energy, and a solid work ethic. JB's tastes were shaped by the ballet-inflected world that nurtured her. As detailed in earlier chapters, although tap, jazz, and African dance were in the curriculum at the schools where she studied and later taught, ballet was the strongest influence on her artistic development. Had the opportunity been available, she probably would have joined a ballet company, in spite of her relatively late start in learning the technique. As noted earlier, after studying with Virginia Lingenfelder, Antony Tudor, Karel Shook, and others, she carried what she'd learned into her own classrooms, and she still espouses ballet according to Tudor's methods. Following the conventional ballet company model, the Philadanco dancers are required to take company classes given at the school.

What is noteworthy is how few people know that JB not only studied with Tudor, but also that his passing on to her the Cecchetti legacy was a foundation of her artistic vision.[22] Moreover, this particular technique resonates (not in content, but in principle) with the artistic criteria that are basic components of the African American aesthetic and that are thus part of JB's heritage. How? Why? Because the Cecchetti technique emphasized expressiveness, musicality, virtuosity, precision, and strength—all of which are basic tenets of an African American arts tradition. It was serendipitous that a white Englishman was the teacher who came

to Philadelphia in the late 1940s and in the early 1950s and nurtured a uniquely talented group of black ballet hopefuls. A match was made that was instrumental in the formation of a school and a dance company of international repute. The popularity of the Cecchetti technique has waned, and the Philadanco/PSDA ballet classes today are taught in the style of the now popular Russian School.[23] Nevertheless, this little piece of Philadelphia dance history—essential to understanding the Philadanco aesthetic—has remained hidden for decades.

But the Danco training doesn't stop at ballet. Its dancers are versed in modern and jazz as well. In 1990, for their twentieth anniversary and their first season at the Joyce Theater in New York, *New York Times* critic Jennifer Dunning characterized them as moving with "the clarity and the pulled-up look of ballet dancers, the stretch and the direct emotional commitment of modern dancers and the sharp attack of jazz dancers."[24] Reviewing Danco's July 22–27 1996 Joyce season, the *Backstage* writer pointed out, in discussing Donald Byrd's *Everybody*, their "exceptional training in classical ballet. There are even two sets of breathtaking *adagios* which would do credit to any major ballet company."[25] And in 1998 during a tour in Bermuda, *The Royal Gazette* critic commented on the "strength and precision of this company's technical training that cares as much about line and epaulement as it does about the admittedly spectacular leg and foot work." In the same review, and hitting the nail on the head, the writer also praises Milton Myers's *Variation #1*, which she describes as "a thrilling spectacle in which the freedom of the jazz idiom is rooted in the discipline of classical technique."[26] This is one of the many reasons JB has engaged Myers as the company's resident choreographer: he knows how to use the company's strengths to best advantage, and he choreographs accordingly.

Zane Booker articulates a noteworthy component of the Danco technical brilliance, which he calls its "moving technique":

> You know, a contraction in Talley [Beatty] is not different from a contraction in a [Martha] Graham class. It has to be that deep. Now, the way we do it and the way we move is the other part of Danco, the energy that we can move across the stage with. The moving technique would be a signature for Philadanco. I don't know if that kind of energy and that kind of commitment and that kind of power is found in other companies. [We have it] because of what [we] choose to dance. If pieces like that are the bulk of our rep, then we become really good at doing pieces like that. And I think that's how the vocabulary or the tradition or the style is grown. These dancers use space in the most incredibly dynamic way.

What he's addressing is a subtle concept that dancers probably know about but are seldom required to articulate. An accomplished dancer must have the talent to move and articulate her body. On top of this, the adept dancer will have mastered the talent of also moving with and within the space, or actually *moving the space*, so that her dancing body makes the space dance in partnership with her. It is a dynamic relationship with the stage: the body not only makes shapes, but shapes the space—thus, the "moving technique." Booker's observations reinforce my assessment of Danco's rationale in maintaining a choreographer like Myers. He and Beatty represent, respectively, the new and old generations of dance makers whose deep understanding of this company enabled the dancers to grow and the choreographers to create some of their strongest works.

Does the dancer come to Philadanco with this acumen, or is the training responsible? JB seeks out dancers with this potential at company auditions, but that seed must be nurtured through *grooming*, to use Booker's word. Myers claims that Danco-ites are "strong, pure movers. And they have a fierceness about them. Some come in with it, but it's not fully developed. Hope [Boykin] came in and she had it, but it was developed in this company." Former company member Tracy Vogt laughed as she told the story of being spotted at a master class in a way that made her want to be in the company:

> Philadanco came to Erie, Pennsylvania, and I was at the Lake Erie Ballet School at the time. They taught a Dunham master class, and in the class Kim Bears-Bailey singled me out and made me go back [across the floor] by myself and said, "That's the way you should do it," and right then and there I knew that's where I needed to be!

When I asked why she thought she'd been singled out, Vogt gave a telling response. She claims, with a chuckle, "I had a little pizzazz; I'm a little spicier than most normal people! I had the energy and the passion. I just didn't have the technique yet." She'd been studying dance since she was two years old and was on scholarship at the ballet school in Erie, so Vogt certainly was not unskilled, technically speaking. She didn't have that special Danco technique, but that spark was a clue that it could be brought out of, or put into, her. According to Myers,

> Joan tends to pick dancers that can really see movement and interpret it. Because sometimes when we're having auditions, I may question, or I may see someone, and Joan doesn't see it the same way—or even Debbie [Debora Chase-Hicks]—and we see differently, but ultimately,

she's right. As we get to watch them, we know that she was right! But I think that the dancers in Danco are magnificent movers, and they don't tend to put on top of it what isn't there. They can put themselves in it, but they will reproduce what you've asked them to do in terms of movement.

What Myers describes is every choreographer's dream: that the dancers will do the movement the choreographer intended, in the way (s)he dreamed of it being accomplished.[27]

3. *Ensemble Emphasis*. When I interviewed her in May 1985, JB had this to say in response to the question, What makes a good dancer?

It's hard to pinpoint. There are so many things I like and demand. I guess *attitude* is the most important thing. They should have the *attitude* of wanting to give their all and being totally committed to what they're doing. I like a dancer with a good facility who is able to get along with her peers—no animosity and jealousy—a person who doesn't create problems in themselves and other people. I think the most important thing is dedication to their craft. They should have the *attitude* of wanting to give all and being totally committed to what they're doing. [My emphasis]

Her declaration is a manifesto of sorts, her mission statement for ensemble dancing, and it contains all the conditioning forces of the aesthetic described in this chapter: work ethic, rigorous professionalism, strong technique, and, most significantly, that intangible thing called attitude. It reminds us of Arthur Hall's statement in chapter 2 about the atmosphere of mutual artistic respect that Marion Cuyjet required of her students. When I found this statement, culled from those early interviews, I was impressed by the fact that JB cites craft—rather than art—as central. This, again, suggests the importance of having a strong work ethic. Do-or-die dancing, passion, and right attitude are the subject of her final sentence.

From its inception back in 1970, Philadanco has always included dancers who represented a range of human diversity. Be they tall or short, long-legged or grounded; stocky or slim; black, brown, or white, talented dancers have found a home in this company. And the extraordinary part is that, through strong training in technique and style, but without erasing their differences, these artists learn to move together: they look like and gel as an ensemble. The difference in the dancers' body types is what makes the ensemble emphasis

all the more remarkable. To have an ensemble—meaning a group of dancers able to perform effectively together in unison, rather than standing out as soloists—an artistic director or choreographer has traditionally looked for dancers who are similar: all the women about the same height, with similar line and proportions to their bodies, same skin color, and so on, so that they meld into one. Not so for the Philadelphia Dance Company. Danco's ensemble quality is based on unity of *purpose*, with the Danco aesthetic instilled in the dancers through rigorous training, company classes, and rehearsals, rehearsals, rehearsals. Danco is at once a star-studded company with no stars and an ensemble in which dancers retain their individuality. Each of its members can interchangeably perform a solo or dance in a trio, quintet, or unison line. The ensemble emphasis prepares them to do anything and everything. So, on a given evening, a dancer might have a solo or pas de deux in a Christopher Huggins choreography, followed by a minor role in a Rennie Harris piece, and also perform in two additional ballets on the same program. Dancers understudy each others' roles. (This happens in most small companies, partly out of necessity. Without enough dancers to have two separate full casts, everyone has to know all roles in case someone is injured and must be replaced.) When the company performed Donald Byrd's *Bamm* in Bermuda in 1998, the local reviewer commented that "the emphasis is on the electrifying discipline of the ensemble rather than on individual dancers."[28] In 1995 the *Village Voice* called Philadanco "a company of stars who don't act like stars—performers whose blazing physicality and commitment light up the stage."[29]

The company's choice of choreographers also supports the development of ensemble dancing. By their very nature, dances such as *The Philadelphia Experiment*, Huggins's *Enemy Behind the Gates*, Byrd's *Bamm*, and the full range of Myers's works for the company—in fact, almost all the dances commissioned by JB—support this ideal. For the June 20–25 1995 Joyce season, *Dance Magazine* commented that *The Walkin, Talkin, Signifyin Blues Hips, Sacred Hips, Lowdown Throwdown*—a specially choreographed version of Jawole Willa Jo Zollar's *Batty Moves*—"is amazingly lacking in ego. It provides the dancers with a context in which to strut their stuff and represent the complexity of women's lives."[30] And that's the point: what this ensemble has are performers with distinct personalities and talents who also have the ability to drop ego and work for the good of the whole dance and the whole cast. This is a quality that Danco can be proud of, and it's thanks to JB's perspicacity.

Kim Bears-Bailey eloquently recalls the communal, ensemble spirit that enveloped her as a young dancer, pointing out that the work of Gene Hill Sagan, Danco's first choreographer-in-residence, not just allowed but actually

"provoked trust. There was always the sense of something that had to connect you so strongly with the person that you were dancing with.... I got to really feel like I was a part of somebody else's soul, doing Gene's work." Talking about Donald Byrd's *Bamm*, she continued,

> When Donald Byrd came here, he did a collaborative work on Danco and Dayton [DCDC]. He based the type of choreography and the work that he did on each company by the energy and the essence that he got from each company. And if you look at the work, Danco's part is very connected. There's a trust factor there. They're throwing bodies; people are catching people. There's a lot of hands-on partnering stuff. There's this connective stuff he was inspired to do that was a sense of what he got from our dancers. When you look at Dayton's part, it was a bit more detached, not much of a trust factor. There was this, this window that he felt like he could go inside of with us that maybe wasn't as accessible from that company.

The trust and creativity Bears-Bailey describes are the result of ensemble building, an essential component in the aesthetic edifice constructed by Joan Myers Brown.

4. *Rigorous Professionalism*. Like *Philadelphia attitude*, this principle involves a battery of characteristics: directness; precision; do-or-die dancing; and, once again, work ethic. It goes without saying that any dance company worth its salt must be rigorously professional to survive. Dance is a field renowned for its hard taskmasters. Each ensemble takes on this responsibility in its own unique fashion, and professionalism grows and evolves with the development and continuity of the organization.

The principle of *directness* resonates with JB's demand for rigorous professionalism. In some surprising ways she is like the Zen masters who "push students to see how deep the desire for practice is, to see whether the student will climb back up on the cushion despite the rough treatment. Is the student seeking candy from the teacher or is she seeking the real thing?"[31] As Elisabeth Bell put it, "Her message could be harsh. In the end, I have to say she may not always be tactful, but she was always truthful." Bell uttered these words in loving tones, as though she were speaking of a family elder. And, in fact, she was—the most respected elder of her extended family. It is also remarkable how much her directness has been extolled by her dancers who work with her, who appreciate that she "tells it like it is," whereas other professionals in high places might beat around the bush, sometimes particularly in dealing with black dancers. Zane Booker also

appreciated her eye for detail, her specificity in directing choreographers to fix what needs fixing, and the clarity of her message:

> She appreciates all those things that go into the craft of choreography, and she can call you on it, you know what I mean? When I did one piece she said, "You know, they're not really doing that section well. It looks kind of out of place." And, really, it did. And every time I looked at it, there was this place where I was like—aaarrggghhhh! Her seeing the weakness in the piece made me have to fix it. So the standard of the piece came up, with just that one little note. She didn't go on about the whole piece.
>
> What's unique about Danco is that you know where you stand. And I love that! You're too fat? You're too fat! If you're dancing like a sissy, you're dancing like a sissy. If you're not getting your leg up, you're not getting your leg up. You know what I mean? You don't find it on the casting board; you know why you were out of the ballet. *It is not like that in the rest of the world. People are not that direct. Things happen, and they lie. I was much more neurotic and insecure out in the other space [namely, the white dance world]. Because how do you read people if they're lying?* [My emphasis]

Booker concluded by saying that this approach gave him a tenacity that he carries with him now. Although JB's strength and straightforward presentation of self may inspire the best in her dancers, it can also be intimidating. Her charismatic presence cannot be ignored. Tracy Vogt explained it to me this way:

> Vogt: You set Joan Myers Brown in the front of the room, and it changes the way you dance.... Something happens when she walks into the room. You're going to be able to do things you've never done before. Because she doesn't come in that often, so when she does, you know....
> BDG: Is it fear and trembling?
> Vogt: Yes, a little bit, yes. Because she's very direct, very honest, very forthright.

JB admits to this, drily commenting that

> [w]hen I teach, the kids get sick, they don't wanna dance. They just don't wanna be bothered with me. I go back to the pliés and relevés.

And if I'm going to rehearse them, I will say, "I want to feel it down to your fingertips—you all stopped at your wrist," you know, or "you stopped at your ankle." You know, there's that extra that we demand from them, not so much in classes as it is rehearsal and coaching.

JB's direct approach and the toughness and raw energy of the Philadelphia attitude combine to create resilience and a savvy born partly out of living in the shadow of the Big Apple, whose footprint is large and often overbearing. Philadelphia and its arts communities, both black and white, have developed their own strategies for maintaining balance and groundedness, despite the city's proximity to New York's gravitational pull. No need to dilly-dally in this city that's often regarded as an outpost of something bigger and more spectacular just seventy miles away. As Rennie Harris said, Philly's a tough city and, if you can make it here, you'll be able to make it anywhere. Harris feels that the city pushes artists "to the brink. They get pushed to wherever their top is gonna be. 'Cause you have to.... If not, you're not gonna make it with [by] being mediocre."

Like Booker, Harris talked about JB's targeted aesthetic in a way that shows his deep appreciation of her directness:

> She is very direct. There's nothing to fall back on. You don't get to contemplate and think about what she meant. You're fat, you need to lose some weight: that's it! Whatever the situation is. [He laughs heartily] In a sort of summer program she does [the annual summer dance camp], she pulled my whole class out, kids I had, and said "all of you go to the bathroom and put deodorant on!" You know, like there's no middle ground, and that's how I like it. That's what I respect about her and you can tell that [is the status quo] in Danco because it's not a lot of conversation. She's like "so and so"—boom—that's it. Feelings are hurt, and they pick up their feelings and keep going.... That's what's dope about Danco: it's a "knock-it-out-in-the-park" relationship.... That's what confirms them as dancers. The directness: "Let's get to the point. Why are you playing around? I don't got time for excuses. If you're here, do it or don't." As simple as that.
>
> Like, you know, when she said to me, she just said to me, "I want you to choreograph for my company. This is how much money I have. Can you do it?" Literally, just like that, as she was walking through the hallway with a toothpick in her mouth! And I said "Okay." Straight. It wasn't like, "let's talk."

And here is Ron Brown, speaking, like Harris, to JB's blunt directness combined with her "guardian angel'ing":

> The thing is, she is forthright. So she has told me, "I think you should send different videos to grant panels, because people think your work looks the same. And maybe it's because you're sending the same work all the time." Or she and Jeraldyne Blunden told me, "Well, I'm tired of being on [the board of] Dance USA, or I'm tired of being on this board, but someone [hinting at Brown] needs to be at the table." And so, in the field, that kind of making sure that I didn't retreat. So that kind of responsibility on the business professional tip—she has taken care of that.

Unlike a mega company such as the Alvin Ailey American Dance Theater, Philadanco can still negotiate on the grassroots level and produce jewels of choreography and performance via a hands-on business style, rather than a more corporate, less personal model. In these interactions with choreographers, JB actually combined her trademark directness with total artistic freedom for the dance makers. She wasn't tampering with Booker's conception, only pushing him to be better in one small section that could change and strengthen his dance. Her advice to Brown was, in essence, to diversify. And Harris said that, in creating *The Philadelphia Experience*, Brown left him alone, only occasionally dropping in to see the work in progress and make specific, limited comments (mainly about the music). Nevertheless, both Philadelphia choreographers cited JB's tendency to call attention to issues like a dancer's weight in a way that could be considered insensitive. For the female dancer— and they are the ones generally singled out—such comments can be devastating, despite the payoff of working with an internationally-acclaimed ensemble. In traditional dance culture based on the ballet ensemble model, the dancer learns to accept the aesthetic criteria established by artistic directors and choreographers. There is a strict pecking order, and the dancer is at the bottom rung. Similarly, in Philadanco there is no question as to who is in charge and maintaining the company aesthetic. The choreographers who have stuck and the dancers who stay on or return appreciate that, in the Danco ecology, there is no beating around the bush.

Next on my list of characteristic rigorous professionalism is *precision*, a word frequently used to describe Danco's impeccably on-point work. Turning again to the press, this word was used and quoted earlier in the section on strong

technical training. In another year and another context, the *Los Angeles Times* reviewer touched on what I'm getting at:

> You can think of them as the ultimate inexhaustible speed demons of modernism, but velocity and stamina are just the most obvious hallmarks of the dancers belonging to the 29-year-old, Philadelphia-based institution known as Philadanco. *Precision* is another, for even if they look permanently on overdrive, their onrush of dancing delivers the sharpest freeze-frames imaginable: *poses and movement accents of perfect clarity.*[32] [My emphasis]

In one of my interviews with her, JB said she knew from the start that her African American dancers would be judged more critically than their white counterparts, given the racial tenor of our great nation. Therefore, they'd have to be more than perfect, giving 150 percent just to be considered on a par with them. This is why JB rehearses her dancers like the Clydesdales that Manning St. Charles jokingly alluded to. She insists that her dancers are clear, direct, to the point or, in a word, precise. Of course this training applies to all her dancers, black and non-black. When I asked her what qualities she thinks contribute to creating the Philadanco aesthetic, she gave this example that illustrates the ideal of precision:

> I think a perfect example is that of Francisco Gella, a Filipino guy, and he was mainly a ballet dancer, a modern dancer. [He performed with Danco from 1999 to 2002.] The first thing he says is, "I'll never be able to dance that fast! I'm not going to be able to do that!" You know, so him spending time with us, and us nurturing him and working with him so that he was able to dance that fast and dance that well, because he probably stayed with us three and a half to four years. And so funny, now he's teaching someplace in California, and he sent me a flyer, and everything he says that he's teaching them how to, you know, move and how to relate to your audience, and all that stuff that we beat in him to death—he's calling it a new style of teaching!

Do-or-die dancing is another component of rigorous professionalism. In its twentieth-anniversary New York debut at the Joyce, the company was roundly praised by the critics. Among many insightful comments, Jennifer Dunning said, "But most of all, the performers dance as if possessed, and that sense of stimulation is infectious."[33] This quality is a function of all the others—toughness, raw energy,

strong technical training, ensemble emphasis, directness, precision—but it also encompasses something else: a love of movement. JB declares, "Everyone can kick and twirl now. I look for a magic, a sense that they love to dance—that they have a love affair with the audience—that catches my eye."[34] And that's the quality that inspired the phrase, "kinetic empathy," from Anna Kisselgoff at the *New York Times*. Expressing a similar sentiment, Merilyn Jackson, reviewing the company in the June 2, 2000, issue of the *Philadelphia Inquirer*, wrote, "To see dancers perform at this level at the end of a program is to know what professionalism and heart are." Again, they were at their "do-or-die" best, having already performed Walter Nicks's *Trance Atlantic*, Milton Myers's *Echoes*, David Brown's *Labess II*, and concluding with the dance to which she refers, Ronald K. Brown's *Gatekeepers*. This aura of heart—or love, or kinetic empathy—is where the buck stops for the Danco dancer. It is a tangible quotient in Danco concerts and a reflection of the expressive, emotive element prevalent in most forms of African and African American/Diasporan arts. Elisabeth Bell said that JB always reminded them what the bottom line was: "It's *you* on the stage!" Love, compassion, and *passion* are integral components of the Philadanco brand of dancing. Returning to Jennifer Dunning, in reviewing the company in 1999, she aptly characterized it as "known for its provocative modern-dance repertory and its do-or-die dancing" and credited it with combining "a fierce appetite for dance, an appreciation of dance history and a coolly knowing approach to movement."[35] Again, Dunning got it right: it is the work ethic tempered by heart and soul.

The company's strong *work ethic*, revisited here, is part and parcel of do-or-die dancing and a rigorous professional credo. The 1996 *Backstage* review mentioned earlier reinforces my claim and speaks to the on-target professionalism of this organization. The *Backstage* critic described Milton Myers's *Variation #1* as having "immediately established the discipline, incredible balance, impeccable form, and staying power of the Philadanco dancers."[36] Staying power—yes! Another critic, praising JB for cultivating "top-notch talent," quipped, "For this is 'The Little Company That Could,' always full of energy and self-determination."[37]

Elisabeth Bell addressed the work of being a Danco dancer, reminiscing about studying with Delores Browne (ballet), Pat Thomas (Graham technique), and Milton Myers (Horton technique) in the classes company members are required to take, reminding her of a conservatory as much as a professional performing ensemble: "It kind of reminded me of still being in training school. Monday is Horton. Tuesday is Graham based. And Wednesday is ballet. And not wearing 'junk.'" (Dancers frequently wear layers—leg warmers, ankle warmers, sweaters, sweatpants, and so on, to class to protect their muscles.

These layers hide the body and prevent teachers from seeing if the dancer is correctly articulating the movement.) She continued, confirming that the Danco instructors wanted "to be able to see your body...and that was the big thing, just having a truly regimented work ethic so that we could get the end results [we wanted]." She also mentioned how important it is to take classes so that the dancer's technique is tight and injuries, always a hazard, are kept to a minimum. The stronger one's technique and the more she refines it by taking class as a daily practice, the less likely she is to suffer injury or, at least, the more likely to fully recover.

JB demands the same *work ethic* from her teachers and explains, "I'm not interested in teachers who say, 'I wanna show you what I know. I'm gonna give you a class.' I bring teachers in who are gonna *teach* dance." As Bears-Bailey claimed, "[The Danco instructors] are people who understand the essence and the beauty of what makes Philadanco what it is. It's not somebody just coming in to give a class." And that same cadre of teachers has remained. They include thirty-year veterans Pat Thomas and Delores Browne and Myers, who has taught the company since 1986. Moreover, this continuity-based teaching tradition pervades PSDA as well. Manning St. Charles, after her dancing as a student at Dance Arts from the age of three and pursuing performing careers in Danco and Ailey, returned to Philly and has taught ballet and Dunham technique at Dance Arts for the past fifteen years. She declared that "I give my same Dunham class—I give it the same way Harold Pierson gave it to us on Sunday mornings."

Sometimes it meant putting in extra time, as Bell recalled. This dancer goes on to explain that, in order to learn her parts, she was obliged to work out dance passages in her living room, in the house where she was babysitting (her second job), or, occasionally, in the Danco studios. "That whole dedication of doing your homework and doing the extra, I know that JB definitely respected the dancers that she could see did their homework, and she definitely made it clear that she was disappointed when she felt that you were not." Likewise, JB talked about encouraging dancers to "come in on your own and get in the mirror and spend time on yourself. Take that video or ask someone to come in with you, and even if they teach 'em wrong, we can correct it. But at least they're working on it."

Excerpts from a 1993 *Village Voice* review by Joseph H. Mazo work to sum up this section; his words imply all the elements I've attributed to *rigorous professionalism*: directness, precision, do-or-die dancing, and a strong work ethic[38]:

> When teaching company class at the New York City Ballet, George Balanchine used to tell the dancers, "Do it as if you were going to die

the next moment": In other words, hold nothing back. That's the way the Philadanco dancers perform.

Their energy is intense, but it's never diffused. You can see the shape of every step, the full stretch of an arm or a leg, the precise sculptural value of each position a dancer passes through.

He continues to extol the dancers, saying

Most of the dance, though, is exuberant [referring to Talley Beatty's *Morning Songs*]. Legs scissor open as dancers flash past, their bodies square with the front of the stage; flexed feet threaten the ceiling at the end of swift, high extensions; the performers travel as if propelled by an explosive force.

What makes this all the more remarkable is that nothing slops into a blur. We see every moment clearly—a tribute both to Beatty's skill in measuring out rhythms and to the dancers' astonishing physical control. The energy and inventiveness of Mingus' jazz finds its equivalent in Beatty's choreography.

5. *A show business élan on the concert stage.* We could actually include this principle as part of Philadanco's rigorous professionalism, but I've chosen to tease it out as a separate strand. This aspect of the Danco aesthetic has been praised but also criticized as too commercial. There are those in our profession who draw a line between so-called art and so-called entertainment and rue the day that the latter took its place on the concert stage, a space they feel should be reserved for "high art." But here is Joan Myers Brown, who began her professional career as a ballerina, moved on to become a show dancer and choreographer, and then established a dance academy and a modern dance company. It makes sense that she would bring all these talents to bear in the repertory she chooses for her company. In her fifteen-plus years of touring with, performing in, and choreographing for top-drawer show business revues, she acquired crucial skills involved in putting together an evening's entertainment. What she knew about how to package a revue was now channeled into how to program an evening of concert dance, with evenings frequently orchestrated around themes such as "On the Shoulders of the Ancestors" (2000), "Movers and Shakers" (2008), and "New Faces" (2009), for example. Make no mistake: her savvy in pleasing the audience is always grounded in solid values and high standards. Interviewed in 1995 by Christopher Reardon, she said of her company's performance style, "It's not a wild energy. We're a company of well-trained, highly skilled dancers. We also

happen to be very exciting."[39] She makes it clear that the company profile she has established is a conscious choice:

> I go to a lot of dance concerts and a lot of them are boring. I don't like dance where you have to try to figure out what's going on.... I think you should enjoy dance. You should enjoy movement. I like my dancers to make the audience feel good when they leave... so that people can enjoy, and just feel that it's something good they've been a part of. Critics don't often agree with me, but my audiences feel that way.[40]

This is the voice of one who knows her public and knows the public has the final say in the life or death of an arts organization like Philadanco. Although she gives choreographers free artistic rein in creating works for her dancers, JB has been known to argue against their costume wishes in favor of adding more glamour or color. Ronald K. Brown wanted simple beige camp shirts and twill pants as the costumes for his magnificent work, *Gatekeepers*. This was not JB's vision and became a sticking point between them, although they finally reached some middle ground. (The costumes remained beige but were fashioned into more attractive, "dancerly" versions of the shirts and pants.) Similarly, when the Jawole Willa Jo Zollar version of her *Batty Moves* was reconceived for Danco as *The Walkin, Talkin, Signifying Blues Hips, Sacred Hips, Lowdown Throwdown*, the two versions were as different as the two titles. *Batty Moves*, on Zollar's Urban Bush Women (UBW), is danced in black spandex running shorts and matching tank tops, with white UBW tee-shirts tied around the dancers' buttocks: this is postmodernism, straight-up and to the point. The Danco costumes are an array of brightly colored shorts, tight-fitting pants, and midriff-baring tops, with each dancer in this all-female work wearing a uniquely individualized, tantalizing costume. This is show biz meets postmodernism! Nonetheless, Zollar extolled the way JB respects the choreographers whom she entrusts to set dances on her ensemble. In our 2009 interview she said,

> I think her commitment to artists over the long haul is something that you don't see very often anymore. Generally, if you're "hot," then, you know, people are interested in you, and when you fall down, then it's like — onto the next. And that's not Joan. She's *incredibly* — she has an incredibly long view of the artist's career and she knows that sometimes you *will* fall down. She knows that sometimes you're going to do work that's *not* interesting, and she knows that sometimes she's going to invest money and not get a product that's really tourable — and she doesn't storm away

angry or like, "I'm never going to work [with you again]." She really, *really* invests in your career—and that, I think, is unsung about her.

JB ensures her audiences a feast for the eyes, not only in her choreographic choices, but also in the flash, style, and color of the costumes. Sometimes the colors seem chosen purposefully to highlight the beauty of different shades of black skin against bright fabric. A vibrant red outfit may often be the hue chosen for the darkest-skinned dancer. In Gene Hill Sagan's *Ritornello*, all the dancers wear bright red costumes; in Christopher Huggins's[41] *Bolero*, all the women wear red. These choices must be understood in the larger context of an African American élan that emanates from Africanist (meaning African and African American) principles of beauty and a standard of excellence that may seem larger than life when compared to art and concert dance based on Euro- and Euro-American— Europeanist—aesthetics. Moreover, many critics acknowledge, even celebrate, Danco's élan and seem to understand that, if dance as a concert art form is to remain alive and well, it must be open to new influences from a variety of cultural streams, including popular entertainments and world cultures.

To quote Jennifer Dunning again (the *New York Times* 1990 review), she declares that "Philadanco breezed into town like a fresh spring wind."[42] Christopher Reardon, in 1996, characterized the company as having "a reputation for surprising an audience with their energy and grace," and praised the company for its "exhilarating elegance" and the "resilience of its esthetic."[43] For Deborah Jowitt, the dancers in Talley Beatty's *Pretty Is Skin Deep, Ugly Is to the Bone* "streak, explode, and emit sparks like fireworks."[44] Words like skillful, sizzling, energetic, exhilarating, powerful, entertaining, and even gorgeous are the adjectives reached for by many critics, sometimes as put-downs but more frequently as commendations. One critic in Tennessee opened her September 1999 review with these comments, which are a tribute to both professionalism and élan:

> The Philadelphia Dance Company, better known as "Philadanco," danced at the Clarence Brown Theatre Thursday night for what seemed like all of 15 minutes. The dancers in this company made time become irrelevant—if only for a few hours—with their precise form, unmeasurable energy and ability to flat jam. The company hit extremes in virtually every way possible but still managed to keep some sense of focus.[45]

6. To conclude this section on the Philadanco aesthetic, a word about *African American elegance*, what I mean by that phrase and how it plays out in the Danco

worldview. This element must be taken together with the *Southern/small-town etiquette* that was mentioned earlier as a component of Philadelphia *attitude*. It's an Africanist principle that manifests itself across the African diaspora, in the way people of African lineage take pride in and pay attention to grooming (hair, face, nails), dress, and bodily carriage (in posture that is not too loose, not too rigid, but *cool*).[46] So much of this elegance has inflected our American culture that we forget its origins. And we see manifestations of it in, for example, the flamboyant hat worn by Aretha Franklin to sing "My Country 'Tis of Thee" at President Obama's inauguration ceremony in 2009. Indeed, wearing highly styled hats, head wraps, or hair-dos is a staple in African and African American cultures. Here in the United States, this is a culture that, when afforded the means, creates and embraces the most avant-garde trends in haute couture, with a decided fancy for feathers, fur, and other finery. Furthermore, many African Americans continue to dress up formally and meticulously for church, whereas many white churchgoers dress down on Sunday mornings to show how down-to-earth religion can be. Adhering to a principle of elegance involves a reverence for and honors the ritual of dressing up, cosmetic adornment of the body, and the staging and design of ceremonial spaces, be they interior or exterior. This ideal, then, is part of the Danco élan and hearkens back to traditional African values, and the uniqueness and creative innovation of individual elegance is integral to this ideal. Several critics tapped into this quality and mentioned the individual beauty of Danco dancers. Theirs is an elegance that defies Eurocentric stereotypes and mainstream standards. As Tobi Tobias said, referring to Philadanco and also to the Dayton Contemporary Dance Company, the Dallas Black Dance Theatre, the Cleo Parker Robinson Dance, and the Lula Washington Dance Theatre, "The dancers...share superb technical and emotive power as well as a confident sense of self, their human individuality not having been trained or rehearsed out of them....each performer presents himself as *uniquely* gorgeous." [Tobias's emphasis][47] I quote her because the principle of African American elegance suggests being in possession of one's own sense of beauty.

In that regard—possessing one's own sense of beauty—a curious situation developed when the film, *Beloved*, was on location in Philadelphia. Danco had been hired to be in the Ring Shout scene that depicts a ritual ceremony danced by African Americans in a clearing in the woods. It was after they were contracted and already on the set that JB pulled out, though all her dancers took advantage of the opportunity. In her words,

> I quit the first day. Because, you know, the makeup: they made you up to look like a slave, right? They put black stuff on your teeth, and you

wore wigs and dirty clothes and then had to go down in this hole and dance, and I'm like, "I'm not doing that." And I stood up on the edge and all the dancers looked up at me and said, "What's wrong with JB?" I started making a joke of it. I said, "Uh-uh, I was massa's favorite, I lived in the big house, I wasn't in the field!"

And the next day Dianne McIntyre, the choreographer, said "Well, Joan, I've already got your place," so I sent Karen Pendergrass in my place because she could wear my costume. I just did not want to do that. I didn't want to go down in that dirty hole and dance and jump around. Not that I felt that it was beneath me, but I just didn't want to do that. And the kids made a lot of money; they still get checks from *Beloved*. I probably wouldn't have felt that bad if we were dancing. But to get down in that dirty hole and stomp in the dirt: I didn't want to do that.

[I pointed out something she obviously knew: that, in fact, stomping in a dirty hole was a form of dance, to which she replied:]

It was maybe the same thing I felt when I went to Nadia Chilkovsky and she was like, "Pretend you're running through a field and the water's falling," and I'm like, "Well, what happened to *pas de bourrée*?" So maybe that's something that's just in me, you know.

I think that "something" is JB's allegiance to a particular aesthetic, a traditionalist's standard of beauty and African American elegance, which her indomitable spirit refuses to surrender, even for the aesthetic vision of other talented, renowned artists like McIntyre. JB was not and is not ready to abdicate her self-possession and sense of agency and mastery to any ideal—not even to dance. The choreography and mode of dancing she chooses for her ensemble always retain, maintain, and celebrate a specific tradition and standard of black elegance, uplift, and beauty. Though different from the dance genre called for in *Beloved*, her aesthetic choices are consonant with Thompson's Canons of Fine Form[48] and visible in a range of work that is both cool and hot; that inspires (and embodies) call-and-response; that demonstrates a spirit of ephebism, looking smart, dancing many drums, and all the rest. Although she wouldn't prevent her dancers from experiencing other aesthetic premises, despite her personal choice not to take part in the scene, she couldn't make herself cede those principles—even when big bucks were at stake. And she risks seeming rigid and "old school" rather than include in the Philadanco repertory dances that sacrifice her standard. To be clear, in no way did McIntyre and the dancers devalue themselves in this process: it was a matter of different aesthetic principles at work.

Winding up, I give Tobias the last word, quoting again from her review of Philadanco's Joyce season July 22–27, 1996:

> Philadanco's current performers leaven formidable technique—in a mixed idiom of ballet, modern, jazz, and African dance—with unique stage personalities that reflect their rich racial mix and anatomical variety. Like the irrepressible members of a troupe far less sophisticated in experience, they exude joy in being on stage, showing off, entertaining and moving their audience.[49]

PART THREE
EMBODYING THE AESTHETIC AND ISSUES OF CONTINUITY

To gain a sense of the ecology of this community, I asked interviewees what it takes to instill the Danco style, to get a dancer to look like/become a Danco dancer. Many company roles overlap—thus the concept of "recycled people." For example—and to recapitulate—Debora Chase-Hicks began as a student at PSDA for several years before joining the training program, then advanced to the company proper, then left to dance with the Ailey ensemble, and subsequently returned to Danco to serve as rehearsal mistress. Milton Myers is both company choreographer-in-residence and company teacher. Zane Booker was a Dance Arts student, then a Philadanco apprentice, then a full company member; after dancing stateside and with companies abroad (Monaco and the Netherlands), he's resettled in Philadelphia and is a choreographer and guest artist with the company. And the list goes on. The volume and quality of Philadanco's returning artists is a unique indicator of continuity, commitment, and stability. Though it doesn't have all the trappings of a full-fledged fine arts institute—a conservatory—there is a quasi-conservatory approach to the way the dance company is schooled and trained. This approach, upheld as tried and true by those returning Danco-ites, ensures continuity of style and acts as a shelter for maintaining the integrity of the Philadanco aesthetic.[50]

Continuity: The Studio-as-Conservatory Approach

The Philadanco style is closely linked to a ballet standard of excellence and is reinforced by a strong work ethic, including, as noted earlier, the requirement that the company members take (company) classes, regardless of the number or genre of additional classes they may have taken elsewhere. Moreover, dating

back to the legacy of the 1940s and 1950s (chapter 2), there are many opportunities for JB's school students and junior companies (D/2 and D/3) to perform in the community, ensuring that the tradition and aesthetic are not only preserved and passed on in class but also practiced and refined in performance. Likewise, passion, compassion, friendship, and the Africanist principle of extended family reinforce continuity. As noted earlier, many of my interviewees used the word "family" to describe their experience of Philadanco. Tracy Vogt mentions another salient characteristic, calling it a woman-centered environment:

> I think the greatest thing about Danco is the *energy* of Philadanco, and I think it comes from Miss Brown, you know, the passion she has for this, and having Debora Chase-Hicks as rehearsal director...and just the women that are around, Deborah Manning—you're walking around and you see such *history*. These are the people that were my idols, you know, and now I'm in rehearsal with them!

On a structural level, JB's dance philosophy shares similarities with a ballet school-cum-performing-ensemble model as well as with the more Afrocentric Katherine Dunham educational approach, in which the whole person is to be groomed for both the stage and everyday life. With a lifetime of experience as a triple threat—a woman, a dancer, and an African American—JB understood that her dancers needed to be self-sufficient and willing to "work harder than you ever thought you were going to work in your life, and be okay about that," in Chase-Hicks's words. Like black people in the general population, black dancers are too often scrutinized and measured up in ways that reflect the ethnocentricities and racial prejudices of white people. JB's way of dealing with this situation is to ensure that her dancers are trained to a tee for their onstage appearance and decorously dressed, polite, and well spoken for their self-presentation in everyday life. They are also trained in stagecraft. Chase-Hicks explained that dancers are assigned to oversee costumes, be responsible for the music, or help with the lights. Here is where the exigencies of a tight budget can result in dancers learning valuable backstage aspects of their art form. Ironically, this is also one of the ways that continuity is maintained. By dancers assuming non-dance roles, the company can keep running, even in years when bookings are fewer or funding is less.

Besides his role as choreographer in residence, Milton Myers teaches company classes and leads auditions. His is a bird's eye view of the company, and he has developed a talent for listening and responding to the needs of the dancers and the organization. Looking for clues to understand how the company style is

instilled and the standard maintained, I asked him to discuss the way company classes were conducted. Here's what he said:

> The company classes that I teach are geared for what they have to do. I could teach them Horton studies. I could teach them the technique. I find that I can use the technique, but it's important that I see who they are as artists and that I continue to develop that, and not handle them as students. The training program is a bit more academic: it is the technique, it is developing, it is getting them to a certain strength, and sometimes I will say to the company members, "We're working on this study and this study. If you want to come learn this, come on in."

It is noteworthy that Myers makes this distinction. Even though company members are youthful, he is careful to treat them as professionals. Though Philadanco may feel like a conservatory because its dancers are required to take classes, it is different because the classes are not standardized but contoured to meet the dancers' needs for professional development. This is another reason the classes are requisite: they are work sessions that deal specifically with what's going on with the dancers at that point in time, and they ensure that a particular style and standard, which might be slipping, are secured. Essentially, company classes differ from but are a companion to the rehearsal process. Myers continues:

> Sometimes, and depending on what they're doing, if they're not touring so much, I'll say, "Okay, study time. We need to learn this study. We need to develop this. We need to build some strength. Joan's feeling like you're not performing as much. She wants you stronger." So I have to develop things to keep them at a certain level. If they're performing and rehearsing a great deal, it's maintenance and making sure that body is ready to do whatever Debbie Chase or Ms. Bears wants them to do. So I think that handling them as professionals is very important.

He makes it clear to them that they must

> take this class at a very high level, as professionals, not as students. And when they rehearse, they [Chase-Hicks and Bears-Bailey] like to keep it at a very high standard. There's very little time for marking unless they're exhausted. *Things really have to be danced full out, so that they can see what they're doing, so that they can take it further. Also, the endurance level—again, there's that fierceness. They're rehearsed at such a state that to do three*

ballets is not difficult for them. These dancers are in everything and they're dancing at top level. [My emphasis]

One might question whether such a regimen strengthens dancer stamina or leads to early burn-out. Comments by Bell and Chase-Hicks point to the stamina theory, but differences in anatomy, prior training, and personal aspirations can produce a range of responses to any particular training technique. Frankly, like other contemporary dancers, the Danco-ites experience their share of injuries. Despite the company's continuity of training and intent, other influences — new alternative techniques, what a dancer learns taking extra classes with different teachers or doing additional performances with other artists outside the Danco schedule, and outside part-time employment — compete with the Danco vision and focus, and stress and injury are sometimes the result. As Zane Booker pointed out earlier, the Danco training for strength and stability is often resisted by the millennial dancer, despite the possibility of reducing injury by adhering to this regimen.

Hope Boykin danced with Philadanco from 1994 to 2000. In 2009 she celebrated her ninth season with the Ailey ensemble. Like Elisabeth Bell, she talked about the class dress code and the rule of not masking the dancing body with extra pieces of warm-up apparel. As we continued talking about company dynamics she told this story:

> I remember once I had a note on my dressing room table and it said, "Why aren't your costumes hung? Why isn't your make-up table neat and clean? Because when you leave here it should look how it looked when you got here." I didn't think anything about it — I was going to put them back on, you know, so why did it matter? Well, that's not the point! And so now I carry these "Wet Ones" and I go into a place and I clean it before and again when I leave. It's just the, you know, it's the home training.

The note was from JB. It didn't need her signature. It was clear who would be checking, even in the dressing rooms, to make sure a certain protocol was observed. (And JB's large, bold handwriting is unmistakable. Like its author, it is clear, precise, direct.) It is reminiscent of Deborah Manning St. Charles's comment in chapter 3 about the tips on personal toilette offered by Delores Browne. This backstage attitude of keeping things precise and in focus spills over into the dancer's onstage mien and attitude.

In response to my question about the process of becoming a Danco dancer, Boykin emphatically replied that repetition was a key, which sounds a lot like

Manning St. Charles's comment about rehearsing, rehearsing, rehearsing. Boykin specified, though, that it wasn't simply how often something was done but the *quality* of the repetition. This implies that the dancers must have a quick muscle memory for incorporating corrections. It reminds me of a company audition I observed. In attendance at the January 11, 2009, auditions for Philadanco, D/2, and the Training Program (which accommodates promising young dancers who are not accepted in D/2, the second company), I witnessed the Danco aesthetic in action.[51] The entire event was a micro view of what it takes to be a Danco dancer. Here are my notes:

> January 11, 2009: Philadanco auditions are regularly held on the second Sunday in January and June. Today Milton Myers teaches the first part of the audition class for D/2 and the Training Program. His is a gentle, smiling approach. He goes over a long, 24-count combination—a beautiful one, yet not too complex for the abilities of this group of twelve auditionees, four of whom are white females. He's giving them Horton technique. Donald Lunsford, Director of D/2, is in attendance. Myers speaks lovingly, yet with authority. He seems to desire to get the best from them—indeed, to "e-ducare," as in the Latin root for "educate": to bring forth what is already there. This will be an experience they will remember.
>
> While the audition proceeds in the company's big second-floor studio, the Eagles/Giants football game is playing on the television set down the hall in the kitchen, with the sound turned off. This reminds me of Rennie Harris's comments about Philly and sports and that connection with the city's ethos. JB's youngest daughter, Marlisa Brown-Swint, who is second in command in running the PSDA, is a big Eagles fan.
>
> Fast forward to the main company audition: JB's not in attendance, so the auditionees will be required to return on callback, since the final decisions are up to her. But Myers and Chase-Hicks will make their recommendations. This section opens with Myers giving a Horton technique warm-up, known by the Danco company members who form the front line of the audition. (Both sections of the audition included company members dancing in front, so that auditionees had models to follow.) This time it's four male company members and Tracy Vogt, whose knowledge of the technique and the sequence is impeccable. There are eleven auditionees, all African-American, nine men and two women. Danco needs only two more men, although it's always good to have a catalog of competent back-up dancers in case of injury

or other emergency. (Two men in the current roster will move on when their contracts are up.) Right now the company roster is seven men and seven women. Sometimes it's been nine and nine. One of the women auditionees was a former D/2 member, left about two years ago, and is returning with hopes of joining the main ensemble.

The Danco members are dancing fully, really taking this as a class. It's interesting that in this section of the audition no one asked any questions. They picked up the movements from Myers's instructions and the ensemble's demonstrations with what I would call amazing speed. Everyone seems well prepared. And it's probable that some of these people have taken company classes before, like the former D/2 member.

Now, things are heating up for the second half, which Chase-Hicks videotapes [so that JB and others can review. Taping is a regular practice at all company rehearsals and is a general procedure in the dance world]. There are eight men left. The two women and one man were eliminated. Chase-Hicks takes over for this section, urging on the auditionees, giving a rehearsal director's corrections, and expecting them to internalize and externalize her comments, as in, "I said, 'contract'! Use your back! I said 'attitude and plié'! I want to see my corrections used!" Meanwhile, company members are manning the camera, giving counts, demonstrating movement phrases, operating the CD machine, and being present, in every sense. In most cases, before anyone can ask questions, they are answered by Chase-Hicks's corrections.

They are dancing a very fast, intense section from Myers's *Echoes*. Chase-Hicks then directs them not to let her comments throw them. Even if they make a mistake, she wants to see that they can take and absorb her corrections and keep going. They practice and do and re-do this combination for a good fifteen minutes. Company member Jay Staten shows them the combination while Vogt corrects Staten's counts from the sidelines. The auditionees practice first with company members, then perform it all in a group, then in two groups, then two-by-two. In other words, the audition gives the dancers many opportunities to learn the combination and multiple occasions for the "judges" to see not only how they dance but how well they're able to comprehend and manifest corrections. Again, Chase-Hicks tells them, "Don't get thrown. Now, put on a different costume, a different attitude, a different character: this is a section from a different ballet." And what follows is a section from Christopher Huggins's ballet, *Blue*.

By now, the entire room—ensemble members, auditionees, teachers, pianist, and guest (me!)—is grooving with the spirit of "The Dance": tapping a foot or patting a thigh, moving head or body to the emphatic beat of Steve Reich's percussive score. Again, Chase-Hicks warns auditionees to don a new costume and mood in preparation for a new role. They are taught a section of Gene Hill Sagan's *Ritornello*, to music by Bach. It's eye-opening to see these dancers being put through the kinds of paces and changes that they'd have to go through in any one Danco concert. Once more, they are given multiple opportunities to learn it, to pull it together. She is requiring them to go deeply into the movements. Having them dance with ensemble members and at times pairing an auditionee with a particular Danco dancer helps her see how the auditionee's dynamic and thrust feel and fit in the company mix.

Much of my description may obtain at auditions for other concert dance groups, but there are several noteworthy differences. First, the extent and variety of the repertory is remarkable. As Chase-Hicks put it, "a Danco dancer is separated by the repertory that they can handle." Next, the highly professional atmosphere at 9 North Preston Street is punctuated by homespun quirks—like the kitchen down the hall, with JB's grandkids eating lunch while the Eagles game flickers silently onscreen—imparting to the occasion the ambience of a visit to a friend's home, rather than the tension associated with a professional audition. This aura was amplified by Myers's easygoing attitude. Throughout the afternoon—and like everything else at Danco and the school—the feeling was up close, upfront, and personal.

According to former Danco dancer/general manager Vanessa Thomas-Smith, there's some measured thought and calculation that goes into a dancer's decision to audition for Philadanco. It's not taken lightly: "When they get to the point where they want to audition for Philadanco," she claims,

> they know they have to come with some special sparkle, some special flare. Most of the people who have come to audition I believe have seen the company [perform]. They're getting their [dance] degrees or they're professional. They've already got the fever for that type of dance...so when they go to audition, they already have that mental mechanism in place. *There are people that are in the company now who auditioned two, three, four, five times, and they finally got in the company.... They tried again because that's where they felt they belonged.* [My emphasis]

Another significant part of the Danco training is the opportunity given the dancers to teach. This is an ingenious way of instilling the company aesthetic in its members. By having to teach classes, they are obliged to analyze what they do, demonstrate it so that it can be learned, and then make corrections. In learning to be good teachers, dancers learn about the art form from a new perspective. This is a lesson that JB learned in the 1950s from working with Sydney King and Marion Cuyjet who in the 1930s were dance instructors at Essie Marie Dorsey's school and also her star students. Karen Still-Pendergrass began dancing with Philadanco in 1973, left the company around the time that she married vocalist and pop icon Teddy Pendergrass (1987), but has continued to teach at Dance Arts, almost uninterruptedly, over the past thirty-plus years. When I interviewed her in 2009, she was teaching ballet to classes of hopefuls, aged eight to eighteen, as well as jazz and zumba, a new Latin fitness dance technique. "I joined the company when I was twenty," she says,

> and part of our training was to student-teach. I started under Aunt Joan and one day she said, "Karen, count!" and she walked out of the room, and didn't return, and I've been teaching ever since.... Aunt Joan made us teach correctly. She didn't allow you to sit down and teach. You demonstrated. You danced with the students. And you taught technique correctly. It wasn't just about coming and learning combinations. She had a standard of teaching, a level, and if you didn't hold to that standard, she'd embarrass you right in front of your students!

For Tracy Vogt, the experience was heightened when JB paired her with Kim Bears-Bailey on a teaching assignment:

> I had never really taught dance before. And as soon as I got here, JB had me go with Kim to teach master classes. And I *know* how important that class was because it changed my life, to be doing it with Kim, to be trained by this *amazing* teacher, because Kim is an *amazing, incredible* teacher.... And I gained that skill, that I didn't have before I came here, and now I teach all over the place!

The leaders of Philadanco are a community of like spirits working in consonance toward ensemble excellence, individual ascendance, and maintaining (as well as extending) the company's aesthetic integrity. Another facet of the studio-as-conservatory approach, or training the whole artist and the whole person, is a tradition called "Danco on Danco," wherein the company dancers who

are interested in choreography have the opportunity to try out their ideas on dancers in D/2 or the training company. I could have discussed this initiative in this section, since it is an educational component of JB's institution. However, I have chosen to include it in the section "Continuity/Choreographers" that follows shortly.

Continuity/ Aesthetic Issues

Elisabeth Bell tells a story that illustrates the disappointments and tribulations sometimes involved in getting the Danco style:

> There was a time when I had...the most mortifying solo I've ever done, in Lynn Taylor Corbett's *Everything is Everything*. Joan was, like, "Elisabeth, you need to be living in the studio!" That's when it's hard, especially if you're frustrated with yourself, it's like, you can only do something twenty times and still not get it.... Finally I had to share with her that I was hitting a wall.... "Elisabeth is not a person who doesn't take her job seriously"—that was the one thing I needed to let her know, "and because I'm not rising to expectations at this particular moment, please just don't for a second think I'm not taking this seriously." But I had to let her know I'm hitting a wall because, clearly, certain things aren't happening. So that's when she showed me exactly what I needed to do. She even showed it on her body. We worked, we worked, we worked through that solo. Now, my personality is to be non-confrontational and to avoid certain things; I'm just not wanting to hear certain things. I will avoid! But once I had this moment with her, it released a tension. The solo was not made for me [it had been created on another dancer.] But still, after I had this moment with her, I was able to find something.

It was particularly trying time for Bell. The ballet was to be performed at the Joyce Theater in New York City, a prestigious venue in a Philadanco stateside season. Had she been unable to "get" it, the role would have gone to someone else. Usually Chase-Hicks was the person to work out the kinks or, as Bell put it, "to hold onto the integrity of everything." And when a person is learning a new part, the rehearsal director works in a very detail-oriented way to teach it fully and correctly. "Ms. Chase is fabulous and will still get up out of the chair and [do a phrase]," says Bell, "And when you see her do it, you realize that's why she is who she is." Only once in a while, as happened in this instance, must JB

step in. Also attesting to why Chase-Hicks "is who she is," Tracy Vogt explained that the "big coach" will "coach you down, and a lot of times what happens when you first get into the company is, the company will go on tour and those that are new stay with Miss Chase and they rehearse with her privately." These processes ensure the quality of the performance style by helping the dancers maintain an integral relationship with the Danco aesthetic.

Bell gave a "what-if" to illustrate the difference between JB's role and Chase Hicks's:

> Often JB will have a stretch of time before she sees a particular piece. [For example,] she's seen *Gatekeepers* tons of times. [But] If she now sees that we're about to do a show at 8 o'clock and we rehearse at 3, and [if] she sees you marking something [instead of dancing full out]...then, of course, she'll definitely say something. But definitely the day-to-day, the whole point of getting you ready to be on the stage: that is completely Ms. Chase.

Debora Chase-Hicks sets her heart, mind, and body on the line in the service of "getting it right." Choreographer Bebe Miller described Chase-Hicks as "the filter between my ideas and the dancers' execution. I could not have done this work without her."[52] Like everyone else at the Danco/PSDA complex, she practically lives at 9 North Preston Street. In addition to company classes in ballet, Horton, and Graham techniques Monday through Wednesday, the dancers rehearse with Chase-Hicks for two hours Monday through Wednesday, five hours on Saturdays, and three to four hours Sundays; Thursdays and Fridays are their days off.[53] Admitting that she may be "a little prejudiced," Chase-Hicks asserts with smiling confidence that "as far as I'm concerned, we produce more phenomenal, more well-rounded dancers than any other company." Asked how a new company member becomes a Danco dancer, she responded,

> It's a lot of talking. For this generation you have to break it down to the nines. I thank computers for that—they don't have to think for themselves anymore, they just hit "Enter"! But, seriously, it's about consistency—consistently doing things over and over. Now you try this one and do it again and again. And now try this and push a little bit more. *But it's all about consistency, because you get to a level where they don't even realize it will never go below that level anymore because it is consistent. And then you layer it after that.* [My emphasis]

This statement was a revelation to me, exposing a facet of dancer intelligence, muscle memory, and *embodied wisdom* that I'd never before heard articulated in this unromantic, nuts-and-bolts fashion. It's all about "The Work": and transcendence is a result of consistency in The Work. Once you get it under your belt, then you can add complexity (or layering). Chase-Hicks also pointed out the importance of dancing full out at rehearsals, rather than marking the movement. It's through full-body dancing that the consistent level she talked about can be attained. And sometimes it means that something beyond technique is needed to carry the dancer through, which Chase-Hicks describes as, "that power, and that spirit...that's sitting on the outside, that's so intense, it's coming out, just sitting on the outside of your skin, just burning!" Now, this spirit is not something you learn by studying with anyone. It's that ineffable quotient that JB looks for when she auditions dancers—their own sense that they must dance, or die for the lack of it. Vanessa Thomas Smith used the word, *drive*, to talk about this Philadanco quality. She added that JB "reads very well...almost like a therapist," in terms of spotting and choosing the dancers who, beyond their technical abilities, are "artistically driven to do this work." The Danco dancer is taught to refine, hone, and channel that power.

Kim Bears-Bailey is probably the person who is closest to JB in terms of aims, means, and aesthetics. She is JB's right-hand woman, sounding board, confidante, and surrogate daughter all rolled into one calm, centered bundle of vital though contained energy. Her presence is felt in the creative-artistic aspect of day-to-day operations at Philadanco. Also a full-time dance professor at Philadelphia's University of the Arts, she lives a double life, sometimes seeming to be in two places at once. Her statements shed additional light on understanding this ensemble and how its past intersects with and is embraced by its present. Speaking passionately and from the vantage point of having danced with the company, taught classes, assisted at rehearsals and performances, and now being the company's Assistant Artistic Director, she said,

> There is a look of Philadanco—polished women, strong men—there's that thing that people relate to in Philadanco, but it's not one kind [of person, or look]. It's many kinds that become a part of this unit, that find the open window and the little pearl inside of their shell that, for some reason, maybe in another place and time, wasn't as accessible for them....
>
> When I was in the company we did seven to nine pieces [in one performance]. So I got to be nine different people, I got to explore nine

different beauties of my soul, my spirit, through different choreographers in one concert. When I got my Bessie,[54] we premiered nine works at the Joyce Theater. The concert was two hours. But you got to say so much, you got to find so many aspects of yourself through the works. And now it's funny, 'cause the kids are doing three and four ballets and they're dying in the wings.... But also the pieces are getting longer.

With these accounts by Bears-Bailey and Chase-Hicks, we are made aware of an issue around the stamina and loyalty of the millennial dancer that did not exist in the eighties and early nineties. Dancers in the company are no longer all or even principally from Philadelphia. Instead of remaining with the company for seven or more years, the average stay now is generally three, maybe five, years. Nevertheless, the continuity provided by people like Bears-Bailey preserves the company's remarkable and unique ability to create an ensemble of highly individual dancers, and Danco is still unmistakably Danco.

Continuity/Choreographers[55]

I asked Chase-Hicks to break down the interaction among choreographer, artistic director, and rehearsal mistress. She took it from the top, explaining that the conversation begins with artistic director JB and a choreographer. If it is a new piece, the discussion centers on what it's about. If the choreographer is remounting a piece on the company (either one done by another company or in previous years by Philadanco), they would have screened a video of it and then discussed how to approach the work now, given the Philadanco aesthetic and the particular dancers in the company at this time. Chase-Hicks continued,

> So that's done before the choreographer comes into the studio. Once the choreographer comes in, basically Aunt Joan doesn't come in. She's already done that, and that's the beauty of it. She allows them to do what they do. And while they are choreographing, I generally sit up on the ladder and videotape[56].... If I'm watching something and I can help the dancers along, I'll try to very discreetly say something to them so that it keeps the process going for the choreographer. I usually say to them [the choreographer] prior [to the rehearsal period]: "I don't want to overstep your bounds, is it okay, if I see a dancer and can help them do something to get where you want them, if I just kind of pull them off to the side and help?" And they [the choreographers] always say yes, because the time is always limited.

I comment on the fact that choreographers trust her eye and expertise. She responds that it has been wonderful working with choreographers from all over the world who don't know anything about her but believe that she will take the time to

> really watch and try to get a handle on their style and their process, because each choreographer has a different process. Some come in and teach thirty-two counts and then manipulate those counts in fifty thousand ways, or some will teach eight counts and take two days to get to that, to the way they want it to look. Everyone is different, and I have to get a feel for them, and they have to get a feel for me. I have to build their trust, because it really is their vision, their baby.

JB returns at the end of the process. Chase-Hicks's role shifts accordingly; now she sits next to the artistic director and the choreographer, taking notes for them,

> so then I kind of have, not the view from the back, but the view from the front, and I can also hear what they want, and then I ask questions, and we have our dialogue after the rehearsal's over. That [conversation] kind of carries on into the tech rehearsal, the premiere, and the whole run. Whatever the run is, we always have our dialogue after the shows.

Based on these discussions, she takes notes for herself, for JB, and for the choreographer after a performance, goes over the notes with them, and gives them her notes,

> and they [may] say, "Well, that's not important," and I say, "Oh, yeah: right." So we have that give and take. Then, after they leave,[57] it really is my responsibility, first of all, to hang on to the vision, to hang on to the style, to hang on to the clarity, to try to hang on to the story and then to help the dancers find their way in it. And [show them] how to then grow in it as a dancer, as a performer, as an artist....
>
> My greatest responsibility is to keep the ballets intact and to help the dancers mold into that style, because then they can recognize all kinds of styles and be able to do all types of things, and then it opens the door for a career.

For JB, the introduction of each new choreographic work is calculated to not only add to the company's repertory but also to expand its reach, scope, and

expertise. During its first bona fide performance seasons in the early 1970s, the group performed works made by JB herself and her old buddies Billy Wilson and Harold Pierson, both now deceased. By 1977 the first Talley Beatty work, *Pretty Is Skin Deep... Ugly Is to the Bone*, was added, followed in 1979 by Gene Hill Sagan's first appearance with *La Valse*. By the 1980s the list of choreographers and range of approaches was staggering. As Bears-Bailey attested, sometimes there were upward of nine (short) works on a program. (See Appendices: Philadanco Home Seasons Repertory Chronology, 1972–2010; and Philadanco Choreographer Profiles.)

One of the ways that this artistic director develops home grown choreographers is through "Danco on Danco," a concert tradition that began with the early days of Philadanco. JB explains that it started when the Painted Bride Arts Center, presently a 250-seat black box theater, was a storefront performance space founded in 1969 and located on South Street, next to a bridal shop in the Old City area of Philadelphia, which is how the Center got its name. Gerry Givnish, one of the founders and the original executive director, asked her to do a performance. Because it was such a small space, JB came up with the idea of letting the dancers make pieces on one another instead of launching a full-blown, full-ensemble performance. This has become a regular autumn tradition. Zane Booker and Hope Boykin are among the Danco-ites who began their dance-making apprenticeship this way. Now that Booker and Bears-Bailey are dance professors at the University of the Arts, the dancers for Danco on Danco include UArts dance majors, members of D/2 and the training program, as well as members of Philadanco. It is a wonderful opportunity all around: for new choreographers it is a chance to experiment in public; for dance majors it is a chance to dance with professionals; for students, some of whom will never become professional performers, it is an opportunity to experience the magic of performing in a fully-realized situation, as opposed to a school recital or a college concert.

Attending the Danco on Danco performance of October 22, 2009, I was thrilled to see the range of different young physical types working together, making unity out of potential chaos, even with their unseasoned, individuated bodies. Their teachers had given them that important "we're all in this together" Danco lesson, while not suppressing their unique talents. What I saw in some of these young dancers—students and D/2 members—was the raw energy of "The Calling" incarnate, the do-or-die quality wherein dance is a need beyond desire or even physical limitations. Dancers-in-the-rough exposed their simultaneous grace and awkwardness, agility and inflexibility. Sometimes we spectators could see a reach beyond a grasp, a young mind too big for a body, and then, gloriously, sometimes it all fit. In some cases we could imagine a dancer growing

into a particular choreography over time, with a dance becoming an imaginary dress that could be tried on every year or so, to continue to adjust the fit. This is exciting to see onstage; the atmosphere takes on a life of its own and draws the audience into its embrace. We were privileged to see the seed of potential that is sought after in the dancer who will be accepted into the company, and to feel the dynamic energy that Bears-Bailey, Booker, Myers, and others nurture and groom through their teaching and choreography. And the variety of styles and genres — from ballet and traditional modern dance to jazz, African, and hip-hop — allow the young dancers to experience, in front of an audience, the diversity of the Danco repertory and to be in an onstage and backstage rehearsal-performance situation with actual members of the senior company. They are gaining experience in what it means to be professional, in the Danco sense of variety, energy, and endurance. All in all, and like most Danco and PSDA events, the entire concert rocked with the feeling of family — parents, babies, kids, friends, teachers, mentors, students — all rooting for the new dancers and burgeoning choreographers. Holding the fort was the cool, assured, but loving and generous woman whose presence of mind created this baby: namely, JB, who introduced and concluded the show with a few choice words in her down-to-earth, cogent style.

I asked Tracy Vogt to talk about working with any of the Danco choreographers whose dances she'd performed in. She chose Danny Ezralow and Milton Myers as two with whom she had had memorable interactions. Ezralow gave Vogt her first experience working completely from improvisation:

> He would have us rolling around on each other and it made the company get very close because it was around Christmas time, and we were sharing what Christmas meant to us. One day we went on a "field trip" to Fresh Grocer [a large supermarket around the corner from Philadanco Way that carries produce, prepared foods, and has a café on the premises], and I was like, "Who is this man??!" And then he made a solo for me, an improv. He'd make us improvise, and he kept yelling, "Stop! You're thinking too much! Walk around!" And I'd walk in a circle, start dancing, and he'd stop me again for thinking. I had to walk in a circle and just go with whatever came to me. Oddly enough, the solo became "New Year's Eve," the Christmas solo that so many people love! He added men coming in and doing little lifts, and then leaving me, and I just remember being so angry and just kind of flopping around, and people loved it!

The dance she described belongs to *Xmas Philes*, which was choreographed by Ezralow on the company, through improvisation, in 2005. It was a new

experience not only for Vogt but also for other company members who were used to a technique-based style of choreography. But leave it to JB to widen Danco horizons, undoubtedly aware that, as a company dominated by African Americans and headed by a black woman, they were stepping out of stereotypical aesthetic boundaries by doing a collaborative piece like this.

Vogt also talked about working with Milton Myers, whom she knew from the University of the Arts, where he had been one of her favorite teachers:

> And, you know, getting into the company, they don't feed you into the rep right away, unless you're cast into a choreographer's new work, and Milton cast me in *Echoes*, a tribute to Alvin Ailey. He gave me a great part, and I was so ecstatic because he had trained me, and I felt like he trusted me to do this work, and we toured that work for quite a long time.

Elisabeth Bell also mentioned Myers as a favorite choreographer. His easygoing manner, combined with his technical expertise and artistic talent, are an inviting combination.

Ron Brown is another highly esteemed Danco choreographer. With its neo-African, Diasporan lexicon, his choreography is a paragon of blending tradition and innovation. Here are some of my notes from watching a rehearsal of his dance, *No More Exotica*, on September 28, 2008, which was then performed on the home season program the following month. The rehearsal was from 10 A.M. to 2 P.M. I observed the final hour:

> Ron is raining perspiration (so are the dancers), demonstrating his persona through his choreography: sentences, stop-start sentences of movement; small walks, African exclamation points; cool stops; breakdancers' drops to the floor. He repeats certain moves again and again—a slow walk with arms open wide from second position, chest lifted to the sky, followed by a b-boy quick drop to the ground and spin on one hand.
>
> As only a choreographer can do—having created it on his own dancing body—Brown demonstrates the logic of a difficult lift, making it seem more like play than the work of one adult lifting another. These lifts require women to carry men in a complex, upside-down sequence that ends with the lifted dancer cradled like a baby in the arms of the lifter. Amazingly, each couple gets it!
>
> There's always something heroic, elegant, about his choreography— something that makes me want to cry tears of joy—uplifting for the

dancers themselves as well as for spectators. A spiritual experience, even in rehearsal. The Danco dancers take to it like fish to water, and sometimes like birds to air. In an intimate way his movement reflects their complex, contemporary world. It's a language they are versed in from their Africanist-pop-hip-hop-ballet-release-yoga-Pilates wash of cutting-edge movement culture.

Suddenly, breaking out of the "house" music, booms the powerful voice of the great Mahalia Jackson singing "His Eye Is on the Sparrow," and the movement takes on a different urgency as the ensemble takes on another purpose.

The company is dancing full-out. Like Chase-Hicks, Brown says that's the only way to learn a work. He makes dances that stress the sense of community, ensemble, and individuals watching out for one another—soldiers of the spirit trying to "keep it real" and stand not just for self but for community. He is the only choreographer who comes to mind who works this way besides Ailey in works like *Revelations* and *Night Creatures*.

Ron tells them that at some points relaxation will help the movement come out, and he says, "When you're tired is when you need to depend on the group to help you with energy. Don't close off then, but look at one another." He tells them when they rehearse without him to let the dance speak, to find the language through the movement, to find the spirit and the feeling in the movement and in one another, to know that it's the community (of dancers) that will make the movement resonate. He ends the rehearsal by quoting one of his African teachers who now lives and teaches in New York, Marie Basse Wiles: "I can teach you the steps, but I can't make the spirit talk."

For Zane Booker, the transition from student to company member to company choreographer wasn't always an easy one. As a dance maker he didn't have an edge, or any particular favor, with JB, and was obliged to demonstrate his mettle, despite how long he'd known, studied with, and danced for her, He remembers that "[w]hen I mentioned to Aunt Joan that I wanted to choreograph on the company for the Danco on Danco series, she was like, 'Well, we'll see,' but it wasn't like, 'Okay, I'll work that out for you.' So the challenge was to go ahead and get better as a choreographer."

Ezralow, Brown, Booker, and Myers belong to the branch of Danco choreographers who are not in the same generation but are closer in age to the dancers than were Louis Johnson and the late Talley Beatty, who adhered to a more

hierarchical rehearsal format. But the new generation of choreographers could not have developed without the shoulders of their aesthetic ancestors to stand on.

After funding priorities, it's the aesthetic choices, constancy, and creativity that are front and center issues in keeping a dance company alive and well. Another statement by Booker, who has known the company, the school, and their founder for almost all of his life, is a fitting end to this chapter:

> Aunt Joan is the keeper of the standard. Just her presence in the doorway creates a push without words. I felt that when she came into the room, when I was sitting in front of the room as a choreographer: the push towards excellence. Her eye is so amazing. She stays current. She sees everything, and understands good structure, understands that somebody is not a choreographer or that somebody is a choreographer, as far as how you use space, how you use form, how you generate patterns on the stage. All of those things that go into the craft of choreography, she appreciates that and she can call you on it. So her presence in the room pushes toward that standard.

Now that we have established the premises of the Philadelphia/Philadanco aesthetic, we will look at the responsibility of the choreographer in "the house that Joan built" from another vantage point in the next and final chapter, where we continue to interrogate issues of continuity and repertory, and also examine funding, post-racist ethnocentricity, and futurity.

CHAPTER FIVE

AUDACIOUS HOPE: THE HOUSE THAT JOAN BUILT—1980s—TWENTY-FIRST CENTURY

I think that the company exudes movement for your life and people buy into that more so than race.... I think Philadanco supersedes race, personally, with the naming of the company. You know, Joan was very smart not to put it in the bag [as] the Philadelphia Black Dance Company.
—*Vanessa Thomas Smith*

You could not have told me, when I started Philadanco, that forty years later it would not be different. It's not that much different.... There is nothing that is in stone, but the one thing that remains the same is the struggle—always a struggle.
—*Joan Myers Brown*

PART ONE
INTRODUCTION

It's very different. And it's frustrating sometimes because you want that that passion for dance is always ongoing. I mean, I believe that dancers definitely should be paid; they're never paid their worth. I think they always deserve more than they get paid. But I think that when you have that kind of passion where you have to say to them, "You don't have to go home, but you can't stay here"...that passion is always churning, always smoldering. But here

it's like, [a] 5-minute break, so that passion wears down and by the time you get back, it takes you about 15 minutes to get it going again.... It's very frustrating, but that's the difference between then and now.
—*Deborah Chase-Hicks*

With these words, "Chase"—as she is affectionately known at Dance Arts/Danco—the rehearsal mistress who recycled back to home turf after her stellar sojourn with Ailey, is pointing out the difference between her generation of Danco dancers and the current generation. The reader may recall from chapter 3 that, back in the day, JB had to practically throw her young dancers out of the studio, saying, "You don't have to go home, but you can't stay here." This brings us to a consideration of the issues facing Philadanco and its community as they move into the second decade of the new millennium and beyond. To talk about the shifting landscape, I turn to a speech given by President Barack Obama on March 4, 2007, soon after he'd announced his candidacy, given at the Brown Chapel AME Church in Selma, Alabama. Titled "The Joshua Generation," the speech delineated the "Moses generation" as the pioneers of the civil rights movement who fought for the rest of us to have a Promised Land—people like Dr. Martin Luther King, Jr., John Lewis, and Rosa Parks. Then he turned to his own generation, the "Joshuas," for whom things are better, but who must not "forget that better is not good enough."[1] There is still work to be done by and for the Joshua generation, and they must respect and remember that they stand "on the shoulders of giants,"[2] not unlike the biblical relationship between Moses—who fought and pointed the way, and Joshua—who would go on to reap the fruits of Moses's labor and possess the land.

I have adopted and adapted this metaphor to fuel my discussion of "old school" and "new age" manners and mores and how they are played out in the dance culture JB created. Although there is no clear divide separating Joshuas and Moseses, I place Talley Beatty, Harold Pierson, Pearl Primus, and, at the end of the lineage, Louis Johnson and Joan Myers Brown in the Moses school of dance practitioners because of

1) their chronological age;
2) the era in which they became choreographers (they first began making dances before or at the very beginning of the civil rights era of the 1960s);
3) their teaching style (tough love, with few words of praise for the dancer and, in the case of Beatty and Johnson, occasional verbal tirades)[3]; and
4) in the beginning of their careers, the relative dearth of opportunities available to them or concert dance practitioners of any ethnicity because

the field had not yet become a mainstream quotient supported by public and private funding.

These factors and the Moses and Joshua categories apply to non-black dancers and choreographers as well as African Americans. However, the black Moses artists had to deal with American racial discrimination and segregation on top of every other obstacle. The 1960s political and cultural changes radically affected American life, manners, and the arts for both blacks and whites. Thereafter, dance became an art form learned in academia; often the Moses generation of studio-taught dancers were the teachers of the college dance majors. The era of little or no public funding of dance was replaced by public and private foundational grants—some quite sizeable, and some lasting over several seasons—until the recent global financial and political upheavals of the mid-1990s and the new millennium saw all the arts suffer financial blows. The 1960s through the early 1990s were "dance boom" years, seeing the art form achieve a level of public support and audience growth unheard of during the early careers of black and white Moseses like Beatty, Primus, Johnson, Paul Taylor, and Merce Cunningham, for example. The Moses generation of artists profited from progressive changes, but they had been forged in the crucible of an earlier era.

Joshua choreographers came of age after the civil rights era and are securely situated in the Promised Land, imperfect though it may be. They are privileged, consciously or unwittingly, to stand on the shoulders of the Moseses, who fought for recognition and opportunity. Some Joshua choreographers still adhere to a tough love standard, a trait perhaps inherited from their Moses masters. And then there are the true Joshuas, whose easygoing, collaborative, win-win attitude, plus their relative youthfulness, put them clearly in the new consciousness/new age category.

First we take a look at ensemble dynamics, including touring, residencies, and keeping the standard, and then move on to interrogate Joshua and Moses dances and dance practitioners, funding and race issues. We wind up with a section on the critical gaze and its ramifications, ending with a cluster of selected "testimonials."

ENSEMBLE DYNAMICS/KEEPING THE STANDARD/TOURING/ COMMUNITY OUTREACH

Again turning to the interview I conducted with Zane Booker, we find more guidelines pointing to the aesthetic standard so important in defining Philadanco and essential in guiding the ensemble dynamics. He muses about JB's criteria,

saying, "The standard is so high. The standard of discipline. The standard of appreciation for your own personal art form. The standard of the work ethic. Those things I try to give to my kids [his students], so if they would walk up in there [to a Danco audition] they wouldn't have any problem." These thoughts lead him to address the mindset of the dancer, which is as important in maintaining a standard of excellence as technique and passion. Booker contends that, with the right mentality,

> you can help the body. You can transform the body. But if the mentality is not correct it's a very different battle, a very different student or artist. If we have different ideas about what discipline is, then how can we have a conversation? First, we have to establish what I mean by discipline. You may think showing up on time and doing most of the exercise is, you know, a version of discipline: I do not! You may think that going over a step three times for sequence is a way that you work on a combination: I do not!

His sentiments echo the Philadanco aesthetic laid out in the previous chapter and resonate with Hope Boykin's statement about learning by repetition, but not simply mindless reduplication. The dancer needs a thinking body and a dancing mind—needs to engage the whole self to succeed as a member of the Danco ensemble. It requires a sterling level of technical achievement, but not only that. Booker agrees with me when I assert that the Danco dancer's technical level is very high, but responds by claiming, "That's not the *end*, so, for Aunt Joan's head, it's not the technique level [alone]; when the technique level rises, the passion and the understanding of what the process of being in the dance world is [all about] shouldn't change." Booker praises JB for creating situations wherein this understanding can be inculcated into potential company members while they are still young students. He emphasizes the importance of having a training program and a second company—D/2 and D/3:

> There's the kids, and then there's the training company, and there's the Company. I was really happy when Aunt Joan started up the young kids' company again because I think that there's a certain amount of discipline and professionalism that those kids already learned.... So it's ingrained, you know, and it's *a Danco understanding of what a discipline is* [My emphasis].

He realizes that many of his students attend the University of the Arts as an entryway to auditioning for Danco. As he discusses criteria he touches upon the

way an experienced critical nucleus of audience members, faithful followers of the Company's home seasons, plays into maintaining the standard:

> There are a lot of people who know Danco and know the rep and expect a certain style. And when that level is not there, they can call us on it because they've seen the other level. The level has never changed because the company is not doing its job. I think it's just because there's a rotation, and you get 21-year-olds when you just had 25-year-olds. So then you have to start all over.

Indeed, the standard—and the company identity—are partly dependent on dancer stability. When a "rotation" happens and several dancers leave the company in one or two seasons, a sea change may occur. Nevertheless, Booker contends that what really counts is the presence of a few key energy shapers—"if you have four, or at least three of those people in the company that shape the energy in the room," that can be enough to change the tide. Those people may be dancers who have been with the ensemble for some time, or they may be the new entrants. What's essential is that they need to have a hunger to be there—not to be somewhere else, not to use this as a stepping stone, and not simply because they signed a contract and see this as just a job. According to Chase,

> We're always kind of in transition. You may have a good core of dancers for 5 years, and that's just great—if you get a good core of 5 or 6 dancers that you can build around. And then there's another transition, and sometimes dancers that have not been in the company for very long transition on or some of your core members transition, so it's hard to rebuild again. Sometimes it's frustrating because you do miss these people, and then sometimes it's so exciting, you just can't take it because you get this new energy, you know, and it's so exciting it ripples all around the room!

As noted in chapter 4, nowadays dancers may remain in a company for three to five years, whereas in the 1970s and early 1980s it may have been five to eight or ten years. But there are exceptions. Although Danco has had its share of turnarounds, a number of dancers in the past decade—including Odara Jabali-Nash, Tracy Vogt, Mora Amina Parker, and Dawn Marie Watson—stayed on for eight to ten years. Tommie-Waheed Evans recently recycled himself, leaving and then returning to the fold, and as of 2011 has put in nearly a decade; and in 2010 a homesick Roxanne Lyst returned to her Danco roots after having danced several

seasons with the Ailey company. It's hard, labor-intensive work to dance in JB's ensemble, but there are perks: performing such a varied repertory gives the young dancer marketable experience; dancer housing is available should a dancer choose to live in one of the units now owned by the organization located a short block away from the studios; and there is always the fifty-two-week contract, offering a stability that many professional dancers can only dream of. Granted, the salary is substantially smaller than what they'd receive if they were swept up by a major moneymaker like the Ailey ensemble; but Danco offers the stability of a year-round income, and the dancers' schedules allow time for additional part-time employment. Unfortunately, many young dancers regard these advantages and the opportunity to perform with Philadanco primarily as a step on the path that leads to the Big Apple and perhaps dancing with Ailey.

Reiterating a point made in chapter 4—and despite dancers' assistance with costumes, stagecraft, lighting, and rehearsals—the company's organizational model follows that of a traditional ballet ensemble, with dancers, choreographers, and artistic directors having distinct roles. Many contemporary modern dance companies blend these roles; dancers may collaborate on the choreography, for example, but with Danco there's a "clear hierarchy," to use Elisabeth Bell's phrase, and like ballet ensembles, attendance at company classes is required. Vanessa Thomas Smith pointed out some very significant, market-savvy choices made by JB in naming and promoting her ensemble:

> With it being the Philadelphia Dance Company, the public wouldn't actually know what they were getting. So it's a dance company but they didn't know if it's the Pennsylvania Ballet, if they were getting Arthur Hall Dance Ensemble or Group Motion [names of other dance groups in Philadelphia in 1970]. I mean, what they understood out there as a branding was that they were getting a dance company that was epitomizing Philadelphia.... Does it make it a black company because it's run by a black woman? No. Does it make it a black company because she uses black choreographers? No. Does it make it a black dance company because some of the vernacular or some of the movement is "black?" No. It doesn't make it any of those, which has made it difficult to put a label on it.... and Joan with her forethought put that mechanism in place, so that what happened in the transition—that we were all from Philadelphia, and that we were all kids growing up in Philly and that we were black, when it transitioned and went through a period where, number one, none of the dancers were from Philadelphia; number two, there are other ethnic backgrounds, particularly Caucasian, in

the company as well as a period where we had dancers in the company that were not American either—that when it transitioned *the makeup of the company was still Philadanco*. One time we had in the male ensemble a guy who was tall, blonde hair, blue eyes: he was German[4]; we had a guy who was Ethiopian and Italian[5]; and another who was of Filipino descent.[6] So they were all in the company at the same time, and in rolls the Philadelphia Dance Company, and people go "Huh??? Okay, let's see what they're going to do." [My emphasis]

So there is something about this company that allows it to maintain its identity regardless of the diversity in its ethnic, regional, or national composition and the changes in personnel—a continuity discussed in detail in chapter 4. Thomas-Smith's point is that from the audience perspective and in its ethnic makeup, Philadanco "supersedes race." Indeed, if JB began in 1970 with the aim of giving her most talented students a performance opportunity not available to African Americans in Philadelphia, since then her organization, reach, and goals have all expanded, and the Philadelphia Dance Company no longer represents only Philadelphia—just as the New York City Ballet represents a lot more than the metropolis in its title. Nevertheless, just as the New York City Ballet is understood to be a white company, Danco is understood to be a black company. This fact does not hinder the company or prevent non-black dancers from auditioning and being accepted in the fold.

Touring is a big part of the life of the ensemble. As of this writing, JB still tours with the Company and will travel with her dancers from South Dakota to Vermont, from Massachusetts to Hawaii, from California to New York, in 2011. In 2010 the company toured Europe twice, first in August for the Dusseldorf, Germany, Internationale Tanzemesse (a global dance exhibit and performance opportunity that acts as publicity for other bookings; Danco was a featured company at the event) and again in October for several weeks of performances in Germany and the Netherlands. The Company is now booked every other year for European tours, alternating with the years they are booked at the Joyce Theater in New York. The European publicity for the Tanzemesse performances was interesting in that it characterized Philadanco as "a dance company with political principles that bridge cultural differences," mainly because of JB's intention back in 1970 to create performance opportunities for African Americans excluded from white venues.

According to JB's dancers, the company frequently chalks up their best touring experiences outside the United States. Both Zane Booker and Tracy Vogt cited Bermuda as especially receptive and waxed ecstatic when discussing

the way they were treated. Vogt said she felt as though she "was on a grand vacation, except for the dancing part!" She said Bermudans loved "the artist," and the company had that same kind of reception and respect in Budapest, where the audience was enraptured and demanded several encores: "they just wanted more and more and more." Performing in Europe, JB said there's a level of responsiveness and respect that they don't experience in the United States, sometimes resulting in multiple curtain calls, then followed by encores, "and the way they applaud, simultaneously, you know." That was one of the striking differences they realized on their first European tour: at that time they hadn't even prepared encores, so they simply returned to the stage, when the ovations didn't end, and repeated the final few minutes of the last number on their program.[7]

Seldom does the ensemble garner this kind of unbridled enthusiasm stateside, and just about never in its hometown. We might attribute this restraint to Philly's "atty-tood," as described by Rennie Harris in the previous chapter. Even in their advocacy for and pride in this grassroots company, Philadelphians seldom give them or anybody else any more than two curtain calls and have hardly ever applauded so much that even one encore was called for. (In all fairness, it should be pointed out that, unlike music events, encores are not a tradition in stateside dance concerts, and stage unions have strict rules governing the length of a performance before the workers run into overtime compensation rates.)

For any performing arts company (in dance, theater, or music) on the road at home or abroad, touring offers something else that's essential to copasetic ensemble dynamics: the opportunity for bonding due to the fact that the players must live together as well as work together. It gives members time and space to know one another, and this experience can spill over into their stage presence and make for a higher quality performance. Of course, the opposite can hold true, and "getting to know you" can drive a wedge between people as they recognize their differences. But that is where professionalism must step in to guarantee that offstage rivalries or aversions aren't carried onstage. Vogt mentioned the fact that the tour she went on to Bermuda (and Danco has performed there several times) was helpful "because we had just had a big turnover, so there were a bunch of new people, so it took some time to kind of mold into the company." Besides Bermuda, Hungary, and Germany the company has performed in Poland, Austria, Italy, Luxemburg, Switzerland, Canada, Great Britain, Turkey, and Korea. Their current European booking agency, Landgraf, is located in the German city of Freiburg. JB explained that a Landgraf representative saw them perform in Chicago at the Jazz World Dance Festival and booked them first in 2006. Most of the touring consists of one or sometimes

two nights of performances in a city or town, then on to the next venue. The Poland tour was a different matter: "I think it was the first time we did an extended tour, 'cause even though we had gone to Istanbul this was the first time we were going to be there more than two or three days. We were there for about three weeks." What was different about this tour was that, in Germany or Italy, they'd have one city or town that was their base and would return there after a performance in a nearby city or town. With the Poland tour, which took place in 2001, "we moved the whole shebang," she explained, meaning that they were on the road and staying in different towns each night. There were racial incidents on the Polish tour (discussed later in this chapter). JB doesn't dwell on them but simply says that

> [i]n different places, the response was different. You go into a town, we get there the day before, you get up in the morning, you look for a place to eat, you want to go shopping, you look around, you walk, you see stuff, and people are lookin' at you like you're crazy. And then [on the other hand], like Berlin, it's like being in New York City.

In other words, Philadanco experienced what every person of African lineage—probably every person of color—has endured while working or living in Europe. JB could have mentioned Paris and London in the same breath as Berlin. Those northern cities have African Diasporan populations and visitors, and they are accustomed to diversity. Sadly, many places are not. Although the fast pace of globalization may diminish xenophobia sooner than later, the opposite has unexpectedly occurred in some regions, with new racism sprouting up in areas previously unexposed to ethnic diversity. It is noteworthy that JB cites Turkey as the touring locale she enjoyed most. Back in 1991 the company was there for two weeks, performing in Istanbul and Ankara. Here are her comments:

> Turkey I love. And that's a non-Christian country! I loved the people, I loved the way they treated us. Istanbul is like New York, and Ankara's like Washington. It's so funny, while we were there they kept saying, "Ms. Elam is coming; Ms. Elam is coming from the consulate. Ms. Elam will be here from the Embassy." And I'm like, "Okay, okay." We're trying to rehearse, and they're saying "Ms. Elam, she'll be here real soon." And after a while I look up, and this sharp black woman comes walking down the aisle of the theater. "Ms. Elam is here." And I was like, "Well, alright, sister!" She was a black woman working with the Embassy. She spoke Turkish, and she took us shopping. We got so much good stuff! I'm still in touch with her.

Besides the fortuitous presence and hospitality of Ms. Elam, the audiences ate up Danco's performances.

In 1996 the company toured Italy. They performed in Sardinia, Sicily, and mainland Italy for about three weeks. JB recalls doing Zollar's *Walkin', Talkin', Signifying, Blues hips, Lowdown Throwdown* in what could have been a compromising situation:

> We did it at a street fair, and they had the stage in the middle of the square, and we had to do it backwards because, you know, all that stuff with the dancers' butts to the people—all these old men were sitting around, so we did it backwards, with our butts to the back!

This was an interesting, culturally sensitive adjustment on JB's part—for both the audience and her dancers—which she made regardless of whether it compromised the choreographic idea. She was not about to put her artists on display as sex objects because a dance intended for the stage was suddenly cast in the intimacy of an open-air performance in a provincial town square. Furthermore, the exotic-erotic factor was probably already at work, what with the black female dancers performing for a small, male-dominated, non-black village population who could easily fall back on old stereotypes and interpret the performance as primitive, if not promiscuous. JB made this choice to protect her dancers' image and her aesthetic. Philadanco dancers may exhibit a show-business élan, but they are never guilty of poor taste.

About her travel experiences in general JB had this to say: "You know, what I find amazing when traveling overseas: the moment you come to white Americans, they're rude, they're prejudiced, you know you could meet white Italians, white Germans, but nobody is as rude and as arrogant as white Americans." (The trip to Poland challenged her contention, as I discuss later.) She also told me an amusing story about performing Beatty's *A Rag, A Bone, A Hank of Hair* in Florida. The piece is set to rather risqué lyrics by Prince:

> I'm in Florida, and this woman says, "you cannot do that here! He's saying f...k you till the dawn, f...k you till the morn," and I'm like, "huh???" I'd never even listened to the words—I'm always looking at the dance. She says, "You cannot do that!" I said, "I'll tell you what. If anybody walks out, you don't have to pay us, because most people, they don't listen to the music. You're listening to it because it's at rehearsal." *[And afterwards]* she says, "Oh, nobody left."

The international grasp of Philadanco's reach has not diminished JB's commitment to her Philadelphia community. In 1997 Carolelinda Dickey, at that time the head of the Pittsburgh Dance Council, talked about Danco's outreach activities:

> Alvin [Ailey]...used to talk about his vision for American dance, and he used to talk about that part of the vision that he felt he wasn't doing well, getting out more into the community. Well, as I began watching Philadanco, I realized, it's right here: the vision Alvin was talking about.[8]

Since her beginnings in the Market Street facility, JB has always opened her doors to community members who needed rehearsal space, and not only dancers: "You know, like, Boys II Men and Will Smith and all those guys—Eve—all those guys rehearse[d] here [for free], but you know, they forget." In a much larger sense, if the ethos of community is about giving as much as receiving, then these pop stars would do well to think about becoming regular supporters of Danco and Dance Arts. JB complains that the entertainment industry icons and local politicians seem more interested in supporting the big companies that already have generous support, New York groups like the Ailey ensemble or local (white) institutions like the ballet and the orchestra. On the other hand, Rennie Harris continues to rehearse at Dance Arts when he is in Philadelphia and has maintained a solid connection with JB, as we saw in the previous chapter. Regardless of those who move away and don't give back, JB's commitment to the community remains firm, and she must be ready to respond to immediacies, including the personal needs of her dancers, as pointed out in this 1994 article:

> "We really have to respond to the industry and the community. Our long- term goals usually become short-term. We often find that we have to react to an urgent need for our dancers and for the community," said Brown. "Not five years ago, I got a letter from an arts council saying that we were 'doing too much' and that we basically needed to figure out what we wanted to do." She was referring to Philadanco's social service-like involvement in the community. "Today, all the funders require that arts groups have outreach and other community programs. We've been doing this kind of work since day one. And I don't mean one shot 'outreach visits'. Black arts groups have always had to be social

service/arts groups because there are so many other issues that affect our community."[9]

JB's statement reminds us of Katherine Dunham and her commitment to the beleaguered East St. Louis community where she, too, administered not only art but also social and sometimes financial aid to her people. These are only two examples of many. The price paid for the unequal opportunity and non-affirmative action policies of our nation-state puts a tremendous drain on African American potential. In the early years of Danco's life, when performances were few and far between, part of JB's community service involved performing for local groups at rates far below market value, if not for free. Now that Philadanco has international status, JB is able to send D/2 and D/3 out into the same kinds of venues to continue the community commitment, giving these young dancers a chance to dance, and saving her premier company for the national and international professional jobs. As I write these words (March 2011), D/2 is preparing to perform at the gala for The African American Museum in Philadelphia, while Danco will be performing in Boston. JB explains, "We do a lot of things when people call us, like the senior citizens groups and the AKA *[Alpha Kappa Alpha, one of the foremost national African American sororities]* and the Links. One year D/3 danced more than Philadanco! But they were doing all that stuff where nobody wants to pay you or they take donations or something."

D/3 fills requests to dance on city plazas for mayoral events and at regional amusement venues like the Dorney Park and Great Adventure amusement parks. JB further explains that by the early 1980s, by the time she left the Market Street studio, she had already terminated her company's participation in the Young Audiences and Dance in the Schools programs sponsored by the City of Philadelphia. As explained in chapter 3, the programs offered a way for her young company members to be paid for their work, but the burden of the involvement outweighed the benefits, especially since the company was growing and gaining in status, bookings, and earning power. One of the advantages of being the official Resident Dance Company at Philadelphia's Kimmel Center for the Arts is that groups of schoolchildren are brought to the venue, instead of the dancers going to the schools. Special matinees allow kids who might never be taken to the theater to enjoy performances in a concert setting and participate in question-and-answer sessions afterwards. Since teaching and the school are such an integral part of JB's commitment to dance, out-of-town residencies almost always have both a teaching and a lecture-demonstration component. Here's an example, taken from an article about a Danco residency at Mercyhurst College in Erie, Pennsylvania, back in 2000. The piece begins with a quote from one of

the middle-school female students who, ready to be bored, had declared that, instead of watching a demo about modern dance, she was looking forward to "a modern nap." The writer continues,

> Then Philadanco artistic director Joan Myers Brown emerged and got everyone chanting, "five, six, eighty-four, twelve," her dance equivalent of a quarterback snap. With gentle prodding, she coaxed 1,600 arms into the air to wave and warm up, like her 14 dancers. She invited kids onstage to strut their best dance moves, and they piled up there like she was giving away Pokémon cards. And she introduced her supremely gifted troupe, which showcased a complete piece and excerpts from two others with such grace and daring, so much energy and passion, that every kid on hand, including Tanisha King *[the would-be napper]*, sat in silent awe and admiration.[10]

JB loves kids and adolescents, still gets a kick out of teaching, and definitely knows how to make dance entertaining as well as educational. I asked her to talk about D/2 and D/3:

> Well, in D/2 the kids are probably from about fifteen to nineteen or twenty [years old] because they're often in their last years of high school and the first couple of years of college. And then they can put on their resume that they danced for Philadanco. So a lot of them did get jobs after being in D/2. But when I have auditions, I see all these kids looking for work and I can't hire them all. So I said, okay, let's do something with them.
> D/3 is my kids in the school *[Dance Arts]* who are really talented. We have to encourage them to dance, because so many of them, when they get to the twelfth grade, you know, they go to college and dancing falls by the wayside. And I think there's just so much talent that gets neglected because they're not encouraged to dance. They are in the nine to fifteen age group.

Clearly, JB is carrying on the tradition extolled by Judith Jamison of creating performance opportunities as part of the dance education of talented youth. D/2, the training program members, do not pay for classes and generally receive some pay for performing but not for rehearsals. JB adds, "I tell the kids, 'I think I owe you enough to buy a car,' because every time they perform we haven't been able to pay them."

As I mentioned in the Prologue, the Philadanco Way edifice is made available for Dance Arts alumni, students, parents, and friends of friends to hold baby showers, shoe and apparel sales, planning meetings, and so on. Sometimes a small percentage of the sales goes to the school, more as a courtesy than a money-making strategy. What I find admirable about these ventures is that they are win-win situations, and no one has to feel as though they've been given a handout: D/2 dancers are in a bona fide pre-professional training program, performing but receiving free classes; D/3 students pay for classes at Dance Arts, but they are given sterling opportunities to perform that would not otherwise be available to them as minors; and community members may use the studios for rehearsals free of charge or for a pittance. Another example of this give-and-take was the "winter package" vacation JB offered community members to travel on tour with Danco to Bermuda. JB recalls that about six or seven people came on the tour. Then, in the early 1990s (she couldn't recall exact years) she hosted a radio program on WHAT, a local African American radio station, which lasted for three years and was yet another way to educate the community about its black arts activities: "We just talked about what was happening in the black community and the arts, and we invited people on who were in town to talk about what they were doing and where they were going to be and things that were going on in different institutions. It was called 'Your Cultural Connection,' but I was out [touring with Danco] more than I was in, so I had to drop it." Around the same time she also wrote a column for a newspaper called the *Jazz Philadelphian*. And even earlier, she occasionally wrote feature articles for the *Philadelphia Tribune*, such as the 1977 piece on Essie Marie Dorsey mentioned in chapter 1. Throughout, her ulterior motive is to get the black community to support black arts in general and dance in particular. Through venues such as these as well as the thousands of students who have graced the studios of her main and satellite schools, JB's influence has had, and continues to exert, a lasting effect on many lives. What she offers is a dance magnetism that draws people back to the fold while still encouraging them to spread out and fly. Here's what Chase said, when I asked, first, how contact with JB had influenced her career and, then, how the Philadanco dancer fit into the larger dance picture:

> I don't know, don't see anything else I could have done with my life, you know. There's no looking back and going, "maybe I should have done this," or "my life would have been this"—and I'm sure some people do, you know? They don't enjoy their jobs! *[I came]* from Sarah Conway[11] to Joan Myers Brown, and then from Joan Myers Brown it was to Alvin Ailey and then back again, but in a whole new capacity and in a

whole new learning experience that's kind of taking this love of dance to another level. It may be like another passage in the lane, but it's an even brighter and bigger passage, so I know that she's given me this wonderful opportunity....

Our dancers are everywhere! So it's something about Philadanco and the training at Philadanco that they can go anywhere just about, and do anything. It would be a big chunk out of the larger dance picture if Philadanco wasn't there. They give you every last thing they have when they're on that stage: "Nothing to prove, everything to share," Ulysses Dove said that, and I shared that with them when I came back *[from Ailey to Danco; Dove had also been an Ailey dancer]*, I shared it with the group that was here. And it's something they kind of held onto and passed on, and that's what's unique about Philadanco dancers is that they're not trying to prove to you how good they are—they really want to share with you *who they are*.

Underneath the technique, glamour, and flair is the passion of their sheer humanity, onstage for all to witness. The passion has to be there, but how to use and share it is a learned experience. For Chase, Bears-Bailey, and Milton Myers, their particular task is to keep alive the original spirit and passion that make Danco unique, while balancing tradition with contemporary needs. It's almost as though their mandate is to teach a Moses sensibility to a Joshua generation of dancers.

THE JOSHUA GENERATION

It is November 27, 2010, the Sunday of the Thanksgiving weekend. I've cut out early on my family gathering to sit in on the Danco rehearsal for their special Danny Ezralow program, scheduled to run December 9–12 at the Kimmel Center's Perelman Theater. No matter that it's a holiday weekend, the show must go on. JB and her staff have struggled to set up a rehearsal schedule that would allow Ezralow to leave the New York rehearsals of *Spider-Man: Turn off the Dark* for just one day to clean up the three works of his to be presented on this program. All three have been performed before and so there are performance and rehearsal videos, as well as the sure hand of Chase as rehearsal mistress and eagle eye of JB, who doesn't miss a beat. Still, the eye and hands-on presence of the choreographer are usually expected when a work is remounted. But the *Spider Man* schedule hasn't yet allowed the visit: Ezralow's over his head as choreographer for this Broadway musical and all the big-bucks strings attached, and those

rehearsals aren't going well. He's told JB, in phone conversations, that they're working from morn till midnight, then starting over the next day for another round of 12-hour rehearsals and revisions.

The Jewish-American Ezralow is a quintessential Joshua. He reaped the benefits of having studied dance in a university setting (University of California, Berkeley, graduating in 1976) and danced with a true Moses giant, Paul Taylor. Ezralow is a particularly media-savvy Joshua, having choreographed for advertising products put out by clothing companies and designers such as The GAP, Hugo Boss, and Issey Miyake; for the Los Angeles and Houston Opera companies; for film and television; and for theatre, including the current much-touted, multi-million dollar *Spider Man* musical. The Joshuas are digital age multitaskers, and their commitments are thickly layered. Ezralow's is a quintessentially West Coast, California, Los Angeles sensibility: for him, the separation between art and entertainment is smoothly erased. I took notes while observing the final hour of the Sunday rehearsal—disappointed that the choreographer wasn't in attendance:

> It's always interesting to see the dancers working with Chase, and she's taking small sections, one at a time, and cleaning up. They're rehearsing the Louis Armstrong "Is That You, Santa Claus?" final section of Xmas Philes.[12] While Chase leads and corrects, they're also watching a video of a rehearsal as well as working things out singly or in pairs on the sidelines. No one is idle. The Moses-Joshua dichotomy emerges at one point: Chase is directing the dancers in how to perform a certain step to this 1950s jazz tune and says, "You know, you gotta get down like this [she demonstrates] and dig in to get that old-school, down-home jazz feel to it." Her demonstration is not the highly technical style that these dancers immediately associate with the term "jazz dance." JB comes in at the very end. She doesn't say anything, though she observes the final run-through. Obviously Chase has done what was needed for this rehearsal, at this moment. Rehearsals will continue right up to the day of performance.
>
> Chase is superb at what she does: not only cleaning up the detail on each body (and each body in the ensemble is so very different) but also for the spacing; the rhythm; the dynamics. She is keeping the integrity of both the piece and the overall ensemble aesthetic. When I asked about several new faces in the ensemble, JB tells me that Roxanne Lyst (a white dancer) is back with Danco after seven years with Ailey. And Janine Beckles, new to the company, has come in from

the Dallas Black Dance Company, a route that many of Danco's dancers have traveled.

What a rehearsal: JB must look incredulously at what she's created: how could she know that she'd institute such an amazing edifice?

As for the actual performance, the Ezralow program consisted of *Compassion and Revenge*, *Pulse*, and *Xmas Philes*, performed in that order. The opening dance is an unfinished statement sparked by Ezralow's response to the 9/11 attacks in three United States locations. It serves mainly to introduce us to the dancers, dressed as they are in street clothes and speaking directly to the audience. Ezralow's choreography offers a different experience for the Danco dancers, a collaborative situation that serves to show us another side of the Philadanco aesthetic. In *Pulse* the dancers wear sock-shoes (invisible to the audience) and slide-glide across the floor singly or in simple groupings, their shapes in space shifting smoothly and the flow of movement unfolding like puffy clouds—people clouds—filling the space. It is a short work of simple, uncomplicated body shapes that moves the space and effectively uses the full ensemble in many exits and entrances. It's like flying through the air—if the floor were the sky—fulfilling the desire to move with the speed and lightness of birds.

Xmas Philes is another example of Ezralow's simple movement style. The opening is composed of just a few Yoga-based movements—downward dog, pigeon, upward dog—and, in Pilobolus style (he had danced with that company in his early career), the dancers wittily shape their bodies to spell the words, "Xmas Philes," the orthography obviously a reference to Philadelphia. There is a cartoon quality to his choreography, in the best sense. Dark lighting and short "takes" parallel the separate story-pictures in comic books. It's the final dance on the program, created to a bevy of Christmas songs, and is the perfect short form for his ideas. What is marvelous is that this dance gives these superb performers the opportunity to play silly, childlike characters—not your usual Danco profile. The ensemble has always excelled in dramatic characterizations, but this is their first opportunity to really cut up with slapstick humor. Nevertheless, the piece also has sobriety to leaven the comedy. The eleventh of eighteen dances, "Jingle All the Way," is its serious centerpiece. To the familiar *Jingle Bells* song the company performs a hard-hitting, ironic work. The bells are on gumboots, jingling because the dancers are stomping rhythmically without a smile or laugh to be had. They are garbed in work suits. We think of South Africa and the gold mines, but we are also reminded that the heritage of most of these artists hearkens back to the forced labor of American slavery. It stood out as an oddity in the midst of the other seasonal songs and celebrations, but it was done with the right attitude.

Another dance also referred to the Africanist heritage: for "Santas in Black" seven Santas disrobe and morph into aloof men in black suits and sunglasses, which I presume is a reference to the men of the Nation of Islam. The ensemble makes amazing transformations in personality and in costumes for each number. The dancers' input was a significant contribution to the choreography—a new direction for JB's "children."

Let us move to a different choreographer and a different kind of dance and set of circumstances. Hope Boykin, an African American woman, is a Joshua who returned to Philadelphia to choreograph for the company she used to dance with. In addition, she counts resident choreographer Milton Myers as one of her mentors and guides, along with JB. Here are sections from an article I wrote for the *Philadelphia Inquirer* based on rehearsals I observed in February 2009 as Boykin prepared the ensemble for the premiere of her new piece, *Be Ye Not*:

> "Just be clear about what you know, and the rest will fit!" So she exhorts the dancers as she prods them to move in her special style—taut, quick, asymmetrical, grounded, percussive, and at the same time ecstatic and exhilarating. In verbal and body language she relates to the Danco dancers like a big sister on leave from her day job, spending quality time with the family and showing them her stuff....
>
> Seventeen minutes long and set to music by the Ahn Trio, Be Ye Not is a minimalist story dealing with insider-outsider, loner/group encounters....
>
> This work, on these dancers, is very Philadelphia, quintessentially Philadanco, and the epitome of urban-tough "attitude"....
>
> In describing a lift,...Boykin urges, "You're just gonna run and jump, like you're jumping a fence and you just don't care. Then I'll give you the movement." (In the same spirit, she quips, "If I had anybody standing someplace, and I told you I was gonna put some movement to it, please remind me!") Later, she muses aloud, "This last section has to be more aggressive—not the movement, but the intention."
>
> That's Boykin, and the organic, space-conscious way she approaches dancemaking: Get the overall feel and attitude of the movement, then go back later to fill in the holes. And let the intention drive the shape.[13]

Boykin has an ease and familiarity in dealing with the Danco dancers that sits well with them. Even before she left Danco for Ailey she exhibited interest in choreography and had already tried her hand at making dances for the "Danco

on Danco" concerts. Nowadays she is not only dancing with Ailey but has choreographed for that ensemble as well. As shown by the *Inquirer* excerpts, her process and personal style is friendly and hands-on. She is yet another Danco-Ailey-Danco link, a Joshua dancer and choreographer standing on the achievements wrought by a particular Moses teacher and artistic director—namely Joan Myers Brown.

Kim Bears-Bailey extolled the virtues of Trey McIntyre,[14] who choreographed *Natural Flirt* for Danco in 2002. McIntyre, who is white, has choreographed for ballet companies across the nation, having begun with the Houston Ballet Company. Bears-Bailey pointed out the differences in ethnicity, gender, and even class that are represented in the choreographers JB has chosen to make dances on her ensemble: "We have a director who only allows people to come into our home who want to make the best for us," Bear-Bailey said, equating the nurturing they receive in the workplace with domestic comfort and security. "Trey McIntyre was a choreographer who Joan had researched and looked into his work," she continued, "a warm, wonderful gentleman. He was about 6 foot 7. He was amazing because he looked like a basketball player. He came in with no preconceived notions about what we could or couldn't do, but went, 'This is my canvas, these are my dancers, let me create.' And it was wonderful."

Milton Myers, who is African American, is, as we saw in chapter 4, a particularly loved dance figure, a Joshua described affectionately by the dancers interviewed for this book. Hope Boykin, Elisabeth Bell, Zane Booker, and Tracy Vogt singled him out as an important mentor. JB hired him as resident choreographer when she saw that Myers manages to find the right key in which to "play" the music of the Danco dancing body, as this newspaper review in the *Pittsburgh Tribune* points out:

> The first piece on the program, "Pacing," *[choreographed by Myers]* set the stage for the remainder of the performance. Unlike many dance programs, which seem designed to start out slowly and build in intensity, "Pacing" was a blockbuster. The combination of African and ballet movements provided an intriguing and demanding challenge, which Philadanco's highly trained members met without hesitation. The balletic influence was reinforced by the physical appearance of the dancers, all of them elongated and elegant in form with the women's hair tied back in ballerina buns, and an array of classical steps—arabesques, swooping lifts and formal landings. These were interspersed with the intense contraction-expansion movements and rhythmic swinging of the body characteristic of African dance.[15]

Myers came to Danco in 1986, when the company received a "National Choreographic Project grant for him to do one piece, and he's been here ever since," says JB. He considers JB his mentor and model. When I asked him to tell me what was the first impression that comes to mind when he thinks of her, he said, simply, "A force. A force. A powerful force to deal with." Like Rennie Harris and Zane Booker, he credits JB with nurturing his career and making him a better choreographer, not so much by what she did but by questioning

> why I would choreograph the way I did. What's the reason. She sometimes would stop me and say, "I want you to do what you want to do, but I think you can do better. Can we not do this piece? Will you consider something else?" And so we've had those discussions, and sometimes of course we've had our conflicts as well, because I think, "Well, why not this? I feel this." And Joan has always said, "Because I believe I know what I need from my company." And in the process, as she got to know more about me, she said, "And Milton, I believe that there is more to you than that."

JB saw that Myers brought something that could amply utilize her dancers' ballet training—perhaps in some way fulfilling her own long-ago ballerina aspirations for, in truth, some of Myers's works (like Gene Hill Sagan's) lend themselves to performance on pointe. And she also understood that having her as his mentor and her company as his proving ground would allow him to grow. Back in 1986, as noted earlier, even though Danco was clearly ballet trained and performed dances by Sagan, the public and critical perception of the company was of a "black" dance company performing "black" dance. Myers came to Danco after having taken over the Joyce Trisler Danscompany, a predominantly white company, when Trisler passed away.[16] It was rare enough for a black male to be at the helm of a white company, but according to Myers, the public "had kind of an acceptance of me a bit—'Well, Milton does this [kind of] work.... [but] why is he doing it for Philadanco?' And so a bit of what I wanted to do with the company and with Joan was to *infiltrate* that and to put that in. I wanted the public to look at the company in a different way." Let us continue with some of the interview that followed:

> BDG: So, in other words, "Oh, it's alright if Milton Myers, of African American lineage, does a certain kind of dance for the Trisler company, a basically non-black company, but then if he, as a person of

African American lineage, does that on a company that is predominantly black—

MM: "Why is he doing that?"

BDG: Huh!

MM: I found that very strange. I thought, "Why are you asking me why I'm doing it?" Because this is what I do!

BDG: Right—race in the late twentieth century and in the new millennium—very interesting.

MM: Yeah. Like the choice of music...I think it was very surprising when we went to the Joyce, I was still pretty new with the company and I had done a couple of works to kind of get my footing with Philadanco and the dancers, and then I said, "I'm going to do a piece called *Joy*, and it's going to be to Bach, and...." And I remember when they premiered it at the Joyce, the critics and the public, they all said, "Well, this was a breath of fresh air and something new for Philadanco." And I thought, "Really?!" Really—because I had seen Gene Hill Sagan's work, which used the classical way and it was almost ahead of its times in terms of contemporary ballet, and so I thought, "Wow, have you not *seen* Philadanco—*truly seen* Philadanco?

For many spectators caught in the thrall of an unconsciously biased white cultural gaze the answer is, no: they had not truly seen Danco but seen, through an ethnocentric lens, what they presumed they would see from a "black" dance company (or a "black dance" company). It's an updated version of the John Martin critique in 1940 that the young Talley Beatty's dancing was inappropriate due to his "serious dallying [in] ballet technique."[17] If a black dance, dancer, or dance maker leans toward the balletic, something must be wrong, period. Myers appreciated JB's mentoring because he explained that her role has been to encourage him to go further "in every direction possible. And to not say, 'Well, I should do this because of [whatever],' but to really go deep inside myself and say, 'I want to do something because of Milton Myers,' and not because I was maybe fighting with the system to accept [me]. She wanted what would be the best for Philadanco in relationship to what was coming from me, and not to worry so much about the public."

Back to Tracy Vogt, another Joshua, whom Myers had mentored from her days as a student at the University of the Arts. A statement she made in the course of our interview shows just how much race can be a non-issue in this era and for

this generation. It is noteworthy that Vogt is white, so we might assume that it is white privilege that allowed her to not register Danco in terms of race. She said that, "To me, quite honestly, the first time I saw Philadanco, I didn't even realize it was a predominantly African American dance company. I just saw the style of dance and was like, 'What *is* that?!' You know, and I'd never seen modern dance."

Nevertheless, I believe that all of us growing up and living in post–civil rights era United States, regardless of ethnicity, have had the luxury of "disremembering" race at some time or other. Take, for example, close friends or workplace colleagues, or, for me, it's my husband. Most of the time I forget that he's white, and he does, too. But we know that race discrimination is still with us in our private and public lives. JB's ensemble is seen and assessed as a black company, while no one thinks of all-white groups as white companies; and Danco is often booked in the United States as the token black entry on a presenting organization's series. If another "black" company is booked the same season, then Danco isn't. White groups don't have to deal with these issues. They are the norm. That's what white privilege means.

Elisabeth Bell talked about the struggle that she and her Joshua generation faced in learning to dance Talley Beatty's historical saga, *Southern Landscape*. It's an object lesson in Moses versus Joshua, old school/new age friction. Choreographed in 1947, the dance depicts the post-slavery, Reconstruction-era oppression, torture, and murder of African Americans in a South ruled by the emergent Ku Klux Klan. Musical accompaniment is provided by ageless Negro spirituals. Bell and her contemporaries may have felt removed from this past generation, but I believe that the entire "landscape" is the kind of painful memory that a young black artist could discuss intellectually but wouldn't want to dance. To perform this modern dance classic means embodying the pain of one's ancestors, not in church or at home, but before large audiences of "others." However, for an ensemble that prides itself on dramatic characterization, a dance of such choreographic skill and historical significance was an important addition to its repertory. The dancers were obliged to get it right. This is how Bell explained it:

> EB: She [JB] wants to move with the masses in many ways, but she refuses to forget what has gotten her to where she is. I think sometimes of issues for dancers of today who want to keep doing, like, "the now," but she's very adamant. I remember when they were revamping *Southern Landscape*, and that was a huge project that Danco was undertaking—a part of history. Well, she definitely had some "moments" with us as a company, and once again she was right. Because I was part of that group, I have to include myself, and *[we were]* just not getting, not getting it, you know,

BDG: How to perform it?

EB: Part of that, but really putting ourselves in those shoes, so it wasn't playing, you know.

BDG: Play-acting.

EB: Play-acting. I mean, the oldest—someone might have been born 1977, [19]76, maybe [19]75, but still it's nothing in comparison with *[the suffering depicted in the dance]*. I've had valid experiences that show race is still an issue in America now; I've had experiences to remind me that, yes, I am a person of color. But it's just not the same magnitude of the people before us. So just not only in not play-acting, but for people, for us as dancers to see what that was, what we were having an opportunity to be a part of. Many of us could not truly fathom that in the experience.

BDG: Do you fathom it now in hindsight?

EB: Oh of course!.... Yeah, I mean, to look at the videos, I think they showed us the video of Talley Beatty actually doing the "Mourner's Bench," and JB really being adamant with the dancers who were doing that. You know, her standard is so high, and her demanding from her dancers that we have the exact same high standard. And once again I felt like, I agree with her. It's kind of hard to be living in it in the moment, but to me in hind', she's right.

For Bell and others, the Moses generation's obstinate demand of them to keep to a standard that is not "the now" requires a dramatic stretch that, in hindsight, is valued because it increases the dancer's range and grasp but is not easy to live with in the moment. JB wouldn't settle for play-acting; her dancers had to "get it," embody it, from within. In a sense she was requiring them to be Method actor-dancers for this work.[18] Hindsight is twenty/twenty vision, so Bell ultimately saw the value of JB's old-school determination.

When asked what she learned from JB, Vogt cited "the whole 'fake-it-'till-you-make-it thing'—not feeling quite comfortable, but exuding confidence—and so that inevitably turns into inner confidence. I really learned that from her, because she can walk in and take control of a room and I wanted to be able to have that command and that power." As Vogt continues to tease out her meaning, we realize that it's not so much about faking, but more about finding your core and leading from that place of strength:

I wanted to be able to have that command and that power, that I don't just kinda slink into the back *[of the room]*, because I'm a very quiet

person. I was always very shy and that's why I *dance*, because I didn't have to *talk [she laughs]*, and I realized I could be, I could *talk with my body*, you know and I don't have to say a word. So you know I really think that *that*, for *me*, that Danco helped me find myself, to find *that*.

So let us look briefly at the Moses generation, on whose shoulders the Joshuas stand.

THE MOSES GENERATION

Nonetheless, Beatty was unpredictable. Talley taught and choreographed on Philadanco beginning in the mid-seventies; however, sometimes when Talley went to Philadelphia to create, his stay would end abruptly. According to [Joan Myers] Brown, "Some days Talley just didn't feel like working. He would come to Philadelphia and he would say a few profound words. And then you look and say, 'well, where is Talley?' And Talley would be on a train back to New York!" Myers Brown would ask the dancers, "What did you do? Who made him mad?"[19]

This is a description of Talley Beatty, the brilliant, moody genius who set his works on Danco, Ailey, the DCDC, the Cleo Parker Robinson Dance Ensemble based in Denver, Colorado, and other so-called black dance companies. It remains a mystery—and an indication of the racial divide that still exists in the United States—that only these companies of color perform and preserve the choreography of Talley Beatty and a handful of other gifted African American choreographers. After all, they are American choreographers, and theirs is a shared heritage. In his homeland white companies do not perform his work.

The opening quote appeared in the essay written for one of the programs connected with Danco's remounting of Beatty's *Southern Landscape* in 2007. In the same article, Cleo Parker Robinson characterized him as "A very complex and sensitive man. The era that Talley came from made him feel disconnected with the young people he worked with, but he fought hard to connect with all of them." Indeed, he did not have to resort to Method acting to relate to pre–civil rights era racial terror. Born in 1918 in Louisiana, his family joined the tens of thousands of African Americans who migrated from the South to points North in what is known as the Great Migration.[20] He grew up in Chicago at a time when anti-black racism was rampant, even in Northern metropolitan areas, with black movement and potential severely limited in every aspect of daily living. But it

was better than lynchings, sharecropping, the Klan, and all the other horrors of post-Reconstruction, pre-1970s life in the South for African Americans. No wonder he was unpredictable; no wonder he could react with verbally abusive anger; no wonder he felt a disconnect between these new, academically trained dancers, unhindered by the racism he'd endured, and his own generation. The politics of experience created a gap separating him from them. It was thanks to Chase and Kim Bears-Bailey that a bridge was made between the two generations. As early Joshuas directly trained by Moses giants, these gifted women have a foot in each camp.

At the 2007 Philadanco Symposium held in connection with the *Southern Landscape* reconstruction, Delores Browne spoke intimately of Beatty. She had danced with his company in two of his masterly works, *The Road of the Phoebe Snow* (1959) and *Come and Get the Beauty of It Hot* (1960). She remarked that Beatty's mantra was "just be present." He had a respect for the space, the room, and disallowed knitting, chatting, or stretching on the sidelines. In the spirit of Balanchine (who compared making dances to cooking, rather than composing music), he had declared, at some point, "I like to make dances—no big deal about it."

Bears-Bailey talked about transmitting the work of Sagan and Beatty to the generations of dancers who came after their demise. (Sagan died in 1991, Beatty in 1995.) She addressed the deep significance of their work to Danco's sense of identity and how important it is for the dancers to

> embody these dances, to not just come in and do steps: to embody Talley, to embody who Gene was. Being retired, when I remounted Talley's work I got myself back into classes so that I could physically be able to dictate what was needed of the dancers as well as verbally and spiritually pass that torch on. I think that's important for them to physically see it, because we did. Talley didn't move a lot, but just an arm gesture, you didn't forget it. Gene moved a lot: "Pick me up. Feel what that feels like," you know, so we got to be a part of that, to [bear] witness to that. And these dancers don't. So Chase and I have an incredible opportunity—the opportunity to give that to the dancers through our teachings.

It is noteworthy that she describes as an opportunity what others may have understood as a burden. But her and Chase's respect for and devotion to the work are such that they joyfully take on their challenging avatar roles, bringing the good news to the next generations.

Chase was part of the generation that danced when they weren't paid a rehearsal salary, didn't have year-long contracts, and had few performance opportunities. She talked about the Dancemobile performances:

> In the summertime, 99 or 100 degrees, we were doing Talley on the side of a truck, and it would have bolts sticking up and we would just dance our hearts out.... The Walnut Street Theater was our big concert, then the rest of the time we'd do high schools, maybe, and then Dancemobile. So I always remember sweating bullets, dodging people, sticky Marley *[a commercial dance floor covering]*—but we were dancing!

Again she cited the friendship, the feeling of extended family, and the passion that characterized their dancing and their young lives. As mentioned in previous chapters, they danced together and, as much as possible, hung out and lived together: "We would leave rehearsal because we couldn't stay any longer, and we would then go to somebody else's home. And we would put the music on—Talley's music on—and we would move furniture and we would do Talley.... So that's that passion I was talking about...."

Gene Hill Sagan was central to Chase's and Bears-Bailey's development as dancers. He and Billy Wilson are Moseses who trumped the race card and made their own Promised Land by expatriating to Europe (and, for Sagan, Israel as well) for a formative, racism-free time in their careers. When Sagan returned he became the resident choreographer for Philadanco. The story of how Sagan found his way to Philadelphia and JB is worth telling. The auspicious moment took the form of a letter. He had returned from abroad just for a visit but found instead a niche that didn't exist when he had expatriated years before. It is an eerie, magical story. JB told it to me when I interviewed her in 1988.

> Thelma Hill sent Gene Sagan to me. He just walked in one day [in 1980] and said that Thelma Hill sent him and [she said] that when he came to Philadelphia he should choreograph for Philadanco. At that time, Thelma had just died, and Gene was very emotional about that. [They had toured and danced together in the New York Negro Ballet.] Five days after her death, I had gotten a thirty-two-page letter from her telling me all the things I should be and the people I should be in touch with. Seemingly, she went out to mail that letter to me and came back, and then her apartment caught on fire the same night. When I got that letter, it was like getting a letter from the grave. Every now and then I go back and read that letter and try to make sure that I touch base with all those people she advised me to. But Gene had walked in the door and has been here

ever since. He says I saved his life, and he sort of saved mine. He's been a wonderful contributor to our repertory.

Sagan remained with JB until his demise, choreographing a key group of beautiful dances that fit to a tee Philadanco's classical spirit. Chase emotionally admits that it was Sagan who "really made me believe I could dance." She tells me that Danco dancers of the current generation compete to be cast in his works: "They love it. It's just how his movement is so...it's organic. And you just have to go there with it in order to really experience it. And once you do, as a dancer, it's phenomenal. I've had dancers cry, you know, they're so happy. And I know what that feels like." Zane Booker vividly recalls working with Sagan:

> Me and Gene just connected. The way I learned to be in the creative process was through Gene and Louis *[Johnson]*. And they were similar but very different. Gene would do a phrase and then you would copy the phrase. And then he would start to mold the phrase. I didn't know that then, but he liked me because I didn't ask a bunch of questions, I would just repeat what he did. So he would go whooooaahhh *[he makes a whooshy wind sound on a long exhale]*, and he would go spinning across the floor. And then I would imitate it, and then he would start to shape it. He just made you dance, I don't even know how he did it. He insulted you: "You look like a wet noodle. I don't know what that is." But I just remember a supportive energy. I never remember feeling rejected in that space. I never remember not being challenged in that space. I always remember trying it over and over again, you know, and him working on it and fixing it and then creating this phrase. I remember Kim, how she used to get us to all be on time *[in dancing together]* by little noises or the way she would move her body.

Booker's reminiscences take us into the heart and soul of dance culture: not what the audience sees on stage but the quotidian tedium of working through a dance, movement by movement, phrase by phrase, day after day, in the studio — doing it and doing it until you get it right. It is noteworthy that he cited "supportive energy" in the same breath as he told me that there could be insults. Perhaps it was because he was so young and so eager that he didn't ask a lot of questions. He was the kid who stood at the door while the "grownup" company members rehearsed, and he dreamed of joining them. He continued:

> I remember watching *Conversations for Seven Souls*[21] before I got *[cast]* in it. How powerful the first drop was that Carlos Shorty used to do in

connection with Dr. Martin Luther King, Jr.'s voice. There was a line in the speech when he said, "death," and Carlos would do this contraction, he would fall and catch and then would chaîné[22] out. It was an amazing piece to me. I was so enthralled with it and I just remember wanting it so bad—wanting to be part of dancing like that. You know, because it just moved. Gene's work just twirled. It was like a series of tornadoes and shapes and forms in his work, and it was so much power. And he was such a classical person, really. His whole approach was classical.

Booker contends that Sagan "never did the same thing twice." Thus, the version of *Conversations* that he danced in later seasons was molded to the bodies and needs of the new dancers. Many choreographers of any generation adhere to this policy of not forcing a dancer to fit into a mold he/she can't sustain but reshaping the movement to the dancer, instead.

On the other hand, with Louis Johnson, "You had to do the step," says Booker, with a laugh. Johnson gave Booker a different set of important qualities:

Now that I've worked with him over the years in different situations as an assistant, I realize what it was that he got out of us. He could make you move around your center classically and technically and still move around that center with speed and clarity. He would always pull exactness from the technique.... We'd be like, "there's no preparation in that, how we gonna do that, where's the preparation?"[23] But the way he coached you into it, it was there.... Gene really created the movement around you and Louis might tailor it to you, but he was gonna push you for his vision. I think that was the difference. So you grew in that way. Gene had a little bit of both. He may have a vision for the role, but he was definitely into creating stuff with the dancers that were in the room and with him. He wanted you to get out there and follow him and spin and twirl and go over the phrase and see where it would go.

[In my own choreography] I think in the first phase I'm a Gene and in the second phase I'm a Louis!

Both Sagan and Johnson were important shapers of the early Philadanco aesthetic, and both approaches set the company on the road to becoming one of the finest modern dance repertory ensembles in the country, able to interpret and embody many choreographic visions. But working with genius can be nerve-wracking, and artists can become short-tempered and vitriolic when a

performance is at hand and they aren't getting what they want from their dancers. Continuing with Booker's reflections on Johnson,

> He started working with me before I had a chance to work with Gene Hill Sagan. So he was my first male [mentor] from that *[New York professional ballet]* world. He was the first male that really grabbed me. And he used to curse me out and lock me into a studio, and we would work on double tour[24] for an hour—or at least forty to forty-five minutes. And it wasn't just me: he was that way with everybody. I remember the first time he made me cry. But at that time I didn't know what kind of coaching I was getting. I was just trying to get it....
>
> By the time I was fourteen I was performing with the company—by fifteen, for sure, I was both taking classes and rehearsing with the Company. I have a strong memory where Louis hurt my feelings *[and it was]* devastating. Because at Danco, you know, you get cursed out all the time! [Laughing] So by the time I'm fourteen or fifteen that kind of thing is—you know, your skin is really thick. You hear the note *[the correction]* but you stop hearing how it's presented 'cause that's just, you know, that's how Mom talks. And it doesn't penetrate your soul. But this note from Louis: he was so mad at me, and he told me I couldn't dance, and you think you're trying to hit the right mark and everything. I remember we were doing *Treemonisha [Johnson's choreographic interpretation of the Scott Joplin opera]* at the Mandell Theater[25] And I remember being in the hallway and being cursed out. [He said,] "you can't f...ing dance, you can't even count to ten!" I remember going behind the curtains and crying and before I came out I had stopped, 'cause I didn't want anybody seeing me do all that.
>
> I think I did okay with *Forces of Rhythm [a Johnson choreography]*, but by the time we got to *Treemonisha*, I used to get cursed out all the time!

It is only fair to Johnson to explain that Booker and Kim Bears-Bailey were the new soloists being worked into the remounting of *Treemonisha*. Carlos Shorty and Karen Still-Pendergrass, the older originals, had moved on. Booker himself admitted that "probably my focus wasn't there. I think when you're younger you don't really know when you drift." Johnson was old enough to be Booker's father, and, in a sense, he was treating this adolescent performer like a child who needed scolding. In spite of its harshness, these experiences add up to the consummate artist Booker has become. (And scolding and harsh treatment are historical precedents in dance cultures everywhere.) Having danced professionally

with Philadanco as a young teenager, by the time Booker was 18 and ready to go out in the world he had worked with Sagan, Johnson, Beatty, Billy Wilson, and Milton Myers (who had set his first piece on the company before Booker moved on)—artists of the highest order. He had sterling credentials.

I would be remiss were I not to reiterate that Joan Myers Brown is a true Moses. In all of her actualizations her brand of tough love spills over in the dance classes and company rehearsals and is the air one breathes in dealing with her—just as Rennie Harris described in chapter 4. I must admit that, personally, it took me a while to adjust to her curt style, and my feelings have been hurt more than once by a bluntness that I was not accustomed to. JB is elegant, but she is unceremoniously outspoken, as her quotes throughout this book clearly demonstrate. She doesn't mince words or waste time with nice embellishments, and her comments can be cutting. Women mustn't be heavy. Men must project maleness. Everyone must give 150 percent, and the show must go on. She's a woman with a purpose and an agenda who wears several hats and multitasks as a fact of life. Her overarching concern is the quality of the work. Sometimes that aim is met at the expense of individual egos. But she expects her dancers and staff to do what she learned back in the day: bite the bullet, try harder, and work longer until you get it right. Put dance at the center of your life. Be your best at all times, onstage and in life, and be a role model for those who will come after you. That's Moses, all right!

To conclude the Moses generation section, I offer this extended excerpt from a three-hour interview I conducted with Kim Bears-Bailey. Her detailed, sometimes painful narrative of working with the great Pearl Primus deserves our attention. At times a convoluted and unsettling story, the subtext touches on genius, perfectionism, humility, pride, love, challenge, frustration, resignation, the generation gap, perseverance, continuity, and, ultimately, a spiritual exercise in walking through fire. It is important to realize that this was the first time Primus put herself in the position of "giving" three of her most important solos to any dancers. She had choreographed *The Negro Speaks of Rivers*, *Strange Fruit*, and *Hard Time Blues* on her own young dancing body in 1944–1945. Four decades later she was nearly seventy years old and living in a dance world that looked upon her and her work as a cross between a relic and a classic. She held a professorship in dance through the University of Massachusetts Five Colleges Dance Consortium, and the prestigious American Dance Festival had given her this opportunity to remount these works. But the 1980s dancers—their concerns, training, and very existence—were worlds apart from the dance and life experienced by a woman who had already lived half her life during the era of institutionalized American racism. These solos graphically embody the sorrow and anger of her people, not

as historical afterthoughts but as lived experience. They are not simply academic reconstructions for Primus. They must be danced as if the dancers' lives depended on it—as did hers when she danced them back in the day. And this is what she demanded of Philadanco dancers Kim Bears-Bailey and Warren P. Miller. In a newspaper article about her rehearsal process she said she felt compelled "to bring to them some of the social environment in which these dances were created. It is not just a matter of lifting a leg, it's the why."[26]

Primus aimed to strip away from her young soloists their old dance habits, to purify them for the task she set before them. Her intention has aspects both of a spiritual master initiating a neophyte and the many Moses teachers and choreographers who take on discipline and tough love as though it is a religion. A personification of both, Primus inspired love and terror. In the end, her goal was transformation. Bears-Bailey danced *Strange Fruit* and *The Negro Speaks of Rivers*. Remarkably, and daringly for 1944, the first solo is by a black woman dancing as a white woman. Primus explained, "The dance begins as the last person begins to leave the lynching ground, and the horror of what she has seen grips her, and she has to do a smooth, fast roll away from that burning flesh. The hurt and anger that hurled me to the ground in that solo were translated into an anger that took me into the air in *Hard Time Blues*." Miller danced *Hard Time Blues* because Primus "could not find a female dancer who could execute the five-foot high jump that made her famous." About Bears-Bailey's work on her roles, Primus said that the young dancer "wants to go deeper, and her body is questioning." The "maestra" continued, saying that her choreography is inspired by the power of African sculpture and "the force that seems to enter you. Any dancer should go beyond the natural and give it a different level of dynamic. In Africa, the dance is the going beyond."

And "the going beyond"—the transformation—is what Bears-Bailey attempted to do, prostrating herself at the altar of Primus's ancestral wisdom and heroic testing. Read on.

> BDG: I know you have had the luxury and privilege of working with some of the most revered choreographers in the dance field. Even though we don't have much time, I want you to take as much time as you wish to talk about it. Let me ask: the Pearl Primus work that you did, was this for Danco for ADF *[the American Dance Festival, held annually in Durham, North Carolina]*?
> KBB: Yes, for Danco for ADF.
> BDG: And I was just thinking of the kinds of interactions between you, the choreographer, the company, the particular works you had

to learn, the occasions for the performance and interactions with JB, the choreographers and the dancers—whatever *[you want to talk about]*.

KBB: Well, Pearl Primus—Momma Pearl, I call her—ah, that was a very high moment for me and my artistic growth process. I met Dr. Primus in the mid-to-late [19]80s. Of course I knew about her but did not really understand the magnitude of everything she exuded. She came to Philadanco initially to teach classes. That's the beauty of Aunt Joan, exposing us to any and every possibility of the wealth of what we have as artists. Little did I know that she was looking to pass on her legacy through three of her works. And I didn't know at the time when she was coming to Philadanco that ADF had commissioned her to do them. So I guess during her process of teaching here she had been looking. And I don't know how we got to be the chosen company, but it's written in the stars somewhere!

Aunt Joan had approached me about her *[Primus]* choosing me and another dancer in the company, a male dancer, to do her works for the 1988 project. I would say that by [19]86–[19]87 we knew we were the chosen ones. I think through watching us, watching our journey in her classes, watching a performance or seeing us in other classes, she got a sense of what our strengths were—our emotional content. Our technical abilities had very little to do with it. It was more about the human spirit than anything—how we related to our peers, to each other, what she got from us. Once we were chosen then she set up a rehearsal regimen. And, you know, I'm thinking, "Why me?"—again not realizing that it was written in the stars, that God already foresaw it.

So we had several rehearsals at the University of Massachusetts where she was a professor. *[Note: Bears-Bailey later added that there were rehearsals at Hunter College in New York.]* I think we spent a two-or three-week period that we almost did consecutively. *[Meaning the dancers traveled back and forth between these locations to rehearsals over the course of several weeks.]* And she rehearsed Warren and I separately. So I never saw his rehearsal process and he never saw mine. She wanted it to be that way. It was the most challenging, to date, experience of my career.[27] At that age I didn't understand that, from the generation that she came, she had to strip me first. I didn't understand that it had to be from a spiritual place.

BDG: And what does stripping mean?

KBB: Well for me it was stripping me of habits, stripping me to be pure, to find the purity in myself, in the translation of the movement—to find the in-depth meaning of what she wanted from me.

BDG: But you have so much technical training, you were a ballet major, it wasn't stripping of technique.

KBB: Right. No: *[her attitude was]* "You have that, fine: that's a given.... You are all so used to people coming in the studio and saying '5,6,7,8,' and you doing the step. Why are you doing it? What's the purpose? Where is it going? Where is it coming?" But when a choreographer comes in and you have two days to do a piece it *is* about what count are you on—count 8—it *is* about that. But she wanted to find out who I was through the movement. *She needed to find out Kim!* So when we went to New Rochelle, there was only Warren and I. We stayed in this little cabin. She said you musn't have any TVs nor outside visitors. It was just us and her. She needed it to be [like that] because the time frame was short. I think it was hard for her to think that she's passing on what was a deeply rooted part of her, her life, her history.

BDG: And these themes...

KBB: Oh, my goodness! But I didn't understand that at the time. And I have a feeling I wasn't meant to understand it at the time. I used to say that I wish I was older, but I think it would have probably been harder to strip me. I don't know. I don't know. I quit twice. I called my mom and said, "Can I quit?" I did!

BDG: How come?

KBB: I thought I couldn't please her.

BDG: She was tough?

KBB: She was very tough. I thought everything I did was not right. And it was as simple as walking. We would do it over and over and over again. Repetitiveness wasn't the problem, because I would work as hard as she wanted me to. She was doing it because I wasn't getting it. And I couldn't understand why I wasn't getting it. I think I was trying to define it without allowing it to be. I think I was trying to count it. I was trying to put a reason on it, and she just wanted it to be. She wanted to see my journey from this side of the room to there without me telling her [that is, not *demonstrating* the movement but *becoming* the movement]. She wanted to feel from my back. She wanted to feel in my feet. As you know, *Strange*

Fruit is based on a lynching, someone witnessing a lynching, and I'm going, "This is out of my league. I've only read about it, I don't know. I'd never witnessed it." I can imagine. I can take myself to what my ancestors probably felt. But how do you bring that to reality, how do you make that...

BDG: In a dance?

KBB: In a dance! And the fine line of how do you keep control of it. That was the hardest part for me. It was so emotional. And at the end of the piece there's a place where the dancer collapses from literally emotional exhaustion. And there was this moment where we were in a little cabin, I'm thinking we were in New Rochelle. And there was this studio in this little cabin by the lake. It was right on the lake, and I'm thinking, "this is great." Because usually we were in a studio—just me and her in a huge studio. [*As it was with the Hunter College rehearsals.*] I don't know where Warren was at the time. He was probably in New York. And there was a huge bay window and little ducks out in the pond. And I'm thinking this is great, just to get out [*of the city*]. Well, we ran in that studio for about six hours—nothing but running! But I ran to that point of exhaustion that she wanted [*me to*] recall. And I didn't really get it [*at first*], and then I got it. Then I got it, and she was like, "That's it—that's it!"

BDG: But then how do you call that up, so you don't have to get to that point again to dance it? Or was it just that you had to reach that point once to understand it?

KBB: It's a place. It's a simmering of energy, which, you know, is why when I came here [*to Philadanco*] you never marked, you did everything full out. There was a place just in your core that, to this day, allows me to remember stuff. And stuff comes, 'cause I just recall that place in my core that is not just "1 and 2." It's "a-1-and-a-2-and-a": it's that place where you can recall. And that place where it clicked in, it was almost like somebody took my voice away. What it caused me to do is recall something in my life that maybe peaked that same place. Whether it was a fear of a dog or whatever it was, there was a place that helped me find "Oh, that's the thing I needed to find again." Or "that's that place emotionally of exhaustion that I need to get to and not just say 'Oh, Kim, you're exhausted at this point, fall!'" She wanted me to physically feel it, from a real place. And I ran, and luckily she was gracious....

She loved me! I would sit at her feet and she would talk about how she sat at Langston Hughes' feet. And she would talk about her journey and her fight to make life different for other people. This was her platform: to make a difference.... When they knew I was selected I got phone calls from Joe Nash, Eleo Pomare, Louis Johnson, Donny McKayle. They all just kind of embraced me whenever I was in their presence.[28] They knew how difficult it had been for her... to relive it, and to release it.

The woman who is writing a book about Pearl *[Peggy Schwartz]*,[29] she came to me—she had actually witnessed a little part of the rehearsal process, and I think at the end of that particular rehearsal I just broke down in tears. I just felt like I didn't understand, there was nothing I could do right. She came and embraced me. She said you have to understand this is difficult for her to release this, difficult for her to go back into the time that she lived.

And then *[at ADF]* the first night we had our longest rehearsal, from sun up to sun down—and then down some more—where I felt like I was just going to fall over, Onwin Borde, her son, took me out. And he said something like "You know Momma loves you? You know that, right? You know that you are the chosen one, and if she didn't think you could do it, you wouldn't be here." He was just so comforting! I needed that—a reassurance just to know that it was okay to feel everything I was feeling, and to say that this is a part of it, this is a part of the journey. That, yeah: you're supposed to phone your mom and quit.

BDG: I mean, what JB and Danco were asking of you, what we talked about for the past two hours, was certainly the truth of yourself, the truth of your being—not just steps.

KBB: And she *[JB]* had been preparing me, little did I know. She had been preparing me for this. Because I believe that if Aunt Joan didn't think I was ready I would never have been that chosen one. You know, Pearl Primus is a goddess—so giving and nurturing at the same time and making you go beyond the dance. You had to go beyond the dance. You have to transform yourself to being it when you came in the studio. She never wanted to see me do my warm-up process.

BDG: Interesting.

KBB: No: because that's you being in this body. She wanted me to become whatever the journey was, I had to "be there" when she

walked in the room—*when she walked in the room!* And she didn't walk in the room until I was ready for that.

I think it was wonderful that ADF saw that to be a place to bring these works back to life. I understood that it wasn't a place for it to be in the Philadanco repertoire, mainly because of the magnitude of the emotional content. Very hard driven works. Physically *The Negro Speaks of Rivers* was more demanding. Emotionally, *Strange Fruit* was. I think we had three days of performances. I never saw Warren perform. I did the two pieces back to back and then Warren performed after me. Emotionally it took me a good fifteen to twenty minutes to find myself again, so I was usually in the corner sobbing in costume. So I never got to see Warren. When I did it the first time I realized it just kind of took over my spirit. And I was so glad that it took over after the applause came, because I thought, had I "lost it" within *[the dance itself]*, they wouldn't have gotten it, because it would have overshadowed it. So there was a place where choreographically she hit it right where it was supposed to hit. That at the end of it, by the time you left it, it actually kind of tapped you on your back! So that was really interesting.

I was prepared to sit in the wing and watch Warren and support him. At the same time I felt like I was still supporting him by allowing that *[the losing it, the sobbing]* to continue, because I wanted the space *[of my performance, just completed]* to be a continuum for him. And so it built up a nurturing bond for us, because even though we were separated he understood what I was going through. At night we would go, just the two of us, with our little radio and talk about our day, and he'd just be there: "Here's my shoulder, whatever you need, I understand. And you can do this: you can do this!" Not once did mom say I could—meaning Ma Pearl—but not once did she say I couldn't. And I think that was what spoke volumes to me.

BDG: That's interesting. So she didn't say that you could?

KBB: But never said I couldn't!

BDG: But even after...

KBB: After the performance she came to my dressing room, she peeked in the door and said, "Bravo! That was about 70 percent." But that was gracious! You have no idea of the magnitude of it. I was thinking, like, 20 percent–30 percent. And she said 70 percent, and if you know Ma, for her to even say that was BIG!

BDG: You are so gracious!

KBB: No. Because Ma—all she had to do was give you a look. More of what she didn't say—that was the beauty that compelled me to keep coming back. Just to be able to say that, because she said it at a time when I needed to hear it. If she said it anytime before then I would have gotten comfortable, been okay with "here I am, and we're good." It was never good, so every moment I was trying to find something else. I was trying to help myself through the journey instead of letting her do all the work[30]....

And then *[after the performance]* her colleagues, Eleo, Joe, and all of them, came up to me and just embraced me and said, "Thank you for that!" So that was wonderful. And I went. And I survived! That means I'm supposed to be exactly where I am. It was like, you know, confirmation. It was like going through confirmation. Confirmation.

BDG: Sounds like it made you grow.

KBB: It did. It made me find places in myself that I didn't even know that was possible. And it made me understand a little bit of her world.

⁂

PART TWO
FUNDING ISSUES

The two most central elements to a company's health and continuity are audience support and funding. This may sound counterintuitive, since the choreography and the dancers are what first come to mind when we think of a dance company. Nevertheless, a professional ensemble without a fan base and fund base is an ensemble in name only. It has been a constant battle for JB to secure the subsidies essential to obtain and maintain Danco's position as a high-quality national and international presence. Like arts organizations everywhere across the nation, Philadanco has seen a retrenchment of available capital since the 1990s. The situation becomes more tenuous for a "black" arts organization like JB's, because all too often funding issues dovetail with racial politics.

Take, for example, this paragraph from an April 1997 article in the *Pittsburgh Post-Gazette* previewing Philadanco's forthcoming performance at the city's prestigious Benedum Center in 1997: "Philadanco is one of the top four African-American companies, along with the Alvin Ailey American Dance Theater, Dance Theatre of Harlem and Dayton Contemporary Dance Company. It is the only one that is solvent, thanks to Brown's business acumen."[31] The writer

intended this as a flattering comment in a feature that was meant to draw audiences to the show. It is complimentary on two counts: first, it classifies Danco with Ailey (AAADT) and Dance Theater of Harlem (DTH); and, second, it praises JB's business savvy. But the race card is under the radar. First, why compare Danco solely with black dance companies, when the entire field of dance was suffering financial woes? This puts Danco and "black" companies in a separate category. Didn't we learn from a hundred years or more of struggle that "separate is not equal"? Secondly, the subtext of attributing Danco's solvency to JB's business sense lays the blame for insolvency not on retrenched funding but on incompetent management. And since no white companies were mentioned, it then appears that black companies are at fault. Regardless of how the reader may choose to interpret the quote, here we see the way funding issues can be cast in a racial context when a "black" company is the topic of discussion.

Oddly enough, the following month *The Philadelphia Inquirer* ran a lengthy Sunday article, featured on the cover of the "Arts & Entertainment" section,[32] in which JB is quoted as saying, "For the first time since we started I'm running a deficit." She explains that, about to begin its twenty-eighth year, the company owed over $60,000 in back taxes to the IRS. This wasn't the end of the company. Somehow she scraped through the crisis, maybe relying on the "fake it till you make it" philosophy: it is sad but true, nobody loves a loser, especially not in the world of arts funding. Saving face often means that the world at large, funders included, will continue to believe in you and seek some avenue to bail you out. JB tends to be more open in her conversations with Philadelphia journalists and more about keeping up a good face, especially in financial comments, when on tour. That said, it is still difficult to reconcile the difference between the claims in the *Inquirer* article and those in the *Post-Gazette*. When I asked JB about the discrepancy, she bristled at the fact that funding has always been a problem and, yet, she has fought all along to maintain quality and keep the company up and running. She said, "You could not have told me, when I started Philadanco, that forty years later it would not be different. It's not that much different.... There is nothing that is in *stone*, but the one thing that remains the same is the *struggle* — always a *struggle*."

Now, let us scroll back to 1990, a more difficult financial period for the company. The information appeared again in a *Philadelphia Inquirer* article, where it was revealed that after the company's fall season at the city's Mandell Theater, "the 14-member company will suspend operations for a month.... Brown simply does not have the $6,000 she needs each week to meet her payroll and pay for the upkeep of Philadanco's studios on North Preston Street.[33] In fact, each year brings fear and trembling around funding. JB is an excellent manager and

a down-to-earth practical planner where money is concerned. She explains in the article that she doesn't plan her budget based solely on grants. The city of Philadelphia had a financial crisis and so cancelled a promised $50,000 grant, and a bureaucratic glitch delayed an $80,000 grant from the state arts council. The only thing she could do was to temporarily shut down operations. With exasperation, she said, "If I have to sit down again with some young, dippy, funding person and tell them what Philadanco is, just to get a check for $1,000, I think I'll...." In one of our interviews in 2008 I asked her to talk about how she was able to weather this particular storm and how she manages, in such a crisis, to get back to where she was. Her response indicated her frustration:

> You never get back to where you were. You feel like you're starting all over again. I don't even really remember how I bailed out. Probably we started getting some work, and probably some grants came in, but I know I cut back on the number of dancers, which is what I did now, because there used to be eighteen dancers [in 2007] and now I've got sixteen.

I asked if cutting back on dancers meant a furlough or something more permanent. She replied, "Just let 'em go. When their contract's up, you let them go. [And] cut back on programming, you know, instead of doing it for forty weeks, you do it for thirty weeks. I'm talking about the training program, all those things." Thus, lack of funding affects all the performing programs—Danco, the Instruction and Training Program, D/2, and D/3—until the revenue gap is closed. (The school, Dance Arts, is not funded.) She clarified, explaining that back in 1990 she hadn't had to lay off any dancers but it was the first time she'd had a deficit. "The deficit just carries over, and you just continue to operate. You never really eliminate that deficit because nobody ever gives you a million dollar grant. So your deficit continues. I've carried a deficit now continually!"

That was then. The 1990s were perhaps the definitive end of the so-called dance boom that began in the mid-1960s with the first big foundation and government grants and the founding of the National Endowment for the Arts in 1965. The current climate is another matter, as JB explained:

> Actually, a lot has changed [in the new millennium], not so much for Philadanco but for the whole arts community, with all the corporations that are moving out of the city. And the banks have all merged. Where there were four banks, they've merged to become one. So it's very difficult. The foundations have come up with all these *initiatives* that you have to try to *fit in*. So it's different. Now, in the electronic age,

everything is on computer. On the internet they don't even have to *meet* you. So it is *much* more difficult now.

On top of these procedural burdens, there was a matter of in-house bookkeeping fraud that put JB's organization on shaky ground for several years. Before computerized bookkeeping became the norm and she had to start interviewing and hiring strangers to keep the company's books, JB's good friend Mary Johnson Sherrill (see chapter 3) had taken care of the books faithfully, and there was no question of trust or honesty. After Johnson Sherrill passed away, Karen Pendergrass's sister helped out, to maintain continuity. When she left, the trouble began. First, there was the college accounting student who had volunteered to help out and ended up embezzling $10,000. JB and her staff had had no inkling that anything was amiss until, on returning from a tour, JB noticed a gap in the books and couldn't figure out where the money had gone. The student was found out and put on restitution. But JB was burned again, this time by a professional accountant of some repute who happened to have a gambling addiction. Rather than recount this painful story of broken trust and ruptured books, I will suffice it to say that JB now hires a part-time comptroller to oversee finances. It's another example of a crisis best summed up by JB's comment, "you never get back to where you were." In some ways, running a dance company is as risky as being a day trader on the stock market.

As part of her determination to keep on keeping on, JB finds simple, creative ways to involve the community in helping out. "We used to do golf tournaments and the celebrity auction and Danco Dollar Days, which is easy. There's a million people in Philadelphia, and if everyone gave us one dollar, we'd have a million dollars, right?" She first initiated the dollar day concept in 1991 and brought it back in 2009 following this interview and when the country was in the throes of the global economic meltdown that began in 2008. Coupons that looked like a dollar bill were mailed out and placed in neighborhood newspapers. Some donors came to the school in person to drop off their donations. Many gave more than one dollar. In three weeks, the donations amounted to $36,000.

I asked JB what other major obstacles she faced besides the woes and perils of funding:

BDG: And beyond finances, in what other ways is it always a struggle?
JB: Well, without funding, you can't do most of it. But it's maintaining the dancers, and keeping your dancers. Running your program. You can't do *any* of it without funding. And if I had all the money in the world, *then* I would say, "What other problem?"

BDG: Let's pretend that you do. What are the problems?

JB: I wouldn't have any. Because I could pay everybody, I could hire the best dancers, I could hire the best choreographers, I could pay my staff, I wouldn't have any debt. So I wouldn't—there wouldn't be any [problems].

BDG: But that almost sounds like the thing where you think, "If I were rich I'd be happy." And we know that's not true. So then...

JB: Well, then, you're talking about emotion, and now we're talking about reality! Paying bills, paying dancers, buying choreography, buying costumes. Next month [October 2008] we've got to go to Colorado for five days and I have *no idea* how we're going to get there. Everybody's on unemployment, I have no money, how am I going to buy $7,000 worth of airline tickets, plus $3,000 for per diem? Is the hotel included, or do I have to pay for that? How do I make this work? So you know, it's *very* difficult. The dancers can dance, they are ready to dance, but we've got to *get* there.

BDG: I guess my questions at this point must seem like, "What is she talking about?"

JB: You know, I had a meeting for a long-range strategic plan, where they're talking about 2011. But I'm like, "What about *tomorrow*?"....

[she engages in an imaginary conversation with a funder]

[voicing the imaginary funder's response]: "Well, we have to plan ahead."

JB -"But do we *really* have to plan ahead?"

Funder -"We have to plan ahead so that we're not in this situation again."

JB -"But how do we get out of this situation? And what happens about *tomorrow*? And you haven't said to me that you're going to plan a fundraiser to help pay the bills, to invite six of your rich friends over for lunch and have them write a check: *that's TOMORROW!*"

Granted, September 2008, when I conducted this interview, was a nadir for JB and her entire organization that they have transcended since then. On top of the escalating national economic crisis affecting all Americans, a large grant owed to Danco had been put on hold because of the ensemble's unpaid back taxes. It looked as though this time the indomitable woman might not pull through, after forty-eight years of running the school and thirty-eight years of running Danco. Her mood was decidedly blue. Her pragmatic, Capricorn-grounded sense that

money would solve her problems was based on the reality and immediacy of her needs. And it is clear that, despite her comments above, she undoubtedly maintains an ensemble of exceptional dancers and, at the very least, interesting choreography. Money would not necessarily solve all her problems, but it would help ease the pain.

The question of the interface between funding issues and race issues resurfaced in my interviews with Vanessa Thomas Smith and Kim Bears-Bailey, who have witnessed, firsthand, the tug-of-war JB is obliged to wage with backers. Here is Vanessa speaking:

> You know, it gets to the point where you put your gloves on and you fight, and then sometimes you go, "I can't fight this anymore. I can't fight this battle anymore." If a funder can't see this product and all they can understand is that "there's some black woman from West Philly running it," you know, then even if you feel that that's wrong, you still have to deal with it. And it can be very much undercover and behind the scenes. Up front, they're like, "Yeah, diversity, this is wonderful and great." And then behind that door, they're sitting and having a discussion or a beer with their friends, and they're like, "She better not bring him home!"

Kim Bears-Bailey picked up on this under-the-radar race issue, the millennial subtext that sits as the backseat driver in many funding discussions:

> Joan Myers Brown is a fighter. As hard as it is behind closed doors, one of the places where she tries not to make that scene is in her company, meaning, the product. And so no matter what is happening—even if we have to close the doors down here [at the school and studios] whatever that product is, it's top-notch quality. The costumes aren't halfway because the budget is down. No. She makes sure that product is seen 100 percent in its best light.... We've got to stand strong, which could be seen as kind of hurting ourselves a little, with people thinking, "Oh, they're gonna make it. They're gonna get out of it. We don't need to help." But how much do you have to sink for somebody to help pull you out? And for us, the reality is for a predominantly African American company, that if you do sink, it's going to take you a little bit longer [to dig out] because somewhere underneath there may be that [attitude of], "Oh, I knew they [wouldn't come through]. We had them booked, but let's not take another chance." It's just those other questions that

unfortunately come into play when you put a label on an African American or a black anything. I think, even with Barack Obama, somewhere along the line I think there are still questions that they are asking, or that are coming to the surface—even if they don't say it out loud—that would not present themselves if it was a white president-elect.

It is noteworthy that Bears-Bailey's stream-of-consciousness line of thinking traveled from the plight of Joan Myers Brown to the white middlebrow funder to the general populace to the then president-elect—from black artist to white establishment to black politician. She is right: the roads are all connected, and some of them bear "no trespassing" signs for black people.

THE WHERE/WHY/HOW: RACE ISSUES IN CONTEMPORARY PRACTICE

I just echo—I hear Joan Myers Brown in my head. I witness what this company has done for almost forty years. If you parallel that to a white company and the support, be it financial, be it advertising, be it what they've accomplished, I hear her and I understand it. When she used to say it, I didn't really get it—that if we were a white company, the struggles.... You know, I'll never forget when Pennsylvania Ballet had their full page coverage in the Daily News *and the* Inquirer *when they were under financial strain. They made it public, people pulled out their checkbooks right and left....[34] And when it became our time to be in that kind of need—even though I think as a predominantly black company you didn't want to just shout that to the world, but people were aware—and with the black company...it doesn't become that we have done all that we could do, and we're just not getting the support. It becomes something else when it's an African American company. And I'm thinking, we're still selling out in New York City. We're still doing European tours; we're still having two and three seasons a year. When you look at that and all that Philadanco has accomplished under the tutelage of an African American director and founder, I do believe that it would be different if she were white. And that's sad to say.... It's like what Obama said about if you question that it's possible after tonight [referring to the President's victory speech on election night]. Yes, we can! So if you're questioning us after twenty years, okay, thirty maybe, but almost forty years? Don't you think we've got it by now???*

—*Kim Bears-Bailey*

As a member of the Joshua generation, Kim Bears-Bailey, JB's metaphorical right hand, began finally to "get it"—to perceive the underbelly of old racist codes disguised in a millennial costume. She describes a situation she endured in her ballet class at the University of the Arts in the 1980s. I asked her how the issue of race played out in her life, her career—a question I posed in all the interviews, regardless of the ethnicity of the interviewee:

> KBB: Directly, I don't feel like it [racism] has totally affected my career. I think what it has done [i]s kind of opened an awareness that it is still there. I've never been turned away from being allowed to do something. I don't know what it's like for someone to tell me not to come into a room because of the color of my skin. I have been in a situation—as a student I had a white teacher—and I was a ballet major student—and this particular teacher didn't really recognize African American women or men in acquiring a field in ballet.
>
> BDG: Was this at the University of the Arts?
>
> KBB: It was at the University. I was the only black major in my class at the time—black ballet major. And it wasn't something that I felt was personally driven to [or directed at] me, just somebody's views on how they thought [about a black presence in ballet]—maybe that. I don't know what specifically it was, I just knew there was something there.
>
> BDG: How did it play out?
>
> KBB: Because I never really got the—it was almost like she knew I was there but didn't recognize it. She taught the class...
>
> BDG: You were invisible.
>
> KBB: I got the corrections that my fellow white counterparts would get. I would take notes from what she would give to them. It [a direct racist remark] was never really directed to me, never like, "Okay, you're here, but you're never going to make it there." But she was a good teacher, and I just felt like it was almost, like, "No. This is not where your passion goes. You don't have the right body."
>
> BDG: She never said this?
>
> KBB: She never said it. Never physically said it or verbally said it, but you had a sense of it. You had a sense that maybe it was how she was reared in terms of the ballet world, or maybe I just wasn't that chosen one in her eyes. And so that was the first time I felt like I was kind of alienated, but not alienated, in a sense—I mean, I came to class every day and she taught a good class, and it [individual

instruction] didn't have to be directed at me. But one time, you would love to hear somebody say, "Well, Kim, blah blah blah"—not just to your other counterparts, and so I just—it made me stronger. It made me stronger to go in and do what I set out to do....

So in terms of it [racism] affecting my career, [it's] not [like] when I hear Talley Beatty say he couldn't go into a studio or Joan Myers Brown say "my white girlfriends had to teach me." But there are challenges, and I think we as young artists have to be able to change that. That road isn't just for whites unless it's specific for that. We have come a long way. We can produce exactly what you're asking!

The fact that Bears-Bailey was a ballet major tells us that the audacious hope of the black ballerina is alive and well, and that even in the 1980s, it could be dampened by an instructor with a Eurocentric bias. Her reflections remind us of what President Obama said in his Joshua Generation speech: that this generation must remember that better is not enough and that we still have a long way to go to dismantle the house that racism built. This gifted dancer–teacher, who doesn't know how to do a job except fully, had a couple of other anecdotes illustrating under-the-radar racist experiences she has encountered. It is important to understand that she was neither complaining nor bemoaning her plight but simply and directly answering my question. Her examples may sound bizarre to the nonblack reader, but I would wager that any person of African lineage reading this section would have racked up similar experiences. She told the following story about a Broadway audition experience in 2001, the year after she retired from dancing with Danco. At this tryout, the choreographer

specifically stated they were looking for a white dancer, 5 foot 7, who could do tricks. Now there were at least, I would say, eight to ten African American women in the audition....

But what they didn't say is that you have to leave. And so that opened up the window that, hey, maybe I can change their minds. Maybe that white, 5-foot-7 dancer is getting ready to turn into an African American 5-foot-5 dancer, who maybe can't do the tricks you want.... Usually if you're going to be that specific, then you have to say, "If you are not that, please leave." And since they weren't, I stayed.

This decision gives us a taste of Bears-Bailey's staying power, literally. All the women of color left the audition, except for Bears-Bailey and one other. She went on to explain that she didn't mind being told that a white character was needed if

it was inherent in the nature of the production. What she did object to was when the black dancer is summarily rejected "because we don't think you are appropriate, because we don't think you have the skill because you're a black dancer. It's when it's like that then it becomes a problem. Or that you don't give us an opportunity because of the color of our skin." In any case, Bears-Bailey was kept at this audition until it was down to three dancers left—herself and two others: "But when they said 'tricks,' one girl pulled out a baton, the other tap shoes, so I missed that memo! I didn't have a trick. My trick was my artistry and the legacy that I left at Philadanco."

Tracy Vogt's privileged colorblindness on first seeing Philadanco perform was mentioned earlier in this chapter. Once she was in the company she was able to find her comfort level while being in the racial minority, except for one touring incident. The company was performing Talley Beatty's *Pretty Is Skin Deep, Ugly Is to the Bone*, which contains a solo performed on a ladder by a woman wearing a short nightgown. Tracy was chosen to do the solo, and four Danco males, all African American, carried her in on the ladder. Here is a portion of our interview. The reversal of who is booing, and why, says a lot about how far we Americans, black and white, have come since the civil rights era. Just the mere fact that the audience was integrated would have been impossible down South in the 1960s.

>TV: We were on tour, I believe we were in Mississippi, and we were doing *Pretty Is Skin Deep, Ugly Is to the Bone*, and they carried me out on the ladder, and you could just hear some people yell, "Boo!" as loud as could be.
>
>BDG: Oh wow: okay!
>
>TV: And this is at the beginning of the solo, but by the end people were screaming and clapping and cheering *because* that had happened, I think. You know what I mean? I was like, "Wow!" I hadn't really thought—you know, I think they just heard the *song* [Billie Holiday's "Good Morning, Heartache"] and didn't feel as though I knew anything about heartache, you know [she laughs].
>
>BDG: Oh, yes, now I see what you're saying. This is interesting because I thought it was going to be the reverse of what you're saying. I thought it was going to be a white audience [angry that black men carried a white woman]. But it's sounding now like it was a black audience....
>
>TV: Yeah, mostly—predominantly. And I think having me in that position, I hadn't really considered.

BDG: Sort of on a pedestal.

TV: Yeah, *exactly*. And four men carrying me out—in a nightie!

What was touching is that the spectators ensured the return of this dancer's comfort level by perhaps applauding excessively to compensate for the rejection at the opening of the dance. Like Bears-Bailey, who said that first she had no inkling of what JB was talking about in addressing racism, Vogt learned by her decade-long contact with African American dancers what at least a portion of their history was all about, and how their history was also her history.

In an online commentary on the dance performances at the 2009 International Association of Blacks in Dance Conference and Festival, held in Denver, Colorado, the writer points the finger at racial exclusion—not the way JB and others experienced it growing up in the 1940s and 1950s, but the systemic, under-the-surface kind that we Americans have become accustomed to since then:

It seems dance writers and dance critics are missing this entire event. Why? Or am I wrong? IABD will present two more concerts on Friday and Saturday nights at the Paramount Theatre in Denver (7:30 P.M.). My guess is that, as with this Youth Concert, both will more than sell out. But, who will write about them? I've been to or covered other dance festivals, like the June 2008 Ballet Across America at the Kennedy Center, the Jacob's Pillow Dance Festival in Becket, MA, and the American Dance Festival in Durham, NC. The line where critics pick up their comps for performances at those festivals are populated by [a] whose [*sic*] who of dance writers from all local media, and New York media. So where are even the local media here? I know the above festivals are in amazing venues, and/or have historical standing that goes back to the mid 20th century, but—and you have to trust me here—the dance being presented by IABD is as good as anything those festivals present, and none of them present emerging artists like IABD is doing.

During a recent Dance Critics Association meeting, the Artistic Directors of three major regional ballet companies lamented that they could not recruit Black [*sic*] dancers. Some critics expressed the opinion that that was odd in that the Alvin Ailey and Philadanco companies had no such problems—nor had Elliot [*sic*] Feld with his Ballet Tech in New York City. One of those three companies was the Washington Ballet. The Washington Ballet's home venue is the Kennedy Center. The Kennedy Center is about ten blocks from the Duke Ellington School of the Arts.[35]

It used to be that white ballet companies complained about African Americans having the wrong kind of bodies for ballet. That was proven false. Then it was said that blacks weren't interested in doing ballet. That, too, was disproven (and this book offers further proof, dating back to the 1920s). Now, they say they can't find black ballet dancers. The writer shows that, by ignoring black dance festivals and not exploring the talent in their local arts high schools, those company directors weren't really looking for black dancers to populate their ranks. But their comments are the "speak" of our times: no outright exclusion, no sins of commission, but the easy way out by omission.

In a 1995 article, JB surprisingly cast her unique role in the light of another issue: gender discrimination. Describing herself as a "triple-whammy," she said, "I'm a woman. I'm black. And I'm not homosexual. I've never really fit into any of the traditional groups of people who run arts organizations. My staff and I have to prove ourselves time and time again. Our white counterparts can play musical chairs and move from one organization to the next. We don't have the opportunity to make the same kinds of mistakes that others do and expect to get another job."[36]

As noted earlier but worth repeating, JB has never discriminated against homosexual people and makes it clear that it's what happens in her dancers' professional lives that is her concern—not their private lives. She has welcomed gay males and nurtured them, as she does all her dancers, like they were her own children. Nevertheless, she is aware of her minority status in a field dominated by gay white males and makes no bones about it. Zane Booker is one of the many declared gay males who was and continues to be fostered by her. Here is a portion of my interview with him. I asked how race and/or racism issues affect his career, if at all, and like other Joshuas, his first response was negative. Exploring the question further, he answered a bit more thoughtfully:

> ZB: I mean, I don't think it's affected [interrupts himself and drops his voice]—how can I say that?! I mean, on a daily basis, right here in Philadelphia, right now, I don't think that it is affecting me—racism. I mean I just did a piece for Ballet X, I did a piece for Dance for Nia. [Two local dance companies, one white, one black.] I get support from all of the people in Philadelphia.
>
> BDG: God, this is great!
>
> ZB: I feel that the entire dance community is very supportive of the work I'm trying to do.
>
> BDG: Then, how has the changing face of racial politics affected your overall career?

ZB: [long silence] There's racism, but there's also homophobia and classism and...and the nuances of humanness when it comes to prejudice. Because it's not like a one-battle war. It's many conversations that we need to have about many different types of prejudices. And a strong, empathetic ear, because I know that even in my personal relationships, I get used to listening for facts that back up my opinion, as opposed to listening to people and trying to figure out what it is that they are actually trying to communicate to me....

My opinion is that everybody has some kind of prejudice connected to homophobia, racism, and class—something or other.... So my effort has been to identify it in myself.... Because whatever I'm feeling about the homeless person I walk past four or five days a week—like, I can make him disappear—people who are in a class above me are doing the same thing to me.

Let us now look again at Philadanco's Poland tour. In the summer of 2001, the ensemble had a ten-day tour to that Eastern European nation, which had shaken off its Communist cloak a little more than a decade earlier. The Eighth Annual International Contemporary Dance Conference and Festival took place in Warsaw and in two smaller cities: Poznan and Bytom. Merilyn Jackson, a *Philadelphia Inquirer* dance writer who traveled with the company, described Bytom as an "outpost" characterized by "public drunkenness, a sizeable red-light district, a few restaurants, and only one grimy hotel." Some of the dancers, strolling through the town's main square, were called monkeys and animals "in English by people who also threw things at them from a window above. New York's famed LaMama Theater founder, Ellen Stewart, visiting a concurrent theater festival in Poznan, was similarly insulted while being refused service in a restaurant there." Polish people had not encountered many people of African lineage on their streets in the past, but that seems no excuse for the hostility—rather than curiosity—that they demonstrated. Unshaken, JB responded with typical aplomb:

The racial slurs are, to me, universal prejudices, often fueled by film and television. It is never an expected, overt action, but it happens all over the world. We just live it. Despite this and the travel problems [their luggage, containing costumes for three of the four dances on their program, had been lost], we take back important and good memories of Poland.[37]

That is the diplomatic voice of JB, the international dance figure, speaking! There is no doubt that this was one of the most challenging tours for the

company: Eastern European security issues, lost luggage, and race prejudice on top of everything else. It is noteworthy that the problems were not with their reception onstage: their performances were greeted with the enthusiasm they are accustomed to in other venues. According to Merilyn Jackson, "As far as I could tell, there was absolutely no racial issue going on in the Warsaw performance. For Jawole's *Hand Singing Song* the audience stomped, whistled, and then stood for an ovation that included synchronized applause that only ended with an encore. But that was mostly an 'intelligentsia' crowd, not the provincial and unemployed drunks in the streets of Bytom."[38] Nevertheless, the Bytom calamity was a step backward in time and sounds like something that might have happened in the American South during the civil rights era protest movement, when young black and white civil rights workers were openly attacked. The fact that the insults were shouted in English indicates that the bigots had some education, even if they were out of work and living in a small town. It is unsettling that American-style antiblack racism, now erased from public displays on home turf, can flourish in a frontier town in Eastern Europe. But that is the reality, and this new, global xenophobia goes hand in hand with the under-the-radar bigotry of our own "postracist" millennial moment in the United States—a phenomenon amply dealt with by a nucleus of current analysts, such as Tim Wise and John L. Jackson, Jr., to name only two.[39]

I conclude this section with a brief but telling look at a kind of self-inflicted racism as described by JB. It takes us back to the issue of arts funding but addresses the role of the black public. JB fumes when she thinks about the possible funding that doesn't come her way from the African American community. She is thinking about the sizeable possibilities from the area's black bourgeoisie, whose numbers are considerable. As for contributions from this socioeconomic class, she disconsolately admits that there is only one person who regularly supports her:

> JB: There are people who have given me smaller contributions, but I'm talking about over $25,000. That would be Dr. Walter Lomax. If you're talking about $2,500 to $5,000, there are a few individuals. But I think the black community still doesn't know what to do about supporting, financially supporting, not only artists, but even social service organizations. The people that have the capability of making major contributions to organizations like mine, they would rather give their money to the opera and the orchestra and the ballet, so that they can look important when they're with their peers.
> BDG: Their peers being—you think other black people?
> JB: Other people who are making money.

BDG: It doesn't matter if they're black or white—it's money?

JB: I don't think they really care about impressing black people. They want to impress white people. And I think that's a hangover from our slavery days that we still haven't gotten past: the approval of and by whites and the validation by whites.

She voiced a similar sentiment nearly twenty years prior to this 2008 interview in the same *Inquirer* newspaper article where she announced that Danco would be on furlough for a month for lack of funds. Back then, she felt that "There are many rich black people in Philadelphia who could help, but they don't. They give to churches, to political causes, but when it comes to the arts, there are only a few who make contributions. If the black community doesn't take ownership of institutions, they'll all go down the drain."[40] Like the other funding issues touched on in this section, this one is a JB refrain. She may feel that not much has changed, but she also knows that everything has changed because Philadanco and PSDA, by dint of their excellence and perseverance, have become as important to this city as its orchestra and ballet. It's enough to make you feel that Philadanco *is* Philadelphia!

CRITICAL GAZE/CULTURAL CONTEXTING/COMMUNITY VOICES

Over the years Philadanco has had its share of both positive and negative reviews. The dancers have been characterized as sizzling, undulating, pulsating, exuberant, energetic, powerful, sassy, naughty, and so on. I'm taking these adjectives out of context, but the point is that there is a certain way of describing these predominantly black dancers that is stereotypical, and the stereotype is carried in these descriptors. I asked JB how she felt about it, and she replied,

> I used to be angry about that. I used to say, "How come they don't talk about their technique: why don't they talk about this?" And Nikki Shepard,[41] for one, said, "Just capitalize on it. If they're going to say you're 'high energy,' just capitalize on it." Say "The HIGH ENERGY of Philadanco!"

To get a taste of the variety of responses in the critical gaze, let us take a look at just a small sampling of reviews from the company's spring 1993 season. As is often the case with other ensembles, regardless of ethnicity, reviewers' opinions on the same dance in the same season vary widely.

> With strong, gifted dancers so committed that they appear to take flight with each soaring leg extension, with contracting torsos and

undulating hips seemingly powerful enough to twist off a limb, with outstretched palms and fingers spread so wide as to hold the story of black America, Philadanco gives us the unadulterated joy of pulsating, dramatic dance.

This is the opening salvo from *The Globe and Mail* (Toronto) review of Philadanco in March 1993.[42] It is a beautiful encomium to the dancers. Nevertheless, like most of the press in the 40 years of its life so far, this critique gives a picture of strength and power that belies the subtle nuances this ensemble is capable of. The review ends by declaring, "This sizzling, infectious show is unabashedly entertaining." In between this beginning and conclusion the writer mentioned each choreography. She finds the first dance, Milton Myers's *Men Against the Wall*, "a definite crowd-pleaser." She doesn't discuss Myers's choreography for *Love 'n Pain* but declares that it was danced by Kim Bears with "strength, charisma and funky nuance." I don't know why the nuance has to be described as "funky." Is it because of the theme, love and pain? Or the music (it is danced to a suite of Aretha Franklin songs)? Or because it is a "black" dancer dancing to "black" music? I believe the writer is reaching for a culturally appropriate way to context the specific kind of subtlety she sees in Bears's performance, but she takes back what she gives by settling on the easy word—funky—to qualify and actually set parameters on Bears's subtle shadings. This reviewer felt that "The most cohesive, thought-provoking dance of the evening was *Dreamtime* by Elisa Monte: "This octet stood out for its accentuated abstraction, its golden colours [*sic*] and bold, celestial lighting." By contrast, here is the succinct put-down made by the Philadelphia reviewer when Danco performed the Monte piece at home in June of the same year: "Elisa Monte's *Dreamtime* becomes increasingly vapid with each viewing."[43] That sentence was the full extent of her treatment of Monte's work. This is why it is so disconcerting to learn that many readers follow reviewers' opinions in deciding whether or not to attend a performance and, once they are in the audience, in how to *see* a dance.

Talley Beatty's *Morning Songs* was also on the program. The (New York) *Daily News* reviewer said, "This looked like a diluted version of the urban-angst dances of the '50s, including Beatty's own works in that genre. Everybody moved on a grid, looking annoyed, and there was a rape. But the piece was well made and danced to an exciting Charles Mingus score."[44] Again, for contrast, here are the words of *The New York Times* reviewer describing the same dance in the same city and season. I take the liberty of quoting her review in greater length. The writer is Jennifer Dunning, whose familiarity with the company over the years

through interviews and performances (see quotes from her reviews in chapter 4) give her an ability to view and assess the company from a more balanced cultural perspective than many of her peers:

> Philadanco saved the best for last on Tuesday when it opened a week-long season at the Joyce Theater. There were moments of choreographic distinction throughout the evening. But nobody does it quite like Talley Beatty. And his recent *Morning Songs* ended the evening on a note of soaring triumph.
>
> There was nothing terribly new or different about the group piece. The elements of its jazz-dance style—high, split-legged jumps, cross-stage runs and spinning turns—have been seen on Broadway and on the concert dance stage for years. But there was a magnificent weight and evocative power to *Morning Songs* and to its surging score by Charles Mingus that are rare in modern and jazz dance today.
>
> The Philadanco performers, dancing this demanding last of five pieces with astonishing energy and subtlety, didn't skim across the ground with the usual ballet-inspired lightness. Though the dancers moved with that kind of speed and focus, they dug into the ground and used it to spring from. Instead of fleet ranks of gorgeous youngsters, these were men and women who looked as if they had lived through difficult experiences.[45]

This excerpt and the review as a whole are jargon-free, cliché-free, and stereotype-free. Dunning tells us that the strength of the dance is not in its innovation—perhaps implying that the choreography is hackneyed—but she is able to communicate to the reader that there are deep qualities in the work that are as important, if not more so. She finds a way to enter the work without grasping for the nearest cliché. In her final paragraph we are treated to one of the rare occasions when a reviewer says more about the quality and content of a dance than a few flashy phrases.

An intertextual (or subtextual) reading on the difference between saying "nothing terribly new or different" and "a diluted version of urban angst dances of the '50s" marks the distance separating a writer who liked a work and one who didn't. "Everybody moved on a grid, looking annoyed, and there was a rape." As structuralist philosophy taught us, every text is an intertext—in other words, the words we choose and the way we put them together tells what we are thinking in between the lines and beneath the words. The *Daily*

News reviewer clothes her opinions in a voice dripping with condescension: this dance is below her. And she forces her opinion on the readers, knowing full well that they may not actually see the performance itself and may have her review as their only frame of reference for this company, for this dance. (In fact, many dance reviews are published after a run is over.) Again, let us remember that reviews are opinions.

Just one more comparison from this spring 1993 Danco season: Also on the program was a dance by Lynne Taylor-Corbett, titled *Surfacing II*. Here is the acerbic comment by the reviewer for *New York* magazine:

> Then there was Lynne Taylor-Corbett, a choreographer who is all surface and maudlin sentiment, appropriating common flamboyant moves and stringing them together with little physical logic and no discernible meaning, while stating in the program note that the dance is meant to honor the souls our community has lost.[46]

Compare that assessment to this one from *The Philadelphia Inquirer*:

> The second Philadanco premiere, by Lynne Taylor-Corbett...honors her friends and colleagues who have died of AIDS.
>
> Although no explicit reference to the disease is made, an atmosphere of foreboding is provided by the score.... The deeply impassioned dancing of Kim Y. Bears, who opens the piece with a long solo, sheds over the dance a sense of mournful dignity, of dignified mourning.

Throughout the years, the dancers themselves have been praised, even in the most negative reviews. Mixed reception to the choreography has been an issue, as this sampling shows. But this doesn't mean the choreographies are throwaway works. It's all about expectations, criteria, and contexting. The *Daily News* reviewer ended her tirade by stating that, "Whatever her [JB's] taste in choreography—or, to put it more realistically, whatever the difficulty these days of finding good choreographers—she certainly knows something about training dancers."[47] Likewise, the *New York* reviewer ended her piece by writing that JB "has nurtured such an admirable ensemble, one can only wish her access to more significant material for it to perform—if not from the admittedly meager present, then from the past."[48] Both critics echo a complaint that has been voiced by the dance elite for decades, bemoaning the dearth of good contemporary choreography, so this complaint could have been directed at any white modern dance or ballet ensemble as well. But all of it is opinion—not fact. Despite their powerful position as spokespersons writing for major publications, there is no reason to

assume that these women have the last word on the quality or triviality of a particular choreography. The fact is, for choreographers to grow and improve, they must submit to what Jawole Willa Jo Zollar called "a public learning" when I interviewed her: "You look at it [the dance you've created, once it's onstage], and you get some distance, and you go, 'Oh.'"

Another critic, writing about Danco's twentieth-anniversary performance and premiere at the Joyce Theater in 1990, said something that bears repeating. Alluding to JB, he said she was obviously a skilled teacher, judging by the three dancers he named who'd gone from Danco to Ailey, and then added that she was not herself a choreographer "and, as a result, has been forced to develop a repertory for her dancers from a wide variety of sources. From the program I saw, which included ballets by Milton Myers, Billy Wilson, Elisa Monte, Gene Hill Sagan and Talley Beatty, this has worked out well for the troupe." He continues, saying that the variety of choreographers has denied the company "any strongly personal creative profile," and that they have developed their character in the "style and spirit of its performing."[49] Again, it's all about criteria, contexting, and expectations. What he describes is exactly the way of the world for ballet repertory companies, from the American Ballet Theatre through ensembles across the nation and abroad, and for mixed-repertory modern companies such as the José Limón Company and Paradigm, two contemporary ensembles based in Manhattan. Philadanco was never intended to be a company like the Martha Graham or Paul Taylor or Bill T. Jones groups that feature the works of one dance master. So in using a particular kind of modern dance company as his unspoken model, the writer's frame of reference was off kilter. Danco is a modern dance company, but JB used repertory companies as her model—and justifiably so, since ballet was her training ground. Furthermore, any company worth its salt must "find its own character in the style and spirit of its performing." And that is what JB and her team work to achieve, as outlined in chapter 4. A dance company would be hard pressed to be successful were it to depend only or mainly on the choreography to give it character. It is essential to be able to know both the *dancer* and the *dance*, and work both ends against a compatible middle ground.

Writing in 1998, the *New York* magazine reviewer echoed both these opinions, stating that the ensemble needs to resolve the repertory issue, because its mixed bag of dances "give it an air of vague eclecticism rather than a distinctive profile." Yet she also praised the dancers for their dancing and their sheer humanity, characterizing them as "sensational movers" combining "swiftness and strength with voluptuous fluidity, their action seeming to originate in a coiled-spring spine." How much this writer is able to say in a few descriptive

sentences and, despite her criticism of the choreography— she never falls into stereotyping. She ended her opening paragraph with this homage:

> Their carriage is notably proud and elegant, the exquisite balance of their posture inevitably suggesting harmony of spirit. Each performer has retained—and can project—an individual temperament; a stageful of them looks like a group of real, idiosyncratic human beings who are fiercely committed to a common cause.[50]

Perhaps this issue of the choreographer or the performer, the dancer or the dance, is best summed up by one giant of a Moses. In a television interview a few years ago, Paul Taylor said, "Sometimes I think a company's morale is more important than the choreography."[51]

How do I end this book? How might I leave the people and concerns that I've visited, observed, and lived with constantly in my mind, heart, and world for the past three years? There is so much more to say! The chapters in this book are long, but they are mere snapshots in a huge album of these lives lived in dance. Here follows a selection of voices from the ecological ground that is home turf to JB and her institutions—namely, dance culture insiders representing the rich and fertile environment that she has nurtured. In contrast to reviewers, who for ethical reasons must maintain an outsider perspective and keep their distance—though I question the concept and possibility of objectivity—these voices shout praises. I present them here in no special order, and I realize that they may include sentiments that sound familiar from previous chapters. Yet, I am compelled to share them with you. These statements—testimonies of love and admiration—fuelled my fire and inspired me as I prepared this book. With no contexting comments from me, they stand alone and speak for themselves.

Tracy Vogt

(Danced with Danco for ten years; excerpted from my interview with her, fall 2008)

A lot of times we're compared to Ailey and I just don't see the similarity. I mean, Ailey is *beautiful*, and there *are* a lot of our former dancers there, too. But the passion behind Philadanco, to me, is what separates Ailey from Danco, and some of the times we have some of the same pieces. Recently, I went to see *Sweet Otis* by George Faison, and it was hard for me to see—not that they aren't beautiful dancers, but the passion that we're coached to—you know, as Chase would

call it, "No guts, no glory!" She says that all the time, you know, "You don't leave anything behind." It's that *passion*—it's like your life depends on it! And so it's hard because, you see, I'm used to the way that we do it, and it's a little bit "over the top," some would say. I couldn't feel it [the Ailey performance of *Sweet Otis*], especially some things that are a little sassy—I was like, "Oh, no! We're so much sassier than that!" You're going to *feel* a performance by Philadanco, you're not just going to visually *see* a performance.

Antonio Sisk

(b. 1974, d. 2009. Spent five seasons dancing with the Dallas Black Dance Theatre and went on to dance for four years with Danco. Was living and teaching in Atlanta and Roswell, Georgia, and heading the Roswell Dance Theatre at the time of his demise. Excerpted from a spring 2008 interview conducted by Nyama McCarthy-Brown during her tenure as a doctoral candidate at Temple University)

Joan Myers Brown is my mentor. Unlike [the director of another dance company]—she tore me down. The parts Ms. Brown tore down, she built back up. She didn't leave me broken. No one else has done that for me. She forced me to see my gifts. She is there for her dancers. If a dancer is in school, she won't take them, she tells them to get their degree, she will be there when they get out. Danco 2 is not a feeder company into Philadanco, it's a training company. Actually, Ms. Brown will not take dancers straight from Danco 2; you have to leave and go dance with someone else. You can only get into Philadanco from Danco 2 if you work for another company in between. Ms. Brown wants to make sure Philadanco is what you really want to do and that you have been out and done something else, so that Philadanco is not all you know. Her thing with Danco 2 is not about feeding her own thing. It's about developing black dancers.

Wanjiru Kamuyu

(Paris-based freelance dancer-choreographer-teacher on both sides of the Atlantic; staff choreographer-dance captain for the London production of *Fela!* Was in the Instruction and Training Program while pursuing her MFA in dance at Temple University, September 1996–May 1998. E-mail communication, spring 2011)

I remember having a challenging time in Philadelphia, and Philadanco became a haven of safety and clarity. My first ever audition was for Philadanco's Training Program. The audition also included professional dancers who were looking to work in the performing companies—Danco 1 [namely, Philadanco proper] and D/2.

I have memories of Ms. Brown's direct, no-nonsense interaction with the auditionees. She clearly communicated what she was looking for in a dancer, her expectations, and her demands of the artist. She said the men needed to dance like men. They can be whatever they wish to be outside the studio and offstage; however, in her space she needed men. She told the women that she was making one cut based on weight. She did not need her men tired and injured from lifting heavy women!

After a full day of auditioning I was fortunate to be one of the select few to be accepted into the training program. This program enabled me to take forty weeks of intense dance training—a pure slice of joy!

The conservatory approach to training and preparing emerging professional dancers included a specified and mandatory uniform for each student—leotard and tights, with hair pulled back, along with ballet slippers for ballet class and bare feet (no socks) for modern dance classes. The structure and discipline of the curriculum created an environment conducive for an emerging professional dancer to thrive and soar as a technician.

Each week I took Horton technique with Mr. Myers; Graham, with Ms. Thomas; ballet, with Ms. Browne. There were times when Hope Boykin would teach Graham or Horton techniques. All my teachers were amazing. Their stern, no-nonsense approach to shaping and molding a future professional dancer—laced in with kindness and gentleness—was very gratifying. After class I would stay and quietly observe Philadanco's company class. I was curious to see how the professional dancer interacted and reacted in a class. I was impressed by how focused yet lighthearted the dancers were. I remember observing them as they hung out around the studios and one could really sense they were a family, not merely colleagues but also friends. Studying at Philadanco was a great investment in my dance training, contributing to the success of my career.

Erika Hand

(Freelance dancer, now Brooklyn-based, whom I met at a dance conference at Hollins University, Roanoke, Virginia. E-mail communication, fall 2008)

Seeing Philadanco was a formative experience for me as a young dancer. At the time I was a teenager studying dance at Booker High School for the Visual and Performing Arts in Sarasota, Florida. It is located in a primarily African American neighborhood and is a "magnet school" that draws students from all parts of Sarasota County. Our learning environment was a meeting place for different cultural points of view, and these exchanges were often negotiated as we danced, rehearsed, choreographed, and collaborated. I was in a raw place as

I was becoming aware of racial politics and what my standpoint was as a young middle-class white woman artist.

Philadanco toured to Sarasota and even taught a dance class at the high school. My memories of the technique class are vague, but I can recall their performance at the Van Wezel Performing Arts Hall clearly.

Philadanco was fierce. Women dancing their hearts out and moving in ways that spoke to the necessity some of us feel to propel our bodies through space as a way of understanding the world. Who were these women? Where did they come from? What did they think about? I was enchanted with Hope Boykin and her fierceness. In her strength there was a softness. I read it as a palpable sensitivity or compassion.

There was one white woman in the company. [Tracy Vogt] I identified with her. She challenged me to expand the meanings I was placing on the work. As cliché as it seems I thought to myself, "That could be me one day." I focused my attention on the women in the company. They empowered me as a young artist. There was something about them: it was like they were on fire.

Lisa Nelson-Haynes

(Philadelphia native. Associate Director, The Painted Bride Art Center. E-mail communication, fall 2008)

My mother signed me up for dance classes at Philadanco when I was just four or five years old. She did this because it's what her mom did when she was a little girl. My mom studied dance as a child with Marion Cuyjet. In fact, Judith Jamison was in my mom's dance class when she was a little girl.

When I started at PSDA, I took two classes on Saturday morning at their studios at Sixty-Third and Market. I remember vividly the cramped quarters of the dressing room and how uncomfortable I felt changing in front of so many other girls. The two classes I took were ballet and tap, but after only a few weeks, Miss Joan asked to speak with my mom privately and explained that I had way too much energy and offered to put me in an acrobatics class on Saturday afternoons for no additional charge. She gave me a "scholarship"! When I think back on this now, I understand what an incredible gift she gave us, because it probably was a financial struggle for my parents to keep me in the two classes and meet all of the financial commitments of the year-end recital, and instead of making my mom fret over how she would pay for an additional class, Miss Joan simply offered us this gift. Amazing!

In my ballet class, I was often intimidated by Miss Joan's loud, firm voice. She would walk up and down the ballet barre and critique our positions and

as she did so she would offer anecdotes about her own experience as a young dancer. She would say that she was told that she couldn't be a prima ballerina because her butt was too big, but she would tell us just tuck our butts in. She would holler at us to suck in our tummies and ask what we had for breakfast and offer advice in making good food choices. She always encouraged us to be our best, with no excuses. No one in my life spoke to me as frankly as Miss Joan did at this stage in my life.

My mother also signed me up for classes at Freedom Theater, and I would split my time between Philadanco and Freedom Theater. [Note: Eugene Waymon Jones's Heritage House became Freedom Theatre in 1968, specifically for theater arts instruction.] I studied at both Philadanco and Freedom Theater well into my teen years, and I attribute both with being secondary only to my immediate family in impacting my development. A day doesn't go by that I don't refer to what I learned from both Miss Joan and John Allen [founder of Freedom Theatre]. I know that my keen interest and openness to all art forms can be attributed to my time with the both of them. Neither focused on making me into the best dancer or actor, but the best Lisa I could possibly be, and for this I am eternally grateful.

For me, Miss Joan represented a refined lady and demanded that her "young ladies" act accordingly. About seven years ago, while working at the Bride, I saw Miss Joan come into our lobby while Danco 2 was preparing for their annual Bride engagement [the "Danco on Danco" concert]. I went over to introduce myself to her, but before I could get the words out, Miss Joan assured me that she remembered me well, and I cannot tell you how much that meant to me.

Susan Glazer

(Retired in 2010 after twenty-nine years as director of the School of Dance, University of the Arts, Philadelphia. Peer review assessment, fall 2010. Used with permission)

This year, 2010, marks the 40th anniversary of the founding of Philadanco. From this platform, Joan Myers Brown—teacher, artistic director, visionary, and pioneer—has made and continues to make significant contributions to the art of dance. Joan's influence radiates from its epicenter in West Philadelphia across the country and the world. She has carefully built an expanding artistic community, affording the young people of Philadelphia the opportunity to earn a living through dance. As an unofficial ambassador when she has toured Europe and Asia, Joan has brought renown to her city by demonstrating the beauty of her art form and the splendid talents of her dancers. As a visionary, Joan has used the transformative power of dance to change our community and the thousands

of young people whose lives she has touched. She is one of only five women in America who have founded distinguished modern dance companies with roots in African American culture.

Dianne McIntyre

(Founder/Artistic Director of Sounds in Motion, legendary dance company [1972–1988] that originated onstage collaborations with renowned avant-garde jazz musicians. Freelance choreographer for musical theater, films, television, and the concert stage. E-mail communication, summer 2011)

Sometime in the late seventies or early 1980, I just seemd to know Joan from "around"—at meetings, concerts, conferences—just from our world of Black [sic] folks in dance. I can't remember ever meeting her—just knowing her. I realized that the elegance I saw in the dancers was directly from Joan's person. Elegant with grit—that's her. And that's the company as I see it. In 1982 I appeared on the same concert with Philadanco. It was called Dance Black America. I performed a solo all in silence (that in previous concerts had been extremely well received). However, on this occasion at BAM (the Brooklyn Academy of Music), I was on the program following Joan's Philadanco who had just brought the house down—these young dynamic dancers took New York by storm that night. The audience was still buzzing from watching them when the lights came up for my piece, and I actually never captured the audience. Later backstage I remember Joan saying to me, "My goodness, where do you get all that energy? It's great!" That was special and really lifted my spirits.

I have been watching Philadanco over the years, admiring their work and the power of the dancers. In 1996, Kim Bears and I were featured on a special event at the American Dance Festival. Both Pearl Primus and Helen Tamiris were receiving the Scripps Award posthumously. Kim performed a Primus solo and I performed Tamiris's *Negro Spirituals*. Tamiris and Primus had a connection in life.... That night when Kim and I performed it was explosively powerful, as if the spirits of those two artists were reunited. We felt it. Everybody felt it. Afterwards as we both limped with aching bodies toward the [post-performance] reception, Joan told us (dryly), "You just performed brilliantly, you can't come out here walking like that. Huh!"

I was quite honored that Joan became a central force for me when I was choreographing a segment of *Beloved*. It might have been a stretch for her because she had mentioned to me earlier that her "people" (board and followers) do not like dances with references to anything reminiscent of slavery times. I needed 150 people, 50 men, 50 women, 50 children. Joan sent former dancers, present dancers, future dancers, plus their friends and relatives to be part of the piece. We had other people there as well, including dancers I knew from New York—however

the core and strength came from Joan's people. They were so giving, supportive, patient, and offering time, energy, and creativity with a lot of love. That was one of the most special projects I've ever done.... At one point during the shoot the director, Joanthan Demme, asked me, "How did you locate these people? They look so beautiful and so 'present' in every way?" I asked for a "thank you" in the credits for Philadanco and was very happy the producers agreed to that.

Vanessa Thomas Smith

(Former Danco dancer; former Danco general manager. E-mail communication, spring 2009)

About Anna May & Joan:

Anna May, the elephant I rode at Big Apple Circus, was named after Anna May Wong, a silent film actress. I spent time with her at the Circus, performing an act with the Woodcock Family for two years. It really piqued my interest in elephants. The circus was continually feeling the heat from PETA [People for the Ethical Treatment of Animals], and I really felt like I wanted to speak very specifically and eloquently about the relationships between humans and animals and why the circus was a wonderful environment to live in.

I went with a circus friend and colleague on a safari. We were in Kenya and Tanzania at several animal reserves for two weeks and really got to observe animals in their natural habitats. I was especially looking to see if there were behaviors that were asked of them by their trainers in captivity that were things that they weren't doing in their natural habitat. I saw elephants crawling on the knees, up on their hind legs to retrieve items from the tops of trees and traveling altogether in a herd as protection.

Elephants are very matriarchal. There is a lead female of the herd who takes care of the others, similar to the Queen Bee of the beehive. She has several other elephants who are also female that help her with the herd. The small elephants, male and female, stay with the herd until the male elephants mature and go through a hormonal period where they are *OUT OF CONTROL*. The males are kicked out of the herd and sent on the way to take care of themselves and their needs.

The more I thought about it, I realized it was very much the way Joan had run the dance school and company. There were times where as the "mother" figure she nurtured dancers to be dancers but more importantly to be independent and to take care of yourself, no matter what your life may bring to you. A few times she sent a few students on their way when they started to "smell themselves"—just like the male elephants! She keeps some around a little longer when she feels a little more nurturing is needed. All in all, Nature (I guess

that's why they say "Mother Nature") knows the divine order and as much as we humans try to control that, we can't. Joan has the uncanny ability to know what's good for dancers before they know it for themselves.

A good nurturer is like a great female elephant, and I have been blessed to have both in my life.

Figure 5.1. Philadanco Newsletter Announcing Artists Housing Initiative. Mayor Wilson Goode with JB—1986.
Source: Joan Myers Brown, private collection.

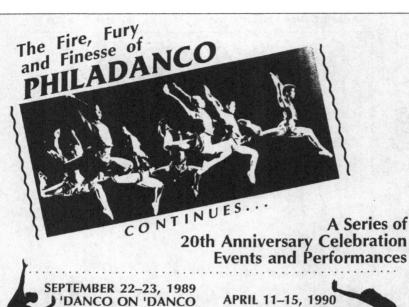

Figure 5.2. Philadanco 20th Anniversary Events
Source: A. Turner Design/Alfred Turner Jr.

Figure 5.3. Danco on Tour—Leverkusener (Germany) Performance—1992
Source: A. Turner Design/Alfred Turner Jr.

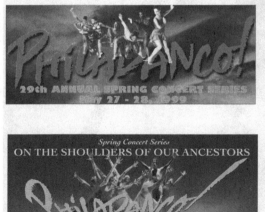

Figure 5.4. A panoply of collateral designs for Philadanco.
Photographers – Deborah Boardman, Philadelphia (1995, 1996, 2001) and Rose Eichenbaum (1999, 2000).
Solo dancers — Uri Sands (1995); Dawn Marie Watson (2001).
Source: A. Turner Design/Alfred Turner Jr.

THE WHITE HOUSE
WASHINGTON

August 2, 1994

I am delighted to honor the Philadelphia Dance Company as you celebrate your twenty-fifth anniversary.

One of the most rewarding of human experiences is the coming together of people to share common experiences and interests. For twenty-five years, Philadanco has maintained and built upon the wonderful legacy of your founders. The strength of your organization today is a testament to the vision of your founders and to your commitment to your shared goals.

I congratulate you on your achievement, and I extend best wishes for many years of continuing success.

Figure 5.5. Anniversary Letter to Danco from President Bill Clinton
Source: Joan Myers Brown, private collection.

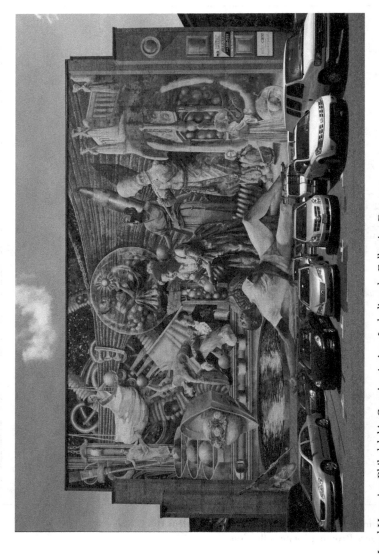

Figure 5.6. Mural Honoring Philadelphia Creative Artists, Including the Following Dancers: Top: Danco's Kim Bears-Bailey (Holding Sun)—"Muse of Human Spirit"; Danco's Candace Smith (Brown Robe/Turban)—"Visual Arts"; Danco's Francisco Gella (Lower Left, in Backbend)—"Symbolic Invention"; Pennsylvania Ballet's Meredith Rainey (Reclining, Front Center)—"Muse of Movement."

Source: Philadelphia Muses ©1999 City of Philadelphia Mural Arts Program/Meg Saligman. Photo ©Lonnie Graham

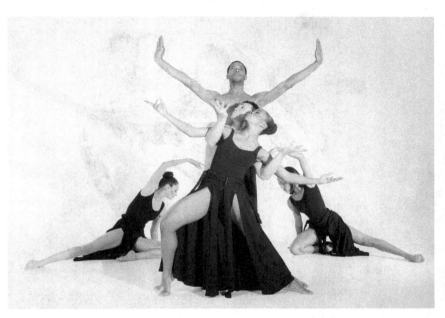

Figure 5.7. Danco Dancers in Pose for Gene Hill Sagan's *Elegy*—2000. Kneeling, Left—Roxanne Lyst; Kneeling, Right—Dawn Marie Watson; Center, Front to Back—Hollie Wright, Francisco Gella, Warren Griffin.
Source: ©Deborah Boardman, Philadelphia.

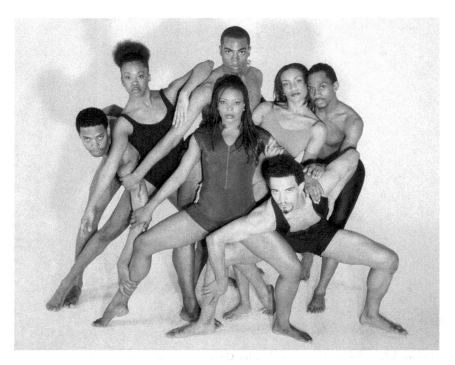

Figure 5.8. Danco Group Pose, ca. 2000.
L. To R. – Warren Griffin, Hollie Wright, Odara Jabali-Nash (Center), Kristen Irby (behind Jabali-Nash), Dawn Marie Watson (Right), Ahmad Lemons (Right, Embracing Watson), and Gabriele Tesfa-Guma (Crouched, Lower Right, over Jabali-Nash's Thigh).
Source: ©Deborah Boardman, Philadelphia.

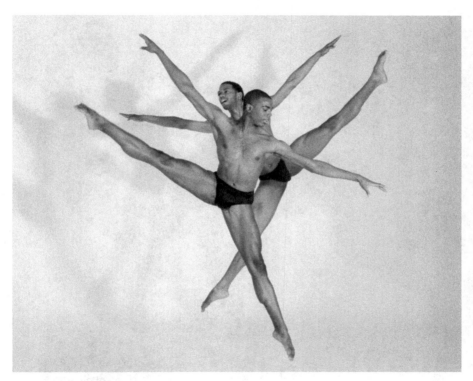

Figure 5.9. Kristen Irby (Front) and Warren Griffin in Studio Shot—Early 2000s.
Source: ©Deborah Boardman, Philadelphia.

Figure 5.10. Collateral Design — Philadanco Fall Concert, 2003
Dancers L. to R. — Antonio Sisk, Tommie-Waheed Evans, Ahmad Lemons.
Source: A. Turner Design/Alfred Turner Jr.
Photograph ©Deborah Boardman, Philadelphia.

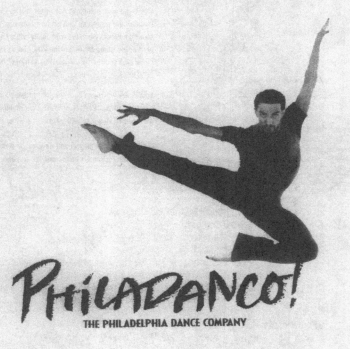

Figure 5.11. Polish Dance Festival Program—2001
Dancer—Gabriele Tesfa-Guma
Source: Photograph ©Deborah Boardman, Philadelphia

Figure 5.12. Fund Raising Drive—2009.
Dancers—Mora Amina Parker (Large); Teneise Mitchell (Small)
Source: A. Turner Design/Alfred Turner Jr. Photograph ©Lois Greenfield.

Figure 5.13. Philadanco/PSDA 40/50 Anniversary Celebration
Left—Michael Jackson Jr./Rosita Adamo,
Source: Photograph ©Lois Greenfield;
Right—Amari Brown Swint (Front); Naiya Brown (Rear)
Source: Photograph ©David Male/DSM Productions; A. Turner Design/Alfred Turner Jr.

Figure 5.14. Moving On—Philadanco, 2011. Dancers in Pose from Ray Mercer's *Guess Who's Coming to Dinner*. L. To R.—Atop Table: Michael Jackson Jr.; Alicia Lundgren, Jeroboam Bozeman; Under Table: Lamar Baylor, Chloe O. Davis. *Source:* ©Lois Greenfield.

EPILOGUE

To: Brenda Dixon Gottschild
(for Joan Myers Brown)
Good Morning Ms. Joan Myers Brown......
O how you captured life with your conversation of
feet. legs. thighs. hands. dancing blue midnite
bells for our African American pulse......
O how you opened up the American dance stage to
the flutters. pirouettes. jazz steps/petals coming
from a thousand feet dropping red yellow purple
block prints against past silences until we
shimmered with dreams and memory of our own eyes......
O how your legacy: Philadanco: awakened us to
the wings of butterflies humming sweet life. life. life.
as you documented our dreams that ran from our knees
to our heart....
O how we treasure you; give thanks to your vision of
new clothing for this Thing called American dance......
O you woman close to the ancestors....

©2011 by Sonia Sanchez. All rights reserved.

"Fulcrum—the point or support on which a lever pivots; an agent through which vital powers are exercised." This was the definition I used in the Prologue to describe, in a nutshell, the scope and extent of Joan Myers Brown's influence. I return to this description in closing this finite study of an ongoing tradition and the woman who is in the driver's seat. The path she travels, like all human endeavor, is neither straight nor narrow, but a long, wide, winding, often bumpy road. In fact, as Vanessa Thomas Smith pointed out in our interview, JB manifests a

> sensibility in life of understanding that our path is very circular. Our interactions with each other, with our careers...but eventually, your paths will cross again: to me a very Afrocentric sensibility in understanding our life cycle and the cycle of things.

We see this in the cycles of recycled people who find their way back to "Aunt Joan" after months or years or even decades. "Gone without the *e*,"—the funny way that JB describes these goings-comings—and, even as the body recedes and the door is closing, that same body is perhaps already on the road to return, from the wide-angle perspective of the larger picture. The circle. The cycle and its evolutions: the audacious hope that black kids can grow up to be ballerinas or even the president of the United States. And, even though a token number of black ballerinas have seen the light of day in white ensembles—Raven Wilkinson, Debra Austin, Lauren Anderson, Aesha Ashe, Misty Copeland, and a couple of others—the black ballerina's dream of mainstream accessibility remains, by and large, a dream deferred. But whenever we deny something to someone else, we deny it to ourselves. The loss is mutual, because we stand in the same circle of life. As one writer said:

> Whatever I deny to others, I've already lost to myself.... If instead I come to realize that our lives and histories are shared, then the whole world is kin and I take my place at the table where the entire Earthly [*sic*] family is invited to dine. No one told to go hungry. No one left outside.[1]

This book belongs to all those whose voices and memories echo through its pages. But most of all, this is JB's book, and I give her the last word, taken from a moment of glory and triumph during the year of the fortieth anniversary of Philadanco and the fiftieth of the Philadelphia School of Dance Arts: her "50/40 Celebration," as it was billed. Here is the text of her acceptance speech upon receiving the coveted and prestigious Philadelphia Award[2]—"The Eighty Ninth

Philadelphia Award presented to Joan Myers Brown, Monday, May 10, 2010." Let us be there with her, as she stood and, uncharacteristically, delivered this address through a cascade of tears of joy:

To Dr. Parks and the members of the Board of Trustees, I would like to thank you for having selected me to receive this outstanding recognition today. I am thrilled beyond comparison.

To my family, friends, staff, colleagues, dancers, and invited guests — I thank you for having taken time out of your busy day to share this very special occasion with me.

I am both honored and indeed humbled that I, a small part of all that makes Philadelphia such a special place, would be chosen to receive this, the Philadelphia Award.

For the past few weeks, since being told of this honor, I have been thinking what would I say and how I would ever get through it. I certainly am somewhere between feeling like an Oscar winner or a rock star — and as Vice President Biden said, "This is a big deal!" And I am sure you will all agree it is a tremendous honor, especially following in the footsteps of last year's honoree, Jerry Lenfest.[3]

I would especially like to thank my friend, Ms. Mary Hurtig, who has nominated me for this award since 1985 and probably almost every year thereafter and who, along with her husband, Dr. Howard Hurtig, and her father, the late Dr. Edwin Wolf, has encouraged and supported me in many ways for many years. Each time Mary told me she was going to submit my name for consideration, I would chuckle and say, "Yeah, Mary, I'm never going to win that. I'm not really important enough, but thanks for thinking that much of me." But obviously she, along with many others who also submitted my name for consideration, believed that my doing what I loved was worthy of this recognition. So I would like to thank my Board president, Ms. Beverly Harper, my Board chairman, Mr. Spencer Wertheimer, the Honorable Blondell Reynolds Brown,[4] and Ms. Susan Glazer for recognizing my commitment to dance and what it means to love the arts. I would also like to thank Ms. Natalye Pacquin for making today's celebration here at the Kimmel Center possible.

I guess I am a Cinderella Story; having been born and raised here in Philadelphia and committed to Philadelphia; in spite of Philadelphia, I seemingly was able to give Philadelphia something that is considered worthy of awards and rewards over the years. I just believed in, and was committed to, my purpose, and tried to stay with it until today, proving that not only what is so-called Black dance valid and has an aesthetic of its own but that dance *is* a vital part of living and that it can bring joy, peace, love, health, strength, commitment, perseverance, discipline, education, fulfillment, satisfaction, and so much more into our

lives and especially into the lives of our children, making them beautiful, productive, self-assured, and positive human beings.

Ever since my gym teacher presented me with the challenge of being a black teenager in an all-white ballet class in the 1940s, I have been trying to prove that I could do something with dance as a part of my life, if only given the opportunity—and I am still trying to do that today for dancers from all over the world, not just dancers of color, but all those who live to dance.

After spending more than 50 years of telling dancers "you can do it," I find myself today standing here, finally believing what Ms. Katherine Dunham told me: "Joan, just do what you do and it'll be fine," and it is.

My dearest friend who I love and respect beyond comprehension, Dr. Michael Kaiser,[5] has shown me how to sidestep the hurdles of racism, elitism, lack of funding, narrow-minded opinions, hostility, jealousy, and all the things that make the life of an artist difficult. So, I would like to thank him for his many years of dedication to me—all I ever have to do is ask, and it's done. Today, I want him to know I would not have had this moment without him, so I thank him for being here today and the every days: he has been an amazing friend.

To my lovely daughters who lived a great part of their lives without me but who nevertheless continue to love and work with me—I thank you.

To my staff who have stuck with and worked with me year in and year out—some for over 30 years or more—I thank you.

I know there are many others I should thank, and I am sure if I start to name them I would leave someone out and make someone mad, so I'll just say thank you all, and mostly I thank God for the privilege of living in Philadelphia. I am truly a "Philadelphia Story," and perhaps some other young girl here in Philadelphia will dare to dream and have her dream come true!

Of all the awards I have received, this is the one I will cherish the most. The Philadelphia Award has given me a great sense of what I am and what I need to do and to know that what I dreamed of is not impossible and is appreciated. For that I thank you all.

AFTERWORD: BRENDA DIXON GOTTSCHILD—A CRITICAL PERSPECTIVE

1992: A classroom on the third floor of the Vivacqua Building, the Dance Department of Temple University. Professor Brenda Dixon Gottschild is teaching her graduate seminar on Research Methodologies. Even as she introduces us, her students, to multiple modes of organizing research and writing, and different methodological processes, she urges us to pay attention to *how* we formulate our research questions. She introduces her methodological intervention: "digging." You must look for the absences, she urges us, for deliberate and unthinking omissions, and reflect on what erasures exist in the data presented. Who is missing from this picture? Whose voice might have been casually forgotten in this record? She teaches us to look deeply and thoughtfully at images, texts, and movements in order to recognize blurred-over moments of dis/miss/appearance, historiographic aporias.

The professor's classes instilled in my head the urgency of being reflective about epistemological processes, *how* we come to know our world, which ultimately shape the ontologies we work with, *what* we come to know. But it has taken me many years to realize the impact and deep significance of the theoretical reversal she had trained us in. She was not emphasizing the official language of archaeology, with its specific focus on material, empirical evidence in order to construct historical narratives, though she often talked about the scholar-as-archaeologist. Differently, and in contrast to the way archaeological narrativizations of the past have sometimes been deployed to tether a nationalist agenda or to shore up state tourism, Dixon Gottschild's work has often led to an unraveling of unilinear histories, official narratives of cultural production, the undoing of erasure, and, most vitally, to acts of presencing.[1] Recalling Foucaultian methodologies, Dixon Gottschild's "digging" aims also to document the conditions marking the existence of official histories and bodies of knowledge and the particular fields in which they are deployed.

So, when she encouraged dance studies scholars to think of their work as archaeological projects, it was from this somewhat different perspective. Indeed, her pedagogy was carefully structured to train us in conjuring presence from traces in performance, and to construct powerful arguments from what we witnessed in

dancing bodies. Ultimately, this has meant a renegotiation of major historical accounts—few as they may be in dance studies, making it even more sacrilegious to question their "truth"—in order to suggest the continual presence of "othered" bodies and modes of production. A commited scholar of American performance and cultural forms, her cherished project has been to repeatedly draw attention to the ways in which difference has so often shaped and influenced mainstream cultural modes, even when the dominant rhetoric has implied a total rejection of difference, or a subsuming of difference under universalist categories such that difference can no longer be recognized.

This, specifically, was the undertaking of Dixon Gottschild's first book, *Digging the Africanist Presence in American Performance* (1996, Greenwood/Praeger), in which she analyzes movement, choreographic structure, and other elements of cultural production to trace a continuity of subterranean Africanist presence in American concert dance, ballet, modern and postmodern dance, popular cultural forms, as well as other contexts. The digging works more like weaving here, pulling different strands of historical presence together to create a complex fabric of continuous interchange and influencings between Africanist and Europeanist cultural modes. Her writing, especially her acute reading of the Africanist influences in Balanchine's choreography, initially sent shock waves through the dance community here in the United States, and her "polluting" of the purity of the ballet aesthetic through these claims was often received with indignation.

Dixon Gottschild's first public presentation of this specific material was at a talk given at Franklin and Marshall College in Pennsylvania in 1989. As she continued to present this research, she met with substantial resistance in some quarters and enthusiasm in others. In her 2005 essay, *By George! O Balanchine!*, she recounts how, in 1991, a colleague from the University of California, Riverside responded to her tracing Africanisms in Balanchine's work by demanding that she show "a direct line of evolution between specific movements in a Balanchine work and specific movements from a specific African dance coming from, in the colleague's words, a specific 'African tribe.'"[2] While there is much to investigate in the tribalization of "African dance," the obliteration of agency in diasporic cultural production, and the reduction of what Dixon Gottschild terms "Africanisms" to evolutionary charts, comments such as these allowed her to realize that a "laundry list" style of dance research would never work for the complex questions she was pursuing, and she continued to push her own innovative research methods. The resistance she met only deepened her methodological digging. She examined the comments of critics, incorporated them into her research, and retooled her own findings and interpretations to sharpen her landmark theoretical contributions to dance studies.

What, then, are the implications of this scholarship and of this methodology? Dixon Gottschild had repeatedly urged her students never to "go looking for something," and then fit the methodology to suit the hypothesis because we might skew the research to "find what we were looking for," and miss crucial evidence that might complicate the research questions. As she directed us back to the evidence presented by dancing bodies, however, she encouraged us to reach across disciplinary boundaries and methodological specifications. Indeed, this is how she had done her own research: "My task was to find the methodology that suited the research, rather than forcing the research to fit a predetermined mold."[3] This, then, is one of the first implications for dance studies: this balancing of interdisciplinary research that deliberately intersects with other bodies of knowledge and situates dancing as one of several cultural practices, with an intense focus on dancing bodies, honing in on analyzing *the way* bodies are moving as primary evidence.

So often dance studies is plagued by the specter of impermanence, the idea that if what is analyzed is moving bodies at the moment of performance, then little materiality is left behind to investigate. Yet, one of the strengths of Dixon Gottschild's scholarship is her detailed, poetic, and vivid movement description, something she insisted her students also train in. She would have us write and rewrite "thick" descriptions of movements, all the while cautioning us not to "lose the woods for the trees," and reminding us to steer our observations of movement and choreography toward the thesis we were trying to formulate. This focus on bodies-in-motion, on how movements are/were performed, has often been at the core of her arguments and have strengthened her research methodology. For instance, it was not just the choreography of a series of battements, but also how they were performed, with the hip lifted, that in effect transformed the battements into acrobatic kicks (as Dixon Gottschild talks about in her analysis of Balanchine). It was this and other such details that we were to reflect on. This emphasis on the materiality within dancing has come to be a defining factor in dance studies as the field has emerged as its own area of specialization.

Indeed, in the introduction to her third book, *The Black Dancing Body*, published in 2003, Dixon Gottschild shares that when she was approached to write a history of "black dance," she responded by imagining this history as a "geography" of the black dancing body.[4] This horizontal cartography, organized in terms of rippling out circles of "latitudes," in which sections reach across chapters to connect with each other, immediately suggests that her account of black dancing bodies, "from coon to cool," as the subtitle says, has moved away from the hierarchies and chronological causalities that might lean toward linear narrativization. The mapping proceeds through the marking of the context, alternating

with significant ruminations on specific parts of the body-soul. But the feet, the butt, and the hair/skin ultimately function as synecdoche, revealing the layers of assumption and stereotype that have congealed on black dancing bodies and that will need to be dug out. The research leads repeatedly to the inevitable imploding of racialized biological categories: "There are no 'pure' types—no races, as such. Europeans, Africans, Asians—we are all mixed bloods, mixed 'races.' Race is not a biological imperative but a social construct convenient for purposes of classification and differentiation."[5] Yet, instead of dissolving difference, this idea ultimately leads to an argument for difference and specificity in cultural practices, suggesting that form has followed from function: the way we practice bodily acts in turn shapes our bodies.

What the work of digging has also implied is the need to renegotiate textualizations of history, constructed as stable. The revealing of difference in the midst of what were thought to be established narratives also blemishes ideas of cultural purity and asks us to think about the inevitable hybridity across contexts. This, to me, is one of the more enduring legacies of this work: the emphasis on cultural specificity even as we demonstrate intercultural presences, the agreement to rehistoricize with acknowledged relationships to difference, and thus the dismantling of typically accepted relationships of power. Of course, this touches on an abiding anxiety within dance studies about the adequacy of accounts told from "other" perspectives. While fully acknowledging that narratives emerging from identity politics are often plagued by essentialisms and metatheories of ethnonational belonging, it is impossible not to recognize how, almost inevitably, difference troubles. Thus, it is often asserted that markers of historical sufficiency necessitate that well-written texts of dance history are marked by a focus on such things as narrative, aesthetics, or chronology.

The methodology of digging comes full circle in *Joan Myers Brown & the Audacious Hope of the Black Ballerina: A Biohistory of American Performance.* Digging, both in the sense of the physical labor of uncovering facts and bringing them to light, and digging in the popular cultural sense of taking pleasure in, enjoying, simultaneously run through this narrative. Dixon Gottschild's delight in being able to weave together facts, anecdotes, and visual evidence about bodies, and dig deep into the past as she brings together textual archives and oral interviews, is obvious in the vibrancy of the writing. Yet the tenor of this book is somewhat different. Like her other books, it refers to an invisibilized history and documents the contributions of black artists to a mainstream constructed as white only. Differently, it foregrounds the desire of black artists for artistic forms they found beautiful, desired, and chose to train in and perform, forms that were thought of as "white," even in the face of segregation and so much resistance: specifically,

ballet. In the end, they transformed this dance form and claimed it as part of the diverse American cultural resources that were theirs by birthright, while the influences they brought with them often came to be integrated into the form.

Returning to a word in the subtitle: "biohistory." In her book, *A Dictionary of Geography*, Susan Mayhew offers a formal definition of biohistory as "an approach to human ecology which stresses the interplay between biophysical and cultural processes. Its starting point is the study of the history of life on earth; and the basic principles of evolution, ecology, and physiology, and the sensitivities of humans, the emergence of the human aptitude for culture, and its biological significance. It is particularly concerned with the interplay between cultural processes and biophysical systems such as ecosystems and human populations."[6] But, differently from the Darwinian, deterministic lines of several biohistorical arguments, Dixon Gottschild's biohistory painstakingly parses the imbrication of race and cultural production in order to stage a rhizomatic history. Moreover, in keeping with her earlier work, this history turns on a productive tension between a systematic analysis that takes apart notions of purity around race and cultural production and a documentation of culturally specific practices in the black artistic communities of Philadelphia in the first half of the twentieth century, strategies that were necessary to survive as artists.

Indeed, in *Joan Myers Brown & the Audacious Hope*, Dixon Gottschild again reimagines historicizing as nonlinear. But more specifically, ideas of individual genius and inflections of "masterpiece" find little place in a narrative that traverses several decades, tracing several parallel developments in sociocultural contexts to weave together the complex choreography of the unwavering hoping, desiring, and innovating community of artists whose work is invoked in the final success of Brown's Philadanco. In this cool, polycentric history, Dixon Gottschild situates Brown in the particular context of 1920s–1940s Philadelphia and the circumstances it presented. This brings her to the black dance schools in that city in the era of segregation. Readers are introduced to Essie Marie Dorsey and her mentees, Marion Cuyjet and Sydney King, along with other teachers and contemporaries of Brown. In a narrative that constantly reaches out to highlight individuals, we meet Delores Browne, Billy Wilson, John Jones, Donna Lowe, Arthur Hall, and many others. We also share in Browne's remembrance of an Asian man who steps forward in Vladimir Dokoudovsky's ballet class to ask the young ballerina to partner with him when none of the white male students in the class would partner the black female students. The text conjures up a constantly mobile, densely populated scenario, where the intense desire to dance, specifically to learn and practice ballet with excellence and finesse, facilitates multiple strategies to learn and share knowledge and to build skills.

One more word on the deliberate nonlinear organization of this narrative: never is the story of one individual told in one stroke. Rather, as we move through the narrative and turn different corners, we meet that person again and again, thus emphasizing a relational nature of what comes to be considered historic. In a similar move, the narrative does not end with Philadanco, but throws forward to invite in a host of choreographers, teachers, and dancers who worked with Brown at Philadanco and trace their careers, as well as those of other dancers in Philadelphia who have been touched and influenced by Brown. It is as if Brown's trajectory etches a solo in the midst of ensemble choreography, and so to recognize her tremendous accomplishments, we must look back, forward, alongside. Finally, as we encounter a range of different organizations, the Judimar school, the Ailey company, we realize why it is so essential to understand this history as part of an ecosystem through which people traveled in circular pathways. Polycentric, polyrhythmic, intersecting, simultaneously hot and cool.

However, this history does not project a seamless flow. Dixon Gottschild remarks on the tensions that rent the fabric of these times. It is not just the black–white divide that creates exclusions; the racial hierarchy labors through the ways in which race and class collude and the color-caste system weeds out darker-skinned dancers from the lighter-skinned ones. There is also Philadelphia's constant antagonism with New York City, the reputations that accrue to the two different cities and the opportunities they offer to dancers. These then further complicate the way struggles over funding, reception, and the management of never-enough resources cut across the dance world, differently, across the decades.

Once again, I am reminded of Foucault and want to suggest that this text might be read as Dixon Gottschild's re-take on Foucault. It is a genealogy that does not aim to search for originary moments, nor can it work through linear developments. Rather, it intersects with existent histories of dance in the United States to reveal the possible plural and often-contested narrativizations of the past and the ways in which power has worked to assign authorship, suggest rational outcomes, and circumscribe the limits of artistic possibility. Recalling Foucault's tactical organization of genealogies, *Joan Myers Brown & the Audacious Hope of The Black Ballerina* refuses the coercion of a unitary theorization of a past masquerading as history, and instead, through the proliferation of a host of interconnected and intersecting local narratives, asks readers to consider different organizations of historical knowledges.

In the end, I embarked on a different genealogical project of my own to reflect on how this project might be received by academic audiences and invited two students from my Dance History class at the University of Minnesota to

share their thoughts. The four dancers in this choreographed genealogy are, of course, Brenda Dixon Gottschild, respected scholar of dance studies in the United States; me, who immigrated from India in the 1990s, an academic; Mette Towley, a mixed-race second-year student from Alexandria, Minnesota; and Justin Reiter, a white second-year student from South Dakota. I asked Mette and Justin what they might find most interesting in learning about Joan Myers Brown, should they have the opportunity to read a book about her artistic journey. While it was important to Mette to learn about Brown's perseverance and her commitment to create shifts from within a form, Justin wanted her history documented so that his generation would be able to know American history, "what we have had to grapple with in this country."[7] Both wanted to know about the multiple relationships that were part of her world and the community and network that invigorated her world, which they felt would have been instrumental in creating the particular set of opportunities that enabled her to continue to learn and work with her craft at that time.

When I shared the particular way in which this book was organized, Justin was enthusiastic about learning about the "multitudinous branching" that, in fact, is true to the "delinearity" of history. Mette worried if continued racial fissures in current times would result in this book—written by a prominent African American scholar about a black ballerina—sitting sandwiched between many others on a book shelf. But her biggest question surrounded desire: Why would Joan Myers Brown be interested in this aesthetic, despite all the baggage it came with? How did she continue to desire it, embody it, even as she dealt with the racism and exclusion in that world every day? Justin wondered if it was the refusal to accept exclusion that strengthened and shaped Brown's resolve to come out ahead in a cultural field that had done so much to keep her, and others like her, out. He also felt that witnessing works by companies such as Philadanco might in fact bring audiences to an awareness of the undeniable black presence in ballet in this country.

Ultimately, the two young scholars turned the conversation to a more self-reflexive point. Thinking of the tremendous struggles that Brown must have gone through to arrive where she stands now, they thought of the ease with which they, as university students, are able to access the work of so many different choreographers. Justin's poignant comments stay with me: "This brings me to such a keen awareness.... How can I dance in Nora Chipaumire's work just through an audition, yet look at what Brown had to go through to take classes in ballet."[8] Finally, Mette, having thought through the multiple nonlinear circuits of desire and the complex constitution of beauty, took me by surprise as she articulated her final understanding in language that recalled my former professor. She

asserted that, though she could not, for herself, separate the aesthetic from the political, possibly Brown had survived the trauma of racist exclusion from ballet by accomplishing this separation inside her mind, by "stripping the aesthetic momentarily of the cultural identity that had been put on it."[9]

This conversation with my students convinced me that this book—bringing together the power of Professor Brenda Dixon Gottschild's scholarship and Joan Myers Brown's incredible artistic journey—would not just be of interest to the next generation of scholars. Rather, they would find so many of the questions that they are continuing to grapple with today reflected in the stories of this book. They would continue to be challenged and inspired by alternative historiographic formations, and Foucaultian reorganizations of knowledge, even as they remained absorbed in the story of Joan Myers Brown. Continuing circles.

<div style="text-align: right;">
Ananya Chatterjea

Professor, Theater Arts and Dance

Director, Dance Program

University of Minnesota, Twin Cities

May 15, 2011

Minneapolis
</div>

LEGEND

Betty Nichols
ballerina, Ballet Society, NYC; and with Balanchine and Cunningham, Paris

Louise Jackson (Carpenter)
dance school, Bermuda

Eleanor Harris
dance school with John Hines; tap teacher, Ailey school (until 2008)

Billy Wilson
Europe; Broadway

Arthur Hall
The Sydney King Dancers become The Arthur Hall Ensemble

Joan Myers Brown (JMB)
founder, PSDA (Phila. School of Dance Arts), Danco (Philadelphia Dance Company), D2, D3, Instruction and Training Program

Lola Falana
dancer-actor-vocalist: nightclubs, television, Hollywood, Europe

Carole Johnson
studied with JMB at Sydney King's school; (founder) Aboriginal Islander Dance Theatre, Australia

Betsy Ann Dickerson
studied with JMB at Sydney King's school; Radio City Corps de Ballet; dance school, Long Island, NY

Walter Nicks, Joe Nash, Leigh Parham
New Yorkers who taught/choreographed for Cuyjet

Donna Lowe (Warren)
dance school, FLA

Cheryl Gaines
La Cher Teri school, Philadelphia

Ama and Payin Schley
Carol Butcher's twin daughters dance with Kulu Mele, Phila.

Gene Hill Sagan/Milton Myers
Danco resident choreographers

Vikkia Lambert
from PSDA to Ailey Company

Robert Garland
from PSDA to Dance Theatre of Harlem

Bernard Gaddis
co-founder, D2; from Danco to Ailey; Cirque de Soleil; founded Las Vegas Contemporary Dance Theatre

Francisco Gella
from Danco to freelance choreographer, CA

Zane Booker
from PSDA to Danco to Europe and back; Danco choreographer; founder, Smoke, Lilies & Jade Foundation (presenting/performing/outreach)

Antonio Sisk
from Danco to Roswell Dance Theatre, GA

Shawn Lamere
Instruction & Training Program; co-founder, D2; Director, Eleone Dance Company, Phila.

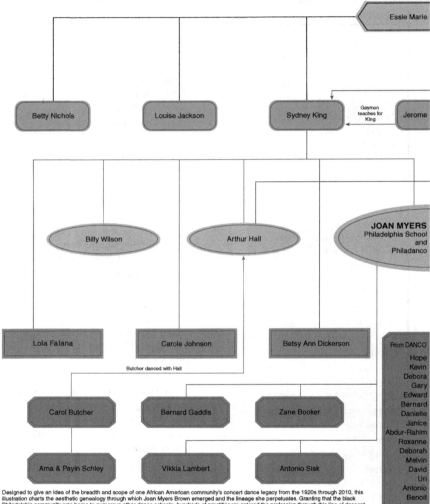

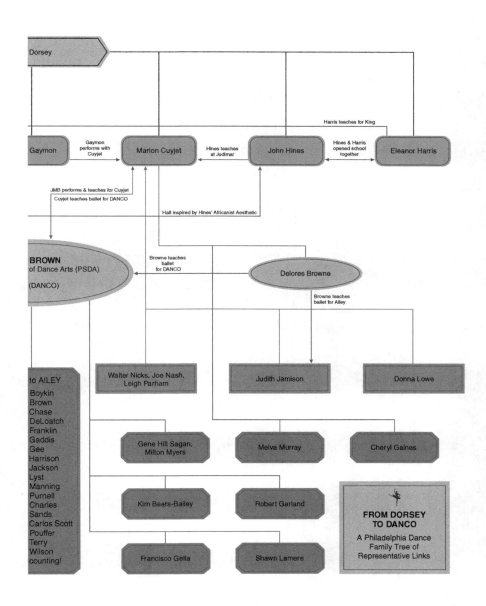

APPENDIX 1: JOAN MYERS BROWN—ANNOTATED RESUME

Compiled by Brenda Dixon Gottschild with input from Takiyah Nur Amin and Nyama McCarthy Brown. Activities recorded through 2010.

December 25, 1931: Joan, their first and only child, is born to Julius and Nellie Myers at Graduate Hospital, Philadelphia, Pennsylvania.

Joan and her parents live in Philadelphia, first at Sixteenth and Christian Streets until they move to Forty-Second and Woodland Streets in 1934/1935 and then to 4638 Paschall Avenue in 1938/1939.

(July 28, 1910: Julius Thomas Myers born in Wadesboro, North Carolina. Of seventeen siblings, he was the youngest of six of the brothers who moved to Philadelphia together around the end of the 1920s. He worked as a chef at 2601 Benjamin Franklin Parkway in Philadelphia. Later he owned a restaurant on Forty-Second and Woodland Street near the family residence. Thereafter, he worked at the Sun Ship Yard. Julius Myers' mother, Mariah Sturdevant passed away in her early forties; Julius Myers said she was a Jewish woman of German descent.

February 23, 1915: Nellie (Lewis) Myers born in Philadelphia, her family having migrated from Virginia. She attended the Philadelphia College of Pharmacy and Science in the 1930s and worked in the chemical research and chemical engineering department of the Arcos Corporation for thirty years.)

1937–1942: Joan attends the Alexander Wilson Elementary School.

1938–1939: Joan Myers trains with Sydney King at Essie Marie Dorsey's dance school and also with King in classes held in the basement of King's residence to strengthen a broken foot. On Saturdays she attends classes at Dorsey's studios at the Elate Club on the second floor at Broad and South Street. (The building's first floor housed the Apex Beauty School.)

1943–1946: Joan attends Shaw Junior High School.

1947–1949: Joan attends West Philadelphia High School.

1948–1949: Joan takes ballet class and engages in ballet-related activities with Virginia Lingenfelder in the ballet club at West Philadelphia High School. (Lingenfelder was a dancer associated with the Littlefield Ballet.)

Performs with the ballet club at the old Philadelphia Convention Center in the "All Cities Parade."

1948: With Lingenfelder's encouragement, Joan takes private ballet classes, including pointe, with Eleanor Breckenridge, a Lingenfelder colleague, who was renting space at the studio of Jay Dash. (Dash does not allow blacks in his classes.)

1949: Joan continues studying privately with Eleanor Breckinridge.

1949: Graduates from West Philadelphia High School.

1949: Trains and teaches at the Sydney-Marion School in Philadelphia. In 1949 the Sydney-Marion School (began in 1947) is discontinued. Marion Cuyjet opens the Judimar School of Dance at 1311 Chestnut Street in Philadelphia. Sydney King remains on Broad Street and opens the Sydney School of Dance.

1949–1951: Joan continues teaching for King and begins to study the Dunham technique with Jerome Gaymon as well as tap with Eleanor Harris at the 711 South Broad Street location.

1950: Joan takes private classes with William Sena at his Philadelphia dance studio.

1950: Joan marries Fred Johnson.

The King School presents a portion of *Giselle* in a recital, King plays Queen of the Wilis and Joan plays *Giselle*.

1950–1953: Joan performs in Philadelphia's Christmas Cotillion Balls.

1950–1951: Joan is awarded a $100 scholarship to study in New York at the Katherine Dunham School of Dance, travels weekly to New York, and studies with Karel Shook, Walter Nicks, Maria Costosa, Syvilla Fort, and Francis Taylor.

1950–1952: Has her first professional performances outside Philadelphia, arranged by Joe Noble at Izzy Bushkoff's Creole Follies Cabaret in Delair, New Jersey.

Mary Johnson [Sherrill], Juanita Jones [Feggins], Roxy Young [Bradford], Andre Pitts, and Noble dance with Joan in the Creole Follies.

1951–1952: Joan trains with Antony Tudor through the Philadelphia Ballet Guild. She is invited by Joe Noble to perform in New Jersey at The New Town Tavern.

Joan's mother, Nellie Myers leaves her marriage to Julius Myers.

1952–1955: Many bookings follow, including work at such upscale clubs as the Latin Casino in Philadelphia.

1955–1956: Joan performs and choreographs with a group of dancer friends she assembles under the name The Savar Dancers at Café Montmarte in Montreal, Canada.

She studies ballet at the National Ballet of Canada in Montreal, Canada.

The Savar Dancers' Canadian tour includes Toronto, Quebec City, and Valdora, Quebec.

1956–1958: The Savar Dancers perform far and wide—for example, with the Fats Domino revue at the Orchid Room of Kansas City's House of Hills and Happiness, then carried over to continue in a revue featuring The Four Tops, a popular vocal group; at the Fiesta Club, Idlewild, Michigan; in Las Vegas, Miami, and New York, as part of Cab Calloway's Cotton Club Revue.

1958–1960: Joan's rich performing and choreographing career continues, with Savar Dancers' bookings as well as her individual gigs. Among the places she performs are the Black Orchid Casino (Canada); the Deauville (Miami Beach); the Dunes (Las Vegas, with Cab Calloway), the Thunderbird (Miami Beach, with Larry Steele), the Riviera (New York City, with Larry Steele), the Apollo Theater (Harlem, with Pearl Bailey), the Masonic Auditorium (Detroit) and the Regal Theater (Chicago).

1959: Begins dancing in Atlantic City with the Larry Steele Smart Affairs Revue, backing up such performers as Sammy Davis, Billy Eckstine, and Billy Daniels. With the Savar Dancers disbanded, JB begins taking on duties as choreographer during her tenure with Steele.

Clyde "Jo-Jo" Smith, Andre Pitts, and Frank Hatchett dance and partner with her during this time. Joan also performs pointe work as the featured ballerina in some of the Steele revues.

1960: Performs and tours as a dancer in Pearl Bailey's Revue with Honi Coles and Cholly Atkins in Las Vegas and Pittsburgh, and also in Miami Beach at the Eden Roc Hotel.

1960: Opened the Philadelphia School of Dance Arts (PSDA), 137½ South Fifty-Second Street, Philadelphia, Pennsylvania.

1960–1967: Continues working nights at Club Harlem and various venues in Atlantic City, while running PSDA during the day. Continued professional friendships with Cab Calloway and Sammy Davis, Jr. when they performed in Philadelphia.

1967: Joan marries Max G. Brown.

February 18, 1969: Daughter Danielle L. Brown is born.

1970: JB founds The Philadelphia Dance Company (Philadanco), a ballet-based modern contemporary dance ensemble, with her school and studio at Sixty-Third and Market Streets.

April 3, 1970: Daughter Marlisa J. Brown is born.

Early 1970s: Arthur Mitchell is a guest teacher at Danco. Mitchell continues to teach at Danco as a guest when Dance Theatre of Harlem has performances in Philadelphia.

1970s: Karel Shook is occasionally brought in to teach Danco company classes in Philadelphia, PA.

1972: JB and Philadanco attend National Association for Regional Ballet (now Dance America) in Wilkes-Barre, Pennsylvania. She makes first acquaintance with Jeraldyne Blunden, founder of Dayton Contemporary Dance Company.[1]

1972: "Danco on Danco" begins—a biannual concert showcasing works choreographed by the Danco professional dancers on one another and on student trainees—at the original Painted Bride Theater on South Street in Philadelphia.

1972: Philadanco's first public performance in a concert at the Philadelphia School of Dance Arts; pieces by John Hines and Harold Pierson are featured.

1972–1973: Philadanco receives first funding grant from the National Endowment for the Arts; JB attends University of Pennsylvania and earns certificate in Arts Management.

Late 1970s: Robert Garland studies with JB at PSDA. She encourages him to follow his dream to be a ballet dancer and go to the Dance Theatre of Harlem in New York. He goes and later becomes assistant director of DTH.

1977: Philadanco dancers receive first paychecks, thanks to a CETA (Comprehensive Employment and Training Act) grant. (CETA is the locally controlled manpower program legislated in 1973.)

1979: JB receives choreographer's fellowship from the National Endowment for the Arts.

1981: She purchases the building at 9 North Preston Street in West Philadelphia.

1986: Philadanco receives National Choreographic Project Grant to commission a work by Milton Myers; Myers later becomes Philadanco's resident choreographer.

1986: JB is co-founder of the Coalition of African American Cultural Organizations in Philadelphia.

1986: JB receives the Theodore L. Hazlett Memorial Award for Excellence in the Arts in Pennsylvania.

1986: She establishes the first artists' housing for dancers in Philadelphia.

1987: At a dance conference in Brooklyn, New York, JB makes first acquaintance with Cleo Parker Robinson (Cleo Parker Robinson Dance, Denver Colorado) and Ann Williams (Dallas Black Dance Theatre).

1988: JB founds the International Conference of Black Dance Companies and hosts the first conference in Philadelphia.

1991: JB is co-founder of the International Association of Blacks in Dance, a direct offshoot of the now-yearly conference.

1991: Philadanco performs in Turkey (Istanbul and Ankara)

1992: Philadanco performs for the first time in Germany at the Leverkusener Jazztage.

1992: First non–New Yorker BESSIE dance Award recipient is Danco's Kim Y. Bears.

1994: Danco dancers placed on fifty-two-week contracts.

1994: JB co-hosts a weekly local radio program, *Your Cultural Connection*, with Helen Haynes, an arts administrator, presenter, and advocate.

1995: Preston Street renamed "Philadanco Way" by city of Philadelphia.

1995–current: JB serves as distinguished guest dance faculty at Howard University in Washington, D.C.

1996: Danco performs in Italy. International touring becomes a regular feature in the company's life.

1997: JB honored in "Dance Women; Living Legends," a tribute to African American pioneer women of modern dance.

1999: National Dance Theater of Bermuda hires JB as arts and business consultant.

2000: Philadanco premiered its first Christmas Show: *Xmas Philes*.

2000: Philadanco receives permanent residency at the Kimmel Center for the Performing Arts in Philadelphia, Pennsylvania.

2000: The International Association of Blacks in Dance receives a BESSIE award.

2004: JB receives and Honorary Doctorate of Fine Arts from University of the Arts, Philadelphia.

2005: JB is honored at Kennedy Center for the Performing Arts—"Masters of African American Choreography."

2006: JB received the Dance Magazine Award for her work with Philadanco.

2007: JB receives Honorary Doctorate of Humane Letters from Ursinus College, Collegeville, Pennsylvania.

2010: JB receives the Philadelphia Award.

APPENDIX 2: PHILADANCO HOME SEASONS REPERTORY CHRONOLOGY: 1975–2010

The company first performed in 1972 at the Philadelphia School of Dance Arts Annual Recital. Information on performances prior to 1975 could not be located at time of publication. Lacking an archivist to preserve and maintain a Philadanco Collection, performance programs and other forms of documentation have been misplaced, lost, or stolen over the years. Moreover, documents housed temporarily in the African American Museum of Philadelphia were unavailable for researchers at time of publication. For program booklets that were missing pages or were unavailable, newspaper clippings and Kim Bears Bailey's memory were helpful in filling the gaps. Although it is unfinished, this document gives a comprehensive view of the company's scope for thirty-five years and reflects the sum of information culled from Temple University's Paley Library Dance Collection and Joan Myers Brown's personal collection, as of 2010. Names of dancers and choreographers and titles of dances and concerts are given as they appeared in the programs, unless otherwise noted.

Data compiled by Takiyah Nur Amin with input from Kim Bears-Bailey (also known as Kim Y. Bears). Supervised and edited by Brenda Dixon Gottschild.

1975 Spring Concert—March 28
Walnut Street Theatre

Title	Choreographer
Time/Space	Harold Pierson
Dvorak Concept	Joan Myers Brown
"...Change"	Joan Myers Brown
Black Roots (Spirituals):	
Motherless Chile	Joan Myers Brown
I Told Jesus	Billy Wilson
Pro-Fusion	MortonW inston
Porgy and Bess	Harold Pierson

Dancers: Debra Chase, Edna Chew, Gwendolyn Coleman, Benita Harris, Janice L. Harrison, Deborah Manning, Karen Still, Jamilla Toombs, Tammy Toyed, Valerie Wilson, Herbert Bailey, Jr., Michael Harrison, Tony Parnell, Leon Washington, David Williams

1976 Winter Concert — February 6
Annenberg Center for the Performing Arts, Zellarbach Theatre

Title	Choreographer
Toccata for Percussion and Dancer	John Jones
Motherless Chile	Joan Myers Brown
I Told Jesus	Billy Wilson
Dvorak Concept	Joan Myers Brown
Getting It On	Morton Winston
Extensions of M.E.	Joan Myers Brown
Time/Space	Harold Pierson
200 Years of Black American Dance 1776–1976	Harold Pierson
Pattin' Juba (Hambone)	HaroldP ierson
KumB 'aya	HaroldP ierson
Looking Out for Number One	DannyS loan

Dancers: Carmen Butler, Davita Butler, Gail Carmack, Edna Chew, Gwendolyn Coleman, Wilfred Croswell, Rolanda Gibson, Janice L. Harrison, Michael Harrison, Pamela Assata Hazel, Robin Jackson, Cassandra Joyner, John Lee, Deborah Manning, Jerome Parker, Phillip Parnell, Blondell Reynolds, Patricia Scott, Marguerite Schumate, Karen Still, Sylvie Steber, Vanessa Thomas, Jamilla Toombs, Leon Washington, David Williams, Gwendolyn Warr

1977 Spring Concert — April 9–10
Walnut Street Theatre

Title	Choreographer
Pretty Is Skin Deep... Ugly Is to the Bone	Talley Beatty
Pas de Deux from Mchagua	Danny Sloan
Meeting at Night	Roy Tobias
Roots/Reflections	Harold Pierson

Dancers: Haywood Coleman, Corliss Graham, Janice L. Harrison, Robin Jackson, Deborah Manning, Aissatou Mijza, Cassandra O'Jener, Maria Perez, Blondell Reynolds, Gayle Samuels, Karen M. Still, Karen Taylor, Audrey Terry, Janice Whiting, Vanessa Thomas, Jamilla Toombs, Joanne Tuilli

1978 Spring Concert — March 31–April 2
Walnut Street Theatre

Title	Choreographer
Wholly Holy	Joan Myers Brown
Promulgation	Joan Myers Brown
Jeux D'Enfants	Roy Tobias
Roots/Reflections	Harold Pierson
Le Corsaire–Pas De Deux	Carl Sandemar
Pretty Is Skin Deep... Ugly Is to the Bone	Talley Beatty
Lament	Joan Myers Brown

Dancers: Deborah Manning, Debora Chase, Jamilla Toombs, Janice Whiting, Karen Taylor, Vanessa Thomas, Kharim Poorman, Nancey Berman, Gwendolyn Coleman, Aissatou Mijza, Karen Calhoun, David St. Charles, John E. Lee, Philip Parnell, Kevin Brown, Amos Moore, Thomas Myles, Robert Garland, Clarence John, Earl McClean, Blondell Reynolds, Marilyn Trousdell

1979 Spring Concert Series — May 10–13
Walnut Street Theatre

Title	Choreographer
Time/Space	Harold Pierson
I Told Jesus	Billy Wilson
La Valse	Gene Hill Sagan
Pretty Is Skin Deep... Ugly Is to the Bone	Talley Beatty
Promulgation	Joan Myers Brown
Octet	William Dollar
God Rode a Windstorm	Joan Myers Brown
Ritual	BillyW ilson
BachO 'Valdi	Bernard Lias
Jeux D'Enfants	Roy Tobias
Wholly, Holy	Joan Myers Brown
Verge	Morton Winston

Dancers: Deborah Manning, Debora Chase, Karen Taylor, Vanessa Thomas, JoAnne Jacobs, Nancy Berman, Cheryl Burr, Anita Tyler, Jamilla Toombs, Jennifer Smith, David St. Charles, John E. Lee, Philip Parnell, Kevin Brown, Amos Moore, Thomas Myles, Robert Garland, Clarence John, Carlos Shorty

1980 Spring Concert Series — May 2–3 (*10th Anniversary Concert)
Annenberg Center for the Performing Arts — Zellerbach Theatre

Title	Choreographer
Degnahc	Joan Myers Brown
Gettin' Down and Cuttin' the Stuff	Al Perryman
AutumnW ylde	Gene Hill Sagan
Reverend Lee	Andy Torres
Ritual	BillyW ilson

Dancers: Deborah Manning, Debora Chase, Karen Taylor, Vanessa Thomas, JoAnne Jacobs, Nancy Berman, Cheryl Burr, Anita Tyler, Jamilla Toombs, Jennifer Smith, David St. Charles, John E. Lee, Philip Parnell, Kevin Brown, Amos Moore, Thomas Myles, Robert Garland, Clarence John, Carlos Shorty

1980 Fall Concert — September 19
Annenberg Center for the Performing Arts — Zellerbach Theatre

Compiler unable to locate program information at time of publication

1981 Winter Concert — January 31
Annenberg Center for the Performing Arts — Zellerbach Theatre

Title	Choreographer
Degnahc	Joan Myers Brown
La Valse	Gene Hill Sagan
Autumn Wylde (excerpt)	Gene Hill Sagan
Valdosta/Vendetta	Billy Wilson
Pretty Is Skin Deep... Ugly Is to the Bone	Talley Beatty

Dancers: Deborah Manning, Debora Chase, Karen Taylor, Vanessa Thomas, JoAnne Jacobs, Nancy Berman, Cheryl Burr, Anita Tyler, Jamilla Toombs, Jennifer Smith, David St. Charles, Carethia Landers, John E. Lee, Philip Parnell, Amos Moore, Thomas Myles, Robert Garland, Clarence John, Carlos Shorty, Karen Still.

1981 Spring Concert Series — May
Walnut Street Theatre

Title	Choreographer
Leftover Wine	Fred Benjamin
It It's Magic	Morton Winston
Soltera	MiguelL opez
Conversations for Seven Souls	Gene Hill Sagan
Forces of Rhythm	Louis Johnson

Dancers: Kim Bears, JoAnne Jacobs, Nancy Berman, Jamilla Toombs, David St. Charles, John E. Lee, Philip Parnell, Amos Moore, Thomas Myles, Robert Garland, Beverly Gilliam, Clarence John, Karen Still, Carlos Shorty, Wendy Tucker, Wendell Wells, Lloyd Whitmore, [list is incomplete]

1981 Fall Concert — September 19
Annenberg Center for the Performing Arts — Zellerbach Theatre

Compiler unable to locate program information at time of publication; Kim Bears-Bailey commented that this would have been the third home season of the year

1982 Annual Spring Concert — May 21–22
Annenberg Center for the Performing Arts — Zellerbach Theatre

Title	Choreographer
BachO 'Valdi	Bernard Lias
Vocalise	Lavinia Reid
Chosen Images	Gene Hill Sagan
Soltera	MiguelL opez

Dancers: Kim Y. Bears, Zane Booker; Karin Coleman, Henry Edwards, Beverly Gilliam, Tobin Green, Claudia Ingraham, Nancy Kantra, Carethia Landers, Sid Lucas, Donald Lunsford II, Corbett McNeil, Michael Myles, Thomas Myles, Valerie McDonald, Michael Oatis, Carlos Shorty, Karin M. Still, Wendy Tucker, Evelyn Watkins, Wendell Wells, Lloyd Whitmore, George Younger.

1982 Annual Fall Concert — October 2–3 (Fall Premiere Concert)
Annenberg Center for the Performing Arts — Zellerbach Theatre

Title	Choreographer
Conversations for Seven Souls	Gene Hill Sagan
Forces of Rhythm	Louis Johnson
Eternal Echo	Saeko Ichinohe

Note: List of dancers supplied from memory by Kim Bears-Bailey; may be incomplete. Dancers: Elana Anderson, Kim Y. Bears, Zane Booker; Karin Coleman, Henry Edwards, Beverly Gilliam, Tobin Green, Claudia Ingraham, Nancy Kantra, Carethia Landers, Sid Lucas, Donald Lunsford II, Corbett McNeil, Michael Myles, Thomas Myles, Valerie McDonald, Michael Oatis, Gaynell Sherrod, Carlos Shorty, Karin M. Still, Wendy Tucker, Evelyn Watkins, Lloyd Whitmore, George Younger, Kathy Southern.

1983 Annual Winter Concert — January 7–8
Compiler unable to locate venue or program information at time of publication

1983 Spring Concert Series — May 13–15
Annenberg Center for the Performing Arts — Zellerbach Theatre

Title	Choreographer
HONHOM-KRA	EvaG holson
Equipoise	Lloyd Whitmore
La Valse	Gene Hill Sagan
The Shadow Sisters	Rodney Griffin
Forces of Rhythm	Louis Johnson
Ritornello	Gene Hill Sagan
Chosen Images	Gene Hill Sagan
BachO 'Valdi	Bernard Lias
Soltera	MiguelL opez

Dancers: Elana Anderson, Kim Bears, Zane Booker, Karin Coleman, Henry Edwards, Beverly Gilliam, Myra Grant, Tobin Green, Claudia Ingraham, Nancy Kantra, Carethia Landers, Sid Lucas, Donald Lunsford II, Corbett McNeil, Michael Myles, Thomas Myles, Valerie McDonald, Michael Oatis, Gaynell Sherrod, Carlos Shorty, Karin M. Still, Wendy Tucker, Evelyn Watkins, Lloyd Whitmore, George Younger, Kathy Southern.

1984 Annual Spring Concert — May 24, 26, 27
Annenberg Center for the Performing Arts — Zellerbach Theatre

Title	Choreographer
Bound to be Free	Tobin Green
I Advance Masked	Ana Marie Forsythe
Treemonisha	Louis Johnson *(this ballet had a cast of over 20 extras not listed)*
Soltera	MiguelL opez
Conversations for Seven Souls	Gene Hill Sagan
Forces of Rhythm	Louis Johnson

Dancers: Elana Anderson, Kim Y. Bears, Zane Booker, Karin Coleman, Henry Edwards, Beverly Gilliam, Tobin Green, Claudia Ingraham, Nancy Kantra, Carethia Landers, Sid Lucas, Donald Lunsford II, Corbett McNeil, Michael Myles, Thomas Myles, Valerie McDonald, Michael Oatis, Gaynell Sherrod, Carlos Shorty, Karin M. Still, Wendy Tucker, Evelyn Watkins, Lloyd Whitmore, George Younger.

1985 Annual Spring Concert — May 11–13
Annenberg Center for the Performing Arts — Zellerbach Theatre

Dancers: Elana Anderson, Kim Y. Bears, Zane Booker, Karin Coleman, Henry Edwards, Beverly Gilliam, Tobin Green, Claudia Ingraham, Nancy Kantra, Carethia Landers, Sid Lucas, Donald Lunsford II, Corbett McNeil, Michael Myles, Thomas Myles, Valerie McDonald, Michael Oatis, Gaynell Sherrod, Carlos Shorty, Karin M. Still, Wendy Tucker, Evelyn Watkins, Lloyd Whitmore, George Younger

1985 Fall Concert Series — October 25–26
Walnut Street Theatre

Title	Choreographer
Bound to Be Free	Tobin Green
HONHOM-KRA	EvaG holson
Pale Lotus in Darkness Becoming	Gene Hill Sagan
Conversation for Seven Souls	Gene Hill Sagan
La Valse	Gene Hill Sagan
A Rag, A Bone and a Hank of Hair	Talley Beatty
Ritornello	Gene Hill Sagan
All Search-One Source Within	RichardM oten
Lelio	Gene Hill Sagan

Dancers: Evelyn Watkins. Kim Bears, Karin Coleman, Sid Lucas, Donald Lunsford II, Erin White, Thelma Smith, Corbett McNeil, Thomas Myles, Warren P. Miller, Zane Booker, Charles Griffin, Deanna Murphy, Gaynell Sherrod, Carlos Shorty, Karina Castenada, Kim Wilson

1986 Annual Spring Concert — May 30–31
Annenberg Center for the Performing Arts — Zellerbach Theatre

Compiler unable to locate program booklet at time of publication. List of dancers supplied by Kim Bears-Bailey. Concert included the premiere of Milton Myers' *Pacing*.

Comment added by Kim Bears-Bailey: "I believe we also danced *The Element in Which It Takes Place* by Milton Myers and *Work-Out* by Louis Johnson."

Dancers: Evelyn Watkins. Kim Bears, Karin Coleman, Sid Lucas, Donald Lunsford, II, Erin White, Thelma Smith, Corbett McNeil, Thomas Myles, Warren P. Miller, Zane Booker, Charles Griffin, Deanna Murphy, Gaynell Sherrod, Carlos Shorty, Karina Castenada, Kim Wilson, Wendy Tucker

1986 Fall Concert Series — October 2–3
Annenberg Center for the Performing Arts — Zellerbach Theatre

Title	Choreographer
Vocalise	Lavinia Reid
Eternal Echo	Saeko Ichinohe
Soltera	MiguelL opez
La Valse	Gene Hill Sagan
Forces of Rhythm	Louis Johnson

Dancers: Elana Anderson, Kim Y. Bears, Zane Booker, Karin Coleman, Henry Edwards, Niles Ford, Beverly Gilliam, Michael Oatis, Tobin Green, Myra Grant, Claudia Ingraham, Nancy Kantra, Carethia Landers, Sid Lucas, Donald Lunsford II, Corbett McNeil, Michael Myles, Thomas Myles, Valerie McDonald, Debi Perkins, Carlos Shorty, Karin M. Still, Wendy Tucker, Evelyn Watkins, Lloyd Whitmore, George Younger, Angela Moreino, Kathy Southern, Janeen Garro, Karen Bradley, Keya Neal

1987 Spring Concert — May 28–30
Annenberg Center for the Performing Arts, Zellerbach Theatre

Title	Choreographer
Quartet	Michael Peters
Witness	Alvin Ailey (Guest Artist – Debora Chase)
The Element In Which It Takes Place	Milton Myers
Pacing	MiltonM yers
At First Stroke	Robert Weiss
Romance Adieu	Gene Hill Sagan

Dancers: Carlos Shorty, Warren P. Miller, Jr., Antonio C. Scott, Kim Y. Bears, Janette Howard, Danielle Gee, Thomas H. Myles, Michael Donaghy, Erin White, Evelyn Watkins, Peter McCoy, Carmella Vassor, Maureen O'Tracye Henighan, David Rose, Gaynell Sherrod

1987 Fall Concert
Compiler unable to locate venue or program information at time of publication

Note: Bears-Bailey remarked that occasionally one of the two home concerts was dropped in some years due to out-of-town bookings.

1988 Annual Spring Concert — May 19–21, 20th Anniversary Concert
Walnut Street Theatre

Title	Choreographer
Dreamtime	Elisa Monte
Cantus	Gene Hill Sagan
Forwards and Backwards	Milton Myers
The Element In Which It Takes Place	Milton Myers
M.P. 1988	Michael Peters
Bound to Be Free	Tobin Green
Pacing	MiltonM yers
Lament	Louis Johnson

Dancers: Kim Y. Bears, Paul B. Sadler Jr., Wendy Tucker, Hector Vega, Sabrina Madison, Bernard Gaddis, Norma Gina Avellino, Danielle Gee, Antonio C. Scott, William Grinton, Karen Pendergrass, Evelyn Watkins

1988 — Fall Concert
Compiler unable to locate venue or program information at time of publication.

1989 Annual Spring Concert — May 18–20
Annenberg Center for the Performing Arts — Zellerbach Theatre

Title	Choreographer
Ritornello	Gene Hill Sagan
SweetA gony	Gene Hill Sagan
M.P. 1988	Michael Peters
Dreamtime	Elisa Monte
Cantus	Gene Hill Sagan
Fire/Water	Saeko Ichinohe
Joy	MiltonM yers

Dancers: Kim Y. Bears, Wendy Tucker, Antonio C. Scott, Danielle Gee, Karen Pendergrass (guest artist), Hector Vega, Sabrina Madison, Paul B. Sadler, Jr., Bernard Gaddis, Norma Gina Avellino, William Grinton, Orlando Rodriguez, Evelyn Watkins

1990 Anniversary Spring Concert — May 30–June 2
Annenberg Center for the Performing Arts — Zellerbach Theatre

Title	Choreographer
Joy	Milton Myers
Rosa	Billy Wilson
Men Against The Wall	Milton Myers
White Dragon	Elisa Monte
Elegy	Gene Hill Sagan
A Rag, A Bone, and A Hank of Hair	Talley Beatty
Ritornello	Gene Hill Sagan
Dreamtime	Elisa Monte
Continuum	Harold Pierson
Sweet Agony	Gene Hill Sagan

Dancers: Norma Gina Avellino, Kim Y. Bears, Bernard Gaddis, Danielle Gee, William Grinton, Maureen O'Tracye Henighan, Sabrina Madison, Corbett McNeil, Orlando Rodriguez, Paul B. Sadler Jr., Wendy Tucker, Hector Vega, Evelyn Watkins, Antonio C. Scott

1990 Winter Concert Series — November 30
Drexel University — Mandell Theatre

Title	Choreographer
Cry	Alvin Ailey (Guest Artist – Deborah Manning)
Such Sweet Morning Songs	Talley Beatty
Joy	Milton Myers
Ghettoscape with Ladder (From Pretty Is Skin Deep... Ugly Is to the Bone)	Talley Beatty
Men Against the Wall	Milton Myers
Elegy	Gene Hill Sagan
The Element In Which It Takes Place	Milton Myers

Dancers: Norma Gina Avellino, Kim Y. Bears, Karin Coleman, Freddie DeJesus II, Evelyn Watkins Ebo, Bernard Gaddis, Danielle Gee, William Grinton, Tracey Ingraham, Donald T. Lunsford, II, Sabrina Madison, Corbett McNeil, Warren P. Miller, Jr., Orlando Rodriguez, Paul B. Sadler, Jr., Wendy Tucker, Sheila Ward, Luctricia Welters

1991 Annual Spring Concert — May 29–June 1
Annenberg Center for the Performing Arts — Zellerbach Theatre

Title	Choreographer
Ebony Concerto	Milton Myers
Men Against the Wall	Milton Myers
Ghettoscape With Ladder (From Pretty Is Skin Deep... Ugly Is to the Bone)	Talley Beatty

White Dragon	Elisa Monte
La Valse	Gene Hill Sagan
Such Sweet Morning Songs	Talley Beatty
Ritornello	Gene Hill Sagan

Dancers: Norma Gina Avellino, Kim Y. Bears, Karin Coleman, Freddie DeJesus, Bernard Gaddis, Danielle Gee, William Grinton, Corbett McNeil, Sabrina Madison, Warren P. Miller II, Orlando Rodriguez, Paul B. Sadler, Jr., Hector Vega, Luctricia Welters, Evelyn Watkins Ebo, Nancey Kantra, Karen Still Pendergrass, Wendy Tucker

1991 Fall/Winter Concert

Compilers unable to locate program information at time of publication

1992 Annual Spring Concert — June 4–6
Walnut Street Theatre

Title	Choreographer
SweetA gony	Gene Hill Sagan
Men Against the Wall	MiltonM yers
Rosa	BillyW ilson
Southern Landscape	Talley Beatty
Love and Pain	MiltonM yers
A Rag, A Bone and A Hank Of Hair	Talley Beatty
Ritornello	Gene Hill Sagan

Dancers: Norma Gina Avellino, Kim Y. Bears, Brian Brooks, Bernard Gaddis, Kim Gadlin, Jennifer Green, William Grinton, Willie Hinton, Sabrina Madison, Kevin Thomas Malone, Warren P. Miller, II, Desiree Pina, Paul B. Sadler, Jr., Luctricia Welters

1992/1993/1994 Fall/Winter Concerts

Note: Kim Bears-Bailey recollects that there may not have been fall/winter home concerts for these three years

1993 Annual Spring Concert — June 3–4
Annenberg Center for the Performing Arts — Zellerbach Theatre

Title	Choreographer
Dreamtime	Elisa Monte
Sketches	Milton Myers
Surfacing II	Lynn Taylor-Corbett
Love 'N Pain	MiltonM yers
Such Sweet Morning Songs	Talley Beatty
Crossing the River	Eva Gholson
Men Against the Wall	MiltonM yers

Dancers: Lynn Barre, Kim Y. Bears, Brian Brooks, Eugene W. Contes, Bernard Gaddis, William Grinton, Willie Hinton, Tomeki Jones, Sabrina Madison, Kevin Thomas Malone, Warren P. Miller II, Desiree Pina, Jeffrey Polston, Monique Rhodriguez, Paul B. Sadler, Sheila Ward

1993 Fall Concert

See 1992 *Note*, above.

1994 Annual Spring Concert — June 3–4
Annenberg Center for the Performing Arts — Zellerbach Theatre

Title	Choreographer
Ebony Concerto	MiltonMyers
La Divinadora	Talley Beatty
Dreamtime	Elisa Monte
Elegy	Gene Hill Sagan
Suite Otis	George Faison
Pacing	MiltonMyers

Dancers: Felise Bagley, Lynn Barre, Kim Y. Bears, Brian Brooks, Eugene Walter Coates, William Grinton, Willie Hinton, Kevin Thomas Malone, Warren P. Miller, II, Ariel Osterweis, Desiree Lynn Pina, Monique Rhodriguez, Uri Sands, Karen Savage

1994 Fall Concert

See 1992 *Note*, above.

1995 Annual Spring Concert — June 1–3 25th Anniversary Concert
Annenberg Center for the Performing Arts — Zellerbach Theatre

Title	Choreographer
BAMM	Donald Byrd
BattyMoves	Jawole Willa Jo Zollar
The Element In Which It Takes Place	Milton Myers
Pretty Is Skin Deep... Ugly Is to the Bone	Talley Beatty
Joy	MiltonMyers
Missing You	Jean Emile and Keith Derrick Randolph
TheGathering	MiltonMyers
Forces of Rhythm	Louis Johnson

Dancers: Kim Bears, Eugene Coates, Lynn Barre, Edward Franklin, William Grinton, Hope L. Boykin, Brian Brooks, Kevin Thomas Malone, Monique Rhodriguez, Uri Sands, Warren P. Miller, II, Karen Savage, Desiree Lynn Pina, Allyson Triplett, B. Swan Pouffer

1995 Fall Concert

Note from Takiyah Nur Amin: According to the *Philadelphia Inquirer*, Philadanco was in performance on October 6 for a 25th Anniversary Gala performance at the Annenberg Center. Though I was not able to find names of the works, the concert featured choreography by Donald Byrd, Milton Myers, and Mauricio Wainrot.

1996 Annual Spring Concert — May 30–June 1
Annenberg Center for the Performing Arts — Zellerbach Theatre

Title	Choreographer
Joy	MiltonM yers
The Walkin, Talkin, Signifying Blues Hips, Lowdown Throwdown	Jawole Willa Jo Zollar
Suite Otis	George Faison
Variation # 1	MiltonM yers
Everybody	Donald Byrd
Love n' Pain	MiltonM yers

Dancers: Lynn Barre, Karen D. Savage, Edward E. Franklin, B. Swan Pouffer, Desiree Lynn Pina, Hope Boykin, Kim Y. Bears, Allyson Triplett, Candace Whitaker, Gene W. Coates, Curtis Glover, Kevin Thomas Malone

1996 Annual Winter Concert — November 22–23
Annenberg Center for the Performing Arts — Zellerbach Theatre

Compiler unable to locate a program booklet at time of publication. A *Philadelphia Inquirer* article indicated that all six pieces featured on the program were choreographed by Milton Myers. Four of the six were as follows: *How Long Has It Been?*; *Love 'n Pain*; *Ebony Concerto*; and *Sketches*. Dancers included Hope Boykin, Karen More, Kim Y. Bears-Bailey, Lynn Barre, and William N. Grinton.

1997 Annual Spring Concert — May 15–17
Annenberg Center for the Performing Arts — Zellerbach Theatre

Title	Choreographer
Ritornello	Gene Hill Sagan
White Dragon	Elisa Monte
100% Cotton Natural Fiber	Blondell Cummings
Such Sweet Morning Songs	Talley Beatty
Courtly Dances	Robert Weiss

Dancers: Kim Y. Bears, Hope Boykin, Carrie Elmore, Morris Edward Gaines, Curtis Christian Glover, William N. Grinton, Gabriele Tesfa Guma, William Nakia Isaac, Morenike Keys, Kevin Thomas Malone, W. Pennington Miller II, Karen More, Desiree Lynn Pina, Allyson Triplett, Candace Alethia Whitaker, Tracy Vogt, Rasta Thomas (guest artist)

1997 Annual Fall Concert — November 23–25, "In the Black Tradition"
The Wilma Theater

Title	Choreographer
Love n'Pain	MiltonM yers
Men Against the Wall	MiltonM yers
Suite Otis	George Faison
Mourners' Bench	Talley Beatty
Ghettoscape with Ladder	Talley Beatty

Dancers: Kim Y. Bears, Hope Boykin, Carrie Elmore, Morris Edward Gaines, Curtis Christian Glover, William N. Grinton, Gabriele Tesfa Guma, William Nakia Isaac, Morenike Keys, Sabrina Madison, Kevin Thomas Malone, W. Pennington Miller II, Karen More, Desiree Lynn Pina, Allyson Triplett, Candace Alethia Whitaker

1998 Annual Spring Concert Series — May 29–30
Annenberg Center for the Performing Arts — Zellerbach Theatre

Title	Choreographer
Gate Keepers	Ronald K. Brown
La Valse	Gene Hill Sagan
Echoes: A Celebration of Alvin Ailey	Milton Myers
Dreamtime	Elisa Monte
Suite Otis	George Faison

Dancers: Kim Y. Bears, Hope L. Boykin, Brandon Ellis, Curtis C. Glover, William N. Grinton, Gabriele Tesfa Guma, William Nakia Isaac, Kevin Thomas Malone, W. Pennington Miller, II, Willa-Noel Montague, Desiree Lynn Pina, Allyson Triplett, Tracy Vogt, Candace Alethia Whitaker, Hollie E. Wright

1998 Annual Fall/Winter Concert

Compiler unable to locate program information at time of publication.

Note: Bears-Bailey recollects that there may not have been a fall/winter concert for 1998

1999 Annual Spring Concert Series — May 26–29
The Prince Music Theater

Title	Choreographer
Labess II	David Brown
Heat	MiltonMyers
Elegy	Gene Hill Sagan
Exotica	Ronald K. Brown
Beattyville	Fred Benjamin
Variations # 1	MiltonMyers

Dancers: Kim Y. Bears, Hope L. Boykin, Jody Cumberbatch, Brandon Ellis, Francisco Gella, Curtis Glover, William N. Grinton, Gabriele Tesfa Guma, W. Pennington Miller II, Willia Noel Montague, Eddie Stockton, Tracy Vogt, Dawn Marie Watson, Candace Alethia Whitaker, Hollie E. Wright, Dion Wilson

1999 Annual Fall Concert Series — November 19–20
Annenberg Center for the Performing Arts - Zellerbach Theatre

Compiler unable to locate a program booklet. A *Philadelphia Inquirer* article revealed that the concert featured Dwight Rhoden's *Tribute*, Ronald K. Brown's *Exotica*, an excerpt from Talley Beatty's *Pretty Is Skin Deep...Ugly Is to the Bone*, and Barak Marshall's *Shoshana's Balcony*. [As the kick-off to the 30th Anniversary season, Rhoden's *Tribute* featured music from Philadelphia International artists under the direction of Kenny Gamble and Leon Huff, including Teddy Pendergrass and The O'Jays.]

2000 Spring Concert—"On The Shoulders of Our Ancestors"—May 31–June 3
The Harold Prince Music Theatre—30th Anniversary Season

Title	Choreographer
Labess II	David Brown
Trance Atlantic	Walter Nicks
Echoes: A Celebration of Alvin Ailey	Milton Myers
Gate Keepers	Ronald K. Brown

Dancers: Kim Y. Bears, Hope L. Boykin, Jody Cumberbatch, Brandon Ellis, Francisco Gella, Curtis Glover, William N. Grinton, Gabriele Tesfa Guma, W. Pennington Miller II, Willa Noel Montague, Eddie Stockton, Tracy Vogt, Dawn Marie Watson, Candace Alethia Whitaker, Hollie E. Wright, Dion Wilson

2000 Winter Concert—December 6–9
Annenberg Center for the Performing Arts—Zellerbach Theatre

Title	Choreographer
Elegy	Gene Hill Sagan
Gate Keepers	Ronald K. Brown
Xmas Philes	Daniel Ezralow

Dancers: Francisco Gella, Kristen J.S. Irby, Willa-Noel Montague, Antonio Sisk, Tracy Vogt, Warren B. Griffin III, Ahmad Maverick Lemons, Odara Nefertiti Jabali-Nash, Gabriele Tesfa Guma, Dawn Marie Watson, Romnee Marisa Hayes, Roxanne Lyst, Marc Aurel Nelles, Allyson Triplett, Hollie Wright

2001 Annual Spring Concert Season, "Messages from the Heart"—May 31–June 2
The Harold Prince Music Theater

Title	Choreographer
The Temple of My Listening	Eva Gholson
My Science	Bebe Miller
Circular Ruins	Elisa Monte
Hand Singing Song	Jawole Willa Jo Zollar

Dancers: Francisco Gella, Warren B. Griffin III, Gabriele Tesfa Guma, Romnee Marissa Hayes, Kristen Irby, Odara Nefertiti Jabali-Nash, Roxanne Lyst, Marc Aurel Nelles, Antonio Sisk, Allyson Triplett, Tracy Vogt, Dawn Marie Watson, Hollie E. Wright, Ahmad Maverick Lemons

2001 Annual Fall Concert
Kimmel Center for the Performing Arts—Perelman Theatre

Title	Choreographer
Tribute	Dwight Rhoden
Variation #1	MiltonMyers
Gate Keepers	Ronald K. Brown
Elegy	Gene Hill Sagan
Beattyville	Fred Benjamin

Dancers: Francisco Gella, Warren B. Griffin III, Gabriele Tesfa Guma, Romnee Marissa Hayes, Kristen Irby, Odara Nefertiti Jabali-Nash, Roxanne Lyst, Marc Aurel Nelles, Antonio Sisk, Allyson Triplett, Tracy Vogt, Dawn Marie Watson, Hollie E. Wright, Ahmad Maverick Lemons

2002 Annual Spring Concert
The Harold Prince Music Theatre

Title	Choreographer
NaturalF lirt	Trey McIntyre
Kinesis	Milton Myers
Circular Ruins	Elisa Monte
Hand Singing Song	Jawole Willa Jo Zollar

Dancers: Francisco Gella, Warren B. Griffin III, Gabriele Tesfa Guma, Romnee Marissa Hayes, Kristen Irby, Odara Nefertiti Jabali-Nash, Roxanne Lyst, Marc Aurel Nelles, Antonio Sisk, Allyson Triplett, Tracy Vogt, Dawn Marie Watson Hollie E. Wright, Ahmad Maverick Lemons

2002 Annual Winter Concert—January 17–19
Kimmel Center for the Performing Arts—Perelman Theatre

Title	Choreographer
Kinesis	Milton Myers
Rosa	BillyW ilson
Conversation for Seven Souls	Gene Hill Sagan
Enemy Behind the Gates	Christopher L. Huggins

Dancers: Francisco Gella, Warren B. Griffin III, Gabriele Tesfa Guma, Romnee Marissa Hayes, Kristen Irby, Willia-Noel Montague, Odara Nefertiti Jabali-Nash, Roxanne Lyst, Marc Aurel Nelles, Antonio Sisk, Allyson Triplett, Tracy Vogt, Dawn Marie Watson, Hollie E. Wright, Ahmad Maverick Lemons

2003 Annual Spring Concert Series—May 8–10
Kimmel Center for the Performing Arts—Perelman Theatre

Title	Choreographer
Steal Away	Alonzo King
Sweet in the Morning	Leni Wylliams [re-staged by Eleo Pomare from Notation]
Back to Bach	Eleo Pomare
Blue	Christopher L. Huggins

Dancers: Corey Baker, Elisabeth Hazel Bell, William V. Credell, Bellamy F. Eure, Tommie-Waheed Evans, Warren B. Griffin III, Gary D. Jeter II, Ahmad Maverick Lemons, Roxanne Lyst, Odara Nefertiti Jabali-Nash, Mora-Amina Parker, Monique Smith, Marc Spaulding, Dawn Marie Watson, Hollie E. Wright

2003 Winter Concert Series—November 20–22
Kimmel Center for the Performing Arts—Perelman Theatre

Title	Choreographer
Steal Away	Alonzo King
Sweet in the Morning	Leni Williams [re-staged by Eleo Pomare from notation]

Echoes: A Celebration of Alvin Ailey	MiltonMyers
Forces of Rhythm	Louis Johnson

Dancers: Corey Baker, Elisabeth Hazel Bell, William V. Credell, Bellamy F. Eure, Tommie-Waheed Evans, Warren B. Griffin III, Gary D. Jeter II, Ahmad Maverick Lemons, Roxanne Lyst, Odara Jabali-Nash, Mora-Amina Parker, Monique Smith, Marc Spaulding, Dawn Marie Watson, Hollie E. Wright

2004 Annual Spring Concert Series — April 1–3
Kimmel Center for the Performing Arts — Perelman Theatre

Title	Choreographer
Suite Otis	George Faison
Pretty Is Skin Deep... Ugly Is to the Bone	Talley Beatty
No More Exotica	Ronald K. Brown
Enemy Behind the Gates	Christopher L. Huggins

Dancers: Corey Baker, Elisabeth Hazel Bell, William V. Credell, Bellamy F. Eure, Tommie-Waheed Evans, Warren B. Griffin III, Gary D. Jeter II, Ahmad Maverick Lemons, Roxanne Lyst, Odara Nefertiti Jabali-Nash, Mora-Amina Parker, Monique Smith, Marc Spaulding, Dawn Marie Watson, Hollie E. Wright

2004 Annual Fall Concert — November 11–14
Kimmel Center for the Performing Arts — Perelman Theatre

Title	Choreographer
Sigh of the Rock	Dianne McIntyre
BAMM	Donald Byrd
Of Kinship and Exoticism	Milton Myers
Enemy Behind the Gates	Christopher L. Huggins

Dancers: Corey Baker, Elisabeth Hazel Bell, William V. Credell, Bellamy F. Eure, Tommie-Waheed Evans, Warren B. Griffin III, Gary D. Jeter II, Ahmad Maverick Lemons, Roxanne Lyst, Odara Nefertiti Jabali-Nash, Mora-Amina Parker, Monique Smith, Marc Spaulding, Dawn Marie Watson, Hollie E. Wright

2005 Annual Spring Concert Series — May 5–8
Kimmel Center for the Performing Arts — Perelman Theatre

Title	Choreographer
Between Earth & Home	Jawole Willa Jo Zollar
Everything is Everything	Lynne Taylor-Corbett
Genesis: The Blues & the Bible	Geoffrey Holder
For Mother	Ronald K. Brown

Dancers: Corey Baker, Elisabeth Hazel Bell, Erin D. Barnett, Neda Ebrahimi, Miguel Edson, Bellamy F. Eure, Tommie-Waheed Evans, Gary D. Jeter II, Ahmad Maverick Lemons, Roxanne Lyst, Erin N. Moore, Odara Jabali-Nash, Mora-Amina Parker, Devin L. Roberts, Tracy Vogt, Dawn Marie Watson, Hollie E. Wright

2005 Winter Concert Series—December 16–18
Kimmel Center for the Performing Arts—Perelman Theatre

Title	Choreographer
Pulse	Daniel Ezralow
LaValse	Gene Hill Sagan
Xmas Philes	Daniel Ezralow

Dancers: Corey Baker, Erin D. Barnet, Elisabeth Hazel Bell, Neda Y. Ebrahimi, Miguel Edson, Bellamy F. Eure, Tommie-Waheed Evans, Afua Hall, Odara Nefertiti Jabali-Nash, Gary D. Jeter II, Mykal D. Laury, II, Ahmad Maverick Lemons, Erin N. Moore, Mora-Amina Parker, Devin L. Roberts, Jay Staten, Jacinta Vlach, Tracy Vogt, Rikki Wess

2006 Annual Spring Concert Series—May 18–21
Kimmel Center for the Performing Arts—Perelman Theatre

Title	Choreographer
Pacing	MiltonMyers
For Mother	Ronald K. Brown
Love Stories	Carmen De Lavallade
Cottonwool	Christopher L. Huggins

Dancers: Corey Baker, Erin D. Barnett, Elisabeth Hazel Bell, Miko Doi-Smith, Neda Y. Ebrahimi, Miguel Edson, Bellamy F. Eure, Tommie-Waheed Evans, Afua Hall, Odara Nefertiti Jabali-Nash, Gary D. Jeter II, Mykal D. Laury, II, Ahmad Maverick Lemons, Erin N. Moore, Mora-Amina Parker, Devin L. Roberts, Jay Staten, Tracy Vogt

2006 Winter Concert Series—November 16–19
Kimmel Center for the Performing Arts—Perelman Theatre

Title	Choreographer
Dance for Six	Joyce Trisler [re-staged by Regina Larkin]
ForT ruth	Ronald K. Brown
The Foul	Robert Moses
Enemy Behind the Gates	Christopher L. Huggins

Dancers: Corey Baker, Erin D. Barnett, Elisabeth Hazel Bell, Chellamar J. Bernard, Chloé O. Davis, Miguel Edson, Tommie-Waheed Evans, Odara Nefertiti Jabali-Nash, Gary W. Jeter II, Mykal D. Laury, II, Ahmad Maverick Lemons, Teneise L. Mitchell, Erin N. Moore, Mora-Amina Parker, Devin L. Roberts, Jay Staten, Tracy Vogt

2007 Annual Spring Concert Series—May 10–13
Kimmel Center for the Performing Arts—Perelman Theatre

Title	Choreographer
In Between Time	Zane Booker
Southern Landscape	Talley Beatty
La Valse	Gene Hill Sagan
Philadelphia Experiment	Rennie Harris

Dancers: Corey Baker, Elisabeth Hazel Bell, Erin D. Barnett, Miguel Edson, Tommie-Waheed Evans, David Holland, Joan Kilgore, Mykal D. Laury, II, Gary D. Jeter II, Ahmad Maverick Lemons, Odara Nefertiti Jabali-Nash, Erin N. Moore, Mora-Amina Parker, Devin L. Roberts, Jay Staten, Tracy Vogt

2007 Winter Concert Series — December 13–16
Kimmel Center for the Performing Arts — Perelman Theatre

Title	Choreographer
Light Lies	Elisa Monte
Violin Concerto	MiltonM yers
Xmas Philes	Daniel Ezralow

Dancers: Corey Baker, Eliabeth Hazel Bell, Chloé O. Davis, Tommie-Waheed Evans, Brandon Glasgow, David Holland, Odara Nefertiti Jabali-Nash, Joan Kilgore, Mykal D. Laury, II, Teneise L. Mitchell, Mora-Amina Parker, Tyrell V. Rolle, Jay Staten, Tracy Vogt, Dawn Marie Watson

2008 Annual Spring Concert Series — May 8–11
Kimmel Center for the Performing Arts — Perelman Theatre

Title	Choreographer
Ritornello	Gene Hill Sagan
Commitments	Hinton Battle
From Dawn til' Dusk	Christopher L. Huggins

Such Sweet Morning SongTalley Beatty
Dancers: Penelope J. Armstead-Williams, Erin D. Barnett, Chloé O. Davis, Miguel Edson, Tommie-Waheed Evans, Brandon Glasgow, David Holland, Odara Nefertiti Jabali-Nash, Joan Kilgore, Teneise L. Mitchell, Mora-Amina Parker, Tyrell V. Rolle, Jay Staten, Tracy Vogt, Dawn Marie Watson

2008 Winter Concert Series — October 16–19
Kimmel Center for the Performing Arts — Perelman Theatre

Title	Choreographer
No More Exotica	Ronald K. Brown
Pretty Is Skin Deep... Ugly Is to the Bone	Talley Beatty
Philadelphia Experiment	Rennie Harris
Enemy Behind the Gates	Christopher L. Huggins

Dancers: Penelope J. Armstead-Williams, Lamar Baylor, Chloé O. Davis, Tommie-Waheed Evans, Brandon Glasgow, David Holland, Odara Nefertiti Jabali-Nash, Michael Jackson, Jr., Joan Kilgore, Alicia Lundgren, Teneise L. Mitchell, Mora-Amina Parker, Tyrell V. Rolle, Jay Staten, Tracy Vogt, Dawn Marie Watson

2009 39th Annual Spring Concert Series "New Faces" — April 30–May 3
Kimmel Center — Perelman Theatre

Title	Choreographer
The Red Envelope	Zane Booker
Those Who See Light	Camille A. Brown
Rapture	Tony Powell
Be Ye Not	Hope Boykin

Dancers: Penelope J. Armstead-Williams, Lamar Baylor, Chloe O. Davis, Brandon Glasgow, David Holland, Odara N. Jabali-Nash, Michael Jackson, Jr., Joan Kilgore, Alicia Lundgren, Nijawwon Matthews, Teneise L. Mitchell, Tyrell V. Rolle, Jay Staten, Jermaine Terry, Tracy Vogt, Dawn Marie Watson

2009—Annal Fall Concert Series—"Jubilee", A Celebration of PHILADANCO'S 40th Anniversary Season—November 12–15
Kimmel Center—Perelman Theatre

Title	Choreographer
Pulse	Daniel Ezralow
Suite Otis	George Faison
Bolero Too!	Christopher L. Huggins
The Walkin', Talkin' Signifying Blues Hips, Lowdown Throwdown	Jawole Willa Jo Zollar

Dancers: Rosita Adamo, Lamar Baylor, Chloe O. Davis, Brandon Glasgow, David Holland, Lindsey Holmes, Odara N. Jabali-Nashi, Michael Jackson, Jr., Joan Kilgore, Alicia Lundgren, Teneise L. Mitchell-Ellis, Jesse Sani, Jermaine Terry Apprentice – Jodi Pickens

2010—"Jubilee" – 40th Anniversary Concert II—April 15–18
Kimmel Center—Perelman Theatre

Title	Choreographer
A Rag, A Bone and A Hank of Hair	Talley Beatty
The Element in Which it Takes Place	Milton Myers
Elegy	Gene Hill Sagan
By Way of the Funk	Jawole Willa Jo Zollar

Dancers: Rosita Adamo, Lamar Baylor, Jeroboam Bozeman, Justin Bryant, Chloe O. Davis, Tommie-Waheed Evans, Brandon Glasgow, Lindsey Holmes, Odara N. Jabali-Nash, Michael Jackson, Jr., Joan Kilgore, Alicia Lundgren, Teneise L. Mitchell-Ellis, Jesse Sani, Jermaine Terry Apprentice – Jodi Pickens

2010—Philadanco Presents—Celebrating Danny—December 10–12
A program of Choreographer Daniel Ezralow's works for Philadanco
Kimmel Center—Perelman Theatre

Titles	Choreographer
Compassion & Revenge	DanielE zralow
Pulse	Daniel Ezralow
Xmas Philes	Daniel Ezralow

Dancers: Rosita Adamo, LaMar Baylor, Janine Beckles, Heather Benson, Jeroboam Bozeman, Justin Bryant, Chloe O. Davis, Tommie-Waheed Evans, Brandon Glasgow, Jason Herbert, Lindsey Holmes, Michael Jackson, Jr., Joan Kilgore, Alicia Lundgren, Roxanne Lyst, Jodi Pickens, Jesse Sani, Elyse Browning, and members of D/2, D/3 and the Instruction and Training Program

APPENDIX 3: PHILADANCO CHOREOGRAPHER PROFILES

A COMPANION LIST TO PHILADANCO HOME SEASONS REPERTORY CHRONOLOGY

Birth and death dates given for deceased artists. Country of origin given for artists born outside the United States.

Compiled by Takiyah Nur Amin. Supervised and edited by Brenda Dixon Gottschild.

Alvin Ailey (1931–1989): student of Lester Horton and dance partner to Carmen DeLavallade; choreographer of seventy-nine ballets and founder of the Alvin Ailey American Dance Theatre in 1958; a driving force and prime mover in American concert dance.

Hinton Battle: Studied ballet at the Jones-Haywood School of Ballet in Washington, DC; received a scholarship to the School of American Ballet under Balanchine's tutelage; danced in and choreographed many Broadway shows, making his debut as the Scarecrow in *The Wiz*; winner of three Tony Awards; also choreographed for television and commercials.

Talley Beatty (1918–1995): member of the Katherine Dunham Dance Company from 1937–1943; taught and choreographed throughout Europe and in Israel; created work for Dance Theatre of Harlem, Alvin Ailey American Dance Theater, Philadanco, and other American companies devoted to the preservation of the African American concert dance legacy; appeared in Maya Deren's 1945 experimental film *A Study in Choreography for the Camera*; featured performer on Broadway in *Cabin in the Sky*, *Showboat*; formed his own dance company in 1952; choreographed several well-known works, including *The Road of the Phoebe Snow* in 1959 and *Come and Get the Beauty of it Hot* in 1960, both of which are a part of the repertory for the Alvin Ailey American Dance Theater.

Fred Benjamin: danced with Talley Beatty's company from 1963–1966; former artistic director of the Fred Benjamin Dance Company; performed on Broadway with Gower Champion and Michael Bennett; has taught at the Clark Center of the Performing Arts and is currently chair of the jazz department and faculty advisor of the Alvin Ailey American Dance Center.

Zane Booker: began training at the Philadelphia School of Dance Arts at age seven; studied at the North Carolina School of the Arts, the School of American Ballet and the American Ballet Theater; former dancer with the Netherlands Dance Theater, Les Ballets de Monte Carlo, and White Oak Dance Project; performed as a guest artist with the National Theater of Tokyo, Complexions Dance Company, the Opera of Monte Carlo, and Rhythmek; founder and artistic director of The Smoke, Lillies and Jade Arts Initiative.

Hope Boykin: trained/danced at Howard University with Lloyd Whitmore's New World Dance Company; was an original member of Dwight Rhoden and Desmond Richardson's Complexions company; danced with Philadanco; has been dancing with Alvin Ailey since 2000; has choreographed for the Ailey company, Dallas Black Dance Theatre, D/2, and Philadanco.

Camille A. Brown: Danced with Ronald K. Brown/Evidence (2001–2007); and as a guest with Rennie Harris Puremovement; has choreographed for Alvin Ailey American Dance Theater, Ailey II, and Urban Bush Women.

David Brown: born in Jamaica; choreographed work for Monte/Brown Dance, the Tunisian National Ballet, Dallas Black Dance Theater; co-choreographed *Run to the Rock*, *Absolute Rule*, *Vejle*, and *Fatidic Embrace* with Elisa Monte.

Ronald K. Brown: founder (1985) and artistic director of the dance company EVIDENCE, Inc.; has created choreography for the African American Dance Ensemble; Cleo Parker Robinson Dance Ensemble; Dayton Contemporary Dance Company, Alvin Ailey American Dance Theater, Ailey II, Jennifer Muller/The Works; choreographed the off-Broadway production of *Crowns: Portraits of Black Women in Church Hats* (2003).

Donald Byrd: studied at Tufts and Yale universities, the Cambridge School of Ballet, the London School of Contemporary Dance, and at the Alvin Ailey American Dance Center; former artistic director of Donald Byrd/The Group, a contemporary dance company; current artistic director of the Spectrum Dance Theatre in Seattle, Washington; creator of *The Harlem Nutcracker*.

Lynn Taylor-Corbett: has choreographed works for American Ballet Theatre, New York City Ballet, Ohio Ballet, Atlanta Ballet, Pacific Northwest Ballet, Pennsylvania Ballet, Carolina Ballet, Alvin Ailey American Dance Theater, and Hubbard Street Dance Company; her choreography was featured in the films *Footloose* and *My Blue Heaven*.

Blondell Cummings: studied modern dance with Martha Graham, Jose Limon, and Alvin Ailey; danced with the companies of Rod Rodgers, Kai Takei, Richard Bull, the New Jersey Repertory Company, and the New York Chamber Dance Company; joined Meredith Monk/The House in 1969 to critical acclaim; most widely known for her solo works, including *Chicken Soup* and *The Ladies and Me*.

Carmen De Lavallade: joined the Lester Horton Dance Theater in 1949; left the Horton Company with Ailey in 1954 and headed for New York; danced in the Broadway musical *House of Flowers* in 1954; thereafter danced and acted extensively on Broadway; appeared in the film *Carmen Jones* in 1995; guest artist in the Alvin Ailey American Dance Theatre; toured Europe under the banner of the *de Lavallade–Ailey American Dance Company*; performed in Agnes De Mille's *The Four Marys* and *The Frail Quarry*; appeared in several off-Broadway productions; choreographed for the Metropolitan Opera; performed as a guest artist with Bill T. Jones/Arnie Zane Dance Company.

William Dollar *(1907–1986):* performed with the Philadelphia Opera Ballet, the American Ballet, Ballet Caravan, Ballet Society, Ballet Theatre, and the New York City Ballet; performed in several George Balanchine works including Alma Mater and Errante (both 1935), Orpheus and Eurydice (1936), The Card Party and Le Baiser de la Fée (both 1937), Ballet Imperial *and* Concerto Barocco (both 1941), and The Four Temperaments (1946); choreographed *Promenade* in 1936 for Ballet Caravan; re-staged Balanchine's *Concerto* as *Constantia* for the marquis de Cuevas's Ballet International; had choreography in the repertories of the original Ballets Russes, Le Grand Ballet de Monte Carlo, and

Ballet Theatre; best known for his work *The Duel,* choreographed in 1949; founded the American Concert Ballet in 1943; choreographed *Ondine* in 1949 for New York City Ballet and *Jeux* in 1950 for Ballet Society.

Besides choreographing for Philadanco in its early days, he was one of the few Philadelphia teachers who accepted black students in the 1940s–1950s. It was not a matter of integrating his classes, but giving them private lessons. He was a lifetime friend and coach to Essie Marie Dorsey.

Jean Emile: worked with Netherlands Dance Theater (1 and 2), Compania Nacional de Danza, Lar Lubovitch Dance Company, and Donald Byrd/The Group; has danced in projects with such choreographers as Francesca Harper and Zane Booker; choreographed works for La Compania in Barcelona and *The Operetta Die Herzogin Van Chicago* for Theater Osnabruck in Germany; former instructor at the Alvin Ailey American Dance Theater.

Daniel Ezralow: performed with 5X2 Plus, Lar Lubovitch, Paul Taylor, and Pilobolus; one of the original members of Momix; founding member of ISO Dance; has created original works for the Paris Opera Ballet, Batsheva Dance Company, London Contemporary Dance Theatre and others; created choreography for the film, *The Grinch Who Stole Christmas.*

George Faison: former dancer and choreographer for the Alvin Ailey American Dance Theater; performed in the Broadway musical *Purlie;* choreographer for *The Wiz* on Broadway; staged works for popular musicians, including Natalie Cole, Dionne Warwick, Melba Moore, and Stevie Wonder.

Ana Marie Forsythe: trained with Fred Danieli and Joyce Trisler; former dancer with the Garden State Ballet, the Joyce Trisler Dance Company and the Sophie Maslow Dance Company before forming her own ensemble; currently codirector of the Ailey/Fordham BFA Program at The Ailey School where she is also chair of the Horton department.

Eva Gholson: studied at the Dalcroze School of Music; former director and choreographer of Sybil Dance Company; has conducted workshops in modern dance, jazz, and choreomusical analysis in Greece, Germany, Hong Kong, and Taiwan; author of *Image of the Singing Air*, a text on choreographic and music collaboration; Professor Emerita, Temple University.

Tobin Green: first Philadanco company member to have his choreography performed as part of the company's repertory (1984).

Rodney Griffin (1946–1992):co-founder of the Theatre Dance Collection in 1971; choreographed for Alvin Ailey American Dance Theatre, the Bat-Dor Dance Company, The Milwaukee Ballet, The Pennsylvania Ballet, The Hartford Ballet, and The Dayton Ballet; and for productions at the Lyric Opera of Chicago, the Boston Lyric Opera, the Metropolitan Opera, and the Goodspeed Opera House.

Rennie Harris: founder and artistic director of Rennie Harris/Puremovement (1993); founding member of the Scanner Boys, a hip-hop performance group (ca. 1980); has choreographed for Complexions Dance Company, Alvin Ailey American Dance Theatre, Dayton Contemporary Dance Company, Colorado Ballet, Ballet Memphis. Teaches at University of California, Los Angeles, in the Department of World Arts & Cultures Dance Division and University of Colorado, Boulder, in the Department of Theatre & Dance.

Geoffrey Holder: made his dance debut in the Holder Dance Company at age seven; former instructor at the Katherine Dunham School; former principal dancer with the Metropolitan Opera Ballet (1955–1956); danced with his Geoffrey Holder and Company

until 1960; his choreographic credits include works for the Alvin Ailey American Dance Theatre and the Dance Theatre of Harlem.

Christopher L. Huggins: former dancer with the Alvin Ailey American Dance Theatre and the Fred Benjamin Dance Company; has appeared as a guest artist with Donald Byrd/The Group, Dallas Black Dance Theatre, Oslo Dance Ensemble (Norway) and Aterballetto (Italy); regular instructor at Philadanco's summer intensive and Ballet Arts at the New York City Center for the Performing Arts; currently choreographing for the New York City Housing Authority, Duke Ellington High School in Washington, D.C., and Eleone Dance Company.

Saeko Ichinohe: born in Japan; graduate of the Juilliard School; has created works for the Boston Ballet, Joffrey II Dancers, Atlanta Ballet, Chiang Ching Dance Company, Eglevsky Ballet, Juilliard Dance Ensemble, Louisville Ballet, and Marin Ballet; has taught at Ballet Arts at the New York City Center for the Performing Arts, Boston Ballet Summer School, Briansky Saratoga Ballet Center, Brooklyn College, the Norwegian Ballet School, Hofstra University, the London Contemporary Dance School, Neighborhood Playhouse, the Netherlands Dance Theater, and the New York City High School for the Performing Arts; former director of choreography for The Association of Regional Ballet.

Louis Johnson: studied at the Doris Jones-Clara Haywood School of Dance and at the School of American Ballet as a scholarship student; made his performance debut with New York City Ballet in 1952 in *Ballade*, a ballet by Jerome Robbins; danced with Jerome Robbins's Ballets USA; starred on Broadway in *House of Flowers* and in the stage and screen versions of *Damn Yankees*; created 'Forces of Rhythm' for the Dance Theatre of Harlem and 'Fontessa and Friends' for the Alvin Ailey American Dance Theatre; Tony-award nominee for his choreography in the musical *Purlie*; most well-known for his choreography in the film version of *The Wiz* and his reconstruction of Scott Joplin's *Treemonisha* at the Houston Grand Opera; conducted black arts symposia at Howard University, Yale University, Virginia State and Hampton Institute (now Hampton University) and Morehouse College; former director of the dance division of the Henry Street Settlement.

John Jones: trained with Antony Tudor at Ballet Guild in Philadelphia; danced with the Katherine Dunham company; Jerome Robbins's Ballets USA; the Rod Rodgers dance company; the Trisler Danscompany; the Robert Joffrey Ballet; Harkness Ballet; New York City Ballet; Dance Theatre of Harlem; former associate artistic director of the Nanette Bearden Contemporary Dance Theatre; choreographed for the Alvin Ailey American Dance Theatre.

Alonzo King: founder and artistic director of LINES Ballet and the LINES Ballet School and Pre-Professional Program; choreographed works for Frankfurt Ballet, Joffrey Ballet, Dance Theatre of Harlem, Alvin Ailey American Dance Theatre, Hong Kong Ballet, Washington Ballet, and North Carolina Dance Theatre; guest ballet master for National Ballet of Canada, Les Ballets de Monte Carlo, San Francisco Ballet, Ballet Rambert, and Ballet West.

Bernard Lias (1946–1990): student at the Anderson Sisters School of Dance; joined the Alvin Ailey American Dance Theater and became a principal dancer with the company in 1974; consulting choreographer for the movie, *The Wiz*.

Miguel Lopez (born?- d. 2008): chair, Modern Dance, The American Ballet Theatre School; taught at Alvin Ailey School, Steps Dance Studio, and many other schools,

nationwide.former artistic director of the Joyce Trisler Danscompany; teacher of Lester Horton technique.

Dianne McIntyre: former member of Gus Solomons Company/Dance; founder of the dance company Sounds in Motion (1972–1988); former director of the Sounds in Motion studio in Harlem, New York; reconstructed Helen Tamiris's *How Long Brethren?* in 1991; has choreographed for the Alvin Ailey American Dance Theatre, Ailey II; Cleo Parker Robinson Dance Ensemble and Dayton Contemporary Dance Company; and for productions on Broadway, Off-Broadway, London's West End and in various regional theaters as well as for film and television.

Trey McIntyre: former choreographic apprentice to the Houston Ballet; has choreographed work for the Stuttgart Ballet, American Ballet Theatre, Hubbard Street Dance Chicago, New York City Ballet and Ballet de Santiago (Chile); former resident choreographer for Oregon Ballet Theatre, Ballet Memphis, and the Washington Ballet.

Bebe Miller: Studied with Murray Louis at the Henry Street Settlement in lower Manhattan; danced with Nina Weiner and Dancers before forming the Bebe Miller Company (1985); has been commissioned to choreograph for The Joyce Theater, Walker Art Center, Jacob's Pillow Dance Festival, Bates Dance Festival, Boston Ballet, Oregon Ballet Theatre, and the PACT Dance Company of Johannesburg.

Elisa Monte: studied at the School of American Ballet; danced with the Martha Graham Company, Lar Lubovitch, and Pilobolus, choreographer of over forty dance works, including the widely acclaimed *Treading* (1979); has been resident choreographer at Robert Redford's Sundance Institute, Southern Methodist University, New York University's Tisch School of the Arts, and the Alvin Ailey American Dance Center.

Robert Moses: founder of Robert Moses' Kin Dance Company (1995); choreographed for Cincinnati Ballet, Transitions Dance Company, African Cultural Exchange, Bare Bones Dance Company, and the Oakland Ballet; choreographed productions for the Olympic Arts Festival, the Lorraine Hansberry Theater, New Conservatory Theater, the Los Angeles Prime Moves Festival and Black Choreographers Moving Toward the 21st Century.

Richard Moten: Studied, performed, and taught in the dance culture created by Sydney King and Marion Cuyjet; current faculty member at the Philadelphia School of Dance Arts; former Philadanco dancer (prior to 1975); former dancer with the Philadelphia Civic Ballet.

Milton Myers: organized Black Exodus, a modern dance company, while a student at University of Missouri; worked with Joyce Trisler's company as a dancer and assistant choreographer from 1975–1980; became artistic director of the Joyce Trisler Danscompany from 1979–1986; choreographed for Alvin Ailey American Dance Theatre, New Danish Dance Theater, Ballet Stagium, Dayton Contemporary Dance Company, Cleo Parker Robinson Dance Company, Dallas Black Dance Theater and David Taylor Dance; became resident choreographer at Philadanco in 1991; former Director of Modern Dance at Jacob's Pillow.

Walter Nicks (1925–2007): trained with Katherine Dunham, Lavinia Williams, Talley Beatty, Tommy Gomez, Archie Savage, Marie Bryant, Jose Limon, Robert Joffrey, Karel Shook. Louis Horst, and Doris Humphrey; became a certified Master Teacher of the Dunham Technique in 1948; served as the assistant director of dance at the Dunham School from 1947–1953; was one of Joan Myers Brown's teachers at the Dunham School;

created the dance company El Ballet Negro de Walter Nicks in 1953; performed in Donald McKayle's *Games* in 1954; founded the Walter Nicks Dance Theatre Workshop in 1973; choreographed and guest taught for Philadanco.

Al Perryman (date of birth and demise not located at time of publication): performed as Earl 'Snake Hips Tucker' in the 1984 Dance Black America Festival; former dancer with the George Faison Universal Dance Experience; performed in the 1980 Celebration of Men in Dance at the Thelma Hill Performing Arts Center; dance captain and ensemble member in the musical *1600 Pennsylvania Avenue*; performed in the Broadway productions of *Purlie* (1970–1971) and *Raisin* (1973–1975); performed with Loretta Abbott at the 1977 Clark Center Dance Festival; choreographed the 1983 production of *The Amen Corner*; former artistic director of the Brooklyn Dance Theater; former choreographer for the Brooklyn Opera Society.

Michael Peters (1948–1994): shared a Tony Award for choreography with Michael Bennett for the Broadway musical *Dreamgirls*; performed with Talley Beatty, Alvin Ailey, Bernice Johnson, and Fred Benjamin; directed the Broadway musical *Leader of the Pack* in 1985; choreographed music videos for Pat Benatar, Earth, Wind and Fire, Diana Ross, Lionel Richie and Billy Joel; worked with Michael Jackson for in the music videos *Beat It* (in which he performed) and *Thriller*; developed choreography for several motion pictures, including *Sister Act 2: Back in the Habit*, *The Mambo Kings*, *Sarafina!*, *The Five Heartbeats*, and *What's Love Got to Do With It*; directed episodes of *Knots Landing*, *Fresh Prince of Bel-Air*, and *A Different World*.

Harold Pierson (1934–2000): studied dance with Robert Joffrey and Valentina Pereyaslavec and acting with Louis Gossett Jr. and Sanford Meisner; performed with the Alvin Ailey American Dance Theatre and the companies of Syvilla Fort, Geoffrey Holder, Louis Johnson, Matt Mattox, Donald McKayle and Olatunji; danced in the 1959 premier of Donald McKayle's *Rainbow 'Round My Shoulder*; performed in the casts of several Broadway musicals, including *Golden Boy*; *Sweet Charity*; *Cry, the Beloved Country'*; and *Purlie*; former visiting professor at Howard University and artistic director the Dance Black America Festival presented at the Brooklyn Academy of Music (BAM) in 1983.

Eleo Pomare (1937–2008): born in Cartagena, Columbia; trained with Louis Horst, José Limón and Curtis James; began directing his own dance company in 1958; choreographed works for the Alvin Ailey American Dance Theater, Dayton Contemporary Dance Company; The National Ballet of Holland; Balletinstituttet (Oslo, Norway), the Cleo Parker Robinson Dance Company, the Australian Contemporary Dance Company and the Ballet Palacio das Artes (Belo Horizonte, Brazil); was the first artistic director of the Dancemobile in New York City(1967).

Tony Powell: Choreographer, composer, painter, sculptor, photographer, filmmaker, graphic designer, and writer; Juilliard School graduate (1995); directed Tony Powell/ Music & Movement for ten years; has written orchestral scores for Parsons Dance Company; created dances for Joffrey Ballet, Giordano Jazz Dance Chicago, and Odyssey Dance Theatre, among others.

Keith-Derrick Randolph: former dancer, choreographer, and artistic staff member of the Scapino Ballet Rotterdam from 1989–2004; currently director and choreographer of Rijswijks Jeugdtheater.

Lavinia Reid: founder and artistic director of the Chambersburg Ballet Theater Company; ballet instructor at Wilson College in Shippensburg, Pennsylvania; former instructor at the Ballet Center of Ithaca and the Seneca School of Ballet.

Dwight Rhoden: performed with the Dayton Contemporary Dance Company, Les Ballets Jazz de Montreal and was former principal dancer with the Alvin Ailey American Dance Theater; codirector of Complexions Dance Company with Desmond Richardson; has choreographed for the Alvin Ailey American Dance Theater, The Pennsylvania Ballet, The Joffrey Ballet, Phoenix Dance Company, and Dayton Contemporary Dance Company.

Gene Hill Sagan (1932–1991): trained at the Ballet Theatre School and studied with Michel Panaieff and Nina Vyroubova; made his debut in 1959 dancing with the First Negro Classical Ballet; created choreography for the Alvin Ailey American Dance Theatre, Pennsylvania Ballet, Kibbutz Dance Theater, Batsheva Dance Company and Bat-Dor Dance Company as well as for his own dance group based in Munich, Germany; was resident choreographer for Philadanco from 1976 until his demise.

Carl Sandemar: former instructor with New York City Ballet. Further information not located at time of publication.

Danny Sloan (1939–1988): received a scholarship to study at the Pennsylvania School of Ballet; worked with Talley Beatty in the Dance Company of the National Center for African-American Artists (DCNCAA); formed the Danny Sloan Dance Co. in 1976; taught at The Walnut Hill School, Dean Junior College, Boston Ballet, and the Jeanette Neill Studio.

Roy Tobias (1930–2008): danced with Ballet Society (1950–1960); taught ballet in Japan (1961–1963); former principal dancer with the New York City Ballet, where he later created work for the company's repertory.

Andy Torres: performed with Nancy Havlik's Dance Performance Group, Mason/Rhynes Production, and Liz Lerman Dance Exchange as well as the companies of Fred Benjamin, Talley Beatty, Glen Brooks, Eleo Pomare, Billy Wilson, and Asadata Dafora; Broadway stage credits include *Guys and Dolls*, *The Wiz*, *Purlie*, *Bubblin' Brown Sugar*, *Your Arms Too Short to Box with God*, *Don't Bother Me I Can't Cope*, and *Indians*.

Mauricio Wainrot: In 2006 became artistic director of Ballet Contemporáneo del Teatro San Martin, returning to his homeland (Buenos Aires, Argentina) after a career of international choreographic renown.

Robert Weiss: studied at the School of American Ballet; former artistic director of the Pennsylvania Ballet and the Milwaukee Ballet; former principal dancer with the New York City Ballet; former director of the New York State Summer School for the Arts; has choreographed for the American Ballet Theatre and Bejart's 20th Century Ballet. Became founding artistic director of the Carolina Ballet in 1997.

Lloyd Whitmore: founder and artistic director of New World Dance Company (1991–1993); former dancer with Philadanco, The New Orleans Opera and DC Contemporary Dance Theater.

Billy Wilson (1936–1994): studied dance in Philadelphia public schools and at age 16 won a scholarship to study with Antony Tudor at the Philadelphia Ballet Guild; became an acclaimed performer on Broadway in *Carmen Jones*, *Bells are Ringing* and *Jamaica*; joined the National Ballet of Holland in 1960 and created the title role in Serge Lifar's ballet *Othello*; taught at both Brandeis and Harvard universities; choreographed *Bubbling Brown Sugar*, an all-Black revival of *Guys and Dolls*, and *Eubie* for Broadway; has choreography in the repertories of Philadanco, Alvin Ailey American Dance Theatre, Dance Theatre of Harlem and Dayton Contemporary Dance Company.

Morton Winston: former dancer with the Alvin Ailey American Dance Theater. Further information not located at time of publication.

Leni Wylliams (1961–1996): former soloist with Netherlands Dance Theatre, Donald Byrd/The Group and the companies of José Limón, Eleo Pomare, Fred Benjamin, Rod Rodgers, Pina Bausch and Paul Sansardo; former artistic director of Mafata Dance Company, Danny Sloan Dance Company and the Wyll/Dans Theatre; choreographed works for the Bolshoi Ballet, the Metropolitan Ballet and the Boston Opera.

Jawole Willa Jo Zollar: trained with Joseph Stevenson and Dianne McIntyre; founded Urban Bush Women in 1984; has created works for Alvin Ailey American Dance Theater, Ballet Arizona, University of Maryland, University of Florida and Dayton Contemporary Dance Company; guest teacher/lecturer at Mankato State University, University of California at Los Angeles, Ohio State University and the Abramowitz Memorial Lecturer at Massachusetts Institute of Technology; currently Nancy Smith Fichter Professor of Dance, Florida State University.

APPENDIX 4: DANCE PRACTITIONERS MENTIONED IN TEXT

- Biographical information on the major figures in this book—Essie Marie Dorsey, Joan Myers Brown, Kim Bears-Bailey, Deborah Chase-Hicks and others not listed here—appears in the text.
- Also omitted from this list are local dancers cited in the book whose role was described with passing reference in the text or who were not members of Philadanco.
- Philadanco choreographers' bios appear in a separate appendix.
- See also Philadelphia Dance Family Tree.

Alvin Ailey - A thumbnail biography appears in Philadanco Choreographer Profiles.

Hortense Allen (Jordan) (1920–2008). Longtime Philadelphia resident, originally from St. Louis, Missouri, she began dancing professionally at age fourteen and soon after began producing shows at that city's Plantation Club (the equivalent of New York City's Cotton Club). She later produced and choreographed shows with Larry Steele at Club Harlem in Atlantic City, New Jersey.

Talley Beatty. See Philadanco Choreographer Profiles.

Hope Boykin. See Philadanco Choreographer Profiles.

Kevin Brown (b. ca. 1953; d. 1990s). Studied with Faye Snow at West Philadelphia High School, danced in her Juba Contemporary Dance Theater, then with Philadanco, and then with the Ailey Company.

Ronald K. Brown. See Philadanco Choreographer Profiles.

Delores Browne (b. 1935). Danced and toured with the American Negro Ballet in the 1950s and is a master ballet teacher, having trained generations of dancers at the Alvin Ailey School and at Philadanco, where she continues to teach the weekly company ballet class.

Eric Bruhn (1928–1986). Internationally renowned Danish ballet dancer, choreographer, and artistic director; performed worldwide, including stints with the Royal Danish Ballet and Ballet Theatre; called by critic Clive Barnes "the greatest male classical dancer of his time."

Marie Bryant (1919–1978). Popular exotic dancer, late 1930s–early 1940s, who switched to singing by the end of the 1940s. As a dancer she was known for a classic, cultured style in the exotic genre; danced in films with black casts such as *Gang War* (1940) and *The Duke is Tops* (1938: the first film for both Bryant and Lena Horne, they became lifelong friends). She appeared as a singer in a number of Hollywood films.

Thomas Cannon (b. ca. 1910; d.1977). Founded the Littlefield Ballet Company with Catherine Littlefield and served as ballet master and soloist. He also danced with the Ballets Russes. In about 1953 he opened his own school at Fourteenth and Walnut Streets.

George Chaffee (1907–1984). Ballet dancer, teacher, author, and collector/archivist. Had been a lead dancer with the Metropolitan Opera Ballet in the 1930s. Danced also with the Fokine Ballet and the Mordkin Ballet.

Yvette Chauviré (b. 1917). Prima ballerina (*étoile*) with the Paris Opera Ballet and later its director.

Lucia Chase (1897–1986). Ballet dancer, director, and co-founder of American Ballet Theatre. Devoted her life and considerable personal wealth to the company that she directed until 1980, when Mikhail Baryshnikov was named her successor.

Nadia Chilkovsky [Nahumck] (1908–2006). Modern dance pioneer and educator originally trained in the (Isadora) Duncan tradition. Established the Philadelphia Dance Academy (1944) that became the Philadelphia College of the Performing Arts (1977) and today is the School of Dance of the University of the Arts. JB came in contact with her classes probably in the early 1950s.

Janet Collins (1917–2003). First African American dancer to become a member of the Metropolitan Opera Ballet Company (1951–1954), a non-touring ensemble that functions as a satellite of the world-renowned opera company. She was the cousin of Carmen de Lavallade. (See Raven Wilkinson entry, below. Wilkinson is the first black female in an autonomous white ballet ensemble touring the United States.)

Merce Cunningham (1919–2009). Prolific choreographer/collaborator, former dancer, with a profound influence on avant-garde modern dance. Known also for his use of chance and technology. Formed the Merce Cunningham Dance Company in 1953. Worked frequently in consort with major (white) American avant-garde visual artists, including Robert Rauschenberg, Jasper Johns, and Roy Lichtenstein, as well as the composers John Cage (his life partner) and David Tudor. Until the end of his life he continued to choreograph, presenting "Nearly Ninety" in New York a few months before his demise. Choreographed more than 200 dances and 800 site-specific "Events."

Leon Danielian (1922–1997). Danced with the Ballet Russe de Monte Carlo after having worked in Broadway musicals and with Ballet Theatre (renamed the American Ballet Theatre, ABT, in 1956). Director of the ABT School, 1967–1980; professor of dance, University of Texas, Austin, 1982–1991. He danced the role of Prince Adriano in "The Prince and the Rose," the ballet spectacle presented at the 1956 Christmas Cotillion.

Carmen De Lavallade. See Philadanco Choreographer Profiles.

Agnes de Mille (1905–1993). Already famous for choreographing the ballet *Rodeo* (1942) and for the Broadway musical hit *Oklahoma* (1943), was intimately associated with Ballet Theatre and, later, ABT. Like George Balanchine, she was an "Americanizer" of the ballet medium. Nevertheless, she did not integrate her casts. She had choreographed *Black Ritual (Obeah)* for the first (1940) season of the new Ballet Theatre—a danced version of composer Darius Milhaud's *Creation du Monde* for an all-black cast. In 1965, for ABT, she premiered her *Four Marys*, a Scottish legend of illicit love involving upper and lower classes, which she adapted as a story set in the antebellum South, for which she needed four black women. The original cast included Judith Jamison as Mary Seaton; Carmen de Lavallade as Mary Hamilton; Cleo Quitman as Mary Beaton; and Glory van Scott as Mary Carmichael. Judith Lerner played the Mistress, and Paul Sutherland, her Suitor.

Gary DeLoatch (1953–1993). One of the original dancers in Philadanco, he was a high school gymnast and athlete. Like many others he received early dance training with Faye

Snow and Joan Kerr at Philadelphia's Settlement Music School. He left Philadelphia and studied at the Dance Theatre of Harlem. By 1979 he was a member of the Ailey company. He choreographed pieces for Ailey I and II and was an accomplished children's teacher, leading numerous Ailey outreach programs.

François Delsarte (1811–1871). French music teacher/theoretician, created a system for analyzing body gesture/expression and control of body movement. His theories strongly influenced early modern dance and early twentieth-century trends in wellness and exercise training.

Betsy Ann Dickerson (b. ca. 1940). Ballerina hopeful and student of Sydney King and Joan Myers Brown, she went on to a career in New York in musical theater and later opened her own dance school in Freeport, Long Island, with a musical theater emphasis. Passing for white, she had earlier been a member of the Radio City Music Hall corps de ballet—one of the first black ballet dancers in the ensemble.

Vladimir Dokoudovsky (1919 –1998). Founding member of Ballet Theatre. Principal dancer with Ballet Russe ensembles in the 1930s and 1940s; also had been a member of the Mordkin Ballet. Began teaching at Ballet Arts in the 1950s. He was an influential ballet master teacher.

William Dollar (1907–1986). Dancer, choreographer, ballet master, and teacher who performed with such ensembles as the Philadelphia Opera Ballet and Ballet Caravan; worked abroad as ballet master with the Grand Ballets de Monte Carlo and the Grand Ballets du Marquis de Cuevas. He was one of the few Philadelphia teachers who accepted black students. It was not a matter of integrating his classes, but giving them private lessons. He was a lifetime friend and coach to Essie Marie Dorsey.

Ulysses Dove (1947–1996). Dancer/choreographer with many ensembles. Danced with the Merce Cunningham Company, 1970–1973; danced and choreographed for the Alvin Ailey American Dance Theatre, 1973–1980. Freelance choreographer for international ballet and modern dance companies, 1983–1996, including ABT, Dayton Contemporary Dance Company, Basel Ballet, New York City Ballet, Cullberg Swedish National Ballet, and assistant director of the experimental Choreographic Research Group of the Paris Opera.

Isadora Duncan (1877–1927). Dance performer and teacher who established herself internationally, espousing a natural, nonballetic movement style ensconced in flowing, unrestricted costumes and exhibiting emotional expression. She established schools in Europe and the United States. She is considered by many to be the progenitor of modern dance.

Katherine Dunham (1909–2006). Cultural anthropologist, choreographer, dancer, author, educator, activist, and leader in the field of dance anthropology, she was also renowned as founder and artistic director of the Katherine Dunham Dance Company (perhaps the first permanent black dance company based in North America) and founder of the Dunham School of Dance. From the 1940s through the 1960s she toured Europe and Latin America. She choreographed more than ninety dances. Many who trained with her and/or danced in her company went on to create their own choreographies and/or dance ensembles. Many New York "method" actors found their way to classes at her school, including James Dean and Marlon Brando. Singer/actor/activist Eartha Kitt began her career as a dancer in a Dunham Company European tour. Dunham created a demanding dance technique—a fusion of Afro-Caribbean and ballet motifs—that is taught worldwide. Her influence as an educator of the whole person and the dance professional cannot be overestimated.

Daniel Ezralow. See Philadanco Choreographer Profiles.

George Faison. See Philadanco Choreographer Profiles.

(Ed)Ward Flemyng, No biographical information located at time of publication.

Michel Fokine (1880–1942). Russian dancer/choreographer from the Imperial Ballet Academy/Maryinsky Theatre tradition. Acclaimed as a ballet reformer, he is known for his choreographies, the most famous created before World War I, including many dances for the Diaghilev company. During the War he worked in Scandinavia, then settled in New York (1923).

Syvilla Fort (1917–1975). Renowned dancer and teacher who danced in the Dunham company and was a teacher and the chief administrator at the Dunham School from 1948 until it closed in 1954. She then opened her own dance studio, also in New York City. It thrived until her untimely demise in 1975. She developed her own Afro-Modern dance technique.

Jerome Gaymon (1922–2009). Choreographer for the Cotillion Waltz and other social dances performed by the young "gentlemen and debutantes" of the Cotillion balls. He taught ballroom dance and interpretive dance (based on the Dunham technique) at the Sydney School, and King was his lifelong friend.

Martha Graham (1894–1991). One of the pioneers of mid-twentieth-century modern dance. In a career of over fifty years, she created more than 180 dances, many of which she danced in herself. She is credited with bringing to concert dance an intense emotional expression tempered by the rigorous, innovate movement technique she created. Hers was one of the first major white modern dance companies to hire African American dancers (beginning with Matt Turney and Mary Hinkson, both hired in1951).

Arthur Hall (1934–2000). A major influence on the Philadelphia dance scene. Born in Memphis, Tennessee, he came to Philadelphia (after performing in Washington D.C.) at age seventeen and studied at the Judimar School with John Hines. From 1955–1957 he was in the army, in a special services unit traveling in Europe and performing and choreographing variety shows. In 1957 he returned to Philly and began teaching for Sydney King, later recruiting a group of dancers who became the Afro-American Dance Ensemble. (Subsequently, his name was added to the title.) From 1958 to 1988 he danced, choreographed, taught widely in Philadelphia and in other states, and was artistic director of his ensemble. In 1969 his Ile-Ife Center for the Arts and Humanities was established in a beleaguered section of North Philadelphia, an African American neighborhood. He established a viable, though economically limited, cultural and social center of activity for that community. He returned to Memphis from 1988 to 1995, after which he moved to Maine, where he had taught frequently since 1977.

Eleanor Harris (b. ca. 1923). Anecdotal information: An accomplished tap dancer/teacher, around the age and generation of Jerome Gaymon, who started out with Essie Marie Dorsey. She taught tap at the Sydney School and partnered with John Hines in opening a dance school in West Philadelphia. At some point she moved to the New York area where she taught tap at the Ailey school until ca. 2008. Now confined to a nursing home. (information from telephone conversations with Karen Warrington and Joan Myers Brown, December 29, 2010).

Rennie Harris. See Philadanco Choreographer Profiles.

Frank Hatchett (b. ca. 1930). A contemporary of JB and her frequent partner in her show business career. Master jazz dance teacher currently based at the renowned Steps on Broadway dance studio in Manhattan.

Thelma Hill (1924–1977). Influential dancer, artistic director, teacher (Horton technique), educator, she founded the New York Negro Ballet with Ward Flemyng (1954), was an original member of the Alvin Ailey Company, and co-founded the prestigious Clark Center for the Performing Arts in New York (1962).

John Hines (1924–late 1980s—exact date of demise unavailable at time of publication). Always a mover with a gymnast's flexibility, Hines was self-taught until he began studying with Essie Marie Dorsey at age fourteen, where he stayed until he was nineteen and was drafted into World War II. After the war he went to New York and studied at the Dunham School on the G.I. Bill. For about three years during the late 1950s (ca. 1958–1960), he and Eleanor Harris ran their own school in West Philadelphia. He also choreographed, taught at the Judimar School, and had his own dance group at one time.

Lester Horton (1906–1953). Important modern dance pioneer whose work was based in Los Angeles. He formed his first company in 1934 and was the teacher of and mentor to many fine dancers, including Bella Lewitsky, Janet Collins, Carmen de Lavallade, Joyce Trisler, James Truitte, and Alvin Ailey. Like his contemporary, Martha Graham, he had an integrated company of dancers in the pre–civil rights era.

Judith Jamison (b. 1944)–Philadelphia native best known for her work as a principal dancer with the Alvin Ailey American Dance Ensemble (AAADT), where she performed from 1965 to 1980. After Ailey's death she became Artistic Director of the Ensemble, beginning in 1989. She retired at the end of 2010.

Carole Johnson (b. 1940). Another former Sydney student whose focus was ballet, she became a modern dancer after moving to New York. According to the Australian Government website page on Australian modern dance, she "toured Australia as part of the Eleo Pomare Company and was commissioned by the Australia Council for the Arts to run dance classes for Aboriginal people in Sydney." She then moved to Australia (1974), where she was a pioneer of the modern dance movement in that country and initiated the foundation of the Aboriginal Islander Dance Theatre, bringing Aboriginals into the fold of their previously segregated mainstream dance community. (http://www.cultureandrecreation.gov.au)

Louis Johnson. See Philadanco Choreographer Profiles.

Bill T. Jones (b. 1952). Dancer, artistic director and choreographer; with Arnie Zane he formed the Bill T. Jones/Arnie Zane Dance Company (1982). Has created over 100 works for his own company plus works for ballet and modern dance companies in the United States and Europe. Created, directed, and choreographed *Fela!*, the Broadway musical (2009) for which he won a Tony Award for Best Choreography.

Lisan Kay (1910 – ?). American dancer and teacher, danced with Chicago Civic Opera Ballet, 1926–1927. Toured with small companies and independent partnerships until 1940. Associate and instructor at Ballet Arts School from its inception in 1940.

Catherine Littlefield (1908–1951) Founded The Littlefield Ballet Company (1935–1942) and the Littlefield Ballet School. She is considered one of the pioneers of American ballet. Her company was the first to be composed entirely of Americans—directors, staff, and dancers. The school continued for a period after the demise of the performing ensemble.

Luigi (Eugene Louis Facciuto) (b 1925). Legendary dance teacher and innovator of an internationally famous jazz dance technique that is a patented product with teacher training and certification as part of the package.

Donald Lunsford (b. 1954). Philadanco dancer, choreographer, and artistic director of D/2, the apprentice company to Philadanco.

Thalia Mara (1911–2003). Dancer, teacher, educator, writer; opened the Ballet Repertory School with her husband in 1948; began the National Academy of Ballet in 1963; one of the founders of the USA International Ballet Competition in Jackson, Mississippi.

Matt Mattox (b. 1921). Renowned jazz dance teacher and gifted performer; appeared in the film, *Seven Brides for Seven Brothers*, dancing as one of the brothers.

Dianne McIntyre. See Philadanco Choreographer Profiles.

Warren P. Miller (b. 1958). Danced with Philadanco during the 1980s. Was the first male (and second person, after Primus, herself) to dance the Pearl Primus solo, *Hard Time Blues*. Has worked with numerous modern dance companies and toured with recording artists.

Arthur Mitchell (b. 1934). Ballet dancer, choreographer, co-founder/Artistic Director of the Dance Theatre of Harlem, he began dancing in Broadway musicals and joined the New York City Ballet as its first African American dancer (1955). George Balanchine, its founder/director/co-choreographer, created roles for him in several ballets. He continued with NYCB until 1972, having already founded his Dance Theatre of Harlem School in 1968, with the company debut in 1971.

Mikhail Mordkin (1880–1944). A Russian who had studied and danced with the Bolshoi ballet, he toured with the Diaghilev's Ballets Russes and with Anna Pavlova, then returned to Russia and the Bolshoi, but left after the October Revolution and emigrated to the United States. He founded the Mordkin Ballet (1926) and was an important figure in the emergent American ballet world. He was instrumental in founding the Ballet Theatre in 1940, which later became the American Ballet Theatre (1956).

Milton Myers. See Philadanco Choreographer Profiles.

Joseph Nash (1919–2005). Professionally known as Joe Nash. Renowned dancer, educator, scholar, and archivist of African American modern dance, he was based in New York, guest-taught at Judimar, choreographed for the Christmas Cotillion balls, and amassed a major collection on black dance which he donated to the Schomburg Library in Harlem.

Betty Nichols (dates unavailable at time of publication). John Hines's colleague and contemporary, she danced at the Dorsey school the same time as Hines. Although never hired permanently, she was one of the very few African Americans to find employment with large American ballet companies before the 1950s. She danced in New York in Ballet Society productions of *Zodiac* (1946), choreographed by Todd Bolender, and with Talley Beatty as her partner in *Blackface* (1947), choreographed by Lew Christensen. (Ballet Society was the forerunner of the New York City Ballet.) Her name appeared in the cast lineup for the 1943 Broadway production of *Carmen Jones*, choreographed by Eugene Loring. In Paris, in the summer of 1949, she performed with Merce Cunningham and Tanaquil LeClerq in *Effusions avant l'heure*, and in a duet with Milorad Miskovitch, *Two Step*, both choreographed by Cunningham. (See Cunningham Dance Company online Chronology: http://www.merce.org/archive/chronology.php). At some point she permanently expatriated, married, and raised a family in either France or Switzerland. (Information gleaned from John Hines interview and Google online sources.)

Leigh Parham (dates unavailable at time of publication). New York–based dancer, choreographer, and teacher who performed in Broadway musicals in the 1950s, guest taught

at Judimar, and choreographed and danced for Cuyjet's recitals and the Christmas Cotillions.

Tony Parnell ([Philip Anthony Parnell] 1951–1987). Like Gary DeLoatch and Kevin Brown, he went to West Philadelphia High School and was one of the legendary group of young men who studied there with Faye Snow. He remained in Philadelphia, dancing with Danco.

Anna Pavlova (1881–1931). Internationally renowned Russian ballerina who studied at the Vaganova Academy of Russian Ballet in St. Petersburg and danced with the esteemed Maryinsky Theater Imperial Ballet, under renowned ballet master Marius Petipa. As her career flourished she was allowed to go on tour, which blossomed into a new career. She settled in London, which functioned merely as a new base, while she continued touring worldwide, including places where ballet had never before been seen. *The Dying Swan*, choreographed by Michel Fokine, was her signature piece.

Eleo Pomare. See Philadanco Choreographer Profiles.

Harold Pierson. See Philadanco Choreographer Profiles.

Pearl Primus (1919–1994). Dancer, choreographer, ethnographer born in Trinidad and raised in New York City, she studied modern dance forms and in the 1940s performed solos at venues including Café Society Downtown, an integrated cabaret, and on Broadway. In 1946 she founded her own dance ensemble. Married to dancer–choreographer Percival Borde. Known for basing her dances on racial issues and the works of African American writers, her themes include African, African American, and Caribbean subject matter. She received a Ph.D. in dance education from New York University (1978). In 1990 she became the first chairperson of the Five Colleges Dance Consortium in Massachusetts.

Jerome Robbins (1918–1998). Prolific producer, director, and choreographer for Broadway, ballet, film, and television. Five-time Tony Award winner; winner of two Academy Awards, one for the film of *West Side Story* (which he had also created for Broadway). Was a soloist with Ballet Theatre (1941-1944). He, too, had an early integrated ensemble, his Ballets U.S.A. (1958–1962), with Louis Johnson and John Jones as members. He became ballet master of New York City Ballet in 1972.

LaVaughn Robinson (1927– 2008). Master tap dancer, choreographer, and teacher who grew up in South Philadelphia. Performed in Africa, Europe, and Russia. **Germaine Ingram**, gifted dancer-choreographer-researcher who gave up careers as a Philadelphia lawyer and court judge, was Robinson's final partner.

Gene Hill Sagan. See Philadanco Choreographer Profiles.

Karel Shook (1920–1985).Internationally renowned ballet master, he was the director of the Dunham School's ballet department, 1952–1954. He later had his own school; became ballet director of the June Taylor School; and was the associate artistic director of the Dance Theatre of Harlem until his demise.

Carlos Shorty (b. app. 1956; d 1990 or 1991). Studied at the Philadelphia College of the Performing Arts (which later became the University of the Arts). Performed with the Juba Contemporary Dance Company and the Joan Kerr Kaleidoscope. He was a participant in the Third International Ballet Competition in Jackson, Mississippi. He began his association with Philadanco ca. 1982.

Faye Snow (b. 1939). Important modern dance teacher in the Philadelphia area; trained many local dancers of note at the West Philadelphia High School (including Gary DeLoatch and Kevin Brown) and at other venues in the city such as the Settlement Music School, the University of the Arts, and her own studio. Directed the dance program at the Franklin Learning Center, an alternative high school in Philadelphia. She founded the Juba Contemporary Dance Theater.

Ruth St. Denis (1879–1968) and **Ted Shawn** (1891–1972). Pioneers in early American modern dance. They were married for some time and opened Denishawn schools across America; they continued to work independently after separating. Shawn was the first recognized exponent of a style of heroic male concert dancing in a nonballetic style. Both he and St. Denis were known for their use of "oriental" and ethnic themes in their quest for a freestyle concert dance idiom.

Karen Still Pendergrass (b. 1954). Former Philadanco dancer, she became a member of the company at age twenty and, as of 2011, has been teaching at PSDA for upwards of thirty-five years, having begun as a student teacher soon after joining Danco. She was married to Teddy Pendergrass, the pop music idol.

Maria Swoboda (1901?–1987). According to her obituary in the *New York Times*, August 13, 1987, she "habitually refused to disclose her age." Was a noted ballet teacher at leading New York studios, having emigrated from Russia, where she had studied in Moscow and danced with the Bolshoi Ballet.

Paul Taylor (b.1930). Prolific choreographer, former dancer. Artistic director of the Paul Taylor Dance Company which he began as a small troupe in 1954, even while dancing for seven seasons in the 1950s with the Martha Graham Dance Company and appearing as guest artist with the New York City Ballet, at the behest of George Balanchine. He retired from performing in 1974. Continues to choreograph for the Paul Taylor Dance Company and for ballet companies worldwide and has made nearly 150 dances, as of 2011.

Pat Thomas (b. 1950). Master teacher/mentor/instructor, former chair of the modern dance department of the University of the Arts in Philadelphia (1982–2000), she has taught Graham technique to Philadanco for the past thirty years.

Joyce Trisler (1934–1979). Friend and colleague of Alvin Ailey dating back to their days at the Lester Horton Dance Studio in Los Angeles. She was Ailey's assistant in New York, and a respected dance teacher at the Ailey school. She formed her own dance company in 1974. After her untimely demise, Milton Myers took over the company leadership until 1991.

Antony Tudor (1908–1987). World-renowned dancer, teacher, choreographer, once called "the choreographer of human sorrow" because his dances show a deep sensitivity to suffering. His full list of choreographic and teaching credits is long and impressive and includes *Jardin aux lilas* (Lilac Garden, 1936), *Dark Elegies* (1937), *Pillar of Fire* (1942), and *The Leaves Are Fading* (1975). He moved in 1940 from Great Britain to New York, where he was resident choreographer for ten years with Ballet Theatre, and continued teaching and choreographing internationally. Using New York as his base in the 1950s, he staged ballets on companies stateside and abroad and traveled weekly to Philadelphia to teach for the city's Ballet Guild.

Gertrude Tyven (1924–1966). Ballerina with the Ballet Russe de Monte Carlo, 1942–1959. Danced the role of Princess Lilas to Danielian's Prince in the 1956 Christmas Cotillion ballet spectacle.

Raven Wilkinson (b. 1936). Accepted into the corps of the Ballet Russe de Monte Carlo in 1954, she was the first black woman hired as a permanent member of a major white ballet company that toured extensively in the United States. (She was not passing for white.) Promoted to soloist in her second season, she stayed with the company for six years. Increasingly hostile racism made touring in the South impossible, and she had to leave the company. She became a soloist with the Dutch National Ballet and returned to her native New York in 1974.

APPENDIX 5: PHILADANCO ACTIVITY SCHEDULE
AUGUST 2009–JUNE 2011

AUGUST 2009

3–7	Summer Program, PHILADANCO Studios, Phila., PA–Rennie Harris
10–14	Summer Program, PHILADANCO Studios, Phila., PA–Christopher L. Huggins
17–21	Summer Program, PHILADANCO Studios, Phila., PA—Robert Garland

SEPTEMBER

11	Phila., PA—Pinn Memorial Church, "Soul Food" Youth Program, D/3
19	Phila., PA, Blues Fest, Preston & Market Sts., D/3
26–27	Pittsburgh, PA—August Wilson Center
26	Galloway, NJ—Sigma Pi Phi Fraternity Luncheon, D/2

OCTOBER

2	Hyattsville, MD—Publick Playhouse
17	Indianapolis, IN—Madame Walker Theatre Center
22–23	Phila., PA—Painted Bride Art Center, 'DANCO on 'DANCO

NOVEMBER

6	Clinton, NY (near Syracuse)—Hamilton College
12–15	Phila., PA—Kimmel Center

JANUARY 2010

10	Phila., PA—PHILADANCO Studios—Auditions
13–18	Phila., PA—22nd Annual IABD Conference
15–16	Phila., PA—Merriam Theater—IABD Showcases

FEBRUARY

8–9	South Boston, VA—The Prizery
11	Reston, VA—Center Stage/Reston Community Center
12	McLean, VA—Alden Theatre
19–20	St. Louis, MO—Edison Theater
23	Baton Rouge, LA—Magnolia Perf. Arts Center
25	Pomona, NJ—Stockton Perf. Arts Center

MARCH

9	Monterrey, Mexico—University of Monterrey

APRIL

15–18	Phila., PA—Kimmel Center—40th Anniversary Concert Series
24	Dover, DE—Schwartz Center
30	Wilkes-Barre, PA—Kirby Center

MAY

15–16	Flushing, NY—Queens Theatre in the Park
23	50th Anniversary Dance Arts Recital, Academy of Music, Phila., PA

JUNE

13	Phila., PA—PHILADANCO Studios—Auditions
16–17	Jackson, MS—USA International Ballet Competition

JULY

Summer Program, PHILADANCO Studios, Phila., PA—Pat Thomas
Summer Program, PHILADANCO Studios, Phila., PA—Bill Thomas
Atlanta, GA—National Black Arts Festival, Rialto Theater
Summer Program, PHILADANCO Studios, Phila., PA—Dance Brazil
Summer Program, PHILADANCO Studios, Phila., PA—Mary Barnett

AUGUST

Summer Program, PHILADANCO Studios, Phila., PA—Ameniyea Payne
Summer Program, PHILADANCO Studios, Phila., PA—TBA
Düsseldorf, Germany—Internationale Tanzmesse Festival

SEPTEMBER

	Phila., PA — Painted Bride Art Center, 'DANCO on 'DANCO
	Phila., PA — Painted Bride Art Center, Alumni Performance & Reception
21 — Oct. 18	"JUBILEE" 40th Anniversary Tour — Europe (Germany, Netherlands & other countries)

OCTOBER

	"JUBILEE" 40th Anniversary Tour — Europe (Germany, Netherlands)
19	Fayetteville, NC

NOVEMBER

Easton, PA — William Center
Brooklyn, NY — Brooklyn Center — Rep. includes NY Premiere of "By Way of the Funk"

DECEMBER

Phila., PA — Kimmel Center — XMAS PHILES Rehearsals— Apollo Collaboration

JANUARY 2011

8	Phila., PA — PHILADANCO Studios — Auditions
11–13	New York, NY — Apollo Showcase/APAP
18–19	Rapid City, SD — Black Hills Civic Center
20–22	Sioux Falls, SD — Washington Pavilion
24–25	Castleton, VT — Castleton State College
28	Blue Bell, PA — Montgomery County Community College
27–30	Los Angeles, CA — 23rd Annual IABD Conference

FEBRUARY

	Orono, ME — University of Maine
15	Keene, NH — Keene State College
16–17	New Brunswick, NJ 0 STARC
22–24	Kona, HI — Kahilu Theater
25–27	Hilo, HI — University of Hawaii — Hilo
28– March 3	Maui, HI — Maui Cultural Center

MARCH

Amherst, MA — University of Massachusetts
Boston, MA — Crash Arts

18	Cerritos, CA — Cerritos Center
19	Scottsdale, AZ — Scottsdale Center
21	Palm Desert, CA — McCallum Theater
28 — April 3	New York, NY — Joyce Theatre

APRIL

	New York, NY — Joyce Theatre
9	Sugar Loaf, NY

MAY

	Phila., PA — Kimmel Center
	Portsmouth, VA
20	Washington, DC — Duke Ellington School Award Ceremony
29	51st Anniversary Dance Arts Recital, Academy of Music, Phila., PA

JUNE

12	Phila., PA — PHILADANCO Studios — Auditions

APPENDIX 6: INTERVIEWEES

JOAN MYERS BROWN[1]

Kim Bears—2008
Elisabeth Bell—2008
Zane Booker—2008
Hope Boykin—2009
Ronald K. Brown—2008
Debora Chase-Hicks—2008
Marion Cuyjet (1985, 1986, and 1988)
Daniel Ezralow—2009
Jerome Gaymon—1988
Arthur Hall—1985
(Lorenzo) Rennie Harris—2008
John Hines—1985
Judith Jamison—1985
Sydney King—1985
Deborah Manning St. Charles—2008
Bebe Miller—2008
Elisa Monte—2009
Milton Myers—2009
(Joseph) Joe Nash—1987
Karen Pendergrass and Marlisa Brown Swint—2009
(for 50th Anniversary of Philadelphia School of Dance Arts)
Gene Hill Sagan—1985
Vanessa Thomas Smith—2008
Carmella Vassor—2008
Tracy Vogt—2009
Billy Wilson—1985
Jawole Willa Jo Zollar—2009

NOTES

FOREWORD: BALLET BECOMES BLACK UPLIFT

1. Adrian Stokes, *Tonight the Ballet*. London: Faber & Faber, 1942, p. 29.
2. Ibid., 84.

PRELUDE

1. Novelist/librettist/poet Thulani Davis, "A Graceful Dancer in My Living Room," *Dance/USA Journal*, Summer 1998, p. 23 of pp. 23-27.
2. Quoted in Isabel Wilkerson, *The Warmth of Other Suns: The Epic Story of America's Great Migration*. New York, NY: Random House, 2010, p. 489.
3. Sign posted on the wall in one of the Philadelphia School of Dance Arts/Philadelphia Dance Company studios.

PROLOGUE

1. Also known simply as Dance Arts, or abbreviated elsewhere in this book as PSDA.
2. Because other dance professionals cited in this book share Myers Brown's surname (Camille Brown; Ronald Brown; Delores Browne; Milton Myers), and since it becomes clunky to refer to her constantly as Myers Brown, I will generally refer to her throughout this work as JB, a name by which she is known and that she accepts.
3. As I write this book the old guard is changing. Thomas-Smith, with Philadanco since its beginnings (see chapter 3), has been replaced and is working as a freelancer, though informally continuing her relationship with JB and the company.
4. After decades of working with JB while running a small business of her own, Haughton retired in 2010 and has taken up a position at the city's renowned Freedom Theater.
5. C. S'thembile West, "Danco's Done It," *Philadelphia Weekly*, May 31, 1995, n.p.
6. The International Association of Blacks in Dance (IABD), cofounded by JB in 1991, was preceded in 1988 by the first Association of Blacks in Dance Conference, also spearheaded by JB, with the first conference held in Philadelphia. After three years it was decided that a bona fide organization was needed to support the annual conferences as well as related issues and activities, and the IABD was born. The organization's 2010 conference was hosted by Philadanco and held again in Philadelphia.
7. For thumbnail biographies of many of the dance practitioners mentioned throughout the book, see the *Dance Practioners* and the *Philadanco Choreographer Profiles* appendices.
8. The instruction and training program is the overall umbrella for training dance hopefuls between the ages of seventeen and twenty-three. These students may audition for

D/2, the junior performing group. A six-week annual summer program is held for students aged nine to sixteen, most of whom will study at PSDA for the rest of the year. Youngsters aged nine through twelve are eligible to be accepted in D/3, the preteen performing group. Although this system omits a year-round performance opportunity for youth aged thirteen through sixteen, they are nevertheless able to study at PSDA and perform in the school's annual spring recital. If they continue at the school, they may audition for D/2 or, if not accepted into that ensemble, may be accepted into the Instruction and Training Program.

9. After twenty-seven years and thanks to funding for modest building renovations, this precipitous staircase was replaced by a more traditional one in the summer of 2009.

10. To be clear: My focus is the African American community that birthed and nurtured a concert dance tradition, dating back to the 1920s, with Joan Myers Brown's achievements as central to this picture. Whites were tangentially involved in this movement, but they—and white Philadelphia dance initiatives in ballet and modern dance—are not the main players in this drama. Thus, Nadia Chilkovsky and the institution she founded (the Philadelphia Dance Academy, which later became the Philadelphia College of the Performing Arts, and is now the School of Dance of the University of the Arts) and the emergence of ballet and modern dance in white Philadelphia are not discussed in this book.

1 THE BACKDROP—1920s–1940s

1. Isabel Wilkerson, in *The Warmth of Other Suns* (New York: Random House, 2010), relates an incident of the discrimination "a colored man in Philadelphia faced when he answered an ad for a position as a store clerk. 'What do you suppose we'd want of a Negro?' the storekeeper asked of the applicant" (p. 315). Quoted by Wilkerson from Scott Nearing, *Black America* (New York: Schocken Books, 1929, p. 78); original reference: H. G. Duncan, *The Changing Race Relationship in the Border and Northern States* (Philadelphia, 1922, p.77).

2. In his book *Between Barack and a Hard Place* (San Francisco: City Lights Books, 2009), Tim Wise writes, "The typical white family today has about eleven times the net worth of the typical black family...and much of this gap is directly traceable to a history of unequal access to capital....This wealth gap continues to grow, not only because of past unequal opportunity, but also because of present-day institutional racism" (p. 36). He goes on to tell us that "middle-class black families have to put in approximately 480 more hours per year—equal to twelve work weeks—relative to similar whites, just to make the same incomes as their middle-class white counterparts" (p. 38). Endnotes (14 through 22, pp. 150–152), most of which cite the United States Census Bureau's Statistical Abstracts for 2007, substantiate his claims. They are shocking but true and limn a sad story about the perversity and continuity of systemic racism in our nation. The situation was even worse in earlier eras.

3. Exhibition catalog, n.a., *Philadelphia African Americans: Color, Class and Style, 1840–1940* (Philadelphia, PA: Museum of the Balch Institute for Ethnic Studies, 1988), p. 35.

4. W. E. B. Du Bois, *The Souls of Black Folk* (Chicago: A. C. McClurg, 1931; Cambridge, MA: University Press John Wilson and Son, 1903; Bartleby.com,

1999, www.bartleby.com/114/. In chapter 1, "Of Our Spiritual Strivings," the frequently quoted paragraph, from the first page, reads,

> After the Egyptian and the Indian, the Greek and Roman, the Teuton and Mongolian, the Negro is a sort of seventh son, born with a veil, and gifted with second-sight in this American world, a world which yields him no true self-consciousness, but only lets him see himself through the revelation of the other world. It is a peculiar sensation, this double-consciousness, this sense of always looking at one's self through the eyes of others, of measuring one's soul by the tape of a world that looks on in amused contempt and pity. One ever feels his two-ness, an American, a Negro; two souls, two thoughts, two unreconciled strivings; two warring ideals in one dark body, whose dogged strength alone keeps it from being torn asunder.

5. Vincent P. Franklin, *The Education of Black Philadelphia* (Philadelphia: University of Pennsylvania Press, 1979).
6. Robert C. Toll, *Blacking Up* (New York: Oxford University Press, 1974), p. 198.
7. For a full discussion of the interface between black and white minstrelsy, see Brenda Dixon Gottschild, *Digging the Africanist Presence in American Performance: Dance and Other Contexts* (Westport, CT: Greenwood Press, 1996, 1998 [paper]), chap. 5.
8. See Willard B. Gatewood, *Aristocrats of Color: The Black Elite, 1880-1920* (Bloomington: Indiana University Press, 1993), pp. 10–11, 97, 101.
9. Ibid., p. 10, quoting Willson.
10. The three streams feeding into this aristocracy were composed of native free Philadelphians from the revolutionary era; a Caribbean contingent, especially those from San Domingo and Haiti; and the southern component, consisting "mostly of fair-complexioned, free-born mulattoes from South Carolina, Virginia, and Maryland." Gatewood, *Aristocrats of Color*, p. 97.
11. She passed away in 1996. I interviewed her in 1985,1986, and again in 1988.
12. Information on *The Philadelphia Negro* gleaned from online links at WEBDuBois.org, including H. V. Nelson, "The Philadelphia Negro," in *Encyclopedia of Black Studies*, ed. Molefi Kete Asante and Ama Mazama (Thousand Oaks, CA: Sage, 2004); and Elijah Anderson and Douglas S. Massey, "The Sociology of Race in the United States," in *The Problem of the Century: Racial Stratification in the United States*, ed. Elijah Anderson and Douglas S. Massey (New York: Russell Sage Foundation, 2001).
13. According to Anderson and Massey, cited above,

 The trouble with the standard account of American sociology's birth is that it happened not at the University of Chicago in the 1920s, but at the University of Pennsylvania in the 1890s; rather than being led by a group of classically influenced white men, it was directed by W.E.B. Du Bois, a German-trained African American with a Ph.D. from Harvard. His 1899 study, *The Philadelphia Negro*, anticipated in every way the program of theory and research that later became known as the Chicago School. Although not generally recognized as such, it represented the first true example of American social scientificr esearch.

14. Attached is the complete Table of Contents, copied from http://media.pfeiffer.edu/lridener/DSS/Du Bois/pntoc.htmlDu Bois:

 CHAPTER I. The Scope of This Study: 1. General aim 2. The methods of inquiry 3. The credibility of the results

 CHAPTER II. The Problem: 4. The Negro problems of Philadelphia 5. The plan of presentment

CHAPTER III. The Negro in Philadelphia, 1638–1820: 6. General survey 7. The transplanting of the Negro, 1638–1760 8. Emancipation, 1760–1780 9. The rise of the freedmen, 1780–1820

CHAPTER IV. The Negro in Philadelphia, 1820–1896: 10. Fugitives and foreigners, 1820–1840 11. The guild of the caterers, 1840–1870: 12. The influx of the freedmen, 1870–1896

CHAPTER V. The Size, Age and Sex of the Negro Population: 13. The city for a century 14. The Seventh Ward, 1896

CHAPTER VI. Conjugal Condition: 15. The Seventh Ward 16. The city

CHAPTER VII. Sources of the Negro Population: 17. The Seventh Ward 18. The city

CHAPTER VIII. Education and Illiteracy: 19. The history of Negro education 20. The present condition

CHAPTER IX. The Occupation of Negroes: 21. The question of earning a living 22. Occupations in the Seventh Ward 23. Occupations in the city 24. History of the occupations of Negroes

CHAPTER X. The Health of Negroes: 25. The interpretation of statistics 26. The statistics of the city

CHAPTER XI. The Negro Family: 27. The size of the family 28. Incomes 29. Property 30. Family life

CHAPTER XII. The Organized Life of Negroes: 31. History of the Negro church in Philadelphia 32. The function of the Negro church 33. The present condition of the churches 34. Secret and beneficial societies and cooperative business 35. Institutions 36. The experiment of organization

CHAPTER XIII. The Negro Criminal: 37. History of Negro crime in the city 38. Negro crime since the war 39. A special study in crime 40. Some cases of crime

CHAPTER XIV. Pauperism and Alcoholism: 41. Pauperism 42. The drink habit 43. The causes of crime and poverty

CHAPTER XV. The Environment of the Negro: 44. Houses and rent 45. Sections and wards 46. Social classes and amusements

CHAPTER XVI. The Contact of the Races: 47. Color prejudice 48. Benevolence 49. The intermarriage of the races

CHAPTER XVII. Negro Suffrage: 50. The significance of the experiment 51. The history of Negro suffrage in Pennsylvania 52. City politics 53. Some bad results of Negro suffrage 54. Some good results of Negro suffrage 55. The paradox of reform

CHAPTER XVIII. A Final Word: 56. The meaning of all this 57. The duty of the Negroes 58. The duty of the whites

APPENDIX A. Schedules used in the house-to-house inquiry

APPENDIX A. Legislation, etc., of Pennsylvania in regard to the Negro

APPENDIX A.B ibliography

(from W. E. B. Du Bois, *The Philadelphia Negro* [New York: Lippincott, 1899], table of contents)

15. Bordered by Spruce Street on the north, South Street on the south, Seventh Street on the east, and the Schuylkill River on the west. By 1890, approximately forty thousand African Americans lived in Philadelphia, and approximately one-fourth were living in the Seventh Ward. See also www.mappingDuBois.org.
16. See H. V. Nelson, above.

17. The "talented tenth" theory will be discussed later in this chapter, in tandem with a discussion of Booker T. Washington's opposing parallel.
18. This was true as late as the 1940s. For example, George Balanchine's *Concerto Barocco* premiered in 1940 at New York's Hunter College Theater; his *Four Temperaments* premiered in 1946 in the auditorium of the Central High School of Needle Trades, also in New York. See Horst Koegler, *The Concise Oxford Dictionary of Ballet* (London: Oxford University Press, 1977), pp. 129, 205.
19. Although African Americans also lived in other enclaves in West and North Philadelphia, South Philadelphia was the bustling hub of the black community from colonial times through the 1960s.
20. Carpenter moved to Bermuda, where she opened her own dance studio. Her maiden name was Louise Jackson.
21. I contacted the Library Company of Philadelphia, the Temple University Urban Archives, the Historical Society of Pennsylvania (including its Balch Center for Ethnic Studies), and the Charles L. Blockson Afro-American Collection, all major archives on Philadelphia community culture, with no success. This is a recurring issue with dance history, and doubly so with black dance history. Most information is found through relatives and colleagues.
22. Joan Myers Brown, "Essie-Marie Dorsey Was Pioneer Ballet Teacher for Blacks," *Philadelphia Tribune*, February 19, 1977, p. 12.
23. One of several mid-twentieth-century African American opera companies that took root in major cities across the nation as a performance outlet for black opera talent, since blacks were not permitted to perform in white companies.
24. The Frederick Douglass Memorial Hospital and Training School for Nurses was founded in 1895. Mercy Hospital opened in 1907. Both were founded by, and dedicated to the treatment of, black people. "Yearly local and national musicians, poets, writers, and women's groups feted Douglass and Mercy to raise funds and ward off political threats to cut support for these institutions." Exhibition catalog, n.a., *Philadelphia African Americans: Color, Class and Style, 1840–1940*, mentioned earlier, p. 37.
25. King had studied with Dorsey from 1926, when she was seven and at the time Dorsey opened her first studio. Cuyjet, a year younger than King, had seen Dorsey performances at this time but did not begin to study with her until 1934, when she was fourteen and entering South Philadelphia High School.
26. As part of the survival mechanism needed for living in a segregated society, African Americans since the late nineteenth century had developed their own performance networks, including tent shows, medicine shows, and black theaters on specific touring circuits; cabarets, bars, their own homes, and holes in the wall that featured live performance; as well as hotels and boarding houses that thrived largely due to the patronage of this black entertainment industry. The Lincoln (Philadelphia), Apollo (New York), and Regal (Chicago) theaters were part of the northern, East Coast network. There were other circuits down South and others for vaudeville units going points west. The Dunbar was a hotel that patronized African Americans. There existed one or more of these hotels in cities like New York, Philadelphia, Chicago, and Los Angeles. In the many locales where African Americans performed and white hotels were off limits, the black community opened its homes to its own. In every city or town that had a black performance venue, there were boarding houses or private homes that took in black artists on tour, offering them not only room but

also meals, since most white restaurants would not serve blacks, even in major cities.

Unfortunately, the owners of the most theaters and hotels were hardly ever black. Thus, black enterprise—in the form of a thriving entertainment industry that nurtured *all* Americans—spent its hard-earned cash on institutions that practiced discrimination and profited the white economy.

For an in-depth treatment of African American vaudeville, stateside and abroad, in the 1930s–1940s, see Brenda Dixon Gottschild, *Waltzing in the Dark: African American Vaudeville and Race Politics in the Swing Era* (New York: Palgrave Macmillan, 2000, 2002 [paper]).

27. Young Men's/Young Women's Hebrew Association, parallel to the YM/YWCA or Young Men's/Young Women's Christian Association.
28. Stylized folk dances, whether European or Asian, are a tradition in nineteenth-century ballet, as seen in works such as the *Nutcracker* (1892) and *Napoli* (1842; a ballet by the Danish choreographer August Bournonville), to give two examples.
29. W. E. B. Du Bois, "The Talented Tenth," from *The Negro Problem: A Series of Articles by Representative Negroes of Today* (New York: James Pott and Company, 1903).
30. From its founding in 1881 until his demise in 1915.
31. Full text of the review at WEBDuBois.org, "Book Reviews of *The Philadelphia Negro*," therein cited as *Yale Review* 9 (May 1900): pp. 110–111, by William F. Blackman.
32. Ibid.
33. Ibid.
34. Washington's speech is famously known as "the Atlanta Compromise of 1895"—the name given it by Du Bois, who believed it compromised the potential for black progress.
35. Wilkerson, *The Warmth of Other Suns*, p. 120.
36. Essie Marie Dorsey, "Social Graces," *Philadelphia Independent*, n.d., n.p.
37. N.a., n.d., n.p. Many of these clippings, given to Cuyjet by Dorsey, were cut and pasted together, with as many on one sheet as possible and citation information cut away.
38. "Phillygrams," n.a., n.d., n.p.

It is noteworthy that a considerable number of the society page gossip items, news and reviews were written by African American female journalists who, like their black brothers, were not accepted in the white publishing world and, in the black world, were confined to writing for the society pages, the result of gender discrimination. See "Register of the Papers of Bernice Dutrieuille Shelton," Historical Society of Pennsylvania/Balch Institute, online "Biographical Note."
39. "Dancing School Has Brilliant Opening," New York, October 17, 1929, n.a., n.p.
40. N.a., n.d., n.p.
41. N.a., n.d., n.p.
42. "Essie Marie Potts' Students in Dance Recital," *The Afro-American*, week of May 14,1 932.
43. "Essie Marie Pupils Presented in Twelfth Annual Dance Recital," n.a., n.d., n.p.
44. Pat Sutton, "Essie Marie Dancers in Outstanding Recital," n.d., n.p. Sutton gives the dates as 1939 and 1949. My copy of the actual program gives the dates as 1939 and 1940. It may be that the correct date was 1949 and the "1940" date a program printing error that may have been announced at the actual performance.

45. "Essie Marie Dance Recital Is Success," *Philadelphia Independent,* June 25, 1939, p. 11, n.a. Betty Nichols was one of the early black ballerinas who danced with white American ensembles without passing. See appendix 4.
46. Joan Myers Brown, "Essie-Marie Dorsey Was Pioneer Ballet Teacher for Blacks," *Philadelphia Tribune,* February 19, 1977, p. 12.
47. See also Joan Myers Brown's annotated resume in appendix 1. I interviewed JB for eleven hours in the fall of 2008 following several sessions together in 1985 and again in 1988. As explained in the prologue, this woman, nearly an octogenarian, works 24/7, and has done so for over fifty years, as subsequent chapters will show. Her stamina and appearance belie her chronological age. Nevertheless, in a career as long and rich as hers, there are missing links and forgotten dates. When two dates appear, it indicates that she was unable to pin a single year to a particular fact, even though I questioned her more than once regarding dubious dates, with hopes of gaining clarification. Archival resources at the Temple University's Paley Library dance collection and JB's private collection were used wherever possible to verify facts.
48. All three are Philadelphia natives who had successful dance careers.

2 SPECTACULARLY BLACK ON BLACK—1940s–1950s

1. The tradition of African Americans as caterers to the white elite dates back to the time and household of the first American president, George Washington, who enlisted one of his enslaved Africans, named Hercules, for this task. By the mid-nineteenth century, there were many catering families with Francophone roots and new-world names like Augustine, Baptiste, Dutrieuille, and Cuyjet. The following entry on Philadelphia's African American catering tradition is from BlackPast.org, "An Online Reference Guide to African American History":
"Entrepreneur Robert Bogle was the first of many African American caterers who served nineteenth-century Philadelphia's white elite. Born in 1774, the 1810 federal census shows Bogle and five members of his family in Philadelphia's South Ward, where the majority of the city's African American residents lived. The censuses of 1820 and 1830 record that the Bogles remained in the South Ward as their family increased. A successful businessman, Bogle died in 1848, remembered by prominent citizens in verse and memoir as an essential presence at all of life's main events, from christenings to funerals.
Robert Bogle established his shop at 46 South Eighth Street in 1812 and is credited with having 'virtually created the business of catering' in Philadelphia by W.E.B. DuBois, although the term 'caterer' was not used until the 1860s. In the mid-nineteenth century, the growing African American population of Philadelphia was facing competition from Irish immigrants for service sector jobs. Philadelphia was rocked by race riots in the 1820s, 1830s, and 1840s. Catering and other food trades offered African Americans the opportunity to own their own businesses with little competition from whites. African American catering companies played a prominent role in Philadelphia's social life for more than 150 years, from Bogle's early-nineteenth-century establishment until Albert E. Dutrieuille Catering closed in 1967."
2. Lawrence Otis Graham, *Our Kind of People:Inside America's Black Upper Class.* New York, NY: HarperCollins, 1999, p.378. According Graham, "a study funded by the Russell Sage Foundation in 1995 concluded that whites feel more comfortable around light-skinned blacks than they do around dark-skinned blacks, and

hence light-skinned blacks receive better job opportunities from white employers." Although this study postdates the period in question, we have every reason to assume, based on circumstantial evidence, that this policy was even more widespread in the earlier decades of the twentieth century.
3. Ibid., pp. 367–8. "Many members of black society point out that while it is no longer a city which leads in its number of black elite families, Philadelphia remains an important town because it is where black society's three most important selective clubs were founded." Graham refers to the Boulé (official name: Sigma Pi Phi), a prestigious men's club formed in 1904; the Links; and Jack and Jill. He continues, "In fact, although the city's overall population is considerably smaller than New York's and Chicago's, Philadelphia had a prominent black upper class long before these other northern communities. Many members of the old guard in the North have family histories that seem almost new when they are matched with those with Philadelphia lineage." (p. 68)
4. Wilson had danced with a performing group as a child in North Philadelphia. In his own words: "I was very lucky in that I went to grammar school at the General John F. Reynolds Public School, an all-black school with all-black teachers who were fantastic. There I was introduced to all kinds of music, from the Peer Gynt Suite to Tchaikovsky to Roland Hayes to African music." Wilson performed with the school's Children's Creative Dance Group.
5. The three high-end department stores in Philadelphia were (John) Wanamaker's, Lit Brothers, and Strawbridge's.
6. Isabel Wilkerson, *The Warmth of Other Suns: The Epic Story of America's Great Migration*. New York, NY: Random House, 2010, p. 234. For example, and in another context, Wilkerson cites the following information, culled from Octavia B. Vivian, *The Story of the Negro in Los Angeles County*. Washington, DC: Federal Writers' Project, Works Progress Administration, 1936, p. 31:
"In certain plants, Mexicans and whites worked together.... In others, white workers accepted Negroes and objected to Mexicans.... White women worked with Mexican and Italian women, but refused to work with Negroes.... In the General Hospital, Negro nurses attended white patients, but were segregated from white nurses in dining halls: in a manufacturing plant white workers refused to work with Negroes, but worked under a Negro foreman."
7. Ibid., p. 232.
8. Hines recounted such an example with Cuyjet: "She used to get her hair done on Walnut Street. Being the type of hair it is, she could get it done easy and go in and get whatever—fluff out, shampoo, set. Well, the guy who did her hair didn't know anything until her son, Stevie, who did not look white, came up and said, 'Mommy, Daddy's downstairs waiting in the car,' and sat in her lap. Well, she had to look elsewhere to get her hair done. The guy himself didn't care but said he'd have to do it off the premises."
9. For example, see Bliss Broyard, *One Drop: My Father's Hidden Life, A Story of Race & Family Secrets*.New York: Little, Brown and Company, 2007, Broyard is the daughter of the late writer and *New York Times* book reviewer Anatole Broyard. Not until he died did she and her brother learn that their father was a black man.
10. "Don't ask, don't tell," refers to the controversial policy about gays in the American military that was debated in Congress again and again and finally repealed

under President Obama in 2010. Racism and homophobia continue to plague the American populace and oppress its constituents.
11. Conversation with Nancy Brooks Schmitz, a white, ballet-trained Philadelphian who studied as a child with Cannon. (She wrote her PhD dissertation on the Catherine Littlefield Ballet, Temple University Dance Department, 1985). According to Cuyjet, Cannon allowed blacks to study at his studio, despite complaints from his white clientele.
12. See Mitchell's listing in Appendix of Dance Practitioners Mentioned in Text; and Jones's credits in Appendix of Philadanco Choreographer Profiles.
13. Even so, they ran into problems. Wilkinson (b. 1936), accepted in the corps of the Ballet Russe de Monte Carlo in 1954, was the first black woman hired as a permanent member of a major (white) ballet company. Promoted to soloist in her second season, she stayed with the company for six years. She was not passing for white. Increasingly hostile racism made touring in the South impossible, and she had to leave the company.
14. It is probable that Chaffee knew Dorsey, since at one time they both had contact with Michael Mordkin. Because Cuyjet was a surrogate daughter to Dorsey, it may be that this past connection helped put her in his favor.
15. "Mrs. Roosevelt Gets 1952 Cross of Malta," *Baltimore Afro-American*, January 6, 1953, p. 10, n.a.
16. For the second Christmas Cotillion that saluted Ralph Bunche, *Life* magazine ran a photo spread in its January 22, 1951 issue, titled "Cotillion for Dr. Bunche." (pp.108–110) Ralph Bunche was the pride of the African American community, having risen to new heights for a black American. He was the first black to receive the Nobel Peace Prize, awarded in 1950 for his late-1940s diplomatic mediation in Palestine. He had advanced degrees from Harvard University and was Chair of the Political Science Department at Howard University, 1928–1950.
17. According to Gatewood, Philadelphia's Crescent Club was the "Old Philadelphia" social club of choice from the 1870s to the 1890s and was "famous for its annual Christmas balls," but was replaced by the Bachelor-Benedict Club in the early twentieth century, which also "became famous for its annual Christmas ball and reception." (p.226) Thus, it seems that a tradition was already in place for the bourgeoisie to hold their grandest event during the Christmas season.
18. Greer Gordon, "Cotillion Brilliant," n.d., n.p. The information on Wayman Jones was excerpted from this article, given to me by Jerome Gaymon when I interviewed him in 1988. The author, title, and the clipping were intact, but the name of the newspaper and the date were missing. Besides including a biographical profile on Wayman Jones, it described the second annual Christmas Cotillion (1950) and so must have appeared in print in early January, 1951.
19. It may be that Jones, blonde and blue-eyed, wasn't recognized as black during his tenure at Temple.
20. Greer Gordon, mentioned above.
21. An African American socialite active in the Philadelphia branches of a number of national women's clubs.
22. According to Jerome Gaymon, "He [Jones] struck the Cross of Malta. He would use your birthstone. There were twelve stones in there. He drew that thing up, and Bailey Banks & Biddle [an upscale old-Philadelphia jeweler] did it. I think it cost $6,000 to $10,000 for the cross alone, all depending on the type of stone that was required."

NOTES

23. Reprinted in the 1959 Christmas Cotillion program, Marion Cuyjet's private collection.
24. "Founder of Philly Cotillion Society and Heritage House Dies," *Jet Magazine*, December 31, 1964, p. 28 of pp. 28–29.
25. For information on *echt* cotillions and debutante balls, see Lawrence Otis Graham, *Our Kind of People: Inside America's Black Upper Class*. New York, NY: HarperCollins, 1999, chapter 3, "The Black Child Experience: The Right Cotillions, Camps, and Private Schools," pp. 45–62.
26. In 1954, 1955, and 1956.
27. Edward H. Gaines, "Cotillion's ballet-fantasy fed dance-starved audience," *Baltimore Afro-American*, January 9, 1954, p.8.
28. The Ballet Russe de Monte Carlo was the ensemble created as a result of the contingent that separated itself from the Ballets Russes de Monte Carlo. The opening season of the splinter group was in Monte Carlo in 1938.
29. All quotes taken from *Baltimore Afro-American*, January 6, 1953, p.10, noted above.
30. Brown Babies were children living in Germany born of unions between German women and African American soldiers. They were Frequently placed in orphanages.
31. His book was first published in English in 1957. After becoming the first black to head the American Sociological Society (1948) he had engaged in a heated public debate with anthropologist Melville J. Herskovits, taking the position that African American culture did not include African retentions. Herskovits took the other side. Given the racist views against American blacks, we may understand why Frazier took this position, thus declaring that blacks were as American as, and no different from, any white American.
32. Another moniker bestowed upon this event, used occasionally in the black press.
33. Frazier, ibid., p.202. The title of this subdivision is "The Gaudy Carnival."
34. *Jet Magazine*, mentioned above, pp. 28–29.
35. I presume readers know the achievements of **Marian Anderson** (1897–1993) and **Dr. Martin Luther King, Jr.** (1929–1968) and can understand why they would be recipients of a public service award.
 Dr. Ralph Bunche, see note no. 2 above.
 Dr. Mary McCleod Bethune (1875–1955).Educator and civil rights leader best known for founding Bethune-Cookman University and as an advisor to President Franklin Delano Roosevelt.
 Branch Rickey (1881–1965).As head of the Brooklyn Dodgers he broke the major league baseball color barrier by hiring Jackie Robinson (1947).
 Eleanor Roosevelt (1884–1962).America's First Lady (1933–1945), supporter of FDR's New Deal policies, civil rights advocate, supporter of the formation of the United Nations.
 Mary Church Terrell (1863–1954).One of the first African American women to earn a college degree, activist who worked for women's suffrage and civil rights (helped desegregate public places in Washington DC in the 1940s and 1950s).
 Thurgood Marshall (1908–1993). First African American on the Supreme Court, was the lawyer who argued the winning case in *Brown vs. the Board of Education* (1954), a landmark decision that declared separate (that is, segregated) public schools were inherently unequal.
 Pearl Buck (1892–1973). American writer, spent most of her life in China, most famous for her novel, *The Good Earth* (depicting strife in the life of a Chinese peasant family) that won the Pulitzer Prize for Literature (1932); she also won the Nobel Prize for Literature (1938).

Alfred Gwynne Vanderbilt II (1912–1999). Scion of one of the wealthiest old American families, race-horse enthusiast, and innovator; he was also a naval hero during World War II and campaigned for veterans' rights.

Daisy Bates (1914–1999). Civil rights activist and head of the NAACP Arkansas branch; in 1957 she helped nine black students desegregate Central High School in Little Rock.

A. Philip Randolph (1889–1979). Civil rights leader, founder of the Brotherhood of Sleeping Car Porters (an African American labor organization) and the March on Washington Movement.

36. The video, *711*, was part of the Precious Places Community History Project for 2010, facilitated by the Scribe Video Center of Philadelphia. As of 2010, Warrington is Director of Communications in the office of Robert A. Brady, Congressman, First District, Pennsylvania.

37. Delta Sigma Theta, founded 1913 at Howard University. Though founded by and composed mainly of African American college women, the organization accepts educated women of every ethnicity and has branches worldwide. Jabberwock is the copyrighted name for their annual variety show fundraiser.

38. This is probably the same socialite, Evelyn Reynolds, mentioned by Jerome Gaymon earlier in this chapter as one of the Cotillion Society founders. Reynolds Hall may have been named after one of her philanthropist relatives.

39. Jennifer Dunning, "Classic Dance and Race: A Story Still Unfolding," *The New York Times*, February 24, 1996, arts section, p.13 of pp.13 and 19. Dance critic Jennifer Dunning describes a photograph of the company that was seen in "Classic Black," an exhibition on the history of African Americans in (white) ballet, shown at the Dance Collection of the New York Public Library for the Performing Arts at Lincoln Center in 1996:

"The dancers are ranged along ballet barres set up on a ship's promenade. Dressed in practice clothes, their bodies are elegantly erect, feet pointed in the classic ballet curve and eyes staring solemnly into the camera. They might be any American troupe embarking on some slightly exotic tour except that, unlike the stereotype, these dancers are black."

40. Ibid, p. 19. Delores Browne had this to say about an African American male who was a principal dancer in Germany in the 1970s: "I saw Christopher Boatwright dance Romeo with the Stuttgart Ballet. I wept because he was so beautiful, and the performance was so right, and because he couldn't dance it here."

41. Later, in my twenties and during a brief career as a modern dancer, I continued ballet studies with Maggie Black and Nina Fonaroff, as did many other modern dancers.

42. Jennifer Dunning, the *New York Times*, p. 19.

43. Established by Nadia Chilkovsky in 1944, the Philadelphia Dance Academy was absorbed by the Philadelphia College of the Performing Arts in 1977, which has now become the University of the Arts. It was the city's first racially integrated dance school, with modern dance as its focus. Its alumnae include Judith Jamison and Carole Johnson, both of whom attended in the 1960s.

44. For example, see Karyn D. Collins, "Does Classisism Have a Color? Even Today, Black Ballet Dancers Face Painful Hurdles—And Surmount Them," *Dance Magazine*, June, 2005 (Online archive, http://www.dancemagazine.com/issues/June-2005/Does-Classicism-Have-a-Color).

45. Jennifer Dunning, "Classic Dance and Race....," p. 19.

3 BUT BLACK IS BEAUTIFUL! 1950s–1980s

1. Due to white flight this area and all of North Philadelphia is now an African American neighborhood, with the exception of properties owned and gentrified by Temple University, whose main campus has been in this section of the city since the institution's inception in the late nineteenth century.
2. Bourrée or pas de bourrée: a formalized basic ballet stepping movement performed smoothly either as a series of fast small steps with feet close together to skim across the floor (bourrée) or with the weight transferred from foot to foot with three small steps, usually as a preparation for transitioning into another movement.
3. Mary Johnson (Sherrill) was a lifelong friend and colleague of JB, having studied with her at the Sydney School, performed with her in show business, and serving as bookkeeper and fiscal manager for both PSDA and Philadanco until she passed away in 1999.
4. Originally located at Walnut and Juniper Streets in Center City, Philadelphia, the supper club moved in 1960 to Cherry Hill, New Jersey, five miles away. The McGuire Sisters singing trio were one of the feature acts headlining the show while JB was there.
5. See also Appendix I—Joan Myers Brown—Annotated Resume.
6. JB was definitely dancing for Steele by 1959. She is listed as "Joan Meyers," one of the "Beige Beauts," in the program for the New Year's Eve, 1959, Smart Affairs Revue at Bill Miller's Riviera Club on Broadway in New York City. Also there is a photo of her in a lineup of "Creole-Beige-Beauties" in a Montreal Visitors Guide for the week of April 24, 1959, "appearing nightly in Larry Steele's intimate edition of Smart Affairs of '59 at The Black Orchid Casino" Both programs are originals from her private collection.
7. According to Isabel Wilkerson in *The Warmth of Other Suns* (New York, NY: Random House, 2010), "Thus, there developed a kind of underground railroad for colored travelers, spread by word of mouth among friends and in fold-up maps and green paperback guidebooks that listed colored lodgings by state or city. (p.203)…"Still, the mere presence of the guidebooks and of word-of-mouth advice about places to stay gave a sense of order and dignity to the dispiriting prospect of driving cross-country not knowing for sure where one might lay one's head." (p.204).
8. "Beauties Are His Business," n.a., *Ebony* magazine, February 1960, pp. 77–84.
9. *Baltimore Afro-American*, June 28, 1980, p. 17, n.a.
10. 1967 Club Harlem program, "Larry Steele Smart Affairs." Joan Meyers Brown has an original copy, and it is unpaginated and undated. An online copy is billed as "complete" but doesn't contain the page with photos of JB, among others. Also, the text is illegible online. See barryrich.net/acnj/steele/steele.html. The text I quote is listed online as page 4 of 29. If the original copy were paginated, it would appear on page 8.
11. Jim Walzer and Tom Wilk, *Tales of South Jersey*. New Brunswick, NJ: Rutgers University Press, 2001, p.18.
12. For a narrative account of well-heeled, (upper) middle-class African American citizens trying to crack through 1950s Las Vegas segregation and find accommodations at the city's posh hotels and visit its casinos, see Isabel Wilkerson, *The Warmth of Other Suns*, pp. 310–314.

13. Amy S. Rosenberg, "Hot Club Harlem Memories," *Philadelphia Inquirer*, posted online (Tuesday) February 23, 2010, n.p.
14. Alonzo Kittrels, "Larry Steele Ruled Nightlife," *The Philadelphia Tribune—Metro Edition*, May 2, 2007, p.5-B.
15. From her private collection, a program for the 1963 Phi Delta Kappa Debutante Cotillion lists the Joan Myers Dancers performing in the sorority's "Pageant and Ballet—'Salute to Freedom.'"
16. Manège: Steps or a series of linked steps (enchaînements) done in a circle and allowing the dancer to move from position to position onstage.
17. Sarah Kaufman, "Philadanco Focuses On the Potential Of Youthful Patrons [*sic*]. *The Washington Post Weekend*, April 16, 1999, p. 30
18. Ricardo Bostic, West Set member. Jerome Gaymon was also a member. The upscale club was formed in 1957. For their thirtieth anniversary their president wrote, in retrospect, "We were mainly interested in the cultural aspects of our society. Through travel and study, we learned that we could foster an appreciation for the arts.... In the community we have tried to be of help, giving aid and support wherever possible." Thanks to Kevin Trimble Jones, researcher on a project documenting Philadelphia's early black gay community. See online, "Black LGBT Archivists Society of Philadelphia": http://archivistssociety.wordpress.com/online-exhibition-the-west-set/.
19. She is referring to a trend in the concert dance world: choreographers featured the performer seated on or manipulating a chair. Rather than functioning as a limitation, this prop allowed for new avenues of creativity.
20. She performed with the Ringling Brothers and Barnum & Bailey Circus in 1979, then joined the Vargas Circus (based in California, 1980–1983), followed by a stint with the Big Apple Circus (New York, 1984–1998). In 1998 she returned to Philadelphia, working as Danco's general manager.
21. Daniel Webster, "Local Troupe Convincing in Dance," the *Philadelphia Inquirer*, March 29, 1975, n.p.
22. James Felton, "Phila. Dance Co. Offers Exciting Americana," *The Evening Bulletin*, April 17, 1976, n.p.
23. Daniel Webster, "3 new dance pieces are offered," *Philadelphia Inquirer*, April 1, 1978, n.p.
24. Tom Di Nardo, "Dancers Continue to Impress," *Philadelphia Bulletin*, April 1, 1978, n.p.

4 NOSE TO THE GRINDSTONE, HEAD TO THE STARS: THE PHILADELPHIA/PHILADANCO AESTHETIC

1. In "The Philadanco Story," by Ann Dunn. (Asheville NC) The Arts Journal, February 1989, p. 23.
2. Dan DeLuca, "Late Night with The Roots," *The Philadelphia Inquirer*, Sunday, April 12, 2009, pp. H1, H15.
3. I have purposefully avoided investigation of African American visual arts practices in Philadelphia, especially since Philadanco seldom, if ever, uses sets. Nevertheless, there is a strong visual arts history and aesthetic in this city, as evidenced by such groups as the Brandywine Graphic Workshop (the oldest such African American institution in the nation), Scribe Video (a community project

with national implications that fosters and funds neighborhood film projects and sponsors workshops and tutorials, especially for black youth), and the near legendary Mural Arts Program, "the largest public art program in the United States," according to its official website—responsible for factual, fantastic, and fabulous murals throughout the city. A mural featuring Philadanco dancers adorns the side of an edifice at Broad and Lombard Streets, along the Avenue of the Arts, and another one, shown at the end of chapter 5, stands on a wall at Thirteenth and Locust Streets. There has been a strong commitment to the performing and visual arts in Philadelphia for many generations.

4. Based in Denver, Colorado and led by Cleo Parker Robinson, this is one of five modern dance companies that, like Philadanco, are led by African American women and provide a showcase and home for African American dance and dancers. Besides Philadanco and Robinson's company, the others are the Dallas Black Dance Theater (Ann Williams, Director), the Lula Washington Dance Company (based in Los Angeles), and the Dayton Contemporary Dance Theater (founded by the late Jeraldyne Blunden).

5. The city of Philadelphia is situated on the Schuylkill and Delaware rivers.

6. Phone conversation with Nadine Patterson, November 2008. She continued in this vein and added, "Philadanco is like a character dance company. They can assume various characters and inhabit these different characters—which are the choreographers in their dances—very completely. Whereas other companies, they have their star status, they have their one thing that they do, and it's like watching Tom Hanks and he's always Tom Hanks, you know—or [Robert] De Niro."

7. Terry Gross, "Fresh Air," interview with Kenny Gamble and Leon Huff, National Public Radio, November 26, 2008.

8. And for me, growing up in Harlem in the 1950s, my introduction to modern dance was through an option in my public high school that allowed me to take dance instead of gym. The dance teacher had performed with the Martha Graham Dance Company in some minor capacity during the 1940s. Her influence on me shaped the trajectory of my career and my life, thereafter.

9. A tangential connection: Teddy Pendergrass, popular music icon and Gamble and Huff's star vocalist, was married to Karen Still, Philadanco dancer, during this period.

10. In recognition of their influence and contributions, the 300 block of South Broad Street—along the city's Avenue of the Arts and the site of the Philadelphia International Records building—was renamed Gamble & Huff Walk in a civic ceremony on November 17, 2010.

11. Anna Kisselgoff, "Diverse 2d [*sic*] Program by Philadanco," *New York Times*, April 15, 1990, p.143.

12. No relation to Joan Myers Brown.

13. n. p. - no page number available.

14. Some of its athletes develop a deep devotion to the city. Floridian footballer Brian Dawkins wept on camera when he left the Eagles after the 2008 season to play for the Denver Broncos. Likewise, Virginia-born basketball star Allen Iverson was visibly shaken as he expressed gratitude for being rehired by the Philadelphia 76ers in December 2009, after he'd been traded to the Denver Nuggets in December 2006.

15. MOVE, a Philadelphia grassroots collective, was founded by John Africa in 1972 as the "Christian Movement for Life." All members used 'Africa' as their

surname and espoused a natural, 'back-to-roots' philosophy and lifestyle. In 1985 the Philadelphia Police Department dropped a bomb on the group's headquarters, located in an African American residential neighborhood, resulting in the destruction of sixty-odd homes and the deaths of almost all MOVE members.

16. Ann Dunn, "The Philadanco Story," *The* [Asheville] *Arts Journal*, February 1989, p. 23.
17. Robert Farris Thompson, *African Art in Motion*, UC Berkeley Press, 1974. His Ten Canons of Fine Form, listed here, are detailed on pp. 5–48:
 1. Ephebism – the stronger power that comes from youth
 2. Africanische Aufheben: simultaneous suspending and preserving of the beat
 3. The "get-down quality": descending direction in melody, sculpture, dance
 4. Multiple meter: dancing many drums"
 5. Looking smart: playing the patterns with nature and with line
 6. Correct entrance and exit: 'killing the song,' 'cutting the dance,' 'lining the face"
 7. Vividness cast into equilibrium: personal and representational balance"
 8. Call-and-response: the politics of perfection"
 9. Ancestorism: ability to incarnate destiny"
 10. Coolness: truth and generosity regained
18. Ronald K. Brown.
19. The title of the signature "cool jazz" album recorded by Miles Davis, 1959.
20. As of the 2000s, the company includes thirteen to fifteen dancers. For exact numbers over the years, see Appendix of Philanco Home Seasons Repertory Chronology, which lists dancers for concerts from 1975 to 2010.
21. Martha Graham (1894–1991), Katherine Dunham (1919–2006) and Lester Horton (1906–1953) are major international forces in dance. Each one was renowned as dancer, teacher, choreographer and educator. Each created, evolved and codified her/his own specific modern dance technique, and all three techniques are still taught in dance studios and departments around the world. Many contemporary choreographers are indebted to one or more of these techniques in evolving their own styles.
22. The ballet style taught by Tudor and adopted by JB is the world-renowned Cecchetti technique, named after Enrico Cecchetti (1850–1928), the Italian ballet master for the Diaghilev Ballets Russes who later opened a school in London. Ballet techniques generally utilize the same basic foot patterns, arm motions, and turns that were institutionalized by Carlo Blasis (1797–1878), who codified the technique in the early nineteenth century. But that classical basis has been interpreted differently by subsequent practitioners, including Cecchetti, Agrippina Vaganova (1879–1951), George Balanchine (1904–1983), and others. One of Cecchetti's London students was Margaret Craske (1892–1990), a name familiar to the twentieth-century generation of ballet professionals. Tudor (1908–1987) was one of a cadre of British dancers to whom Craske passed on the Cecchetti legacy.
23. "Russian School" generally denotes the Vaganova technique, a comprehensive ballet pedagogy which encompasses principles laid out by Cecchetti and other technique teachers. Its analytical, dance science approach appeals to contemporary dancers.
24. Jennifer Dunning, "Philadelphia Troupe Makes Its New York Debut," *New York Times*, Thursday April 14, 1990.
25. Jennie Schulman, "Philadanco: Exuberance at the Joyce," *Backstage*, August 9, 1996, n.p.

26. Patricia Calnan, "Dance Ensemble Soars on City Hall Stage," *The Royal Gazette*, Wednesday, February 4, 1998, p. 18
27. This holds true for choreographers who set movement on dancers with the intention of having it reproduced as it was created. Contemporary choreographers who work collaboratively and/or through dancer improvisation adhere to a differentc riterion.
28. Calnan, ibid.
29. Deborah Jowitt, "On Fire," *Village Voice*, July 11, 1995, n.p., reviewing Danco at the Joyce, June 20–25.
30. Alice Naude, "Sweet Silver," *Dance Magazine*, October 1995, pp. 96–97.
31. Brenda Shoshanna, "Religions of Kindness," *Shambhala Sun*[magazine], July 2010, p. 32 of pp. 31, 32, 34.
32. Lewis Segal, "High-Speed Wonders," *Los Angeles Times*, February 22, 1999, p.F3.
33. Jennifer Dunning, "Philadelphia Troupe Makes Its New York Debut," *New York Times*, April 12, 1990, p. C13.
34. Susan Isaacs Nisbett, "A Dynamic Debut," *The Ann Arbor News*, June 21, 2001 n.p.
35. Jennifer Dunning, "A Do-or-Die Essence Fed by Love," *New York Times*, August 21, 1999, pp. B9, B15.
36. Jennie Schulman, "Philadanco: Exuberance at the Joyce," *Backstage*, August 9, 1996, n.p.
37. Jane Vranish, "Fierce Dancers of Philadanco Make 'Sneak Preview' Come Alive," *Pittsburgh Post-Gazette*, December 6, 1999, n.p.
38. Joseph H. Mazo, "A Troupe with a Mission," *Village Voice*, April 9, 1993, n.p.
39. Christopher Reardon, "Philadanco Smolders Quietly on the Edges of Dance Fame," *The Christian Science Monitor*, July 3, 1995, p. 12
40. Ann Dunn, cited in Note #1 above.
41. See Appendix of Philadanco Choreographer Profiles.
42. Jennifer Dunning, "Philadelphia Troupe Makes Its New York Debut," *New York Times*, April 12, 1990, p.C13.
43. Christopher Reardon, "Philadanco Finds Ways to Make a Virtue of Flux," *New York Times*, Sunday, July 14, 1996, p. H7.
44. Deborah Jowitt, "On Fire," *Village Voice*, July 11, 1995, n.p.
45. Melonee McKinney, "Dancers Make Time Stand Still," *The Knoxville News-Sentinel*, September 23, 1994, n.p.
46. Mention must be made here of Barkley Hendricks, visual artist and native Philadelphian, whose paintings pay homage to exactly this elegance. See his work in Trevor Schoonmaker, ed., *Barkley L. Hendricks, Birth of the Cool*, Durham, NC: Duke University Press, 2008.
47. Tobi Tobias, "Wonder Women," *New York* [magazine], December 1, 1997, p.126
48. See Thompson endnote, above, for list of his Canons.
49. Tobi Tobias, "Prime Time," *Village Voice*, August 20, 1996.
50. Mention must be made of the relationship between Philadanco, PSDA, and the University of the Arts School of Dance, an undergraduate degree-granting institution that employs several Danco dancers as permanent teachers (including Kim Bears-Bailey and Zane Booker) and others as guests (including Hope Boykin). JB and Susan Glazer, former Director of University of the Arts School of Dance, share a similar philosophy regarding dance instruction, training, and performance. The three institutions also share facilities (performance, rehearsal, and

class space) as well as students, with many UArts graduates (like Tracy Vogt) becoming Danco dancers, and PSDA students going on to college at UArts.

51. The Instruction and Training Program is the overall umbrella for training dance hopefuls between the ages of seventeen and twenty-three. These students may audition for Danco/2, the junior performing group. A six-week annual summer program is held for students aged nine to sixteen, most of whom will study at PSDA for the rest of the year. Youngsters aged nine through twelve are eligible to be accepted into D/3, the pre-teen performing group. Although this system omits a performance opportunity for youth aged thirteen through sixteen, they are nevertheless able to study at PSDA and perform in the annual spring recital. If they continue at the school, like some of today's auditionees, then they may audition for D/2 or, if not accepted into that ensemble, be accepted into the Instruction and Training Program.

52. Miller choreographed *My Science* for the company's Annual Spring Concert, 2001. I interviewed her in December, 2008.

53. For comparison, The Pennsylvania Ballet, a repertory company of 35 to 40 full time dancers, plus apprentices, rehearses Mondays through Fridays, 11 A.M. to 6 P.M. With such a sizeable ensemble, the ballet company has the luxury of second casts and understudies. Seldom are all members cast in any one ballet, and no dancer rehearses for the full 35 hours per week. As a rule, all Danco dancers are involved in all rehearsals. For further comparison, the New York City Ballet has a roster of 95 to 100 full time dancers.

54. The New York Dance and Performance Awards, annually awarded for creative achievement in dance and dance-related performance, is informally known as the "Bessies," honoring the late Bessie Schonberg, a beloved teacher of choreography and head of the Sarah Lawrence College Dance Department for several decades. Bears-Bailey was awarded a Bessie in 1992.

55. In this chapter I discuss the Danco choreographers inasmuch as their participation reflects the company aesthetic. They are discussed again in chapter 5 from otherp erspectives.

56. The ladder is about nine feet high. Shooting from that vantage point, Chase-Hicks is able to track the path and pattern of a dance and/or focus in on particulars.

57. Generally, choreographers depart after opening night, if not earlier.

5 AUDACIOUS HOPE: THE HOUSE THAT JOAN BUILT— 1980s—TWENTY-FIRST CENTURY

1. David Remnick, "The Joshua Generation," *The New Yorker*, November 17, 2008, p. 70 of pp. 68–83.
2. Ibid.
3. Based on anecdotal evidence, two such Joshua choreographers are Mark Morris and Bill T. Jones. According to Wanjiru Kamuyu, freelance dancer-choreographer on both sides of the Atlantic and staff choreographer-dance captain for the London production of *Fela!*—and similar to JB's admonition to Danco—Jones tells his dancers, "I'm not here to love *[meaning, praise]* you. I'm here to make you great!" Such a statement would follow a verbal tirade by the choreographer. Sheron Wray, dancer-choreographer and professor in the dance and theater department at the University of California, Irvine, attested to Morris's similarly

tough teaching manner in a guest residency when he was setting a work on the London Contemporary Dance Theatre.
4. Marc Nelles, German national, currently Public Information Assistant at the United Nations in New York. He danced with Danco from June 1999 to January 2002.
5. Tesemma Gabriele Tesfa-Guma is Ethiopian, was raised in Italy, danced with Danco for seven years, and now teaches as a guest instructor at Philadelphia's Rock School of Ballet while pursuing a career as a guitarist.
6. Francisco Gella danced with Philadanco from 1998 to 2002. He is now a freelance teacher and choreographer based in California.
7. In 1991 the company performed in Turkey (Ankara and Istanbul). The first Danco European tour was in 1992 to Germany.
8. Lesley Valdes, "Philadanco leaps across the state", *The Philadelphia Inquirer*, May 11, 1997, pp. F1, F8, F9.
9. n.a., "25 years of love, sweat and cheers! Philadanco reaches a milestone," *Collage—The National Journal of African Americans in the Arts*, premiere issue, n.d. [ca. 1994–1995], p. 9.
10. Dave Richards, "Modern Dance Wows Erie Students," *Erie Daily Times*, January 21, 2000, section B, p. 1 of 1B,8B.
11. Conway is one of the "good girlfriends" who was with JB from the beginning, teaching and running the school. For years she has directed the West Oak Lane branch of Dance Arts. She shepherded Chase to JB with the foresight to see that her talented student was on the path to a professional career.
12. First choreographed for the company in 2005. The program note for the Kimmel Center 2010 performances reads as follows:"A full company piece, this ballet was choreographed by Mr. Ezralow in collaboration with the dancers of Philadanco. A tapestry of holiday music, mixing traditional and contemporary versions of holiday classics in a modern dance setting with a "Hollywood" flavor. A wacky, funny, somewhat ironic Xmas with a twist, saving us all from the dreadful onslaught of endless nutcracking."
13. Brenda Dixon Gottschild, "Return of a 'Danco Doll,'" *The Philadelphia Inquirer*, April 23, 2009, Section D, pp.1, 3.
14. See **Philadanco Choreographer Profiles.**
15. Alice Kaderlan, "Philadanco dances its heart out," *Pittsburgh Tribune*, October 31, 1994, p. B5.
16. See **Philadanco Choreographer Profiles.**
17. John Martin, "Dance: A Negro Art," the *New York Times*, February 25, 1940, Section IX, p.2. As quoted in Lynne Fauley Emery, *Black Dance in the United States from 1619 to 1970*. Palo Alto, CA: National Press Books, 1972, p.256.
18. "**Method acting** is a phrase that loosely refers to a family of techniques by which actors try to create in themselves the thoughts and emotions of their characters in an effort to develop lifelike performances. It can be contrasted with more classical forms of acting, in which actors simulate the thoughts and emotions of their characters mainly through external means, such as vocal intonation or facial expression." (Wikipedia online definition)
19. C S'thembile West, "Talley Beatty: The Man and His Legacy," in unpaginated program booklet, "The Life & Legacy of Talley Beatty, A Symposium and Roundtable Discussion," Philadelphia, PA: May 10, 2007, Merck Educational Center at the Kimmel Center.

20. For a long overdue history of this massive upheaval that spanned six decades (1915-1975), see Isabel Wilkerson, *The Warmth of Other Suns: The Epic Story of America's Great Migration*. New York, NY: Random House, 2010.
21. A Sagan choreography for Philadanco first performed in 1981.
22. French ballet term for "chained": a series of fast, smooth turns from one foot to the other, with no shift in weight, performed in a straight line.
23. Dancers precede certain movements with traditional preparations: for example, before jumping one must perform a plié (bending the knees and going down) as a preparation for going up.
24. A turn performed while the dancer (usually male) is jumping vertically into the air, legs straight and held together. A double tour indicates the dancer makes two full turns in the air in this position.
25. A proscenium theater space in Philadelphia, part of Drexel University, frequently used for dance performances.
26. Anna Kisselgoff, "Dance View: Pearl Primus Rejoices in the Black Tradition, *The New York Times* online, originally published June 19, 1988. All subsequent quotes by Primus taken from the same article.
27. I interviewed Bears-Bailey in 2008, nearly ten years after her retirement from performing.
28. A think tank/symposium on The Black Tradition in American Concert Dance was going on at ADF during the same period that Primus held the final rehearsals and premiered the performances. Nash was part of the think tank. Pomare and McKayle may have had their works on the performance schedule. The Primus pieces were never performed by the Danco dancers in a regular Danco season.
29. Peggy and Murray Schwartz, *The Dance Claimed Me: A Biography of Pearl Primus*. New Haven, CT: Yale University Press, 2011.
30. Here are two anecdotes told by Buddhist teacher Pema Chödrön, from her miniature book, *Awakening Loving Kindness* (Boston, MA: Shambhala, 1996). Both resound with the wisdom imparted to Bears-Bailey in her rich though tortuous experience with Primus.

 In the first, Chödrön recounts her conversation with her mentor, Chögyam Trungpa, Rimpoche, about how miserable she is in doing her practice, because everybody else seems to be doing so well, while she is full of doubt:

 "He *[C.T. Rimpoche]* said, I'm always suspicious of the ones who say everything's going well. If you think that things are going well, then it's usually some kind of arrogance. If it's too easy for you, you just relax. You don't make a real effort, and therefore you never find out what it is to be fully human." (p.15)

 A little further on she amusingly describes an experience with another Tibetan master at the Abbey she directs in Nova Scotia:

 "At Gampo Abbey we had a Tibetan monk, Lama Sherap Tendar, teaching us to play the Tibetan musical instruments. We had forty-nine days in which to learn the music; we were also going to learn many other things, we thought, during that time. But as it turned out, for forty-nine days, twice a day, all we did was learn to play the cymbals and the drum and how they are played together. Every day we would practice and practice. We would practice on our own, and then we would play for Lama Sherap, who would sit there with this pained little look on his face. Then he would take our hands and show us how to play. Then we would do it by ourselves, and he

would sigh. This went on for forty-nine days. He never said that we were doing well, but he was very, very sweet and very gentle. Finally, when it was all over and we had had our last performance, we were making toasts and remarks, and Lama Sherap said, "Actually you were very good. You were very good right from the beginning, but I knew if I told you that you were good you would stop trying. He was right.... So for forty-nine days we worked really hard." (pp. 17–18)

31. Jane Vranish, "Philadanco Emerges as an Oasis in a Blighted Urban Neighborhood," *Pittsburgh Post-Gazette*, April 13, 1997, n.p.
32. Lesley Valdes, "Philadanco Leaps Across the State," *The Philadelphia Inquirer*, May 11, 1997, pp. F1, F8, F9.
33. Nancy Goldner, "For Philadanco, a Premiere and Then a Month's Layoff", *The Philadelphia Inquirer*, November 29, 1990, p. 5-D.
34. She is referring to the Pennsylvania Ballet's 1991 crisis, described in the following notice from *The Baltimore Sun*'s online Article Collections (under Pennsylvania Ballet: articles.baltimoresun.com/1991-03-18/features/1991077092_1_pennsylvania-ballet-ballet-dancers-christopher-damboise):

 Dancers and stagehands work for donations in attempt to save the Pennsylvania Ballet. By Knight-Ridder News Service | March 18, 1991 Philadelphia— Usually, dancers perform for the public's pleasure. But these days at the Shubert Theater here, the Pennsylvania Ballet dancers are performing for the public's donations, and their own survival. If $1 million isn't raised through the current save-the-ballet campaign, the dancers—who now call themselves The Artists to Save the Pennsylvania Ballet—will be heading for the unemployment line instead of their daily morning class. Actress and dance enthusiast Mary Tyler Moore was here Thursday to garner support for the ballet, which is in the midst of staging 10 days of performances which had been canceled last week when the company declared insolvency.

35. Donald K. Atwood, "IABD Youth Concert," www.worlddancereviews.com
36. n.a., "25 years of Love, Sweat and Cheers! Philadanco Reaches a Milestone," *Collage – The National Journal of African Americans in the Arts*, premiere issue (n.d. – 1995?), p. 9.
37. Merilyn Jackson, "For Philadanco, Poland proves challenging tour," *The Philadelphia Inquirer*, August 12, 2001, pp. H1, H6, H8.
38. Merilyn Jackson, email correspondence, March 28, 2011.
39. Tim Wise's titles include *Between Barack and a Hard Place: Racism and White Denial in the Age of Obama*, cited in chapter 1; and *White Like Me: Reflections on Race from a Privileged Son*. Berkeley, CA: Soft Skull Press, 2008. John L. Jackson, Jr.'s titles include *Racial Paranoia: The Unintended Consequences of Political Correctness*. New York, NY: Basic Civitas Books, 2008; *Real Black: Adventures in Racial Sincerity*. Chicago, IL: University of Chicago Press, 2005.
40. Nancy Goldner, November 29, 1990, mentioned above.
41. Shepard was the charismatic founder of the 651 Arts Center in Brooklyn, a home and haven for presentation of Diasporan dance.
42. Lisa Cochrane, "A sizzling kaleidoscope of movement." *The Globe and Mail*, March 18, 1993, n.p.
43. Nancy Goldner, "Philadanco Program Premieres Short, Compelling 'Sketches'." *The Philadelphia Inquirer*, June 5, 1993, p. D1.
44. Joan Acocella, "Philadanco Offers Cause to Re-Joyce," *Daily News*, April 8, 1993, p. 49.

45. Jennifer Dunning, Philadanco's Tease and Payoff, *The New York Times*, April 8, 1993, online, n.p.
46. Tobi Tobias, *New York* magazine, April 26, 1993, n.p.
47. Joan Acocella, mentioned above.
48. Tobi Tobias, mentioned above.
49. Clive Barnes, "Opportunities Still Lag for Blacks in Dance," the *New York Post*, April 21, 1990, n.p.
50. Tobi Tobias, "Try a Little Tenderness." *New York*, July 13, 1998, pp. 50–51.
51. Paul Taylor, in an interview with Jeffrey Brown on "The News Hour with Jim Lehrer," National Public Television, 2007—as cited at the end of Taylor's Wikipedia biography.

EPILOGUE

1. Lin Jensen, "Stand by Me," *Shambhala Sun*, November 2010, p. 59 of pp. 55–59.
2. Quoting from the Award invitation:
The Philadelphia Award was founded in June 1921 by Edward W. Bok, who created a fund for this purpose:
"A prize is conferred by the Philadelphia Award Trustees each year upon the man or woman living in Philadelphia, its suburbs or vicinity, who during the preceding year shall have performed or brought to culmination an act or contributed a service calculated to advance the best and largest interest of the community of which Philadelphia is the center."
3. A major philanthropist and entrepreneur, based in Philadelphia. This award is one of the highest honors bestowed upon Philadelphians who have contributed to the image and prestige of this metropolis. Marian Anderson was the first African American to win it back in the 1940s. Other winners include Leopold Stokowski; Russell Conwell (founder of Temple University); the Revered Leon Sullivan (creater of, among other innovations, the Sullivan Principles, which contributed to the overthrow of South African apartheid); architects Louis Kahn and Robert Venturi; Jane Golden (founder of the city's famous Mural Arts Program); Anne d'Harnoncourt (recently deceased head of the Philadelphia Art Museum); and Lorene Cary (African American novelist and educator, founder of the city's Art Sanctuary).
4. Popular Philadelphia councilwoman who began as a Philadanco dancer. JB's students and dancers have gone forth to success in many walks of life.
5. President of the John F. Kennedy Center for the Performing Arts. In his speech preceding JB's acceptance speech (and there were several from various dignitaries) he described her as "a pioneering role model for dynamic, successful business women—not to mention African American women," and "a combination of mentor and mother, with tenacity, creativity, and perseverance." He ended by stating that she has contributed to "the national dance ecology."

AFTERWORD: BRENDA DIXON GOTTSCHILD— A CRITICAL PERSPECTIVE

1. See for instance, Philip l. Kohl's article "Nationalism and Archaeology: On the Construction of Nations and the Reconstructions of the Remote Past," *Annual Review of Anthropology*, 1998, 27: 223–46.

2. Brenda Dixon Gottschild, (2005) "By George! Oh Balanchine," *Discourses in Dance*, 3; 1, 73–79, p. 76.
3. Ibid.
4. Brenda Dixon Gottschild, (2003) *The Black Dancing Body: A Geography from Coon to Cool*. New York and Hampshire, England: Palgrave Macmillan.
5. Ibid, p. 5.
6. Susan Mayhew, (2004) "Biohistory," *A Dictionary of Geography*. Oxford: Oxford University Press, p. 56.
7. Personal communication, 5/8/2011.
8. Ibid.
9. Brenda Dixon Gottschild had published some of the material from her book *Digging the Africanist Presence* as an essay entitled "Stripping the Emperor: The Africanist Presence in American Concert Dance." It was published in *Looking Out: Perspectives on Dance and Criticism in a Multicultural World*, edited by David Gere (1995) New York: Schirmer Books.

APPENDIX 1

1. Blunden (deceased), Cleo Parker Robinson, Ann Williams, Lula Washington, and JB are driving forces in the employment of emerging African American dancers and the creation and preservation of classical African American concert dance choreography. Blunden founded the Dayton Contemporary Dance Company in 1968; Robinson founded Cleo Parker Robinson Dance the same year that JB founded Philadanco; Williams founded the Dallas Black Dance Theatre in 1976; and Washington founded the Lula Washington Dance Theatre in 1980. These five women form the backbone of the International Association of Blacks in Dance.

APPENDIX 6

1. Interviews generally ran from one to two hours. Kim Bears-Bailey was interviewed for three hours. Joan Myers Brown was interviewed for three hours in 1985 and 1988, respectively, and ten hours in 2008. Interviewees whose conversations do not appear in the text nevertheless provided valuable background information.

INDEX

Academy of Music, xxiii, 76, 79, 111, 117
Addams, Jane, 15
Africa, Ramona, 146
African Methodist Episcopal (AME) Church, 3, 36, 60, 88
AIDS/HIV, 120, 240
Ailey, Alvin, xxvii, 33, 139–40, 184, 197.
 See also AlvinA iley American Dance Theatre(AAADT)
Allen, Hortense, 95
Allen, Joan, 246
Allen, John, 246
Allen, Richard, 3
Alpha Kappa Alpha (AKA), 198
Alvin Ailey American Dance Theatre (AAADT)
 Ailey aesthetic, 139
 Boykin with, 172, 204–5
 Brownw ith, 120
 Browne at, 87
 Chase-Hicks with, 125, 139, 149–50, 169, 188, 200–1
 comparisons with/to Danco, 138–40, 147, 149–50, 223–4, 242–3
 debt to Danco, 138–40
 DeLoatch with, 119–20
 ecosystem and, xxvii, 260
 Lyst with, 191, 202
 as mega company, 160
 ManningS t.C harlesw ith, 117–18, 125, 139, 149
 Night Creatures, 185
 Philadelphiaa esthetic exported to, 137

Revelations, 125, 142, 185
 rise of, 83
 St.C harlesw ith, 117–18, 163
 support for, 197
American Ballet Theatre (ABT), 33, 59, 82, 89, 241
American Dance Festival (ADF), 216–18, 221–2, 233, 247, 327n28
Anderson, Elijah, 311n12–13
Anderson, Lauren, 252
Anderson, Marian, 3, 70–1, 318n35, 329n3
Apex Beauty School, 11
Apollo Theater, 105, 313–14n26
Armstrong, Louis, 95, 202
art critics. *See* reviews of Philadanco
Arthur Hall Company, 133, 192
Ashe, Aesha, 252
"atty-tood," Philly, 144, 150, 194. *See also* Philadelphia attitude
"audacious hope," xxvii, xxx, 231, 252
auditions, 44, 85–6, 96, 99, 118–25, 147–8, 154, 173–5, 231–2, 243–4, 309–10n8, 325n51
Austin, Debra, 252
Avenue of the Arts, xxiii, 321–2n3, 322n10

Bacharach, Burt, 141
Backstage, 153, 162
Bailey, Pearl, xviii, 97, 99, 102–3, 105–6, 109, 120, 132, 141

Balanchine, George, 87, 163–4, 211, 256, 313n18, 323n22
Ballet Arts School, 26, 57–8, 82
Ballet Repertory School, 57, 82
Ballet Russe de Monte Carlo, 34, 67, 317n13, 318n28
Ballet Tech, 233
Ballets USA, 48
Baltimore Afro-American, 59, 65, 67, 69, 100
Barrett Junior High School, 26, 41, 43, 51
Bates, Daisy, 71, 318–19n35
Bates, Peg Leg, 100
Bears-Bailey, Kim
 at American Dance Festival, 247
 as Assistant Art Director forD anco, xxv–xxvi, 136, 179–80
 Bessie awarded to, 325n54
 bridging of generations by, xxv, 211
 Browne on, 238
 on Byrd, 157
 on Danco instructors, 163
 on Danco programs, 182
 onf undinga ndr ace, 228–9
 high standards of, 154, 171, 176
 interview, 327n27, 330n1
 on McIntyre, 205
 with Primus, 215–23, 327–8n30
 on racism, 228–33
 "recycledp eople" attributed to, 137

INDEX

Bears-Bailey, Kim—*Continued*
 review of, 240
 on Sagan, 156–7
 similarities to Browne, 179
 stayingp owero f, 231
 teaching style of, 154, 171, 176, 183, 201
 on trust and creativity, 156–7
 at University of the Arts School of Dance, 182, 324–5n50
Beatty, Talley
 Bears-Bailey on, 211
 Bell on, 148, 209
 Booker on, 153–4
 Browne on, 211
 Chase-Hicks on, 150
 Come and Get the Beauty of It Hot, 211
 Morning Songs, 164, 238–9
 as "new age" choreographer, 188–9, 208
 Pretty is Skin Deep, Ugly is To the Bone, 132, 143, 166, 182, 232
 racism and, 231–2
 A Rag, A Bone, A Hank of Hair, 196
 rehearsal form of, 185–6
 reviews of, 164, 166, 207, 238–9
 Road of the Phoebe Snow, 211
 Southern Landscape, 208, 210
 Thomas Smith on, 128
 unpredictability of, 210
Bell, Elisabeth, 148–9, 150, 157, 162–3, 172, 177–8, 184, 192, 205, 208–9
Bellson, Louis, 105, 132
Beloved (film), 167–8, 247
Bermuda, xxvii, 98, 129, 153, 156, 193–4, 200, 313n20
Bernardino, Ann, 74
Bernardino, Veda Ann, 74

Berry Brothers, 95
Bethune, Mary McCleod, 70–1, 318n35
biohistory, xxx, 259
Black Bourgeoisie: The Rise of a New Middle Class in the United States (Frazier), 69–70
Black is Beautiful movement, 69, 84, 91
Blasis, Carlo, 323n22
Booker, Z ane, 205–6
 on Bermuda tour as peak experience, 129, 193
 credentialso f, 216
 with Danco, 118, 121, 128–30, 149, 153–5, 172, 182–3
 founder of Smoke, Lilies and Jade Arts Foundation, 113
 on JB, 114–16, 128–30, 135, 157–60, 185–6, 189–91
 on Johnson, 214–15
 at PSDA, 114–16, 121, 169
 on racism, 234–5
 on Sagan, 213–14
 on Sherrill, 115–16
 at University of the Arts Schoolo fD ance, 324–5n50
Boykin, Hope, 154, 172–3, 182, 190, 204–5, 244–5, 324n50
Be Ye Not, 204
Breckenridge, Eleanor, 31–2, 76
Broadnax, Eugene, 22–3
Brooklyn Academy of Music (BAM), 247
Brothers, Joyce, 97
Brown, Danielle, xxvi
Brown, David, 162
Brown, Joan Myers (JB)
 Ailey's tribute to, 140
 article about Dorsey written by, 10
 athleticism of, xviii
 on attitude, 155

 at Ballet Guild, 32, 45–8
 on being in Philadelphia, 135
 Bell on, 208–9
 Booker on, 114–16, 128–30, 135, 157–60, 185–6, 189–91
 Chase-Hicks on, 134, 170, 200–1
 on Chase-Hicks, 154–5, 171–2
 childhood and education, 27–9
 with Creole Follies, 92–4
 Cuyjet on, 31, 75
 determination and hard work of, 30
 on difference between Danco and PSDA, 117
 at the Dunham School, 58, 92
 on Essie Marie School of Dancing, 11
 father of, 27–8
 on finding Danco instructors, 132–3
 Glazer on, 246–7
 Harris on, 151–2, 216
 Judimar recitals choreographed by, 75
 Kamuyu on, 243–4
 on King, 54
 in Las Vegas, 103–7
 on male dancers, xviii, 118–19
 McIntyre on, 247–8
 on Montreal, 95–8
 mother of, 27–8
 Myers on, 206
 at the National Ballet of Canada, 97, 99
 Nelson-Haynes on, 245–6
 at the New Town Tavern, 95
 on performance props, 72
 physical description of, 44–5
 on her quest for dance classes, 104–5
 on recitals, 110

INDEX

on retirement, 134
on Sagan, 212–13
on segregated
 accommodations, 103
Sisk on, 243
with Steele's *Smart Affairs
 Revue*, 99–107
at Sydney School of
 Dance, 32, 54, 75–6
Thomas Smith on, 247–8
Tudor and, 32, 46–8,
 56–7, 92–3, 99, 129,
 141, 152
on what makes a good
 dancer, 155
Wilson on, 65–6
on Wilson, 132–3
Zollar on, 165–6
See also Philadelphia
 Dance Company;
 Philadelphia School
 of Dance Arts
Brown, Kevin, 120, 125, 140
Brown, Ronald K., 148, 160,
 162, 165, 184
Brown-Swint, Marlisa, xxiv,
 xxvi, 173
Browne, D elores
 on Beatty, 211
 Bell on, 162
 black gay community
 and, 120
 on blacks in ballet, 83, 85
 on Boatwright, 319n40
 childhood and education
 of, 29–30, 32, 41
 Cuyjet on, 84–5
 on Cuyjet, 51
 as Danco instructor,
 121–2, 163
 Jamison on, 45
 Kamuyu on, 244
 Manning St. Charles on,
 123, 172
 in New York, 56–8
 with New York Negro
 Ballet, 81, 87
 on partnering, 57
 student-teacher with
 Judimar, 51–3, 73,
 75–6

on teacher vs. coach, 51,
 83
Bryant Jones, Willa Walker,
 6–9
Bryant, Marie, 97, 104
Buck, Pearl, 71, 318n35
Bullock, Engrid, xxiv, 151–2
Bunche, Ralph, 70–1,
 317n16, 318n35
Bushkoff, Izzy, 92–3
Byrd, Donald
 Bamm, 156–7
 Everybody, 153

Café Montmartre, 95–6, 99
calling, having a, 33–5, 81–2,
 115
Calloway, Blanche, 106
Calloway, Cab, xxviii, 94,
 96, 99, 102, 106, 141
Cameron, Matthew, 140
Cannon, Thomas, 12, 26,
 41–5, 89, 317n11
CAPA. *See* Philadelphia High
 School of the Creative
 and Performing Arts
 (CAPA)
Carnegie, Andrew, 15
Carnegie Hall, 56–7, 82
Carpenter, Louise, 9, 313n20
Carroll, Diahann, 82
caste system. *See* color-caste
 system
caterers to white clientele, 2,
 36, 315n1
Catherine L ittlefield Ballet
 Company, xxvii, 4, 6,
 12, 26, 31, 38, 41–5
Cecchetti technique, 48,
 152–3, 323n22–3
Cecchetti, Enrico, 323n22–3
Chaffee, George, 26, 50,
 57–8, 74–5, 317n14
Charles, Ray, 104, 107
Chase, Lucia, 82
Chase-Hicks, Debora
 with Ailey, 125–6, 140,
 149–50
 Ailey on, 140
 Bears-Bailey on, 211
 Bell on, 177–8

onc horeographers,
 180–1, 325n56
Conway and, 326n11
on dance's role in her life,
 124–6
at Danco company
 audition, 173–5
as Danco's rehearsal
 director, 139, 170–81,
 185, 187–8, 202–3
on D ancemobile
 performances, 212
on JB, 134, 170, 200–1
JB on, 154–5, 171–2
Miller on, 178
on passion, 187–8, 200–1
on rotations, 191
on Sagan, 125, 213
Smith o n, 126
transition from PSDA to
 Danco, 116–17, 121,
 124–5, 169
Vogt on, 178, 242–3
Chilkovsky, Nadia, 168,
 312n10, 321n43
Chödrön, Pema, 327–8n30
Christmas Cotillions, 36, 51,
 59–71, 77, 317n16,
 317n18
civil rights era, 4, 16, 40–5,
 69, 71, 84, 93, 98,
 188–9, 210, 232, 236,
 318–19n35
Clement, Rufus, 16
Cleo Parker Robinson Dance
 Ensemble, 138, 167,
 210, 322n4, 330n1
Club Harlem, 78, 99–102,
 120, 123–4, 320n10
code switching, 3
Cole, Nat King, 102–3, 107
Cole, Natalie, 125
Coles, Charles "Honi," 95
College S ettlement
 Association, 5
Collins, Janet, 34, 46, 84–5
color-caste system, xxvii, 4,
 7, 21, 27, 38–41, 65–6,
 260
Convention Hall, 59, 62, 67,
 70–1

333

Conway, Sarah, 118, 124, 200, 326n11
Cooke, Sam, 100
Copeland, Misty, 252
Cosby, Bill, 55
Cotton Club, 94, 97, 100
Count Basie Orchestra, 68–9
Craske, Margaret, 323n22
Creole Follies, 92–4
Cross of Malta, 59, 62, 69–71, 317n22
Cunningham, Merce, 189
Cuyjet, Marion, xxvii–xxviii, 1, 316n8
 on being too tall, 86–7
 on Cannon, 317n11
 childhood and education, 26
 on "colored elegance," 6–8
 discipline of, 13
 on JB, 31, 75
 Judimar School of Dance, 26, 33, 35, 40, 51–3, 57–9, 64, 72–6, 89, 92, 107–8, 260
 with Littlefield Ballet Company, 4
 on Lowe, 88
 mentor to and influence on JB, 89, 108, 152, 176
 Nelson-Hayneson, 245
 passing and, 4, 88
 recitals and, 110, 123
 scholarship granted to, 34
 as student of Dorsey, 8–14, 34–5, 176, 313n26
 as surrogate daughter to Dorsey, 317n14
 teaching style of, 155, 176
 See also Sydney-Marion School of Dance

D/2, xxv, xxix, 170, 173–4, 177, 182, 190, 198–200, 225, 243, 309–10n8, 325n51
D/3, xxv, xxix, 170, 190, 198–200, 225, 309–10n8, 325n51

Dallas Black Dance Theatre, 167, 243, 330n1
Dance Arts. *See* Philadelphia School of Dance Arts (PSDA or Dance Arts)
Dance Black America, 247
Dance Critics Association, 233
Dance Theater of Harlem (DTH), 72, 89, 119, 224
Dancemobile, 122, 212
Danco. *See* Philadelphia Dance Company (Philadanco)
Danco Dance Camp, xxvii, 159
Danielian, Leon, 67
Daniels, Billy, 99
Dash, Jay, 26, 31–2
David, Hal, 141
Davis, Chloe, 136
Davis, Jr., Sammy, xviii, 55, 99–100, 141
Davis, LeDeva, 76
Davis, Miles, 148, 323n19
Dawkins, Brian, 322n14
Dayton Contemporary Dance Company (DCDC), 147, 157, 210
de Congé, Kay, 95
de Lavallade, Carmen, 33, 84
Deane, Ruth, 18
DeLoatch, Gary, 119–20, 139–40
Delta Sigma Theta Jabberwock, 80, 319n37
Dewey, John, 15
Dickerson, Betsy Ann, 55, 65, 84
Dickey, Carolelinda, 197
Dobravinska, Sonya, 82
Dokoudovsky, Vladimir, 26, 57, 259
Dollar, William, 10, 127
do-or-die dancing, 157, 161–3, 182
Dorsey, Carroll, 10, 20

Dorsey, Essie Marie, xxvii–xxviii
 costumes of, 24–5
 Cuyjet on, 6–9, 34, 41–2, 44
 first studio of, 11
 foundingm embero f Germantown Civic League, 80
 Hines on, 11–13
 JB on, 10, 29, 200
 King on, 11–13
 King with, 313n25
 legacy of, 13, 33–5
 marriages of, 10, 20–1
 memorial service for, 10
 as mentor-mother figure to Cuyjet, 33–4, 40–1, 51, 56, 152, 317n14
 on racism, 86
 recital invitation by, 23
 "Social Graces" column by, 10, 17
 See also Essie Marie School of Dancing
Dorsey school. *See* Essie Marie School of Dancing
double consciousness, 2–5, 14, 17, 39, 310–11n4
Dra Mu Opera Company, 79
Dra Mu Opera Dance Department, 10
dream of becoming professional ballerinas, xxvii–xxviii, 50, 252–4
Drifters, 104, 141
Du Bois, W. E. B., 2, 4–6, 14–17, 29, 48, 50, 62, 64, 69, 77, 127, 311n13, 314n34, 315n1
Du Boisian theory, 4–6, 14–17, 48, 50, 62
Duke Ellington Orchestra, 69
Duke Ellington School of the Arts, 233
Duncan, Isadora, 6

INDEX

Dunham, Katherine, xvii, xxviii, 93, 198, 323n21. *See also* Katherine Dunham School
Dunham technique, xviii, xxviii, 32, 50, 58, 79, 102, 114, 128, 149, 154, 163, 170
Dunning, Jennifer, 153, 161–2, 166, 238–9, 319n39
Dutch National Ballet, 48

Earth, Wind, and Fire, 143
Ebony (magazine), 100–1
Eckstine, Billy, 99–100, 103, 107
ecology, xxx, 4, 169, 259, 329n5
ecosystem, xxx, 259–60
Ellington, Duke, xvii, 95. *See also* Duke Ellington Orchestra; Duke Ellington School of the Arts
ephebism, 148, 168
Essie Marie Dance Clinic, 24
Essie Marie School of Dancing, xxvii–xxviii
 Broad Street location of, 11, 25, 48
 childhood and education of, 25
 closing of, 24
 curriculum of, 11–12
 Cuyjet at, 9, 37, 176
 JB at, 11, 29, 31
 JB on, 11
 recitalt raditiono f, 12–13, 18–23, 25, 48–50
Evans, Tommie-Waheed, 191
Ezralow, Danny, 183–5, 201–4
 Compassion and Revenge, 203
 Pulse, 203
 Xmas Philes, 183–4, 202–4, 326n12

Facciuto, Eugene Louis. *See* Luigi
Faison, G eorge: *Suite Otis*, 43, 242
Falana, Lola, 55, 100
First World Festival of Black Arts, xvii
Fisk University, 84
Flamingo Hotel (Las Vegas), 102, 105–6
Fokine, Michel, 10
Fontaine, Lon, 102
Fontaine Brothers, 100
Fort, Syvilla, 50, 58, 93
Frankie Lyman and the Teenagers, 82
Franklin, Aretha, 100, 143, 167, 238
Frazier, E. Franklin, 69–70, 318n31
Frederick Douglass Memorial Hospital and Training School for Nurses, 313n24. *See also* Mercy-Douglass Hospital
Free African Society, 3
Freedom Theater, 246, 309n4
fulcrum, xxix, 91, 252
Future of the American Negro, The (Washington), 15

Gaines, Cheryl, 27
Gamble, Kenny, xxix, 136–7, 141–3, 322n9–10
Garroway, Dave, 80
Gaymon, Jerome, 9, 51, 54, 61, 63–4, 77, 79–80, 317n18, 317n22, 319n38, 321n18
Gella, Francisco, 161, 326n6
gender discrimination, 234, 314n38
Germantown Civic League, 10, 80
Gibson, Sydney. *See* King, Sydney
Gibson Theater, 19
Givnish, Gerry, 182

Glazer, Susan, 246–7, 324n50
Graham, Lawrence Otis, 315–16n2, 316n3
Graham, Martha, 6, 132, 153, 323n21. *See also* Martha Graham Dance Company
Graham technique, 121, 162, 178, 244
Graves, Joyce, 74
Great Migration, 210–11
Gregory, Dick, 100
grooming ground, 149
Gross, Terry, 141–2

Hall, Arthur, 13, 33–5, 51, 67, 74, 76–9, 155. *See also* Arthur Hall Company
Hall, Reynolds, 319n38
Hand, Erika, 244–5
Harkness Ballet, 48
Harper, Barbara, 55
Harris, Eleanor, 54
Harris, Ellen, 51
Harris, Rennie, xix, 137, 156, 173, 197, 206
 on Ailey, 138–9
 on JB, 151–2, 216
 onP hiladelphiaa ttitude, 137–9, 145–51, 194
 The Philadelphia Experiment, 146–7, 156, 160
 toughness and, 146, 159
 work ethic and, 150
Harrison, J. Michael, 136
Hatchett, Frank, 102
Haughton, Sandra, xxiv, 309n4
Hill, T helma, 81, 212
Hines, John
 Chaffee and, 50, 57
 choreography of, 21–2, 73–80, 120
 on Cotillions, 60–1, 64
 on Cuyjet, 51, 316n8
 on Dorsey, 11–13
 at the Dunham School, 50
 as ice skater, 34

Hines, John—*Continued*
 interest in Afro-Caribbean/
 Afro-Cuban forms,
 21–2, 53–4, 66–7, 74–7
 on private social clubs,
 78–9, 84
 return to Philadelphia, 59
 as student teacher at
 Essie Marie School of
 Dance, 29
 on teaching as social
 work, 77
Holland, Edith, 6–9
homophobia, 235, 316–17n10
homosexuality, 47, 113–14,
 120, 234
Horne, Lena, 95
Horton, Lester, 33, 323n21
Horton technique, 121, 149,
 162, 171, 173, 178,
 244
Huff, Leon, xxix, 136–7,
 141–3, 322n9–10
Huggins, Christopher
 Blue, 174
 Bolero, 166
 Enemy Behind the Gates,
 156

income distribution, 310n2
Ingram, Germaine, 137
Institute for Colored Youth, 3
Instruction and Training
 Program, 114–15, 169,
 171, 173, 182, 190,
 199, 225, 243–4,
 309–10n8, 325n51
International Association of
 Blacks in Dance
 (IABD), xxv, xxix,
 136, 233, 309n6,
 330n1
Iverson, Allen, 322n14

Jabali-Nash, Odara, 191
Jack and Jill of America, 38,
 316n3
Jackson, John L., 236
Jackson, Mahalia, 185
Jackson, Merilyn, 162,
 235–6

Jamison, Judith, xxvii–xxviii,
 199
 advice from, 89
 with Ailey ensemble,
 139–40
 at Judimar, 40, 51–2,
 73–4, 76
 Nelson-Haynes on, 245
 in New York, 58–9, 77
 at the Philadelphia Dance
 Academy, 319n43
 physical description of,
 40, 73, 83–4, 86
 success of, 83–4, 86
 taught by Tudor, 32, 45–6
 on the "Today" television
 program, 80
 trained by Cuyjet, 26, 35,
 55
 Wilson on, 84
Jimenez, Frances (Franca),
 58, 73
Jimmy Fallon, Late Night
 with, 136, 142
Joffrey Ballet, 48
Johnson, Carole, 55, 319n45
Johnson, Fred, 65
Johnson, Louis, 59, 128–30,
 133, 185–6, 188–9,
 213–16, 221
Johnson, Ziggy, 97
Jones, Bill T., 241, 325–6n3
Jones, Eugene Wayman,
 60–73, 80, 101, 246,
 317n18–19, 317n22
Jones, Henry P., 60
Jones, John, xxviii, 32,
 45–8, 75, 259
Jones, Kevin Trimble,
 321n18
Jones, Quincy, 143
José Limón Company, 241
Joshua generation, 188–211,
 230–1, 234, 325n3
Jowitt, Deborah, 166
Joyce Trisler Danscompany,
 206–7
Judimar School of Dance
 graduation pas-de-deux
 at, 73
 Hall on, 33, 35

Jamison at, 35, 51–2, 59
JB at, 75, 92
naming of, 26, 89
Nash on, 74–5, 107–8
recitals at, 52–4, 72–7, 107
reputation of, 40

Kamuyu, Wanjiru, 243–4,
 325–6n3
Katherine Dunham School,
 xxviii, 22, 47–8, 50,
 54, 58, 65, 92–3.
 See also Dunham
 technique
Kay, Lisan, 26, 57
"keep on steppin," 89
Kelly, Gene, 92
Kimmel Center, xxix, 198,
 201, 326n12
King, Jr., Martin Luther,
 188, 214, 318n35
King, Sydney, xvii,
 xxvii–xxviii
 711 video tribute to, 75–6,
 319n36
 childhood and education,
 25
 on Dorsey, 11–14
 at Essie Marie School of
 Dancing, 9, 11, 18–19,
 22, 313n25
 JB with, 176
 on learning to teach,
 13–14
 Wilson on, 54–5
 See also Sydney-Marion
 School; Sydney
 School of Dance
King, Tanisha, 199
Kisselgoff, Anna, 143, 162
Ku Klux Klan, 208, 211
Kylian, Jiri, xxvii

LaMama Theater, 235
Las Vegas, Nevada, 78,
 99–107, 320n12
Lewis, John, 188
Lieber, Jerry, 141
Lingenfelder, Virginia, 30–2,
 34, 41, 43–5, 76, 94,
 141, 152

INDEX

Links, 38, 61, 198, 316n3
Lion King, The, 148
Littlefield Ballet Company, xxvii, 4, 6, 12, 26, 31, 38, 41–5
Littlefield, Catherine, xxvii
Lomax, Walter, 236
Louis, Joe, 102
Lowe, Donna, 58, 73–4, 84, 86, 88
Luigi, 26, 58
Luigi Technique, 26
Lyst, Roxanne, 191, 202

Mabley, Jackie "Moms," 95
Manning St. Charles, Deborah
 with Ailey, 118, 125, 139–40
 on Browne, 123, 172
 childhood and education of, 121–4
 as costume mistress, 122
 at Danco, 121–4, 132, 149–50, 161
 marriage of, 118
 on Pierson, 119
 at PSDA, 163
 on rehearsing, 122, 172–3
 review of, 132
 on Sagan, 125
 Smith on, 126
 transition from being at PSDA to Danco, 116–17
 Vogt on, 170
Mara, Thalia, 57
Mark, Bing, 143
Marshall, Thurgood, 65, 71
Martha Graham Dance Company, 122, 241, 322n8. *See also* Graham technique
Massey, Anna, 126
Massey's School of Dance, 126–7
Mazo, Joseph H., 163–4
McCarthy-Brown, Nyama, 243
McDowell, Yvonne, 82–3
McIntyre, Dianne, 168–9

McIntyre, Trey, 205
Mercy-Douglass Hospital, 10–11, 63, 80, 313n24
Method acting, 209–10, 326n18
middle-class, 1–2, 5, 9, 17, 28, 36, 54, 63–4, 69, 310n2, 320n12
Miller, Bebe, 178
Miller, Warren P., 217
Mills, George, 85
Mingus, Charles, 164, 238–9
Mitchell, Arthur, 46
Monroe, Marilyn, 94
Monte, Elisa, 138, 238, 241
Montreal, Canada, 95–9, 320n6
Mordkin, Mikhail, 10, 317n14
Morris, Mark, 325–6n3
Moses generation, 188–9, 201–2, 205, 208–23, 242
MOVE, 146, 322–3n15
Murray, Jack, 101
Murray-Brown, Melva, 72, 74
Myers, Julius (JB's father), 27–8
Myers, Milton, 121, 148, 156, 163, 169, 173–4, 183–5, 201, 204–7, 216, 241, 244
 as company class teacher, 170–1
 Echoes, 162, 174
 Horton technique and, 162
 on JB, 154–5, 206
 on Joyce Trisler Danscompany, 206–7
 Love 'N Pain, 143
 Men Against the Wall, 238
 as mentor, 205
 Pacing, 205
 Variation #1, 162
 Vogt on, 184
Myers, Nellie (JB's mother), 27–8

Nash, Joe, 58, 64, 73–4, 77, 80, 93, 107–8, 128, 191, 221, 327n28
Nassi, Vaino, 74
National Association for the Advancement of Colored People (NAACP), 11, 14, 16, 19, 42, 318–19n35
National Ballet of Canada, 97, 99
Negro spirituals, 208
Nelson-Haynes, Lisa, 245–6
Netherlands Dance Theatre, xxvii
New Town Tavern, 93–5, 102
New York City Ballet, 87, 122, 163–4, 193, 325n53
New York Negro Ballet Company, 81–2, 87, 212
Nicholas Brothers, 95
Nicks, Walter, 58, 74, 80, 162
Noble, Joe, 92, 93–5, 106

Obama, Barack, xxx, 167, 188, 229, 231, 316–17n10

Paradigm, 241
Parham, Leigh, 58
Parker, Mora Amina, 191
Parks, Rosa, 188
Parnell, Tony, 120, 122
pas de bourrée, 93–4, 110, 119, 168, 320n2
pas de deux, 73–4, 87, 94, 132, 158
passing, racial, xxviii, 4, 14, 36–46, 55, 57, 65, 88, 98, 317n13
Patterson, Nadine, 140, 322n6
Pavlova, Anna, 6
Pendergrass, Karen. *See* Still-Pendergrass, Karen
Pendergrass, Teddy, 176, 322n9

Pennsylvania Ballet
Company, 45, 192,
229, 325n53, 328n34
Perryman, Al, 120
Philadanco Way, xxiii, 183,
200
Philadelphia attitude,
144–52, 194
Philadelphia Ballet Guild,
xxviii, 32, 45–7
Philadelphia Cotillion
Society, 10, 59, 70.
See also Christmas
Cotillions
Philadelphia Dance
Company (Philadanco
or Danco)
Booker on, 128–30
Chase-Hickson, 124–5
Company classes at,
121–2, 152, 156,
169–71, 178, 192, 244
comparisons with/to
Ailey, 138–40, 147,
149–50, 223–4, 242–3
dancers hired by, xxvi
description of, xxiii
enrollment at, 133
finances and, 223–9
Hand on, 244–5
home seasons of, xxix
male dancers in, xviii,
118–20
Manning St. Charles on,
121–4
naming of, 89
opening of, 116–18
reviews of, 130–2, 137,
143, 153, 156, 161–3,
166–9, 205, 237–42
Thomas Smith on, 126–8
tours by, xxvii, 129, 153,
189–96, 200, 224, 226,
229, 232–5, 245
transition from PSDA to,
116–17, 121, 124–5,
169
Vogt on, 242–3
Young Audiences
program, 133
youth emphasized by, 118

See also D/2; D/3; Danco
DanceCamp;
Instruction and
Training Program;
Philadelphia/
Philadanco aesthetic
Philadelphia High School of
the Creative and
Performing Arts
(CAPA), 76
Philadelphia Negro, The (Du
Bois), 4–5, 14–15, 17,
311n12–13
Philadelphia/Philadanco
aesthetic
African-American
elegance and, 166–9
Booker on, 135
choreographers and,
180–6, 325n55
continuity and, 169–86
ensemble emphasis of,
124, 155–7, 189–90,
203
essential premise of,
131–2
Philadanco Symposium
(2007), 211
Philadelphia attitude and,
144–52, 194
professionalism and, 150,
157–64
raw energy and, 144–5,
148–52, 159, 161
"recycled people" and,
169
show business élan and,
164–6, 196
studio-as-conservatory
approach and, 169–77
technical training and,
152–5
toughness and, 144–52,
159, 161
Vogt on, 135
work ethic and, 138, 145,
149–52, 155, 157,
162–3, 169, 190
Philadelphia School of
Dance Arts (PSDA or
Dance Arts), xxiii

Booker on, 113–16
Cuyjet with, 27
founding of, xxvii
Judimar and, 108
Nelson-Haynes on, 245
opening of, 108–10
Philadelphia School
approach of, xxix
recital traditional t, 56, 71,
110–11, 123–4
Tenth Anniversary
Recital, 111–12
transition to Danco from,
116–17, 121, 124–5,
169
Philly Sound, xxix, 136–7,
141–3. *See also*
Philadelphia/
Philadanco aesthetic
Pierson, Harold, 58–9, 99,
112, 116, 119–20, 130,
132, 150, 163, 182, 188
Pitts, Andre, 94, 102
Plessy vs. Ferguson, 16
Poitier, Sidney, 62
Potts, Essie Marie.
See Dorsey, Essie
Marie
Powell, Adam Clayton, 42
Preston Street, xxiii, 117,
130, 133, 140, 175,
178, 224
Primus, Pearl, 188–9,
216–18, 221, 247,
327n28, 327n30
Hard Time Blues, 216–17,
222
The Negro Speaks of Rivers,
216
Strange Fruit, 216–17, 222

racism, 15–16, 27–9, 35–6,
43–7, 86–8, 98, 108,
195, 210–12, 230–6,
261–2, 310n2, 316–
17n10, 317n13, 318n31
Rameau, Pierre, xvii
Randolph, A. Philip, 71,
318–19n35
Reardon, Christopher, 164,
166

INDEX

recycled people, 117, 121, 137, 169, 188, 191, 252
Redding, Otis, 143
reviews of Philadanco, 130–2, 137, 143, 153, 156, 161–3, 166–9, 205, 237–42
Rhoden, Dwight, 142
Rickey, Branch, 71, 318n35
Riley, Gwendolyn, 53
Robbins, Jerome, 48
Robinson, Cleo Parker, 138, 167, 210, 322n4, 330n1
Robinson, LaVaughn, 137
Roosevelt, Eleanor, 59, 67, 71, 318n35
Russian School, 48, 153, 323n23

711 (video tribute to King), 75–6, 319n36
Sagan, Gene Hill
 Ailey on, 140
 Bears-Bailey on, 156–7, 211
 on being a dancer, 33–5
 Booker on, 213–16
 Chase-Hickson, 124–5, 150, 213
 childhood and education, 41, 59
 choreography of, 182, 206–7, 211–12, 241, 327n21
 dance as his home, 87
 death of, 120, 211
 expatriation and, 87, 212
 JB on, 212–13
 La Valse, 125, 142, 182
 with New York Negro Ballet, 81
 Ritornello, 166, 175
St. Charles, David, 117–18, 120, 131–2, 140
St. Denis, Ruth, 6, 20
Savar Dancers, 96, 98
Savar, Bill, 95
Schmitz, Nancy Brooks, 317n11
Scott-Heron, Gil, 136

segregation, 1, 12, 20–1, 55, 60, 63, 98–105, 112, 189, 258–9, 313n26, 316n6, 318–19n35, 320n12
Sena, William, 45
September 11, 2011, 203
Shawn, Ted, 6, 20
Sherrill, Mary Johnson, 93, 109, 111, 115, 118, 226, 320n3
Shook, Karel, xxviii, 58, 93, 152
Shorty, Carlos, 120, 213–15
Simone, Nina, 120
Sisk, Antonio, 243–4
Sister Sledge, 93
Sketches of the Higher Classes of Colored Society in Philadelphia (Willson), 4
skin color. *See* color-caste system
Sledge, Flo, 93
Smith, Clyde "Jo-Jo," 102
Smith, Muriel, 85
Smith, Raymond L., 68
Smith, Will, 197
Sounds in Motion, 247
Spider-Man: Turn off the Dark (musical), 201–2
Squirrel, Jenny, 6–9
Staten, Jay, 174
Steele, Larry, 78, 94–5, 97, 99–102, 106–7
Steele's Smart Affairs, 75, 94–5, 97, 99–102, 106–7, 320n6, 320n10
Steffens, Lincoln, 15
Stewart, Ellen, 235
Still-Pendergrass, Karen, xxv, 168, 215, 226, 322n9
Stokes, Adrian, xvii
Stoller, Mike, 141
survival, 3, 59, 83–90, 123, 157, 259, 313n26, 328n34
Suthern, Orrin C., 68
Sydney School of Dance and, 25, 50–4, 62, 65–6, 71–81, 85, 88–9, 94, 108–10, 123

Sydney-Marion School of Dance, 22, 25–6, 40, 48–51

talented tenth, 5–6, 14, 17, 62, 127, 313n17
Tamiris, Helen, 247
tap dance, 8, 12–13, 17–18, 20–2, 114, 137, 232, 245
Taylor, Paul, 189, 202, 241–2
Taylor-Corbett, Lynn, 177, 240
Terigian, Virginia, 31
Terrell, Mary Church, 71, 318n35
Tesfa-Guma, Tesemma Gabriele, 326n5
Thomas, Pat, 121, 162–3
Thomas Smith, Vanessa, xxiv, 309n3
 on auditioning for Danco, 175, 179
 on being in Big Apple Circus, 248–9
 childhood and training of, 121, 126–7
 on closeness of Danco dancers, 126
 as costume mistress, 122
 on dream of being a ballerina, 127
 on JB, 179, 187, 192–3, 252
 at PSDA, 117
 on race, 192–3, 228
Thompson, Ahmir "Questlove," 136–7
Thompson, Robert Farris, 148, 168, 323n17
timing, importance of, 83–90
Tobias, Roy, 132
Tobias, Tobi, 167–9
touring, xxvii, 81–2, 96–102, 129, 153, 189–96, 200, 224, 226, 229, 232–5, 245
Town Hall (Philadelphia), 12, 53, 72–3, 129
Training Program.
 See Instruction and Training Program

Tudor, Antony, xxviii, 76
 Cecchetti technique of, 323n22
 color barrier and, 45–6
 Cuyjet and, 26
 Jamison on, 59
 JB and, 32, 46–8, 56–7, 92–3, 99, 129, 141, 152
 as late bloomer, 30
 teaching style of, 46
 Wilson on, 54
Tuskegee Institute, 15
Tyven, Gertrude, 67

University of Pennsylvania, 4, 15, 311n13
University of the Arts, xxix, 113, 179, 182, 184, 190, 207, 230, 246, 310n10, 319n43, 324–5n50
Urban Bush Women (UBW), 165

Vaganova, Agrippina, 323n22
Vaganova technique, 323n22
Vanderbilt, Alfred Gwynne, 71, 318–19n35
Vaughan, Sarah, 100
Village Voice, 156, 163
Vogt, Tracy, 135, 154, 158, 170, 173–4, 176, 178, 183–4, 191, 194, 205, 207–9, 232–3, 242–3, 245, 324–5n50

Wade, Bootsie, 104
Walnut Street Theater, 131, 212
Walzer, Jim, 101

Wanamaker's Department Store, 38, 41–3, 61, 66, 88, 316n5
Warrington, Karen, 75, 319n36
Warwick, Dionne, 100
Washington Ballet, 233
Washington, Booker T., 15–17, 48, 50, 313n17, 314n34
Washington, Denzel, 38
Washington, George, 315n1
Washington, Lula, 167, 322n4, 330n1
Waters, Ethel, 95
Watson, Dawn Marie, 191
Waymon Jones, Eugene, 246, 317n18
Webster, Daniel, 131
Wharton, Susan P., 4–5, 7, 15
White, China. *See* Murray-Brown, Melva
White, Geraldine, 47
White, Slappy, 95, 101
White, Walter, 42, 65
Wilk, Tom, 101
Wilkerson, Isabel, 16, 310n1, 316n6, 320n7
Wilkinson, Raven, 46, 59, 84, 252, 317n13
Williams, Ann, 322n4, 330n1
Williams, Leroy "Pops," 99
Williams, Saundra, 112
Willson, Joseph, 4
Wilson, Billy, xxvii–xxviii, 32, 45–8, 51, 56, 77, 85, 112, 120, 150, 182, 216, 241, 259, 316n4
 on black community's role in developing dancers, 81
 on Christmas Cotillions, 36–7
 on Cuyjet, 38
 on expatriation and, 87–8
 on JB, 65–6
 JB on, 133
 on King, 54–5
 on Lowe, 84
 as member of Moses generation, 212
 Nash on, 75
 on Tudor, 47–8
 on Wayman Jones, 65
Wilson, Jackie, 104, 107
Wilson, Nancy, 101
Winston, Morton, 140
Wise, Tom, 236, 310n2, 328n39
Work, The, 179
World War II, 6, 22, 24, 28, 48, 318–19n35
Wray, Sheron, 325–6n3

YMCA, 18
You Chan Yang, 59, 67
YWCA, 42, 57, 314n27

Zane, Virginia. *See* Lingenfelder, Virginia
Zankel, Bobby, 136
Zollar, Jawole Willa Jo
 Batty Moves, 156, 165
 Hand Singing Song, 236
 on JB, 165
 on "a public learning," 241
 Walkin, Talkin, Signifyin Blues Hips, Lowdown Throwdown, 143, 196

BRENDA DIXON GOTTSCHILD, author of *Digging the Africanist Presence in American Performance*, *Waltzing in the Dark*, and *The Black Dancing Body*, is professor emerita of Dance Studies at Temple University and a former senior consultant and writer for *Dance Magazine*. She lectures nationally and internationally, using her own dancing/thinking body to illustrate her ideas and blur the division between practice and theory.

9780230114081